Mitch Tonks

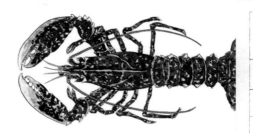

fish

the complete fish & seafood companion

Photography by Chris Terry
Illustrations by Richard Bramble

PAVILION

First published in the United Kingdom in 2009 by
Pavilion Books
Old West London Magistrates Court
10 Southcombe Street
London, W14 0RA

An imprint of Anova Books Company Ltd

Design and layout © Pavilion, 2009
Text © Mitch Tonks, 2009
Photography © Chris Terry, 2009, except page 271 © Farrell Grehan/CORBIS
Illustrations © Richard Bramble, 2009

Commissioning editor: Emily Preece-Morrison
Designer: Louise Leffler at Sticks Design
Cover designer: Georgina Hewitt
Production: Rebekah Cheyne
Home economist: Valerie Berry
Stylist: Wei Tang
Photographer: Chris Terry
Photographer's assistant: Karl Bridgeman
Illustrator: Richard Bramble
Researcher: Helen Stiles
Copy editor: Kathy Steer
Proofreader: Alyson Silverwood
Indexer: Patricia Hymans

ISBN 978-1-862058-33-0

A CIP catalogue record for this book is available from the British Library.

10 9 8 7 6 5 4 3

Reproduction by Dot Gradations, United Kingdom
Printed and bound by Craft Print, Singapore

www.anovabooks.com

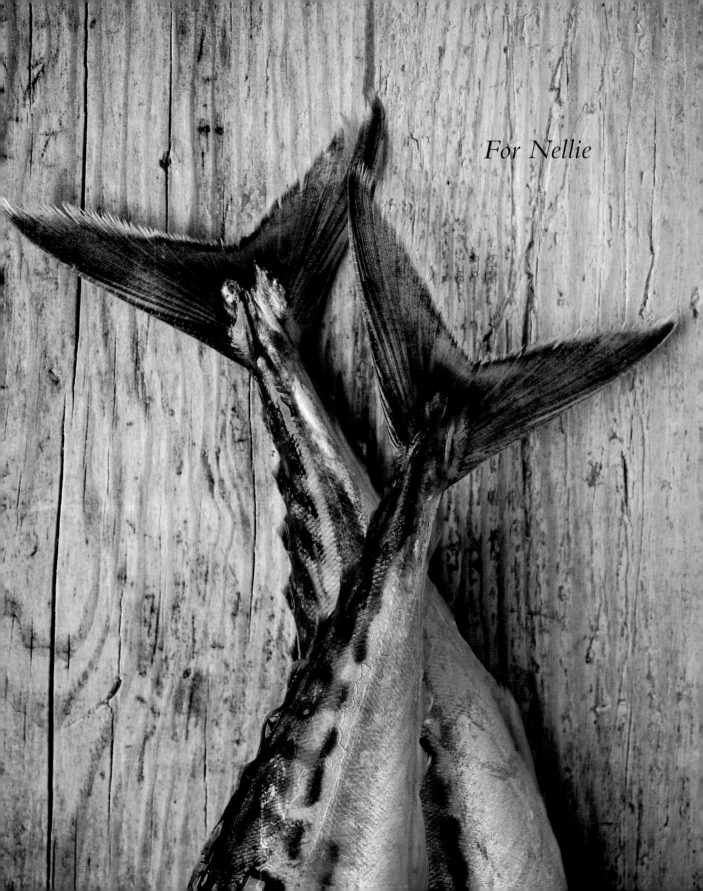

For Nellie

contents

introduction

I think my love of seafood and the sea became apparent to me when I was about six or seven years old – it's hard to tell from the photo of the skinny me holding a rod and a lovely mackerel on the beach at Portmelon in Cornwall when I was on holiday, but it looks around that age. At that time I remember I was a keen fisherman, and I would often venture out on the mud flats of Black Rock in Weston-Super-Mare where I grew up to look at what the ebb tide had left in the fishermen's static nets. It was often only a few dabs – a wonderful fish seldom seen these days, but which always made a good tea for my grandmother and me, just fried in butter with salt and pepper. It's those simple dishes that I remember most when cooking for myself; you just can't beat a piece of grilled fish with some oil or butter and a salad of the season. A good seafood dish conjures up romantic notions of the sea – the fishermen and bustling ports working through the night to land the catch in readiness for the morning auction where the fish will start its journey to homes and restaurants.

Fish and fishing is a complicated subject – even more so today because we have realized that it is a finite resource. It's not just the tricky bones, the cooking times or wondering if something is fresh that puts people off, it's understanding about the all-important issue of sustainability. But this shouldn't deter the modern cook, as there's good news out there and this book to help.

My time working as a fishmonger, chef and restaurateur has given me the most incredible insight into how people see fish: their concerns about how to cook it, how their choices are influenced by reading about environmental issues, and their lack of knowledge about fish and seafood in general. Fish has always seemed difficult to the home cook, and I have encountered many people over the years who love eating it, but are unsure about what to do with it. Seafood is very quick and easy to cook, and once you've mastered the basics and found a good fishmonger you can move on quite quickly to become an adventurous fish cook.

In the world of professional cooking a chef with good seafood skills and knowledge is highly regarded – the same applies, I think, to the home cook.

You may be thinking 'why another fish book?', but I recognize that tastes and issues change with the times, just as my experience and ongoing enthusiasm have grown over the years. I often spend mornings at the fish market across the water from my house and I still get as excited about a box of fish now as I did the very first time I thought about opening my fishmonger's and restaurant, over 10 years ago. It's this enthusiasm that carries me forward, and I want the cooks who read this book to get as much pleasure from cooking and eating seafood as I do. All the recipes are simple to do at home, so whether you're a novice or the most confident cook I hope you will find the results impressive.

I've taken a different approach with this book and have majored on the most widely eaten species. I wanted to add to the magic of enjoying a piece of fish by giving you some knowledge about where and how it was caught, the particular environmental issues associated with the species and a defined taste description for each fish. I have worked with an expert panel, including a wine sommelier and experts at Young's Seafood, to put together taste descriptions similar to the ones used for talking about wine. I hope this approach will give you a better understanding of the seafood you are eating.

I have also included the seasonality of each fish as well as their international names, so when you travel abroad you can recognize your favourite fish in the market. And if you have ever wondered just how much fish you get per kilo when you buy it, and how many calories, how much fat and that all-precious omega-3 are actually in each fish, I've included that too.

The way to use this book is to read through the front section, get yourself fully acquainted with the buying guide, and then enjoy cooking each species of fish. Find your favourites and use the stories behind the fish to enhance the magic of eating. While putting these recipes together, I felt that I was on a mission to get people to enjoy more seafood, and if I pass on enough knowledge for you to enjoy some of the pleasures I do, then I'll have been successful!

Mitch

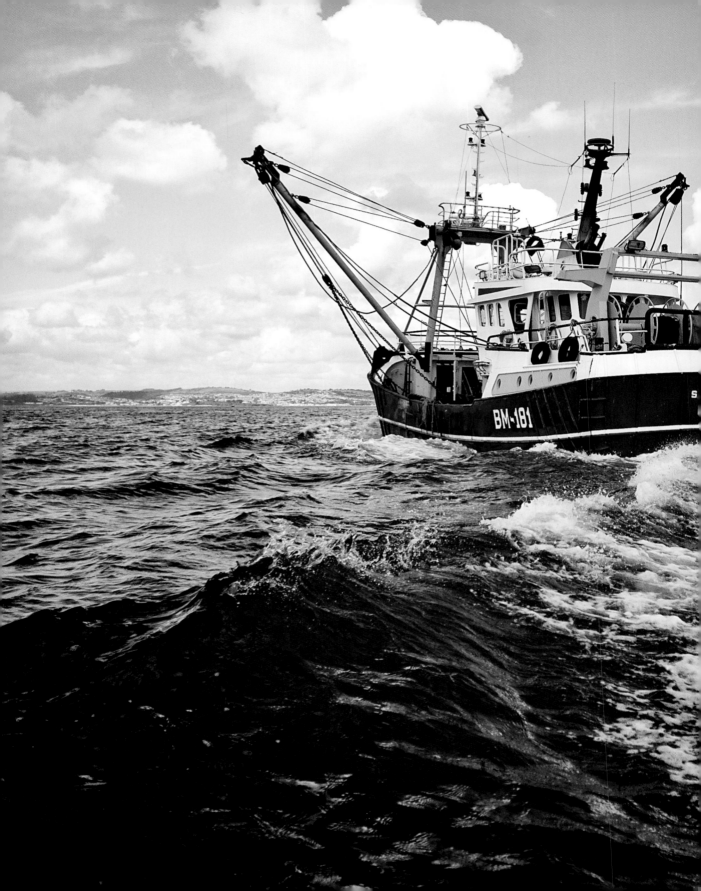

part one

fish – the perfect food

Seafood is exciting because it's healthy, tastes fantastic and is simple to cook – it is today's star ingredient, and there's nothing nicer than sitting down to a freshly cooked piece of local fish. Seafood is regional and different places, ports and countries will celebrate and enthuse about their best local fish, including when it is in season and when it is at its best. So gathering knowledge of your local and regional specialities will stand you in good stead as a seafood cook, and I hope that while reading this book you will not only become more knowledgeable about your favourite species, but will also be inspired to try new ones as well.

I say seafood is exciting because there are so many different species available to eat and enjoy. It's exciting to walk into a fishmonger and take in that lovely ozone smell of fresh fish and enjoy the daily surprises of the ever-changing fish counter. There are so many ways you can cook a piece of fish, from baking and frying to roasting, barbecuing and grilling. Seafood is naturally the easiest thing to cook because it needs no adornment – simplicity is all when it comes to cooking fish. Flavours like garlic, olive oil, sea salt, fresh herbs – rosemary, basil and oregano – and lemon are all you need to make a fabulous fish supper. I love to eat meat as much as seafood, but I can honestly say that a lunch or evening meal of fish suits me extremely

well, as I feel less full and sluggish. Fish is very healthy and nowadays we read endlessly about the properties of omega-3 – the wonderful oil in fish like mackerel, tuna and sardines that is beneficial to our hearts, brains and emotional and physical wellbeing.

In today's world, when time seems to be short and there is less opportunity for cooking, or even sitting down and eating, the speed and ease with which you can cook a piece of fish is invaluable and lets you prepare fresh delicious food for even the biggest family. A fish stew takes no time to prepare, a handful of fresh prawns tossed in freshly cooked pasta, or fish fillets dipped in milk, dusted in flour and fried until crisp are some of the quickest and most delicious recipes I know. And for the lazy cook, roasting a fish couldn't be easier – roast a whole sea bass or sea bream in the oven with rosemary and garlic for just 20 minutes while you relax, chat and have a glass of wine before dinner.

In recent years, food scares and unsettling stories in the news about the way our food is produced have been almost a daily occurrence, but the great thing about seafood is that everybody really can still connect to its provenance. Next time you head for the beach, take a rod or a line with you and catch yourself some fish – enjoy the experience, as anyone can do it and the fun is immeasurable.

"An old fisherman once said to me: 'never eat plaice until it's tasted May waters.' Plaice from January to March are thin and full of roe, in June they are fantastically plump and delicious. I've been doing this job for 27 years and this cycle has not changed. Eating your fish seasonally is the way to go as you'll get your fish at its prime."

Martin Purnell, Channel Fisheries Buyer

twenty-four hours in a fishing port

From my window I look straight up the main channel at Brixham harbour and the fish market is virtually outside my door. It is another world out there and I'll often stand with a cup of tea in my hand and imagine the many fish markets all over the world that are just a hive of activity while everybody else is asleep. The fish market is an ever-changing place, sometimes there is plenty of fish while at other times there is no fish – it depends on the weather.

There are few people who would get up in the morning and go to work not knowing what their pay packet was going to be or indeed what conditions were likely to be at the office. I am sure that on a good day fishing from a small day boat in glorious sunshine is a pleasure, but mortgages have to be paid and families fed, and fishermen can't choose their days, so they have to battle it out in all but the very worst of weathers. I once stood in the wheelhouse of a 30-metre trawler and asked my mate Graham Perkes, who has skippered for many years, "What's it like to be in here when it's rough?" and he said "Horrible". I knew he really meant it. In my own experience as a sailor, I'm afraid I can only imagine what real bad weather is like, as I run to the nearest port for shelter at the first sign of any weather warning. These guys just carry on fishing. In extreme conditions they have to haul the gear in, batten down the hatches and ride the storm out. Something to think about next time you buy a piece of fish – especially in winter.

I have come to realize that the business of fishing is a 24-hour affair. Boats will arrive at the harbour throughout the day and night while the workers on the dockside prepare to help unload the catch and then grade the species into their various sizes in readiness for the morning's auction. The auction here at Brixham is a verbal one, unlike many modern fish markets, which have electronic systems. It is quite a scene to behold, as the auctioneers struggle to get the highest price for the fish – as much for themselves as for the fishermen, as their pay is also based on a percentage of what the day's landings are worth. Auctioneers have to be strong characters, not just to keep the auction going but also to keep the behaviour of the merchants in check and focus everyone's attention at all times. I think there are few people who could apply themselves to this very special skill.

The auction hall is thriving with activity. There are fish merchants with their own special customers whose requirements and needs have to be fulfilled, as well as buyers who have cornered special markets and are looking for a particular species or size of fish. These buyers often go head-to-head for the same fish and are prepared to pay something different to suit their individual customers. It is this commercial secrecy that makes it so fascinating – some of the buyers will even be trying to buy the same fish to sell to the same customer without the other even knowing. Naturally the buyers want the fish at a low price and on the

Right: Velvet crabs being landed at the harbour. The crabs are kept alive in large nets suspended in the water over the side of the boat, before being landed, boxed, auctioned and finally sent on their journey to markets and restaurants.

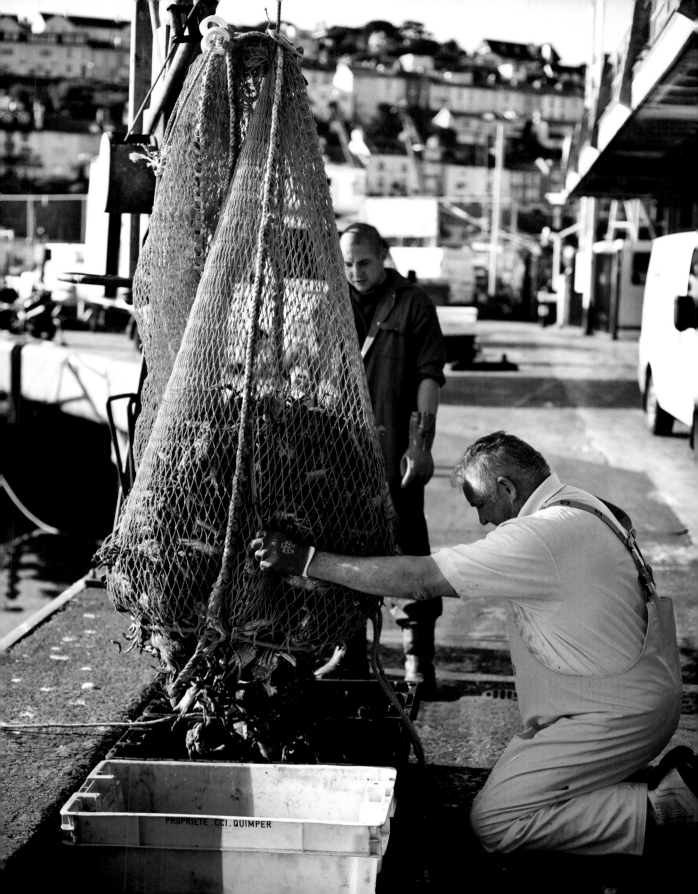

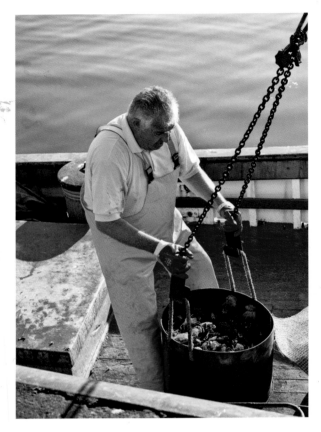 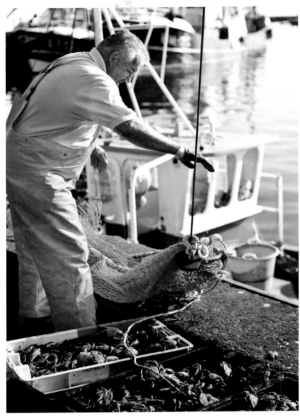

Above: The velvet crab is a wonderful species of small crab with a velvety feel to its shell (hence the name). It will most likely end up in a 'fruits de mer' platter or in a delicious soup.

other side are the fishermen, who want to sell it for as high a price as they can get. At times it can be a fairly stressful place, but these buyers have been doing it for years – they have nerves of steel, good judgement and rarely lose their cool. Once the merchants have secured their purchases, the fish are taken to their premises, where they are regraded, filleted and packed and sent on to the customer. Sometimes the customer will be another fish merchant working on another fish market.

The lorries waiting on the quayside to take the fish on to their destination are usually gone by lunchtime and those fishermen heading back out to sea are refuelling their boats and taking on supplies for the next 6–7 days' fishing. Meanwhile the merchants take care of selling the day's fish and the market workers hose down the auction hall and refrigerators in readiness for the next day's auction and the next boat to land.

So you see, fish can be handled many times before it gets to the fishmonger, and an army of workers is involved in getting it there. And we must not forget the harbour master, the security guards, the fishery patrol vessels, the shipwrights and the engineers who also play an important part in getting our fish to us. Even though all these people play very different roles and all want different things, they will all end up in the pub together at the end of the day! This is what makes fishing towns real communities – everybody really does need each other.

Ian Perkes, export merchant

What sort of fish do you export?
Mainly sole, squid, cuttlefish, scallops, monk, turbot, brill, pollack and ray wings.

Who are you selling to?
Our main markets are France and Italy. The Italian waters are fished out and they had to close the Adriatic due to pollution so they couldn't fish it. The Italians are big fish eaters so they look to source fish from wherever they can. The French have reasonable stocks but don't have trawlers. Beam trawlers are primarily from Holland and Belgium. The French also eat a lot of fish but they can't catch enough for their demand so they have to source fish from elsewhere. Most continental European countries can't catch enough fish to cater for the demand in their own markets.

Which species is in highest demand?
It's all seasonal. In June we do good quantities of small cuttlefish for the Italian market, but May to July is usually a slack time for the fishermen as fishing is poor, so they tend to work on their boats. Then we start getting the squid from August/September through to March/April, again that's good business for the Italian markets. Come September through to Christmas, over the last year or so we've seen an incredible amount of anchovies landed in Brixham, which is a serious bonus for the fishermen as they make incredible money selling them into the Spanish markets. Dover sole are pretty much all year. The Brits prefer their sole plate size, whereas the French and Italians prefer smaller ones so we export all those. Scallops are always very popular. Gurnard we sell to the Belgian market – don't know why! The Belgians like good-quality sole, gurnard, ray wings and scallops. Some brill is sold to our domestic market, mainly for the restaurant trade in London, but the majority is exported, mainly for the French and Belgian markets. The French will take pretty much any fish, though primarily they are after sole. Further south they are after the line-caught bass.

Could you survive without exporting?
I'm from a fishing family – my father and grandfather were fishermen, and they had to dump a lot of the fish they caught because there simply wasn't the market for gurnard, monkfish or Dublin bay prawns (langoustine). Dad would take a couple of large sweet jars to sea with him and fill them with the Dublin bay prawns that would have been dumped. He'd cook them and bring them home for us. We'd eat them like sweets because there was no market for them, whereas now there is pretty much a market for everything. With the likes of Mitch promoting locally caught fish it can only be good for trade. With the industry in a bit of a crisis at the moment with the fuel issue, the more money the fish makes, the more chance the boats have of staying at sea. We would love to sell more fish around the UK, currently 85% to 90% of what we buy is exported. It's the way it is – we have a market throughout Europe who love our fish. There's no fish and chip shop in Brixham that I know of that uses Brixham fish, they all use frozen-at-sea cod fillets from Iceland or Norway and yet they've got some of the finest fish in Europe on their doorstep! The French are much bigger fish eaters than the Brits. I asked a French customer why they buy so much fish and he summed it up by saying that 80% of the French population would sooner have a fish on their plate than a piece of meat. The market is changing though, as people are beginning to make fish a part of their diet for health reasons.

What's your 'desert island' fish?
My king of fish is a turbot because you don't have to do a lot to it – grill it with a bit of olive oil, salt and pepper – job done! Absolutely delicious!

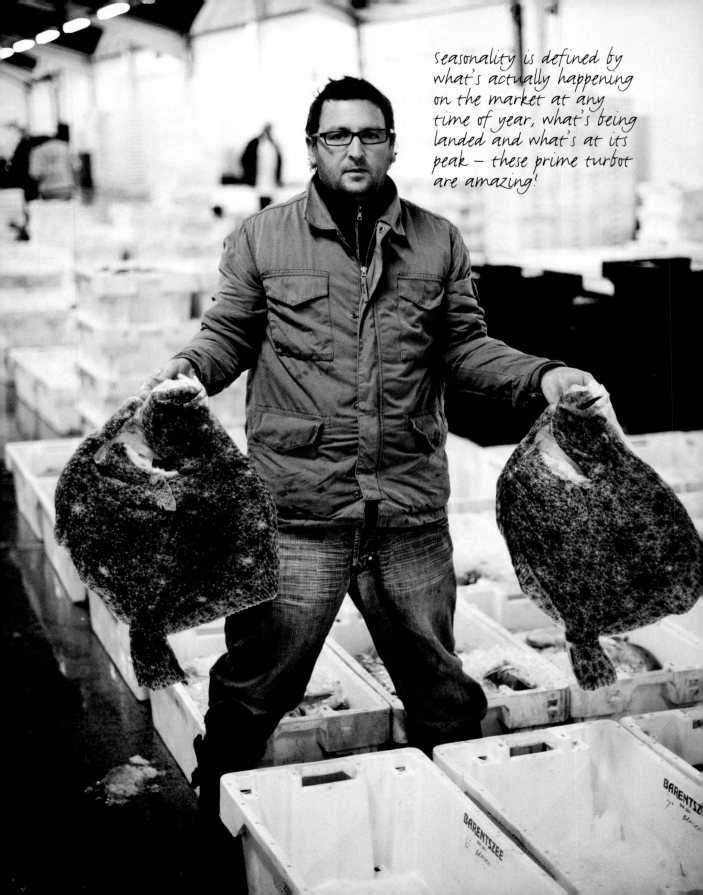

seasonality is defined by what's actually happening on the market at any time of year, what's being landed and what's at its peak – these prime turbot are amazing!

Ultimately, it's the expertise of the buyers, like Nigel here, that secures the very best fish for consumers.

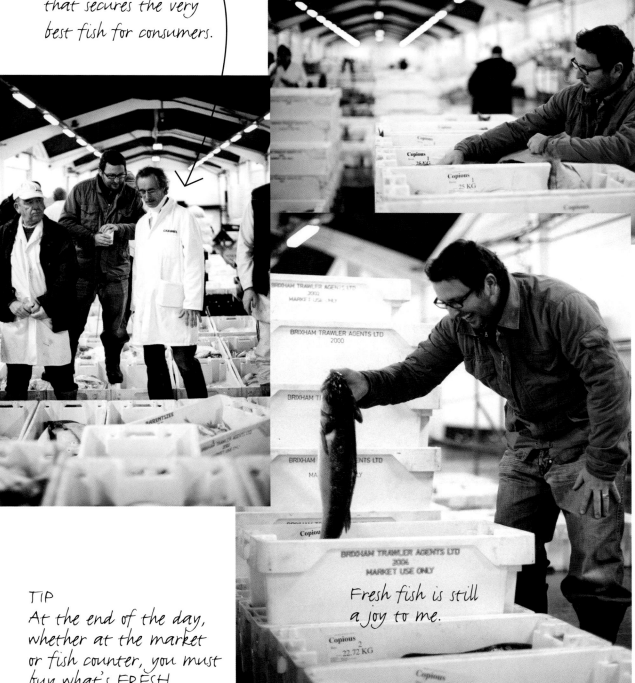

Fresh fish is still a joy to me.

TIP
At the end of the day, whether at the market or fish counter, you must buy what's FRESH.

a brief look at how fish are caught

It's important to understand a little about how fish are caught to help you make the right choices of which fish to buy. There are myths and confusion that surround many fishing methods and in today's world where environmental care and respect is integral to everything we do, often fishermen and certain types of fishing seem to take the brunt of criticism. This book is about fish cooking, but the modern fish cook may be frightened away from cooking seafood by a lack of understanding of certain catching methods, so here is a brief look at how fish are caught. I don't intend to go into great depth on fishing methods here, but if you would like to find out more information on fishing methods then there are great resources, such as the Sea Fish Industry Authority (www.seafish.org.uk), where you can find out detailed information about quotas and commercial fishing.

Fishermen use a variety of methods to catch fish. These range from the traditional rod, line and tackle to nets that are towed behind boats that catch fish at different levels in the ocean dependent upon what the

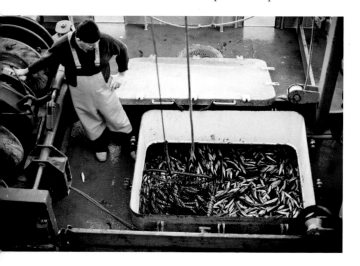

fishermen are targeting. Fishermen catching shellfish will use pots and creels to trap their catch.

Many chefs describe their fish as 'line caught' and in numerous cases this is just virtually impossible as demand for line-caught fish totally outstrips supply, so you need to be careful. Many fisheries that use the rod and line method have a programme of tagging the fish and gills to genuinely authenticate it as the 'real deal'. Line-caught fish are the best as the fish have suffered less stress and have been handled singularly and carefully rather than being emptied from the cod end of a commercial net.

The demand for day boat fish is on the increase, and rightly so, as a day boat by definition fishes for just one day. The fish are hunted, caught and handled carefully by the fishermen, and the catch is returned to the quayside in the evening. However, in winter these small boats can find the weather particularly challenging and their catches are very limited. There are also species, such as sole, turbot and monkfish, that these boats do not catch in quantity, prime species that are in demand. In the summer when the weather is hot, a small boat without ice or an ice-making plant will be challenged by the weather as the temperature quickly melts the ice and spoils the fish.

Along the south coast of England much of the fishing is made up of beam trawlers. These boats tow heavy gear across the ocean floor, targeting valuable species like sole, turbot, monkfish, brill and scallops. Recently, there has been a desire to lower the impact of beam trawling and many fishermen are improving their gear to make it lighter and fish more efficiently, in turn using less fuel. This means that as the fisheries move towards more sustainable methods, fishermen will start to adapt to lower-impact methods of fishing.

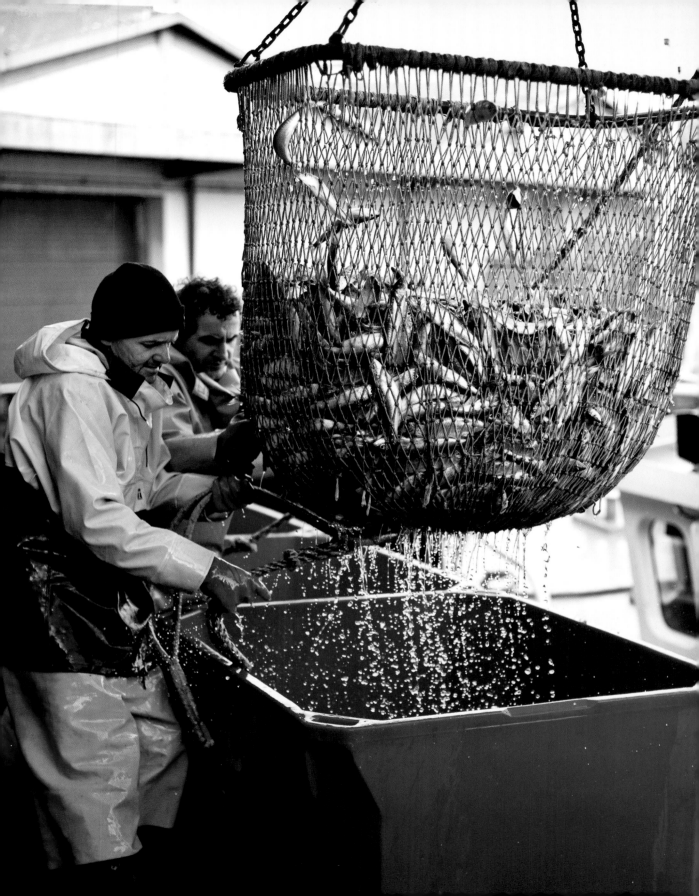

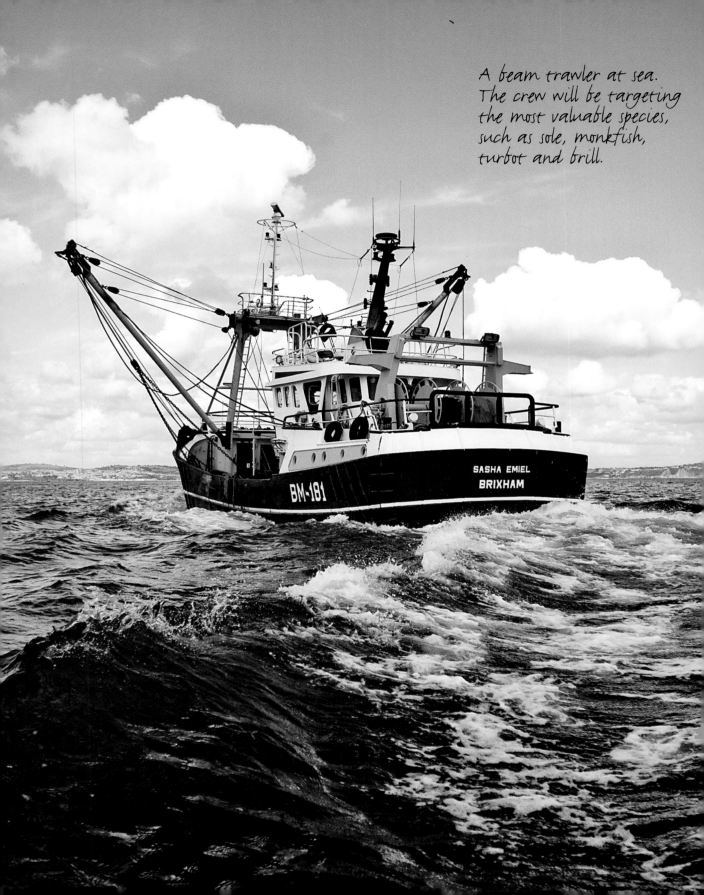

A beam trawler at sea. The crew will be targeting the most valuable species, such as sole, monkfish, turbot and brill.

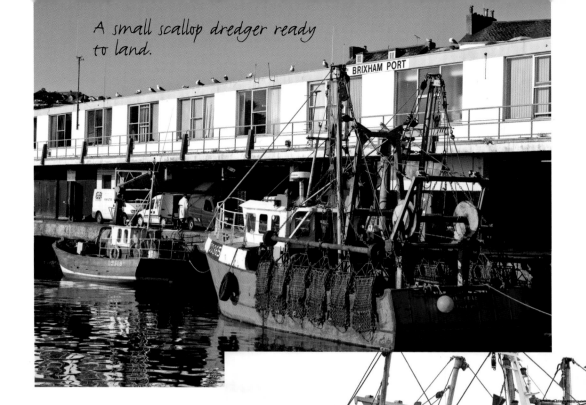

A small scallop dredger ready to land.

A typical day boat.

Beam trawler landings make up much of the catch seen at fish markets.

how to buy fish

To enjoy great fish you have to start with fresh fish. To be able to recognize how fresh a piece of fish is, is a skill worth learning. Don't look for packages and sell-by dates to give you the answers – look at the very simple pointers here and, in a short while, with some familiarization with the fishmonger's counter, you'll be an expert. Look also at the pictures on the species introduction pages in Part Two of this book – these are all prime examples of fresh fish.

In between the fish coming out of the sea and ending up on your plate, there are many people involved in the supply chain, and what spoils fish is poor handling and temperature abuse. Fish does not like to be stored at temperatures above 0–2°C/32–36°F and likes to be covered in fresh ice. Stored correctly, many species can last up to 10 days from the day they are caught – often the first 3 or 4 of these days are on board the boat and the rest is in the supply chain. That doesn't mean I'm encouraging you to eat older fish, as eating it closer to the day it is caught is always going to be the best experience, but you should be aware of what is possible with good handling. If you are driving any distance to your fishmonger, take a cool bag and ask your fishmonger to put a few scoops of ice into a plastic bag so you can keep the temperature down when transporting your fish home.

When storing fish in your domestic refrigerator, I find the best way is to lay it on a plate and loosely cover it with a cloth, then store in the refrigerator for up to 36 hours. Try to make an occasion of your fish purchase and eat it on the day you buy it – if you walk around any Spanish or Italian market you won't see anyone buying fish for the next day. When choosing fish don't always go for the obvious. I know that we love our white fish, but do try other species like mackerel, gurnard, whiting, cuttlefish or plaice. If you eat a little of every species, the pressure will be taken off the mainstream fish like cod and pollack.

You may want to freeze some fish yourself, although professionally frozen fish from a reputable brand will always be better quality than home frozen. This is because the slow freezing time of a domestic freezer can damage the structure of the fish as the ice crystals form and burst, and the fish may become dry and watery.

With all this information, you should have the confidence and knowledge to choose the very best piece of fish from the counter in front of you.

Herring, mackerel and sardines are vibrant in colour and have hues of greens and purples. The scales should all be intact on perfect fish.

The eyes say it all – they should be bright and clear and convex. Sunken, cloudy eyes belong to fish a few days the wrong side of fresh.

Have a look under the gills – they should be bright red. Any sign of brown means the fish is old. Have a sniff too – fresh fish smell of the seaside, old fish smell like fish!

Fresh flatfish should be covered in a healthy slime.

the eating parts

This is the loin. It is the best eating part of the fish, as it has the thickest and flakiest flesh.

The tongue can be great to eat. Some traditional fishmongers can still source them for you.

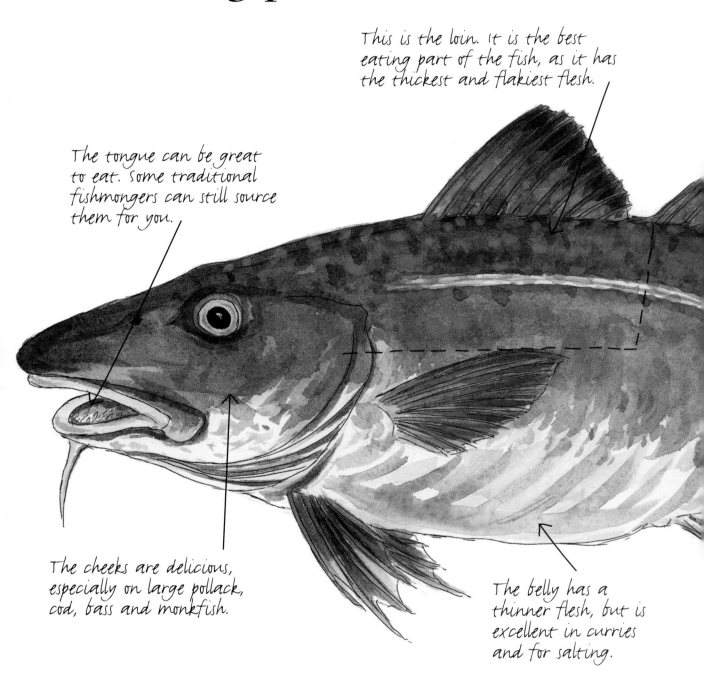

The cheeks are delicious, especially on large pollack, cod, bass and monkfish.

The belly has a thinner flesh, but is excellent in curries and for salting.

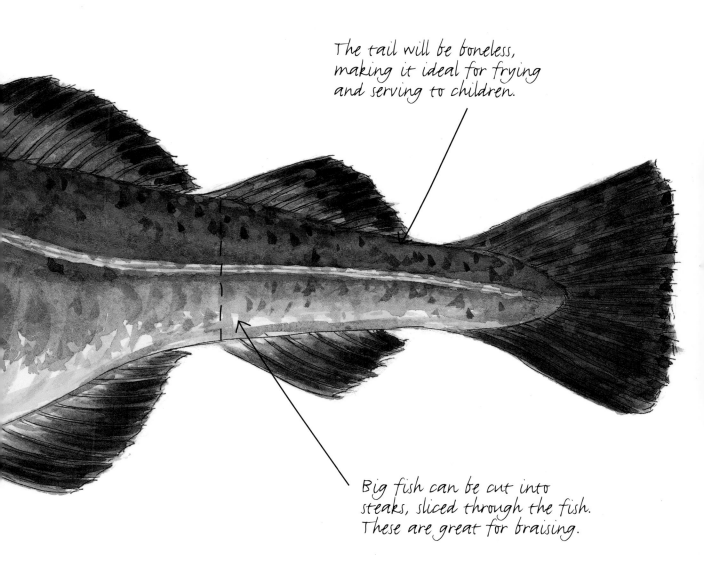

The tail will be boneless, making it ideal for frying and serving to children.

Big fish can be cut into steaks, sliced through the fish. These are great for braising.

three simple cooking techniques

It's easy to say that cooking fish is simple when it's what you do for a living, but I started as a nervous fish cook and over the years, I have mastered techniques and recipes for cooking seafood. My favourite three cooking techniques are: roasting, grilling and cooking fish in a bag, and they are very simple to perfect.

Your oven is always your best tool when it comes to cooking fish; if you are grilling or barbecuing a large piece of thick fish, you start it under the grill or on the barbecue and then finish it in the oven. The temperature guide is easy, you just have your oven preheated and set to maximum. This way the fish is cooked quickly and the moisture is retained, as the fast heat drives flavour and moisture from the central bones.

Without the grill, the oven is the lazy cook's tool – just cut a few slashes in the sides of a fish, about 450 g/ 1 lb in weight, with a sharp knife, lay it in a large roasting pan, then rub the fish with a cut garlic clove, a sprinkle of sea salt and some olive oil into the skin. Cook in the preheated oven for 15–20 minutes while you have a glass of wine and make a quick salad.

Cooking fish in a bag is also very easy to do and the results are impressive. You can prepare some incredible recipes from just a few simple flavours, such as sea bass with ginger, soy and spring onions, or sea bream with roasted thyme, garlic and chilli – these are flavours I love to enjoy whether it's for a casual supper or a dish that's served at my restaurant, The Seahorse.

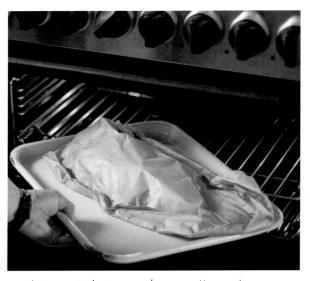

Cooking fish in a bag will work every time. A 450 g/1 lb fish will take 25 minutes with your oven on maximum.

Tuck some herbs, such as rosemary or thyme, into the belly before roasting or grilling whole fish.

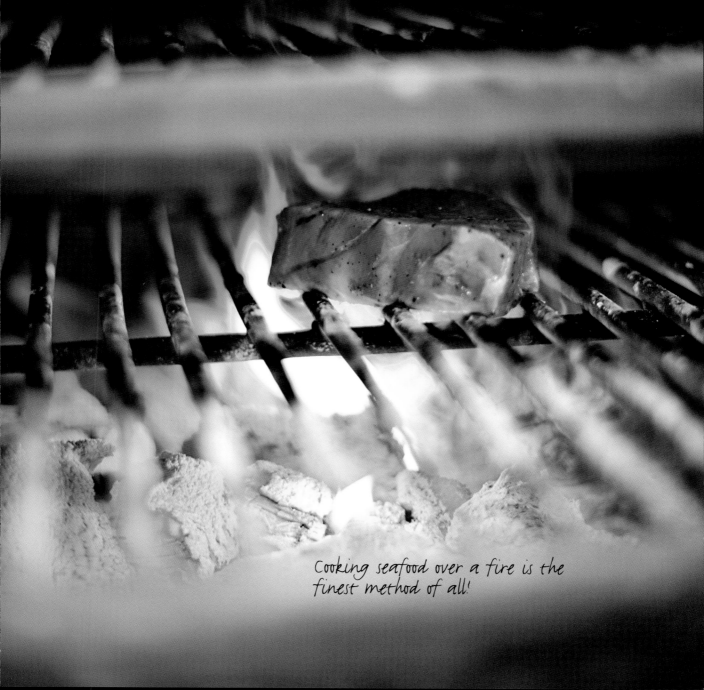

Cooking seafood over a fire is the
finest method of all!

sustainability

Taking fish from the ocean while leaving a healthy population to breed and without upsetting the natural balance of the world's oceans is a challenge that we really have to work with. There has been so much negative press about this issue and I can understand why, because if we have got our facts and figures wrong and we tip the oceans into a downward spiral of depleting fish stocks then the process will be irreversible. This has already happened in some fisheries around the world. The industry, however, has not ignored such a vital issue and has made changes, and some positive initiatives are now in place to try to ensure that this terrible situation will never come about.

Environmental campaigners have done a huge amount to raise our awareness of the potential catastrophes and each year scientists provide advice to governments who then make their decisions on quota allocations. The scientists' advice represents only the biological data of the fish stocks whereas governments have to take into account the social and economic issues of fishing fleets and coastal communities. This doesn't mean that governments are negligent in their approach to recovering fish stocks, but they are taking a longer-term view to get the balance right between the sustainability of the fisheries and social and economic stability.

There are some fishing practices, as well as the quota system itself, that need to be challenged, such as discarding the over-quota of dead fish, which would be perfectly good to eat. I have spent some time travelling around Australia and looking at how the fishermen there have coped with the same challenges. Initially, a quota was introduced that limited catches and in turn limited incomes, so this forced many fishermen beyond just catching fish. I met a fisherman called Neville Rockliffe, now a friend, who has been a fisherman all his life. He has turned his entire operation over to catching a species of crab called spanner crab, off the eastern coast of Australia. Neville's business isn't just about catching crab, it is about extracting the meat in its raw and cooked form and selling it as a top-end product to chefs and retailers. He has increased the value of his quota catch and the economics are working for him. I came across many fishermen like Neville in Australia – including the larger-than-life tuna fisherman Hagen Stehr, who has gone from tuna fishing through to tuna ranching and now become the first man in the world to farm the mighty southern bluefin tuna (see page 251).

In the UK, large established fish companies like Young's Seafood, with whom I have worked closely for a number of years, have contributed towards many initiatives that have triggered change within the industry. This has included strict buying principles that have forced fisheries into using only more sustainable methods, fishing at certain times or improving the way fish is handled and harvested. They have also been part of the Marine Stewardship Council (MSC) initiative, which is an independent UK charity whose role is to certify that a fishery is being fished in a sustainable way. In the future the MSC is going to

Eat seafood with confidence, but ensure that you buy from a fishmonger or a retailer that has a responsible sourcing policy, either by knowing exactly where the fish is from or by looking for MSC and other accreditations on labels. Our choices greatly influence good practice and quality and will help make sure we have fish for tomorrow.

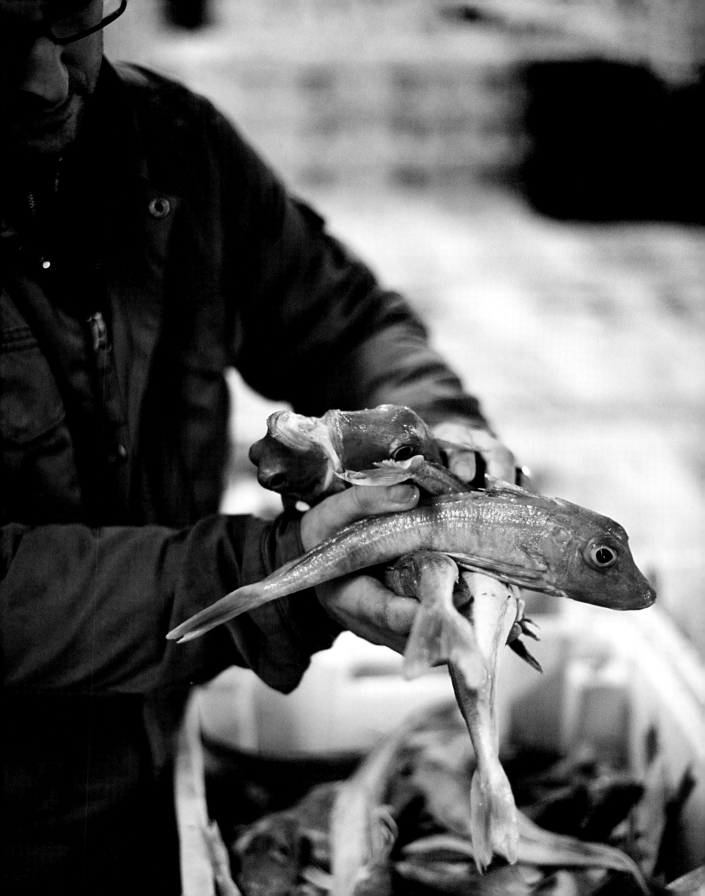

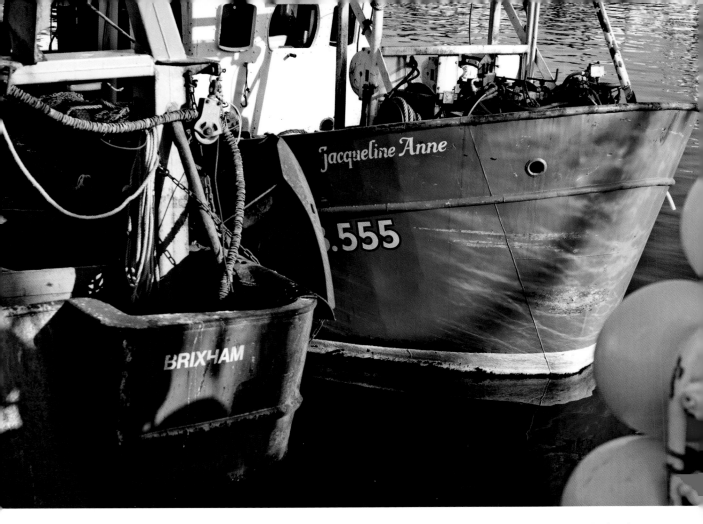

prove even more valuable in helping us all to make the right choices when buying seafood. And while we like to buy from small artisan fishermen and producers, we should also look to buy from larger respected companies who can instigate positive change and make responsible worldwide choices when sourcing raw materials. This will ensure that the supply of fish is selected from the best and healthiest of the sustainable fisheries globally and take the pressure off our local fisheries.

Fishing sustainably isn't the only issue we have to take into account to protect the future. Fishing communities are built around the men who go to sea, and for every fisherman fishing there will be at least three people on shore relying on him for their income, and that's not even counting the fish merchants and those employed in selling the fish. So

the effect of restricting a fishery to below the level at which it can operate economically can have a huge cultural impact on an area and its community. Once these communities are lost I would find it hard to believe we could ever get them back.

I can see and understand all the points of view, both from the fishermen and the environmental campaigners. I believe that if everyone were to talk with each other and not against each other then we could stand a chance of creating a powerful solution to the problem.

In writing this book, I wanted to present my own views on this issue but not to take a definitive stance because I am not sure I know the answers. Instead I chose to interview fishermen from day boats and big trawlers, CEOs of big fish companies, fish farmers, heads of producer organizations and a whole spectrum

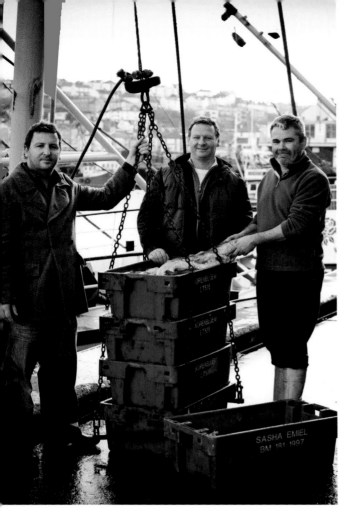

"I'm a great believer in making fisheries into assets that people look after and nurture, so we behave more like farmers than hunters. We need to harvest in a more sustainable manner."

Wynne Griffiths, fomer CEO of Young's Seafood and fishmonger

of people involved in the industry. Their opinions and interviews are scattered throughout the book. They are all great people, many of whom I have known for years and some whose credibility in this subject this book just couldn't do without, like Mike Mitchell from Young's Seafood who has a wealth of knowledge and a powerful voice in bringing about solutions, and John Susman, my fish guru and friend in the southern hemisphere, who, like me, is passionate about fish from the catching to the plate.

I will leave you to draw your own conclusions from their comments. I will definitely say that from my point of view, as someone inside the industry as a chef, fishmonger and restaurateur, positive change is happening and the industry is responding to the pressures put upon it and overcoming the challenges to get to a better place. I also believe that due to the issue of sustainability frozen fish will become a big part of our future and the marketers will no longer be arguing whether frozen is better than fresh. We will simply have to understand that to reduce waste and ensure that we consume everything we catch, frozen fish will be part of our lives and that is a good thing. The same will be true for farmed fish. Years ago I would often read food writers criticizing a restaurant or shop for selling farmed sea bass or sea bream – this is no longer the case and fish farming has become more accepted. I am a supporter of aquaculture and I have seen some beautiful farms in the UK, Europe and Australia, many of which lead the way in what aquaculture can become by raising superb fish and caring for the environment at the same time. We need to look to these producers and work with their expertise so that we supplement the wild catches around the world.

So what can you do? Buy fish with confidence. Don't just read the headlines and get confused – know that these headlines are there to raise awareness, but also be assured that they do promote action.

• Look out for the MSC accreditations on labels.
• Make sure the person selling your fish knows where the fish has come from.
• Buy brands you know you can trust.
• Buy fresh fish in season.

what key people are saying...

We are bombarded with information about fish stocks and I am always keen to champion the good stuff, because there's lots of it. Here are some viewpoints from those taking the whole sustainability issue responsibly and in turn making a difference:

Neil Perry, Australian chef, on consumer-power:
One of the key issues is that fishermen have to change the ways they fish. They have to value everything that comes over the side. The Japanese are brilliant at this – every piece of fish is treated like a diamond. If we are talking about sustainability, we are talking about every kilo of fish that's landed being value added. If you land it on the deck and you don't kill it and ice it straight away, you have an inferior product that doesn't taste good raw and has a limited shelf life. Most people in the world eat fish that *haven't* been

treated well, so it doesn't taste as good as it should. We as consumers and chefs are part of the solution. You need to know where your food comes from – you ask how your piece of beef or lamb has been fed and treated, why not your fish? I want to have great seafood, well fished and well handled from the fisherman right through to retail level. If the consumer gets it, and they can taste the difference and start demanding that quality, the fisherman will get more for his catch because he's looked after it.

Wynne Griffiths, former CEO of Young's Seafood and fishmonger, on how we should celebrate what we have on our own doorsteps:
One of my long-term dreams is that local species are recognized. For example, nearly 90% of the langoustines caught in Scotland are exported to Spain or France and it makes me laugh when

people come back from their holidays in France raving about how they loved eating the langoustines there – langoustines that came from Scotland! This is happening the world over. How do you shift this mind set? You do it with people like Mitch and other chefs spreading the word about the fabulous fish and shellfish we have on our doorsteps. I think restaurants will lead the way with educating the public and broadening their minds and palettes, by putting new and different species on the menu.

Nathan de Rozarieux, Project Director of Seafood Cornwall, on harvesting the seas:
Beam trawlers get a lot of stick from people who don't necessarily understand that much about how they work. We work closely with restaurateurs – some say they only want to source fish from day boats and hand liners. That's fine, but the reality is that from October through to April the weather can be so bad that a lot of these small boats won't be able to go out, so if you're looking at a continuity of supply you will need those bigger boats that go out for several days, that can work in rougher weather – the trawlers and beam trawlers. There's nothing to stop larger fishing being sustainable, it doesn't have to just be a guy in a boat with a hand line.

Mike Mitchell, Head of Seafood Sustainability for the FoodVest Group, on the commercial response to sustainability and the value of MSC accreditation:

"The awareness of sustainability in seafood has moved right up the agenda in the last few years. Back in 2005, Greenpeace published a report called *A Recipe for Disaster* that challenged the retail and food processing sectors about how and where they sourced their seafood, and was it sustainable? Although this was mainly aimed at retailers, big processors and brand leaders were also in the firing line. I was asked to look at Young's sustainability policies, talk to Greenpeace and address the issues raised. This has now evolved into a full-time job. I have both inward- and outward-facing responsibilities. The inward-facing one is to make sure we are not using endangered species or making any environmentally or ethically bad decisions. The outward-facing one is working with scientists, governments, trade associations and NGOs in pushing forward the sustainability debate in a multi-stakeholder environment."

Every decision Mike makes on whether they use a fishery or not is based on current scientific assessment of the stocks. He also looks at the nation of capture, how their fleet is managed, as well as their monitoring, recording and submitting of data to the scientists. Mike calls this the 'Fish for Life' assessment. For example, most of the scientific advice for the North East Atlantic fisheries comes from ICES – the International Council for the Exploration of the Sea. Established in 1902, this is the oldest intergovernmental organization in the world and helps to coordinate and exchange marine research done by scientists within its 19 member countries. Elsewhere in the world there will be similar organizations doing the same sort of thing for their waters. Young's deal with 60 species from 30 different countries, and within those species there may be several different fisheries, all assessed separately, so it's quite a complex operation. Young's

also have very strict criteria about whether the word 'sustainable' can be used about a fishery, as Mike explains:

"'Sustainability' is a word bandied around without people really understanding what it means. The most robust defence of any sustainability claim for a fishery is to say it's independently verified – currently that can only be done through the Marine Stewardship Council (MSC) assessment process. Clearly there are sustainable fisheries that aren't MSC certified, but we have to stand up to rigorous investigation and consumers need to be confident about what they are buying. If it hasn't got that MSC stamp we can call it 'responsibly managed'. The Icelandic cod fishery is a good example of this – it's scientifically assessed, it has biological reference points appropriate to the species and their environmental conditions, and the management of the fishery is in accordance with the scientists' advice. Several 'responsibly managed' fisheries would be good MSC candidates, but it's our corporate view that we hold back on using the word 'sustainable' until it has achieved that independently assessed status."

The vast fishing grounds around the Alaskan, Bering Sea and Aleutian Islands provide the MSC with a raft of large well-managed fisheries for species such as Alaskan pollack, Alaskan cod, several species of salmon, halibut, and flatfish like Alaskan plaice, northern rock sole and yellow fin sole. In the UK it's mainly been small artisanal fisheries that have had MSC accreditation, such as the Thames herring and the South West mackerel handliners, but mixed fisheries are now getting involved. With the Dutch Association of Food Retail pledging to sell only MSC-certified fish by 2011, and many supermarkets and retailers the world over responding to the demands of concerned consumers to source responsibly, the decision by fisheries to get MSC accreditation could be a clever commercial move as well as a sustainable one.

The Marine Stewardship Council on safeguarding seafood for future generations:

As the world's population grows, the demand for fish for food is expected to grow. Based on present levels of consumption and projected population growth, by 2010 demand could reach 120 million tonnes a year, a substantial increase from the 75-85 million tonnes of the mid-1990s.

If we want to safeguard food security for people around the world, and let future generations enjoy the rich choice of fresh, healthy seafood that we know today, we need to ensure our oceans remain productive. At the MSC we believe that the best way to do this is to recognise and reward sustainable fishing, not to exclude fish from our diets. To stop eating seafood would deprive fishers of their livelihoods. It would also mean that consumers would miss the opportunity to influence companies that buy and sell fish towards sourcing more environmentally responsible seafood. And it would mean that we would be depriving ourselves of all the benefits from eating seafood.

By supporting well managed fisheries through your shopping decisions you send a clear message, encouraging more retailers to stock sustainably-sourced seafood and more fisheries to switch to sustainable practices.

Nathan de Rozarieux, Project Director of Seafood Cornwall, on setting quotas:

With the price of fuel being what it is, fishermen have to really maximize every day they have at sea and maximize their quota. They get more for bigger fish than for smaller fish, and fishermen usually know where the nursery or breeding grounds are so can steer clear of them and target the adults who will get a greater market price.

Ultimately fishermen are very much regulated by the scientists. We have set targets for the biomass of the populations. Scientists try to build up a computer model of how much fish there is in each stock, what number in terms of tonnage, but also what the age structure of that population is. You need a mixture of age groups, so you have some breeding stock, and another generation or two coming through. So really it's all about the scientists managing it, then reporting back and saying what they think the stock size for a certain species should be. Then, in order to preserve that and to build it up in future, they allocate what the 'quota' – that is how much can be landed – for that species should be. Some fisheries are managed by area, some are managed by days at sea, so there is a limit to the amount of effort they can use. It's all driven by lots of numbers, lots of data and lots of science. In all cases scientists are trying to increase the biomass, to build up the stocks for the future.

John Susman, leading Australian expert on seafood, on fishery management:

We're pretty lucky because [Australian] scientific agencies realized about 35 years ago that we had fairly limited stocks available to resource, so we were at the vanguard of implementing fisheries management policies.

Fishermen started looking at the fragile resource and saying we'll only take what it can stand. This sounds all rather idyllic, doesn't it? In truth what happened in the case of the Port Lincoln prawn fishery is that they just shut the door on anyone else wanting to enter that fishery and it's been very effective. When the government caught up with that practice they realized this was a way to manage our stocks. So we have had a culture of extreme management. For example, one third of all marine parks on the planet are in Australia. By 2010 our government wants this to increase to 50%. The line fishermen of the Barrier Reef will be most affected by this, as the entire length and breadth of the reef will be closed to commercial fishing, which is an enormous amount of water. For those guys their commercial careers are finished.

On a more positive note, a really exciting example of interaction between the commercial sector and its governing bodies is the story of the southern bluefin tuna fishermen. Their quota was reduced overnight by 97% in 1991 and yet the industry has subsequently flourished. It has gone from being a commodity product with a value of 50 or 60 cents a kilo to a high-quality fish beloved by the sashimi market where it sells for $45 or $50 a kilo.

No-Take Zones – the future of marine management?

The UK's first No-Take Zone for marine nature conservation has produced promising results, with lobsters showing a huge increase in numbers after just a few years.

In 2003, inspired by the No-Take Zones (NTZ) that they had seen working successfully alongside a healthy commercial fishing industry in New Zealand, the people involved in the management of Lundy Island off the north Devon coast decided to set up the UK's first No-Take Zone. The marine environment around Lundy is internationally important and supports many rare species. The NTZ protected by law a 3.3 kilometre square zone off the eastern shore of the island – an area known for its fragile corals and sponges – and banned the removal of any living creature, including lobsters, crabs, scallops and fish.

Results show a very clear signal that lobsters in the NTZ are recovering from the effects of fishing. Chris Davis, Senior Marine Policy Officer for Natural England, comments: "It may be a small area but it has had some dramatic effects. First indications in 2004 were a significant increase of lobsters inside the zone. After 5 years of scientific monitoring there were 8 times the number of lobsters in this area compared with the same area outside and these lobsters are significantly larger so they are more prolific breeders."

Of greater interest to the local fishermen is that in 2007 the benefits started to spread outwards as they recorded an increase in lobster numbers adjacent to the NTZ. Chris Davis: "After a while the stock builds up and you get an effect called 'fishing the line'. Now you can almost see the outline of the area by the pot buoys surrounding it! We had been told to expect this by the New Zealanders who had seen it happen around their NTZs. Obviously if this project wasn't working the fishermen wouldn't have their buoys there."

why is seafood good for you?

Seafood is an excellent source of omega-3, a type of polyunsaturated fat – one of the good fats. There are several types of omega-3 fatty acids, but seafood is the best source of the omega-3 long-chain fatty acids, these are known as EPA (eicosopentanoic acid) and DHA (docosahexaenoic acid).

DHA is a major building block of the brain, it's key for the nerve growth, brain and retina development of babies in the womb. Other vital organs such as the heart are rich in long-chain omega-3s, that is why these fatty acids are also good for heart health and reducing the risk of coronary disease. Historically there has been plenty of anecdotal evidence of how populations with a high fish content in their diets enjoyed a long life and virtual absence of heart disease.

EPA and DHA also have anti-inflammatory and protective roles so are good for joints and the immune system. Fish oils are believed to help with inflammatory bowel disease and inflammatory skin disorders such as eczema and psoriasis. Recent research has also revealed they improve brain health and are being used in the treatment of dyslexia, schizophrenia and depression, as well as improving concentration in children and young people. The highest amounts of these long-chain omega-3s are found in oily fish, which is why we keep going on about how good oily fish is for you. So, when your Mum said fish was 'brain food', she was really on to something!

You'll also find omega-3 in plant-derived foods like soya, hemp, flax and pumpkin seeds and oils, walnuts and leafy green vegetables – but these omega-3s are short-chain ones, containing alpha-linolenic acid or ALA, and need to be converted by the body to the long-chain omega-3s to be used effectively. Unfortunately this conversion is very inefficient, so most of us are probably deficient in long-chain omega-3.

It's difficult to ensure enough long-chain omega-3s are in your diet as so few foods contain these essential nutrients. Oily fish, other fish and seafood are the main sources, with eggs and lean red meat providing smaller amounts. 100 g of fish on average contains 210 mg of omega-3, oysters have 150 mg, prawns 120 mg and lobster 105 mg, compared with 22 mg for beef, 19 mg in chicken and 18 mg in lamb. To prevent a deficiency of long-chain omega-3s, 90 mg a day is recommended for women and 160 mg a day for men.

You will find products such as milk, juices, yoghurts and spreads with added omega-3 in the form of tasteless and odourless fish oils. In my opinion, why waste your money, when one portion a week (around 140 g/5 oz) of a delicious oily fish such as salmon, herring, mackerel, sardines, sprats or fresh tuna would provide you with your recommended weekly intake of 3 g of long chain-omega-3? You can of course take fish oil supplements, but you won't be getting the wider nutritional benefits of eating fish and shellfish: it is an abundant source of selenium, a prime source of iodine; other minerals are phosphorus, potassium, calcium, zinc (oysters are an excellent source of this) and iron (mussels are rich in this); vitamins include A, B, especially B12, D (found in oily fish) and E. The Food Standards Agency recommends a minimum of two portions of fish a week, of which one should be an oily fish – how easy is that!

nutrient chart

Per 100 g/4 oz	Calories (kcal)	Fat	Omega-3	Source
White Fish				
Bream (gilthead, black and red)	96	2.9	★★	McCance & Widdowson *The Composition of Foods* 6th edition #6
Brill	95	2.7	★	M&W Fish & Fish products #155 (Turbot)
Cod	83	0.9	★	M&W Fish & Fish products #12
Coley	82	1	★	M&W Fish & Fish products #31
Dover Sole	89	.8	★	M&W Fish & Fish products #39
Grey Mullet	115	4	★★	M&W Fish & Fish products #95
Gurnard	data not available at time of publication			
Haddock	8	0.6	★	M&W Fish & Fish products #44
Hake	92	2.2	★	M&W Fish & Fish products #70
Halibut	03	0.9	★★	M&W Fish & Fish products #73
John Dory	89	1.4	★	M&W Fish & Fish products #80
Lemon Sole	83	1.5	★	M&W Fish & Fish products #82
Ling	82	0.7	★	M&W Fish & Fish products #91
Megrim	79	1.4	★	M&W Fish & Fish products #102 (Plaice)
Monkfish	66	0.4	★	M&W Fish & Fish products #92
Pollack	72	0.6	★	M&W Fish & Fish products #123
Red Mullet	109	3.8	★★	M&W Fish & Fish products #98
Sea Bass	100	2.5	★★	M&W Fish & Fish products #2
Skate (ray)	64	0.4	★	M&W Fish & Fish products #142
Snapper (red)	90	1.3	★	M&W Fish & Fish products #126
Turbot	95	2.7	★	M&W Fish & Fish products #155
Whiting	81	0.7	★	M&W Fish & Fish products #159
Oily Fish				
Anchovy	131	4.8	★★★	USDA Nutrient Databank
Herring	190	13	★★★	M&W Fish & Fish products #175
Kingfish	309	7.8	★★★	
Mackerel	220	16	★★★	M&W Fish & Fish products #654
Salmon	180	11	★★★	M&W Fish & Fish products #202
Sardine	165	9.2	★★★	M&W Fish & Fish products #212
Sprat	172	11	★★★	M&W Fish & Fish products #218
Swordfish	139	5.2	★★	M&W The Composition of Foods #666
Tuna (yellowfin)	128	2.7	★	Young's Seafood data
Shellfish				
Clam (razor and palourde)	74	1	★★	http://www.nal.usda.gov/fnic/foodcomp/cgi-bin/list_nut_edit.pl
Cockle (meat only, boiled)	53	0.6	★	M&W Fish & Fish products #252
Crab (brown and spider, boiled)	128	5.5	★★	M&W Fish & Fish products #232
Cuttlefish	71	0.7	★	M&W Fish & Fish products #254
Langoustine	92	0.8	★	Young's Seafood data
Lobster (meat only, boiled)	103	1.6	★	M&W Fish & Fish products #236
Mussels (meat only, raw)	74	1.8	★★	M&W Fish & Fish products #255
Oysters (meat only, raw)	65	1.3	★★	M&W Fish & Fish products #260
Prawn (North Atlantic)	68	0.5	★	Young's Seafood data
Prawn (Britsh inshore common)	68	0.5	★	Young's Seafood data
Rock Lobster (western Australian)	112	1.5	★	http://www.pacseafood.com/products/spiny_lobster.html
Scallops	92	0.5	★★	Young's Seafood data
Shrimp (brown)	68	1.4	★★	SAGB/Food RA
Squid	81	1.7	★★	M&W Fish & Fish products #263

Most seafood provides a source of the minerals selenium, iodine, potassium and phosphorous and the B vitamins, especially B12, and vitamin D (oily fish). Worth special mention are: mussels, which are rich in iron, and oysters, which are rich in zinc.

part two

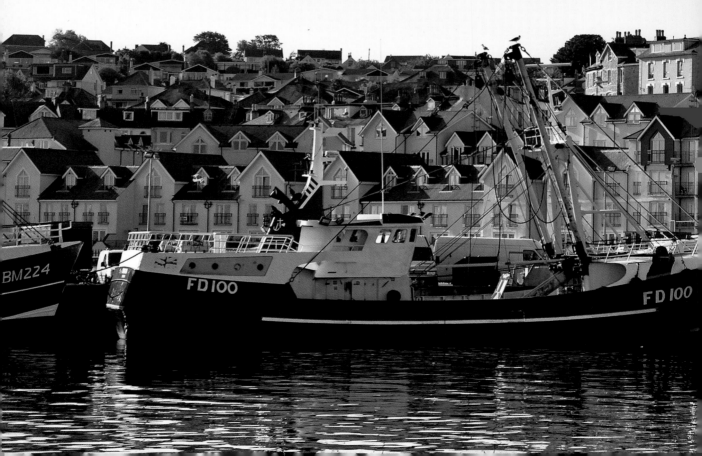

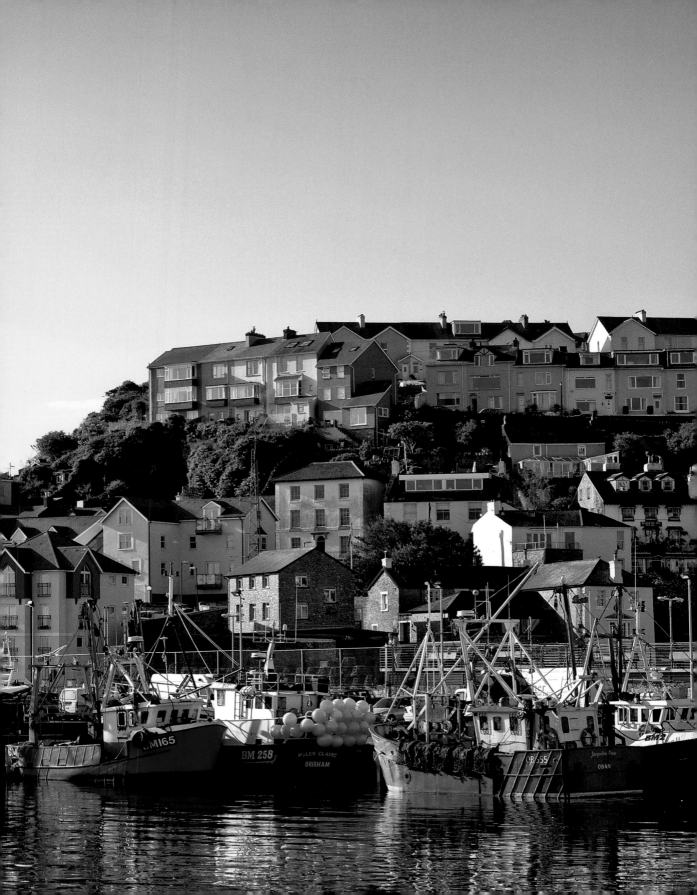

white fish

gilt-head bream *Sparus aurata*

This beautiful fish was once sacred to Aphrodite, the goddess of love, and you can see why. Its dark blue-grey body contrasts with a silver belly, its gill covers are edged in scarlet and black, and a crescent moon-shaped gold band runs across the forehead between black-ringed eyes.

This exotic exterior belies some seriously wicked dentistry inside its thick-lipped mouth. Canine-type teeth at the front rip shells off rocks, while blunter molars behind crush mussel shells, crustaceans and small fish, though this fish also eats algae and seaweed.

Like some other members of the sea bream family, they start life as males, but once over 30 cm/12 inches some become females. They become sexually mature around 2–3 years old and can live up to 11 years.

You will find gilt-head bream in shallow coastal waters over sea grass beds, rocky and sandy bottoms as well as in the surf zone, and they will also go into brackish waters around estuaries. Because this fish can thrive in less salty water and isn't particularly athletic, gilt-head bream are ideal for fish farming, and are successfully farmed in Spain, France, Greece and Italy.

Taste description

Once pan-fried, the skin of the wild gilt-head bream takes on an extraordinary reptilian appearance and its surface is rough with what looks like transparent grains of wheat. This gives the skin an enjoyable crispness, which is the perfect contrast to the uniform richness of the juicy flesh. While the skin has the flavour and aroma of pork crackling, the flesh is more delicate, with notes of the white of a fried egg and the dark meat of a chicken, especially around the fat line. There's a difference in flavour between the loin and the tail too, the latter carrying more oily depth.

Combining the sweetness of vanilla extract and the deep, savoury quality of crab, farmed bream has a richness of aroma that is not reflected in its flavour, which tends towards oiliness (although the taste of the skin is more substantial, with notes of roast chicken). The flesh is pale grey with hairline black veining, and a firm but delicately flaky texture with a moderate amount of juice.

Territory

Common throughout the Mediterranean, they are also found in the Atlantic from the British Isles to Cape Verde and around the Canary Islands.

Environmental issues

This fish farms especially well. They are farmed in open sea pens and are fed a diet reliant on wild fish capture. Look out for organically farmed sea bream, which are farmed with lower stocking densities.

Territory	Local Name
UK/USA	*Gilt-head (sea) bream*
Greece	*Tsipoúra*
France	*Daurade*
Spain	*Dorada*
Italy	*Orata*
Germany	*Goldbrasse*
Holland	*Goud brasem*
Denmark	*Guldbraxen*
Sweden	*Guldbrasse*

Health
Gilt-head bream is a good source of selenium, potassium and omega-3. Per 100 g/4 oz: 96 kcals, 2.9 g fat

Seasonality
Avoid eating wild gilt-head bream during their spawning season (October–December). Farmed fish can be eaten all year round.

Yield
1 kg/2¼ lb weight of gilt-head bream yields 50% edible fillet.

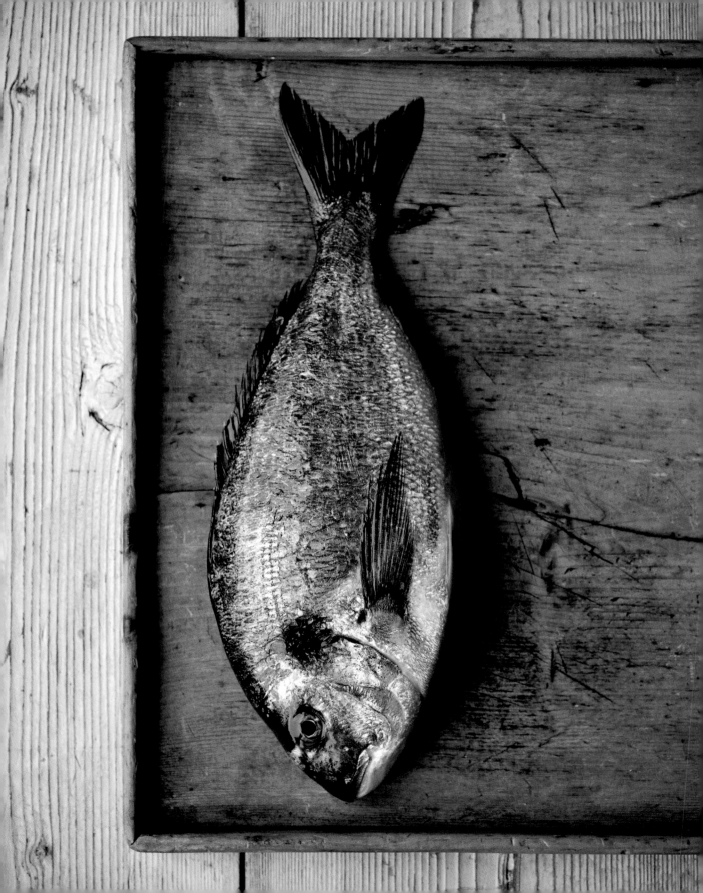

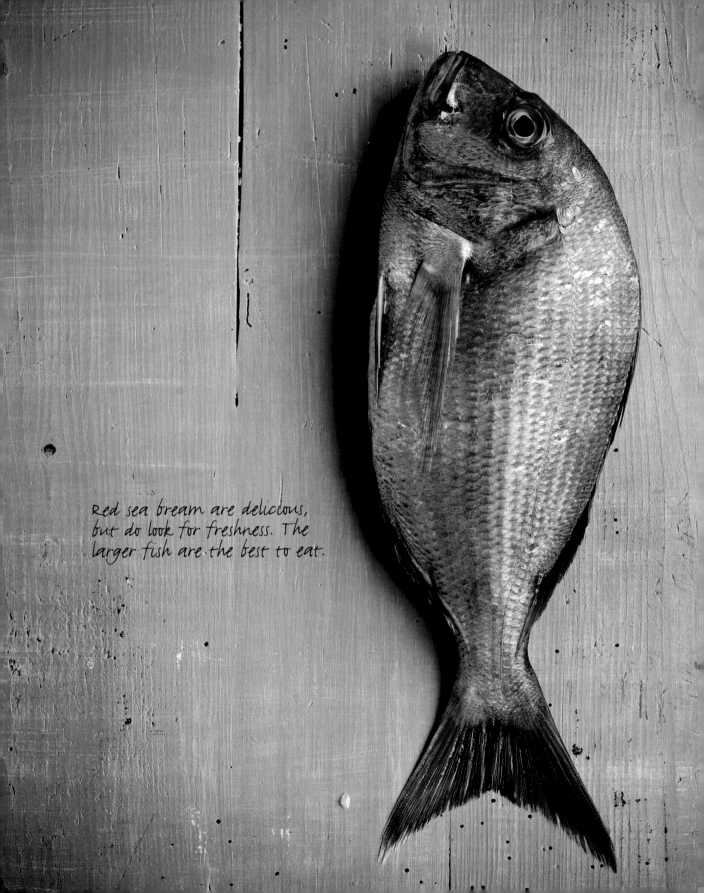

Red sea bream are delicious, but do look for freshness. The larger fish are the best to eat.

red sea bream *Pagellus bogaraveo*

Another member of the *Sparidae* family with firm succulent flesh and an excellent flavour.

Like its cousin the black bream (see page 48) these fish have a fairly alternative life cycle, in this case some of them changing from males into females when they are 4–6 years old. They grow slowly to a maximum size of 70 cm/27½ inches at around 15 years old. This fish looks much the same as its darker relative except its colouring, which is a reddish orange blending to a rosy-tinted silver on its sides. The adults also have a distinct black spot on the 'shoulder', hence its other name 'blackspot sea bream'. Red bream has a very distinctive large eye, giving it the look of a Japanese comic book character, and its French nickname is *gros yeux*, or 'big eye'. The Japanese hold the red bream, or *Tai*, in very high regard as a lucky fish to be eaten at major celebrations. Red bream migrate inshore in summer and gather together in shoals near rocks and seaweed, feeding on crustaceans, worms and small fish.

Taste description
See Gilt-head bream on page 44.

Territory
Red bream are found throughout the eastern Atlantic and western Mediterranean, also the English Channel and off the southwest and west coast of the UK. They are most often seen at the western end of the Channel and southwest Ireland. Summer migration and warming waters have resulted in a wider distribution including the North Sea and even up to Norway.

Environmental issues
They need to reach at least 20 cm/8 inches when they are 4–6 years old before some of them become females and breeding can occur, so older, larger fish are the best ones to eat.

Territory	Local Name
UK	*Red sea bream*
Germany	*Nordische Meerbrasse*
France	*Dorade commune*
Portugal	*Goraz*
Greece	*Lithrini*
Holland	*Roode zeebrasen*
Italy	*Occhialone*
Turkey	*Mandagöz, Mercan*
Spain	*Besugo*
Tunisia	*Murjane*

Health
See Black bream on page 48.

Seasonality
Avoid just before and during their spawning season from July to October.

Yield
1 kg/2¼ lb weight of red bream yields 50% edible fillet.

black sea bream *Spondyliosoma cantharus*

I just love walking into my local market and seeing boxes of this wonderful seasonal fish, which appears in the early part of the year and summer months. It starts life as a female, maturing as a female at about 18 cm/7 inches, but once over 22 cm/8½ inches it may switch genders and certainly all fish over 40 cm/16 inches are males, which is unusual.

Black bream have a deep laterally flattened body, more gun-metal grey than black, with six or seven dusky vertical bars and golden-yellow horizontal streaks on its sides. Large scales cover the whole of the body, and these need to be removed before cooking. It has a long spiny dorsal fin and a small mouth full of sharp inward-curving teeth, perfect for eating crustaceans and small fish. It also enjoys eating seaweed, and when cooked its skin can have a wonderful iodine flavour. Black bream often forage in large gregarious shoals over sea grass beds or congregate around wrecks and natural reefs. The other charming thing about these unusual fish is that they build nests. In spring the male excavates a furrow in the sandy seabed for the female to lay her eggs in, he then guards them fiercely until they hatch. Whether that's why they were given their nickname 'old wife' is hard to say.

Taste description
See Gilt-head bream on page 44.

Territory
Black bream are found throughout the Mediterranean and eastern Atlantic. They are also caught all along the south coast of England and the southwest coast of Wales from early summer right through to November in some spots.

Environmental issues
Avoid eating immature fish less than 20 cm/8 inches caught prior to and during their spawning season. Some local fisheries committees have started some great work to help manage the stocks and have set bylaws forbidding the landing of sea bream below 23 cm/9 inches.

Territory	Local Name
UK	Black sea bream, Porgy
Portugal	Choupa
France	Griset, Dorade gris
Germany	Seekarpfen
Greece	Scathári
Holland	Zeekarper
Italy	Tanuta
Denmark	Havrude
Spain	Chopa
Tunisia	E'houdiya, Zargaïa

Health
Good source of selenium, potassium and omega-3.
Per 100 g/4 oz: 96 kcals, 2.9 g fat

Seasonality
Avoid eating during their spawning season, April and May in UK inshore waters, earlier in more southerly ones.

Yield
1 kg/2¼ lb weight of black bream yields 50% edible fillet.

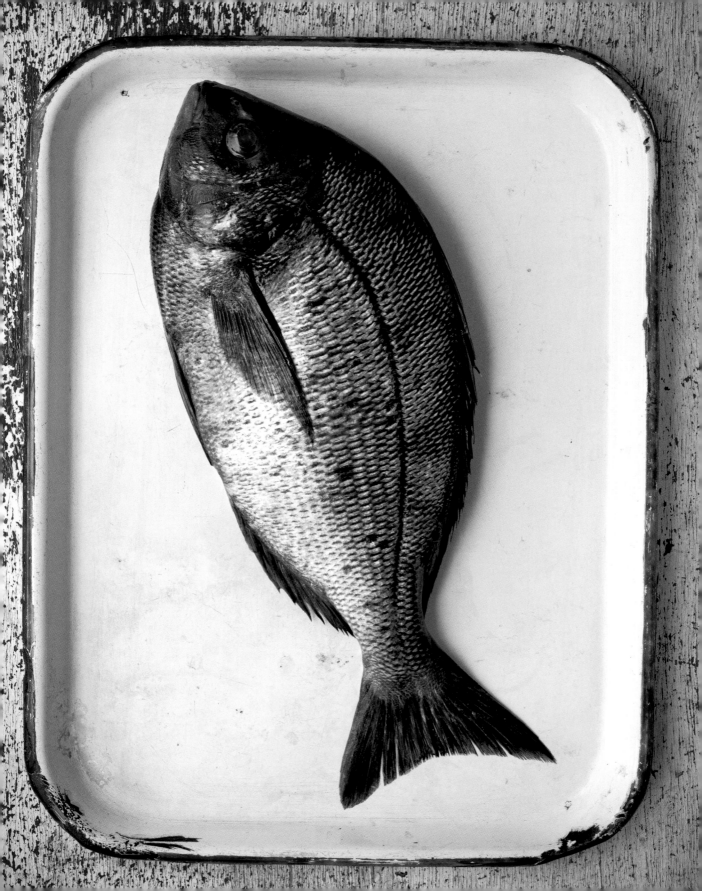

grilled sea bream with cumin, lemon and sea salt

Serves 2

2 sea bream, about 450 g/1 lb each
Juice of 1 lemon
Good pinch of sea salt
1 tbsp ground cumin
1 garlic clove, ground to a paste
Splash of olive oil
Small handful of fresh mint,
 finely chopped

To serve:
Squeeze of lemon

AT THE FISHMONGER
Ask your fishmonger to scale
and butterfly fillet the fish
and remove the head.

I like the way that in some countries fish is cooked slightly more than we usually like in Europe. One of my favourite Chinese restaurants in London, Yauatcha, serves an excellent sweet and sour sea bass where the fish is cut into thin strips towards the backbone and left attached. It is then floured and fried in hot oil until crisp and then dressed with a wonderful sweet and sour sauce. I think it's the texture of the fish I like – to say it was overcooked would be wrong, but it's firmer and drier than you would normally expect, and it is fabulous. I have come across fish cooked like this in Singapore and Malaysia too, and I have cooked fish this way over a fire to produce a slightly crisp but delicious drier texture. Sea bream is excellent for this type of cooking and it's perfect for a barbecue.

I like to serve this dish with a thyme and onion salad made by mixing chopped onion with lots of fresh thyme leaves, some chopped mint, salt, lemon juice and olive oil.

Soak 4 wooden skewers that are 10 cm/4 in longer than the fish in a bowl of water for at least 30 minutes to prevent them burning during cooking.

Place the fish on a large plate or in a shallow dish. Mix the lemon juice, salt, cumin, garlic and olive oil together and rub onto both sides of the fish. Cover and leave to marinate in the refrigerator for about 1 hour.

Preheat the grill to its highest setting or light the barbecue.

Lay the fish skin side up on a large board or clean work surface. Thread a soaked wooden skewer crosswise through the fish, starting from near the tail and then out again on the opposite side of the fish near the thick end. Do the same from the other side so that the fish can be picked up on an 'X' frame when you hold 2 of the skewers. Repeat with the other fish.

Place the fish skin side down under the grill for 8–9 minutes or on a barbecue until it crisps and bubbles, and the flesh is firm. Sprinkle the chopped mint over the fish and serve with a squeeze of lemon.

You can lightly coat the fish in plain flour then insert the skewers and deep- or shallow-fry in oil for 5–6 minutes until crisp, if you prefer.

baked sea bream with potatoes and thyme

Serves 4

3 or 4 waxy potatoes, such as Maris
 Piper or Charlotte, peeled and
 finely sliced
1 red pepper
1 head of garlic, unpeeled
200 ml/7 fl oz/scant 1 cup olive oil, plus
 extra for drizzling
Sea salt
1 tbsp fresh thyme leaves
2 sea bream, about 450 g/1 lb each
50 g/2 oz/¼ cup black olives
6 canned tomatoes or very ripe fresh
 ones, peeled and deseeded
1 dried bird's-eye chilli
50 g/2 oz/1 cup fresh coarse
 breadcrumbs doused in a little
 olive oil

To serve:
Squeeze of lemon

AT THE FISHMONGER
Ask your fishmonger to scale and
gut the fish.

I think out of all the fish that are ocean farmed, the *dorade* or gilt-head sea bream is the best of all. There are not many places that will be able to boast serving wild fish, but if you do come across one then buy it – you will enjoy the finest fish in the sea that I have come across.

This recipe is great because you get all the flavours of the fish going into the potatoes and it's extremely easy as you cook and serve it in one pot.

Preheat the oven to 240°C/475°F/Gas Mark 9.

Blanch the potatoes in a saucepan of boiling water for 2–4 minutes then drain and dry.

Place the pepper and head of garlic in a roasting pan, drizzle with olive oil, sprinkle over a little salt and roast in the oven for about 12–14 minutes. Remove the garlic from the tray and set aside. Return the pepper to the oven and roast for a further 5 minutes or until it is soft and blackened. Place the pepper in a plastic bag, seal the top and leave to cool.

Break the garlic into cloves but leave the skins on. As soon as the pepper is cool enough to handle, remove the skin and seeds and reserve any juices, which are delicious.

Pour the olive oil into an ovenproof dish large enough to hold the fish, arrange the potatoes over the base and sprinkle with salt and thyme leaves. Rub the fish with a little olive oil and some salt and arrange the fish on top of the potatoes. Cook in the oven for about 12 minutes.

Remove the fish from the oven and place the garlic cloves and olives around the fish. Squeeze the tomatoes onto the fish and potatoes to release the juice, then add to the dish.

Using a sharp knife, cut the pepper into rough strips and place around the fish, then pour on the reserved pepper juice and crumble the chilli over the top. Sprinkle over the breadcrumbs and cook for a further 7–8 minutes.

To serve, place a fish on each plate and finish with a squeeze of lemon. Sprinkle some parsley over the potatoes before serving with the fish.

bream cooked *en papillote* with garlic, chilli and rosemary

Serves 1 (1 fish serves 1 person, so multiply ingredients accordingly)

6 garlic cloves, unpeeled
100 ml/3½ fl oz/generous ⅓ cup olive
 oil, plus extra for drizzling
Sea salt
1 sea bream, about 450 g/1 lb
1 small dried bird's-eye chilli
2 fresh rosemary sprigs
50 ml/2 fl oz/¼ cup white wine

To garnish:
1 tsp fresh parsley, finely chopped

AT THE FISHMONGER
Look for a gilt-head bream or
black bream. The farmed gilt-
head bream are delicious and
perfectly acceptable. Ask your
fishmonger to scale, gut and
remove the head from the fish.

Cooking a fish *en papillote*, or 'in a bag', is an excellent way to keep the fish moist, to allow all the other flavourings to develop and create something quite magical. The combination of roasted garlic, chilli and rosemary is a good one, as is thyme, lemon and cumin, but you can experiment to find your own preferences.

Preheat the oven to 160°C/325°F/Gas Mark 3.

Place the garlic in a small roasting pan, drizzle over a little olive oil, season with salt and roast in the oven for 10 minutes. Leave to cool.

Increase the oven temperature to 240°C/475°F/Gas Mark 9.

Place the sea bream on a piece of parchment paper large enough to fold over the fish, crumble the chilli over the top and arrange the garlic around the fish. Tuck the rosemary sprigs into the belly, sprinkle with salt and pour over the olive oil. Carefully fold the paper around the fish to enclose it in a parcel then, just before sealing, pour the wine into the corner and scrunch up the end of the parcel to seal tightly.

Place on a baking sheet and bake in the oven for 15 minutes. Remove from the oven and carefully cut the paper open. Garnish with chopped parsley and serve straight from the bag.

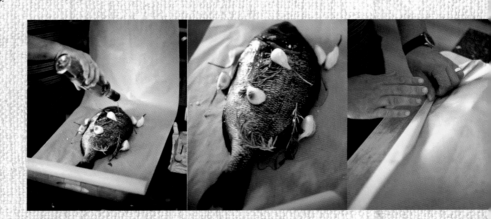

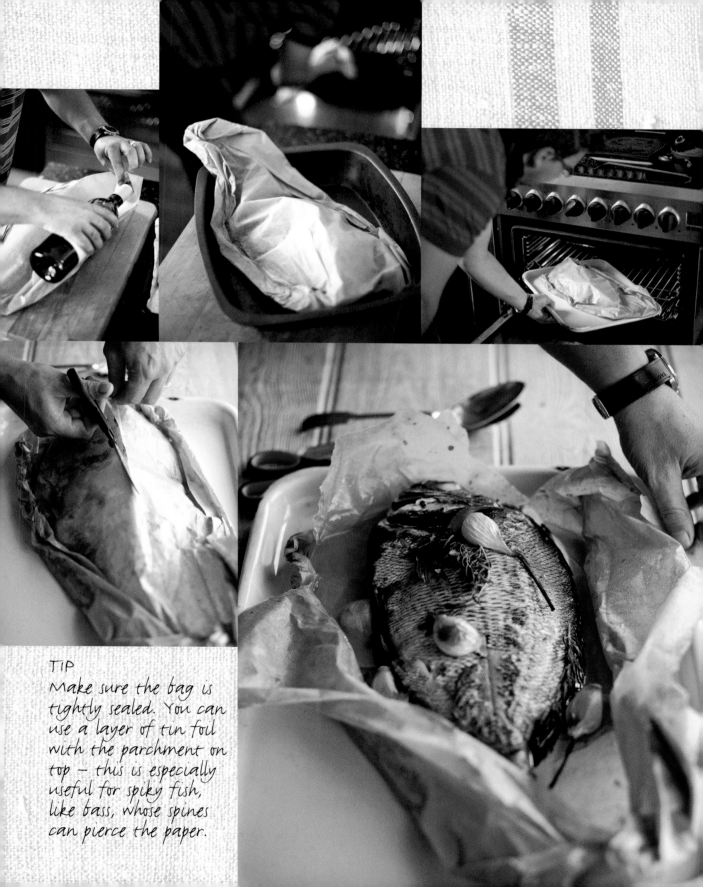

TIP
Make sure the bag is tightly sealed. You can use a layer of tin foil with the parchment on top – this is especially useful for spiky fish, like bass, whose spines can pierce the paper.

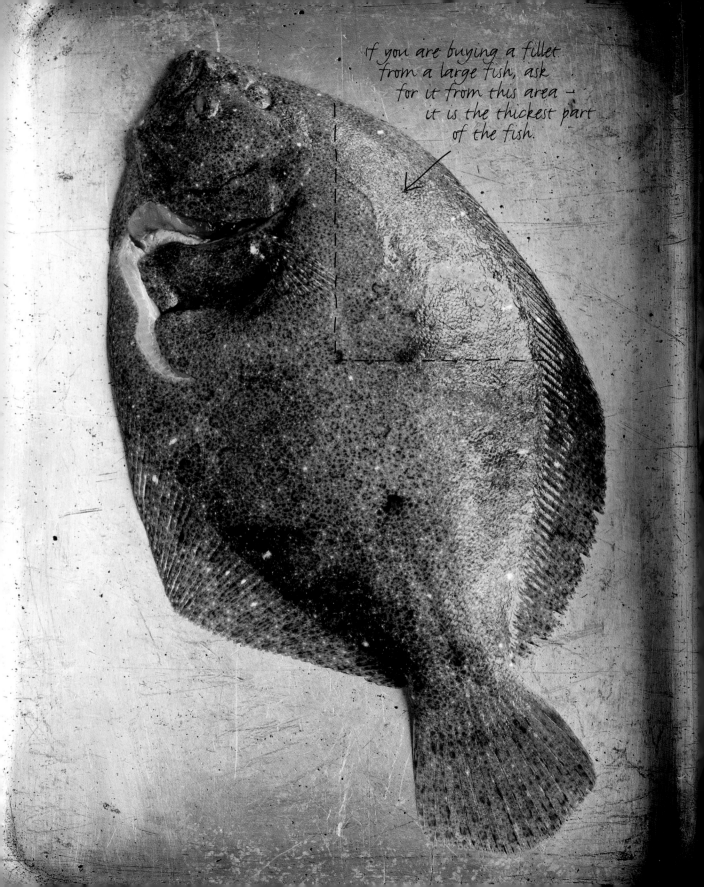

If you are buying a fillet
from a large fish, ask
for it from this area —
it is the thickest part
of the fish.

brill *Scophthalmus rhombus*

Brill is a very versatile fish in the kitchen and delicious when simply cooked. During the 19th century it was regarded with contempt as a fish for the poorer classes, but today rubs shoulders with its illustrious cousin the turbot on many menus.

Brill is similar in shape and colouring to turbot (see page 184), but is smaller and thinner, growing to 40–55 cm/16–22 in in length and very occasionally to 75 cm/30 in. If you're ever unsure if the fish in front of you is brill, run your fingers over the fish and if it has scales and no hard nodules then it's brill and not turbot.

Like many flatfish, brill survives by being a master of disguise, changing colour to match its surroundings, disappearing before your very eyes with a flick of its tail and a cloud of mud or sand. Its speckled skin with light and dark flecks blends magically into the seabed. Female brill start to breed at about 4 years old, when they are around 40 cm/16 in. They spawn in spring and summer in relatively shallow water – you'll often scare tiny juvenile brill when paddling. The young feed on plankton, then move on to crustaceans and small fish living on the seabed. Some of the best brill in the world are landed on UK shores and though it has a similar sweet succulence to its equally sought-after cousin, it's not as expensive.

Taste description
The first bite gives up a blink-and-you'll-miss-it hint of dilute acidity, giving way to a more low-key, consistent flavour like the caramelized edges of fried egg (an echo of the fish's most noticeable aroma). The texture is firm, but not substantial, with a balanced moisture content and something of the turbot's gelatinous stickiness. Avoid eating the skin, which is rough and bitter.

Territory
Brill are widespread all around the coasts of Britain and Ireland, although more common in the south. They are found in the eastern Atlantic from Iceland to Morocco and also in the Mediterranean and the Black Sea.

Environmental issues
Brill are usually caught by beam trawlers, as they live in the sand on the seabed, although small day boats catch modest amounts too. Avoid eating immature brill, less than 40 cm/16 in, that have not had a chance to reproduce.

Territory	Local Name
UK	Brill (Kite in SW England)
Portugal	Rodovalho, Patrúcia
France	Barbue
Germany	Kleist, Glattbutt
Greece	Rómbos-pissi
Holland	Griet
Italy	Rombo liscio
Poland	Naglad
Spain	Rémol
Sweden	Slätvar
Norway	Slettvar
Denmark	Slethvarre
Tunisia	M'dess moussa
Turkey	Çivisiz kalkan, Pisi

Health
Brill is a good source of protein and provides vitamins B and E and magnesium.
Per 100 g/4 oz: 95 kcals, 2.7 g fat

Seasonality
Though brill is said to be in season all year round, avoid brill during its spawning season from April to June. It is at its very best from October to February.

Yield
1 kg/2¼ lb weight of brill yields 45% edible fillet.

brill fillets with sage and lime butter

Serves 4

Plain flour, for dusting
4 x 180 g/6½ oz brill fillets
Sea salt and freshly ground black pepper
75 g/3 oz/6 tbsp butter
Splash of olive oil
8 fresh sage leaves
Juice of 2 limes
Handful of fresh parsley, finely chopped

AT THE FISHMONGER
Ask your fishmonger for pieces
nearer the head end on the top
side of the fish with the brown
skin, as these are the thickest
and best. Ask him to remove the
skin. I don't think you really get
a proper brill experience from a
thin piece of fish.

Try to buy fillets from a large fish – if you have a good fishmonger, he should be able to find you something that weighs a couple of kilos. If he does get them for you, it is quite an experience. It's not very often that I flour fresh fish before cooking, but I quite like the sticky coating you get here. You can cook any piece of fish, except perhaps oily fish like mackerel and salmon, using this recipe.

Sage is a wonderful herb, especially with what I would call quite meaty fish. You could add a few capers or a little dried chilli to this dish and, as with any fish that's cooked in butter, I can wholly recommend it served with mashed potatoes and greens. I also like to serve this dish with a thyme and onion salad made by mixing chopped onion with lots of fresh thyme leaves, some chopped mint, salt, lemon juice and olive oil.

Spread the flour out on a large plate or work surface. Season the brill with salt and pepper, then lightly flour the fillets, shaking off any excess.

Melt 25 g/1 oz/2 tbsp butter in a frying pan and add just a splash of olive oil. When the pan is hot, add the fish and fry gently for 6–7 minutes until golden on the first side. Turn the fish over, add half the sage leaves and continue cooking for a further 3–4 minutes. The fish should be cooked after this time – you can test it by just lifting the corner of one fillet to see if it flakes easily.

Transfer the fish to serving plates, add the remaining butter to the pan and when it starts to foam, add the remaining sage leaves, the lime juice and parsley, then spoon liberally over the fish.

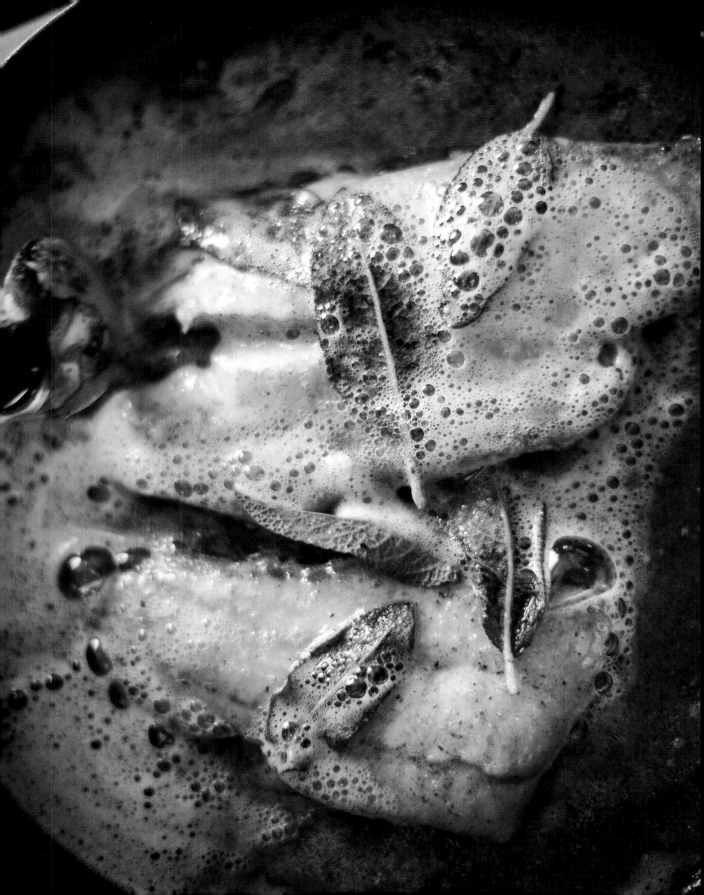

roast chunks of brill with Béarnaise sauce

Serves 4

4 tranches or chunks of brill fillet,
 about 275 g/9½ oz each
2 tbsp olive oil
Sea salt and freshly ground black pepper
Few small fresh rosemary sprigs
 (optional)

For the sauce:
2 egg yolks
2 tbsp tarragon vinegar or white
 wine vinegar
Splash of water
150 g/5 oz/10 tbsp butter, melted
1 heaped tbsp dried tarragon
Squeeze of lemon, to taste

To serve:
Lemon wedges
Fresh parsley sprigs

AT THE FISHMONGER
Ask your fishmonger to cut
tranches or chunks of the fish;
the best ones will come nearer the
head on the right-hand side of
the fish.

I think these big magnificent flatfish are ideal for celebration meals. A chunk cut through the fish will mean that the flesh is cooked on the bone and you get that wonderful extra moisture and flavour. It is also such an easy cut to eat as you enjoy the thick flesh from the top, then simply lift out the large bone and enjoy the thinner bottom fillet with the soft gelatinous skin.

This quick Béarnaise sauce is simple to make – the tarragon, the rich butteriness and the acidity of lemon are a perfect combination.

Preheat the oven to 240°C/475°F/Gas Mark 9.

Rub the tranches or chunks of fish well with olive oil and salt and pepper, then place in a roasting pan and cook in the oven for about 18–20 minutes. You can sprinkle some fresh rosemary over the fish if you wish.

Meanwhile, make the sauce. Whisk the egg yolks, vinegar and water together in a heatproof bowl, then place the bowl over the top of a saucepan of gently simmering water and continue to whisk until the mixture is the consistency of double cream. While whisking, slowly add the melted butter in a gentle stream until the sauce thickens. Add the dried tarragon, then taste and season with salt and pepper and add just a squeeze of lemon to your taste.

Serve the fish with lemon wedges and parsley sprigs with the sauce separately or just pour the sauce over the fish. This is great served with boiled leeks, marrow, spinach and new potatoes.

whole poached brill with tomatoes, thyme and saffron

Serves 4–6

2 tbsp olive oil

1 shallot, finely chopped

2 garlic cloves, finely chopped

4 ripe tomatoes

1 tbsp fresh thyme leaves

Good pinch of saffron strands

1 small dried bird's-eye chilli (optional)

A splash of Pernod or aniseed-flavoured
 alcohol (optional)

125 ml/4 fl oz/½ cup dry white wine

1 brill, about 1.5 kg/3 lb

125 ml/4 fl oz/½ cup water

Sea salt and freshly ground black pepper

A small handful of fresh parsley,
 finely chopped

AT THE FISHMONGER
Buy a whole fish and ask your
fishmonger to remove the head
and trim the fins and tail, so you
end up with a half-oval shape.

If you are looking for an impressive dish to serve for 4–6 people then this is the one. I just love serving whole fish at the table, especially something like this where the fish has been cooked in a really flavoursome juice. If you are worried about the aniseed flavour of the Pernod, please don't – it doesn't take over the dish, but adds a wonderful depth. See overleaf for step-by-step pictures showing how to serve the cooked fish.

Preheat the oven to 200°C/400°F/Gas Mark 6.

Heat the olive oil in a roasting pan large enough to hold the fish and about 600 ml/1 pint/2½ cups of liquid over a low heat. Add the shallot and garlic and fry gently until softened.

Using your hands, roughly squeeze in the tomatoes to release the juices, then add the tomato flesh with the thyme and saffron. Crumble in the chilli, if using, and mix well. Add a splash of Pernod, if using, and allow to boil until all the liquid has evaporated.

Add the wine and boil for a further minute, then lay the fish in the pan and pour in the water. Season with salt and cook in the oven for about 30 minutes, topping up the water if necessary and basting the top of the fish during cooking.

Remove the dish from the oven, sprinkle over the parsley and taste the juice, seasoning if necessary. I find that proper seasoning helps to bring out all the flavours of the sauce. Serve straight from the dish. To remove the flesh from the fish, use a spoon and cut the soft fish down the middle from the head to the tail, then using 2 spoons lift the fish off in chunks. When all the fish from the top is gone, simply lift out the backbone and you'll be left with the boneless underside of the fish.

If you're a shellfish lover, you could add a few live mussels, clams or cockles during cooking. A good accompaniment with this would be some aïoli, quality bread and freshly cooked spinach.

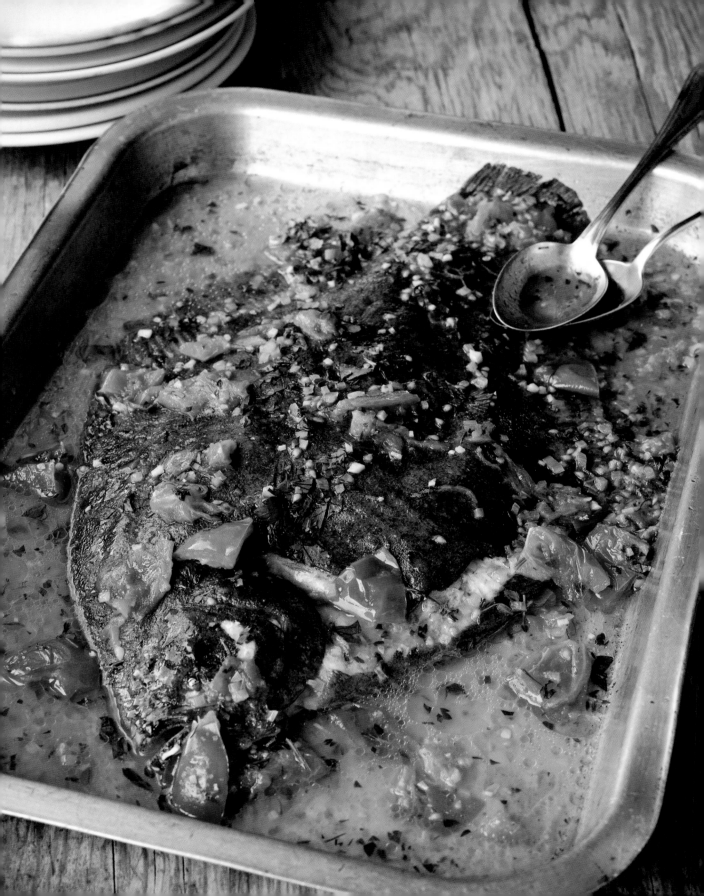

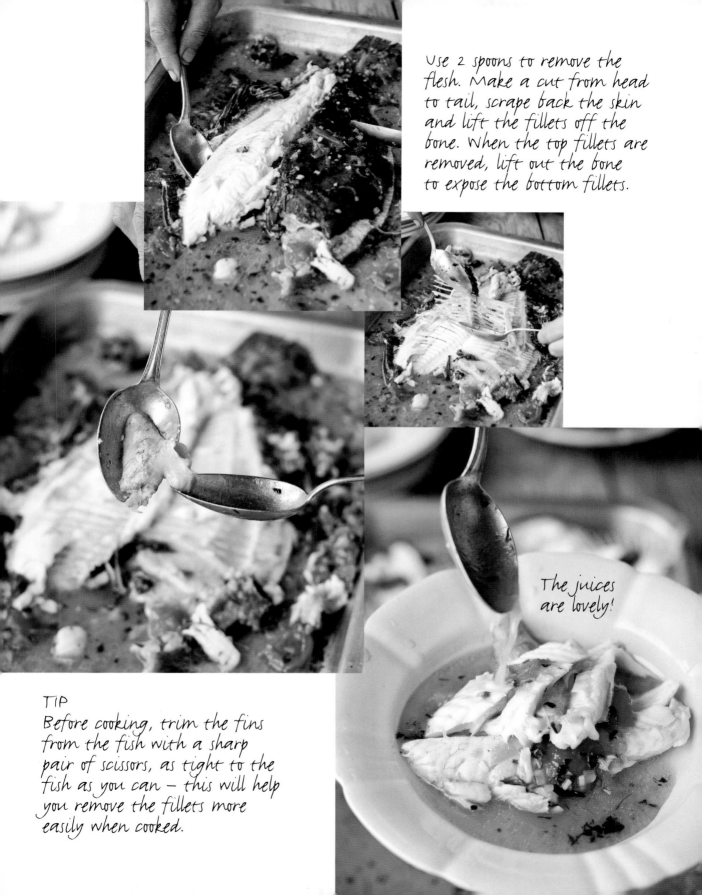

Use 2 spoons to remove the flesh. Make a cut from head to tail, scrape back the skin and lift the fillets off the bone. When the top fillets are removed, lift out the bone to expose the bottom fillets.

The juices are lovely!

TIP
Before cooking, trim the fins from the fish with a sharp pair of scissors, as tight to the fish as you can – this will help you remove the fillets more easily when cooked.

cod *Gadus morhua*

Cod is a great fish with amazing large soft white flakes. A member of the *Gadidae* family, it leads a laid-back life at the bottom of the ocean. That snowy white flesh is designed for just a quick burst of action to grab a snack, so even when danger is snapping at its heels in the form of a trawler net, after a while it just gives up, making it an easy catch.

Cod is a powerful-looking fish with a large head and square-ended tail (see illustration on page 64). Generally it's a pale sandy-grey colour with a mottled brown pattern on the top half. All cod have a distinctive curved white lateral line and a barbel on the chin that's used as a sense organ when searching for food. Cod also manufactures a protein that acts as an anti-freeze so they can survive freezing temperatures.

At spawning time from February to April, they migrate to shallower waters close to coastlines, making them even easier to catch. In the North Sea cod matures at 4–5 years old at a length of about 50 cm/20 in, and can live up to 60 years.

Cod meat has virtually no fat and more than 18% protein, which is high for a fish, and when dried or salted this increases to 80%.

In the fishmonger's, look for a pure white, almost translucent, appearance to fillets and vibrant skin colours.

Taste description

Wild cod has a firm flesh with large, pearly white flakes that fall apart easily when cooked. A soft base note of floury potatoes, lifted by hints of sweet mustard and fresh peas, dominates the smell, and the flavour is unmistakable – an immediate sweet tang of dill, followed by a delicate, oceanic aftertaste. The flesh is moist and silky, and the dense, tight texture of the flakes provides a long, even chew. Cod's characteristically firm nature is particularly noticeable in just-caught examples, but the fish will tenderize in a day or two.

Farmed cod has a distinct aroma of whole milk, which is reflected in its flavour, whose first hit of lactic sharpness gradually softens to an intense, synthetic sweetness, together with a just detectable taint of cod liver oil. Although the large flakes are densely packed, the flesh falls apart easily. Despite its juicy appearance, there's little moisture present to balance out that tooth-resistant mouth feel.

(continues on page 64)

Territory	Local Name
UK	*Cod*
USA	*Atlantic cod or Scrod (young cod)*
France	*Cabillaud, Morue*
Germany	*Kabeljau, Dorsch*
Holland	*Kabeljauw,*
Denmark/	
Sweden/Norway	*Torsk*
Italy	*Baccalá★*
Portugal	*Bacalhau★*
Spain	*Bacalao★*

★ There is no word for fresh cod in these languages, just for salt cod

Health

Oil extracted from cod livers is an important source of vitamins A and D.
Per 100 g/4 oz: 83 kcals, 0.9 g fat

Seasonality

Cod are available all year round depending where the fish has been caught, but to help sustainability avoid fish caught in the North Sea between February and April.

Yield

1 kg/2¼ lb weight of cod yields 70% edible steak.
1 kg/2¼ lb weight of cod yields 50% edible fillet.

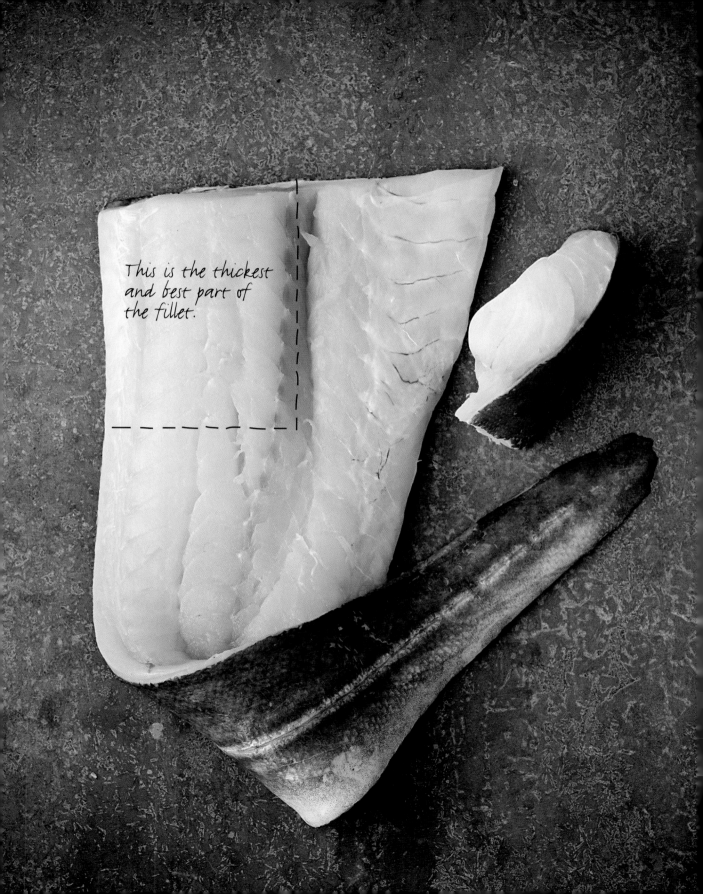

This is the thickest and best part of the fillet.

Territory

Cod is found throughout the North Atlantic ranging from the north and eastern coast of North America, around the southern tip of Greenland to the waters around Iceland, the Faroes, the Arctic Ocean, the North Sea and the Barents Sea. It is found all around the British and Irish coasts.

Environmental issues

One of the key reasons for the collapse of cod stocks in UK waters has been the targeting of the breeding stock just before or during their spawning when they move closer to shore. Great progress is being made with this fish due to public awareness, which has meant that people are buying a more diverse range of fish rather than sticking to the same ones each week. This is good news for fish like the cod.

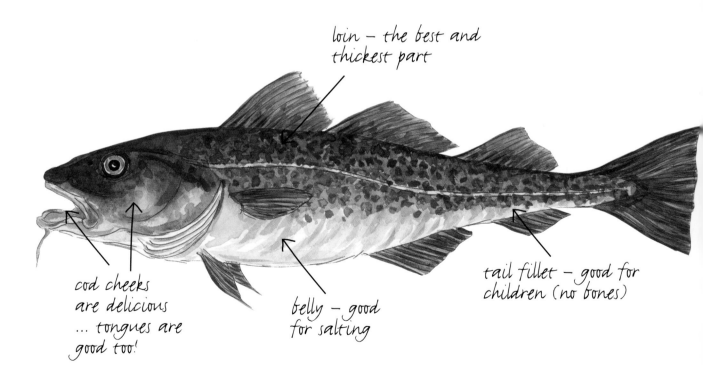

loin – the best and thickest part

cod cheeks are delicious ... tongues are good too!

belly – good for salting

tail fillet – good for children (no bones)

roasted cod with rocket and anchovy vinaigrette

Serves 4

6 anchovy fillets

1 tsp capers

1 small garlic clove

1 tbsp white wine vinegar

½ tsp Dijon mustard

150 ml/5 fl oz/⅔ cup vegetable oil, plus
 extra for cooking

Small handful of fresh parsley, chopped

Splash of Worcestershire sauce, to taste

Splash of Tabasco, to taste

4 pieces of cod, about 180 g/6½ oz each

Sea salt and freshly ground black pepper

To serve:

Enough rocket for 4 people

50 ml/2 fl oz/¼ cup olive oil

Juice of ½ lemon

AT THE FISHMONGER
Buy cod fillet preferably from the
thick (head) end, as the flakes
will be bigger.

There's nothing like the big thick flakes of cod. I think this is what makes this dish so luxurious. I absolutely adore anchovies and, together with capers, they make the perfect dressing for just about any piece of fish. Peppery rocket dressed with nothing more than lemon juice, olive oil and salt is a wonderfully versatile accompaniment and this type of dish is perfect for a quick simple lunch.

Preheat the oven to 240°F/475°F/Gas Mark 9.

First, make the dressing. Place the anchovies, capers, garlic, vinegar and mustard in a small food processor and blitz, then with the motor still running, slowly drizzle in the vegetable oil until you have a smooth emulsion. Add the parsley and Worcestershire sauce and Tabasco to taste. The dressing should be the thickness of single cream. I quite like this dressing spicy, so I always add an extra drop or two of Tabasco.

Heat 2–3 tablespoons of vegetable oil in a small frying pan. When hot, season the fish with salt and pepper, lay flesh side down in the pan and cook for about 2–3 minutes until golden. It is important that the oil is very hot, as this will prevent the fish sticking. If your pan is capable of going straight into the oven, put it on the top shelf and continue to cook for a further 5–6 minutes. If not, remove the fish from the pan and place in a suitable roasting pan and continue cooking in the oven.

To serve, mix the rocket with salt, olive oil and lemon juice, arrange the fish on top and spoon the dressing liberally over the dish.

grilled cod with caper and avocado butter

Serves 2

2 x 200 g/7 oz pieces of cod fillet
Sea salt and freshly ground black pepper
25 g/1 oz/2 tbsp butter, melted, for
 brushing

For the avocado butter:
1 ripe avocado
Finely grated zest and juice of 1 lemon
50 g/2 oz/4 tbsp butter, softened
1 garlic clove, crushed
Splash of Worcestershire sauce, to taste
Splash of Tabasco, to taste
1 tbsp capers, roughly chopped
1 tsp fresh dill, chopped

AT THE FISHMONGER
Ask your fishmonger for pieces
from the thicker head end of
the fish.

I love avocados, especially when they are halved and filled with freshly cooked prawns and a light Marie Rose sauce; it's an old dish but one that works so well. The best I ever prepared was in Menorca where I think they catch the best prawns in the world. It's such a joy at 5 o'clock to look for the fishermen selling their first catch to those in the know.

In this recipe the avocados are mixed in with butter and lemon and provide a perfect topping for a nice thick piece of cod, but you could use it with any fish – it's very versatile.

Preheat the grill to its highest setting.

Place the cod in a shallow dish or on a large plate and cover the fish in 2 tablespoons of salt. Leave to stand for 10 minutes, then rinse the salt away. This helps to firm up the flesh and makes the magnificent flakes meaty in texture, and also adds some salinity to the taste.

Meanwhile, make the avocado butter. Mash the avocado with the lemon zest and juice. Mix with the softened butter then add the garlic, Worcestershire sauce and Tabasco to taste, the capers, dill and salt and pepper and mix well.

Brush the cod with melted butter and cook under the grill for 5 minutes. Remove from the grill and spread some of the avocado butter over each piece, then grill for a further minute or so. This is fantastic with some nice curly kale or purple sprouting broccoli when in season.

TIP
Salting fish removes moisture and
allows you to keep it for long periods.
'Short-salting' for up to 10 minutes
firms up the flesh before cooking.
Salting for a few days will give
you proper salt cod.

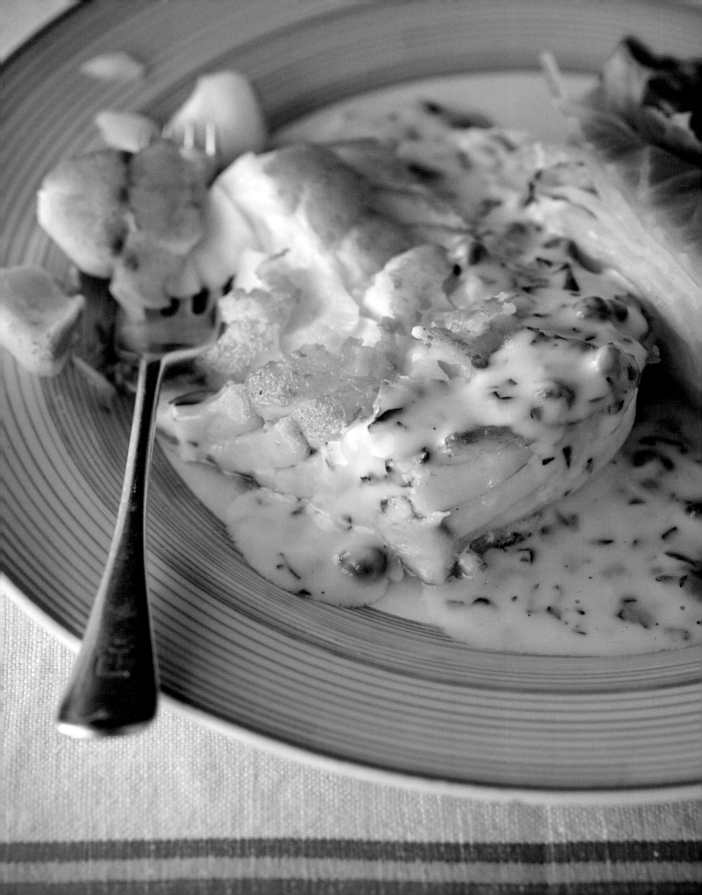

cod in parsley sauce with buttered spring cabbage

Serves 4

1 small onion

2 bay leaves

4 cloves

500 ml/18 fl oz/2 cups milk

60 g/2¼ oz/4½ tbsp butter

3 tbsp plain flour

Handful of fresh parsley, chopped

1 tbsp capers, finely chopped (optional)

Sea salt and freshly ground black pepper

4 pieces of cod, about 180 g/6½ oz each

2–3 tbsp vegetable oil

To serve:

Enough spring cabbage for 4 people

50 g/2 oz/4 tbsp butter, melted

AT THE FISHMONGER
Ask your fishmonger for thick pieces of cod from the head end of the fillet; this is always the best piece. The tail end of the fish has thinner flesh, but is excellent for slicing and making fresh fish fingers or for using in fish pies – its flesh is by no means inferior in flavour, you just don't get those wonderful big thick flakes.

This has to be one of my earliest memories of a fish dish. I remember it coming from a freezer counter in small perfectly square blocks with the parsley sauce already in the bag, the idea being you drop the whole thing into boiling water, cut the corner and serve. I can't remember disliking this but I also don't remember anything that good about it. I do, however, remember my grandmother's creamy parsley sauce that would often smother a piece of cod, and to this day I think a good parsley sauce is hard to beat. I enjoy it not only with cod but with roasted turbot, brill and in particular scallops, which I like to serve with buttered spring cabbage just as I do in this dish.

Preheat the oven to 240°C/475°F/Gas Mark 9.

First make the parsley sauce. Using a sharp knife, make 2 slashes in the onion and insert a bay leaf into each slash, then push the cloves into the onion and place in a saucepan. Pour in the milk and bring to a gentle simmer for 5–6 minutes. Remove from the heat and leave to infuse for 20 minutes. Remove the onion.

Melt half the butter in another saucepan over a low heat and stir in the flour until you have a smooth creamy paste. Slowly pour in the milk while gently whisking until the sauce is smooth and is the consistency of double cream. Add the parsley and capers, then taste and season with salt and pepper.

To cook the fish, heat the vegetable oil in a large heavy-based frying pan. When hot, season the fish, lay flesh side down in the pan and cook for 2–3 minutes until golden. If your pan is suitable for the oven, place on the top shelf for a further 5–6 minutes; if not, remove from the pan and place in a roasting pan and continue cooking in the oven.

Cook the cabbage in a large saucepan of boiling salted water, drain, then toss in melted butter and season with plenty of pepper. Serve with the fish and a good ladleful of parsley sauce.

coley *Pollachius virens*

This underrated relative of cod is enormously popular in the northern hemisphere, where it has a huge number of local names including 'saithe', 'Boston bluefish' and 'green cod'. This last is rather appropriate as coley is being hailed as the sustainable alternative to the hard-pressed cod.

In Germany, coley is called *seelachs*, meaning 'sea salmon', as both the Germans and Danes salt and smoke slices of it and these resemble smoked salmon. In Orkney, coley are preserved by being split, salted and dried over peat hearths. These dried fish have a slight phosphorescence and it is claimed you can read by the light of the fish!

Coley has the typical heavy body of the cod family, but lacks the elegant chin barbel. Most adult fish are 70–80 cm/27½–31 inches in length, although they can grow to 130 cm/51 inches. Its colouring reflects its other name – coalfish – being a dark olive charcoal with a silvery-white belly and a distinct straight pale lateral line running along its dusky flanks, distinguishing it from its close cousin the pollack. It's a voracious fish eater, lurking in groups around wrecks and rocky areas, ambushing any passing fish.

Coley reach sexual maturity when they are about 4–5 years old and around 60–70 cm/24–27½ inches in length, and can live up to 25 years old. Coley spawn from January to March in relatively deep water. Once hatched, the young move inshore, so you may come across them in rock pools, but this fish grows fast, so after a year or two they migrate back to deeper waters to start a lifetime of fish eating.

Taste description

Coley has the same firm but tender texture as cod with large easily separated flakes. This makes it a worthy substitute for cod and haddock in many dishes. The smell has a fresh chicken broth quality with a suggestion of the sea and the flavour is clean but buttery with a faint metallic aftertaste.

Territory

Coley has a similar range to cod, enjoying the same cooler northern waters. It can be found throughout the northern Atlantic from New Jersey to the English Channel, and is common along the entire Norwegian coast. It is widespread all around the coasts of Britain and Ireland, with strongholds in the north and east.

Environmental issues

Avoid eating immature fish below about 50–60 cm/ 20–21 inches.

Territory	Local Name
UK	*Coley, Coalfish, Saithe*
USA	*Pollock, Boston bluefish*
France	*Lieu noir*
Germany	*Kohler, Seelachs*
Holland	*Koolvis*
Denmark	*Sej*
Norway	*Sei*
Sweden	*Sej, Gråsej*
Italy	*Merluzzo nero*

Health

Coley are rich in vitamin B12 and selenium.
Per 100 g/4 oz: 82 kcals, 1 g fat

Seasonality

Avoid coley during its breeding time from January to March.

Yield

1 kg/2¼ lb weight of coley yields 75% edible steak.
1 kg/2¼ lb weight of coley yields 55% edible fillet.

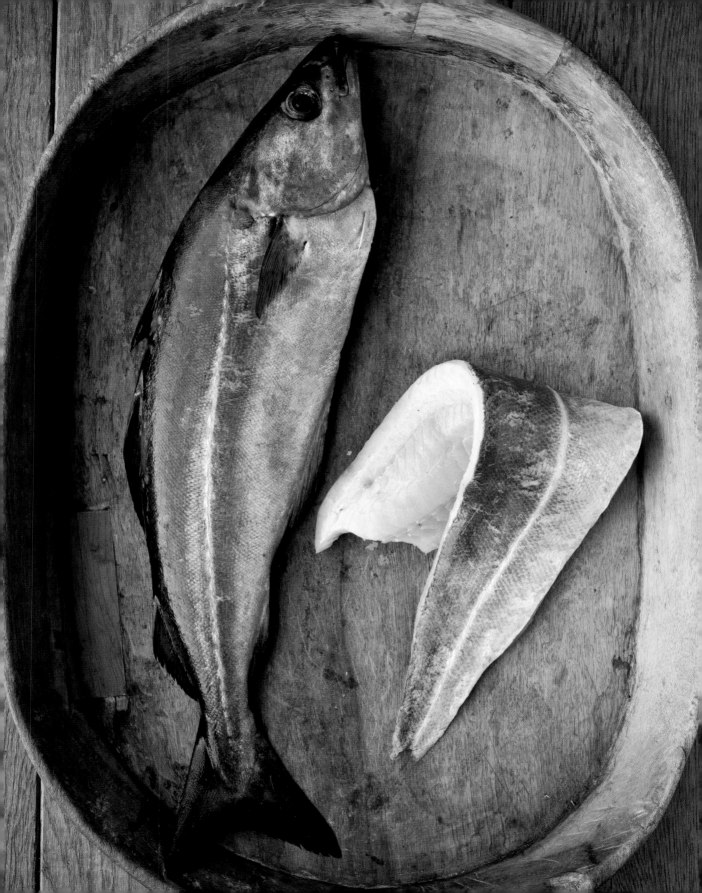

coley poached in olive oil with garlic

Serves 2

2 x 200 g/7 oz coley fillets

6 tbsp rock salt

500 ml/18 fl oz/2 cups olive oil

3 garlic cloves, sliced

2 fresh thyme sprigs

1 tbsp fresh parsley, very finely chopped

Squeeze of lemon, to taste

AT THE FISHMONGER

Ask your fishmonger for pieces from the thicker end of the fish.

This is a wonderful recipe that I first tasted when my good friend and fellow chef Mark Hix prepared it for us at home. He made it with a piece of pollack that our kindly next-door neighbour Terry gave us after a successful fishing trip. It's so simple and just brilliant. This method works with any large flaked fish and here I have used Mark's method with coley fillets. This fish is often overlooked as its past reputation has been so poor, but I think coley treated in this way is magnificent.

Place the fish on a large plate or in a shallow dish and cover the fish in salt. Leave to stand for 30 minutes then wash thoroughly and pat dry with kitchen paper.

Pour the olive oil into a wok or large pan that will allow the oil to be sufficient depth to cover the fish, and warm gently. Add the garlic and thyme and cook until the garlic starts to brown, then remove it from the oil and add the fish. Poach gently for 6–7 minutes or until it is firm and cooked.

Remove the fish and drain on kitchen paper. Sprinkle over the parsley and a squeeze of lemon. I love this dish with new potatoes and mint or courgettes fried in butter with plenty of freshly ground black pepper.

stew of coley, roasted peppers and small mullet

Serves 2

2 x 200 g/7 oz coley fillets, skinned

200 g/7 oz rock salt

1 red pepper

1 green pepper

2 tbsp olive oil

2 onions, finely sliced

2 garlic cloves, finely chopped

1 tbsp tomato purée

125 ml/4 fl oz/½ cup dry white wine

Pinch of saffron strands

2 medium potatoes, peeled and cut into
 2.5 cm/1 inch cubes

1 fresh thyme sprig

2 bay leaves

2 small red mullet, filleted and pin-boned

1 x 400 g/14 oz can good-quality Italian
 plum tomatoes

1 tbsp fresh parsley, finely chopped

6 or 7 black olives, pitted

Sea salt and freshly ground black pepper

To serve:

Crusty bread

AT THE FISHMONGER
Ask your fishmonger to skin the
fish and remove the pin bones.
Look for fillets from a large fish.

Chunks of coley, potato and sweet roasted peppers make a very rich and satisfying stew, and the use of red mullet here adds an extra depth of flavour. This amazing little fish is probably the tastiest in the sea and certainly the most beautiful (see page 154). In this recipe, the coley is salted overnight to alter the texture and add that real Mediterranean flavour of salt fish to the dish.

The day before, place the coley on a large plate or in a shallow dish and cover the fish in salt. Leave to chill in the refrigerator overnight, then wash the salt off and leave to soak in a bowl of cold water for 30 minutes.

Preheat the oven to 200°C/400°F/Gas Mark 6.

Place the peppers in a roasting pan and cook in the oven for 10–15 minutes until blackened. Remove and place the peppers in a plastic bag, then seal the top and leave to cool for a few hours. When the peppers are cool enough to handle, peel off the skins, remove the seeds and roughly chop the flesh.

Heat the olive oil in a large heavy-based frying pan, add the onions and garlic and fry very gently for 10 minutes, adding a little water just to soften them. Add the tomato purée and cook for a further minute, then pour in the wine and boil for a minute. Add the saffron, chopped peppers, potatoes, thyme, bay leaves, mullet fillets and tomatoes and stir together. It doesn't matter if the mullet fillets break up, this is what you want.

Add the coley and add just enough water, about 1 tablespoon, to cover the fish. Cover with a lid and leave to simmer for 15 minutes or until the potatoes are soft. Taste and season with salt and pepper, then stir in the parsley and olives.

Remove the bay leaves and thyme and serve with crusty bread.

If you love chilli, then a dried bird's-eye chilli crumbled in during cooking is a wonderful addition.

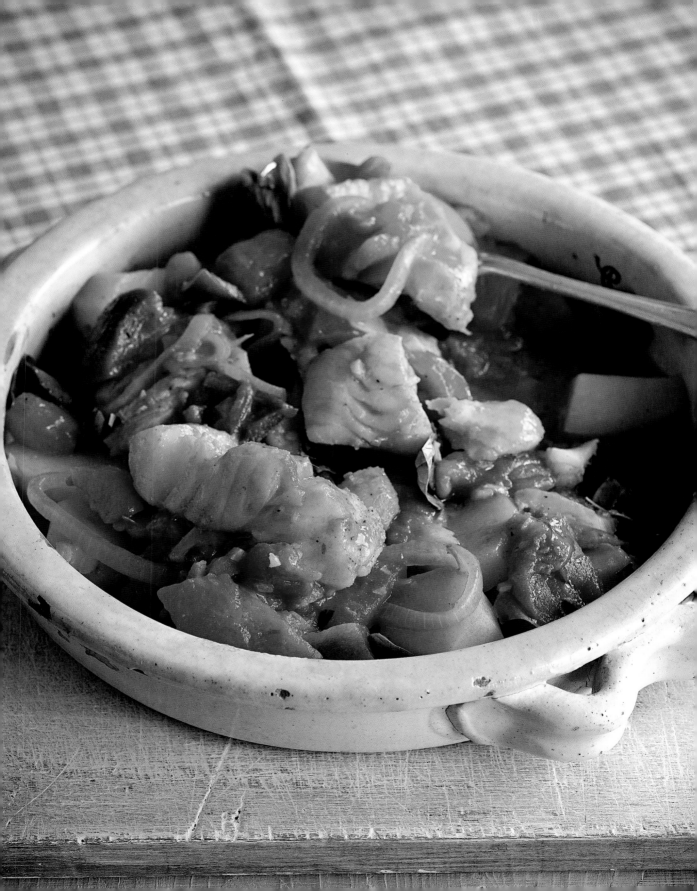

Dover sole *Solea solea*

Wonderfully luxurious and highly sought-after, the common sole is known in the UK as Dover sole, after the English fishing port that landed the most sole in the 19th century. The name has stuck, though by rights it should be renamed Brixham sole, which is where the best fish are landed now.

The sole belongs to the *Soleidae* family, with its eyes on the right-hand side of its body. It is tongue-shaped with a dorsal fin that goes around the whole of its greyish-brown body, the pectoral fin has a distinctive black tip and its underside is white. It's a slow-growing fish – females reaching up to 35 cm/14 inches after 5 years, and males rarely growing bigger than 35 cm/14 inches. You may come across the occasional large fish of 60–70 cm/24–27½ inches, which could be up to 40 years old.

These nocturnal feeders are solitary in their habits, preferring relatively shallow water where they can lurk half buried in the sand or mud, with just their little eyes showing. Their miserable down-turned mouth is perfectly positioned to eat worms, small molluscs, crustaceans and fish from the seabed. When the sea cools in winter, sole move offshore to deeper waters, returning in spring and summer to spawn.

Sole are better eaten a few days after landing. This is due to a particular chemical substance in their muscles, which is also present in plaice. Unlike plaice, which must be eaten fresh to capture this distinctive flavour before it fades, the sole's flavour only develops a day or two after death. So, unlike most fish, they are at their best 1–2 days after being caught.

They are one of the most sought-after fish at the morning's auction – always sold first, and their price is usually determined by central European markets as there's a huge demand in Spain, Holland and France. The prime size fish that weighs around 450 g/1 lb is the most popular, and the simple reason for this is that one fish feeds one person, so it's perfect for a restaurant. This means that the larger fish which appear in February and March (we call these 'doormats') often fetch a lower price, but roasted for two, three or four people they can be wonderful. When they are this size they can be easily filleted and cooked with prosciutto and sage (see page 79).

Taste description

Strikingly elastic in texture, Dover sole is amazingly juicy with small, tightly packed flakes. This close grain

(continues on page 78)

Territory	Local Name
UK	*Sole, Dover sole*
Greece	*Glóssa*
France	*Sole*
Spain	*Lenguado*
Italy	*Sogliola*
Germany	*Seezunge*
Holland	*Tong*
Denmark	*Tunge*
Norway	*Tunge*
Sweden	*Tunga*

Health
Per 100 g/4 oz: 89 kcals, 1.8 g fat

Seasonality
Avoid eating fish caught during the breeding season (April–June). The fish are in poor condition in June and July (post spawning), but reach the peak of perfection in the autumn and winter.

Yield
1 kg/2¼ lb weight of Dover sole yields 48% edible fillet.

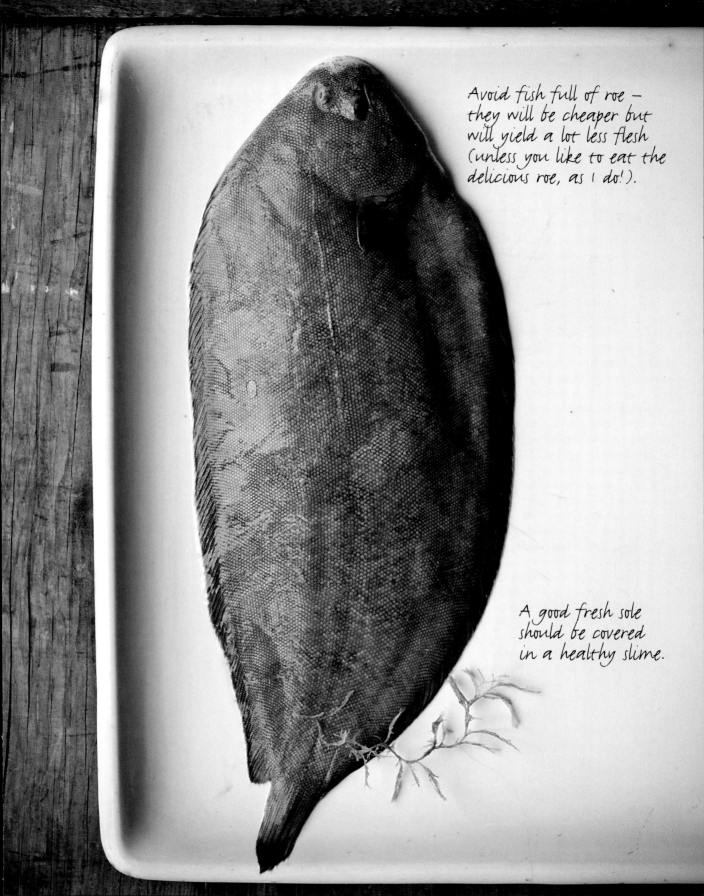

Avoid fish full of roe —
they will be cheaper but
will yield a lot less flesh
(unless you like to eat the
delicious roe, as I do!).

A good fresh sole
should be covered
in a healthy slime.

means that eating it is like taking a bite from a ripe pear or peach – the flesh is yielding, but sufficiently firm to hold a defined bite mark as it's bitten into. The aroma is piquant and savoury like grilled bacon, and the flavour is rich and mouth-filling, with a hazelnut sweetness and depth.

Territory

Dover sole are found in the eastern Atlantic (but not in American waters), the North Sea, western Baltic, Mediterranean, the Sea of Marmara, Bosphorus and southwestern Black Sea, southward to Senegal. They are also found in the coastal waters of western England and Wales, and are abundant in the northeastern Irish Sea and Bristol Channel.

Environmental issues

Avoid eating immature sole, less than 28 cm/11 inches, and fish caught during the breeding season from April to June. Stocks in the western Channel and Biscay are lower but action is being taken to redress this. In the North Sea, Dover sole stock is classified as healthy and harvested sustainably. The Hastings Fleet trammel net fishery in the eastern Channel deals in Dover sole and is certified as an environmentally responsible fishery by the Marine Stewardship Council.

Most restaurants demand prime size soles weighing 450g/1 lb. The next grade down is about 300g/10 oz. Anything smaller than this are called 'slip soles'. They are deliciously sweet and worth buying.

Dover sole with prosciutto and sage

Serves 2

2 tbsp plain flour, for dusting

Sea salt and freshly ground black pepper

2 Dover soles, about 450 g/1 lb each,
 filleted

50 g/2 oz/4 tbsp butter

8–9 sage leaves

6–7 slices prosciutto

Splash of dry white wine

Squeeze of lemon juice

Small handful of fresh parsley,
 finely chopped

AT THE FISHMONGER
Ask your fishmonger to fillet and
skin the fish; larger fish are
better for this dish.

Salty prosciutto and aromatic sage work really well together and make this a lovely recipe for cooking Dover sole fillets.

Spread the flour out on a large plate or work surface and season it with a little salt and pepper. Lightly flour the Dover sole fillets, shaking off any excess.

Melt the butter in a frying pan large enough to hold all the fish in a single layer, or you could use a large ovenproof dish. When the butter is starting to foam, add the fillets and cook gently on each side for 2–3 minutes. Add the sage leaves, then, using your hands, tear each slice of prosciutto into 2–3 pieces. Lay them into the pan so they are cooking in the butter. They will start to crisp up very quickly.

Remove the fillets and equal amounts of prosciutto onto a serving plate. Add a splash of wine and a squeeze of lemon to the juices in the pan along with the parsley, then spoon over the fish. This simple dish is wonderful eaten with a bowl of freshly cooked new potatoes.

crisp fried slip soles with tartare sauce

Serves 4

150 g/5 oz/generous 1 cup plain flour
50–60 g/2–2¼ oz/1–1¼ cups really
 fine breadcrumbs
2 eggs, beaten
8 Dover soles, about 250 g/9 oz each
Vegetable oil, for deep-frying

For the tartare sauce:
2 egg yolks
1 tsp Dijon mustard
Splash of white wine vinegar
300 ml/10 fl oz/1¼ cups vegetable oil
Sea salt and freshly ground black pepper
Squeeze of lemon, to taste
1 shallot, very finely chopped
1 tbsp fresh tarragon, finely chopped
2 gherkins, finely chopped
2 tbsp capers, finely chopped

To serve:
Lemon wedges

AT THE FISHMONGER
Ask your fishmonger to skin
the fish on both sides, remove the
head and trim the fins and
tail completely.

I am always a champion of all grades of fish and you will often find that even though they might not be 'prime' their flavour can be better. I think this is the case with small Dover soles, which we call 'slip soles'. These weigh 250–300 g/9–10 oz, and when skinned and the fins and heads trimmed the small lozenges of wonderfully sweet fish that are left are easily eaten by cutting centrally down the back and just sliding the fillets off the bone. My fish merchant friend, Ian Perkes, prepares them this way.

First make the tartare sauce. Whisk the egg yolks, mustard and vinegar together, then while whisking, slowly pour in the oil in a steady stream until you have a thick creamy mayonnaise. Taste and season with salt, pepper and a squeeze of lemon, then stir in the shallot, tarragon, gherkins and capers. The sauce should be quite piquant and chunky and have the consistency of very thick double cream.

Place the flour and breadcrumbs on 2 large plates and the beaten eggs in a dish. Dip the fish first in the flour, making sure they are well coated, then into the beaten eggs and lastly into the breadcrumbs, making sure the fish have a nice even coating.

Heat the oil for deep-frying in a deep-fryer or suitable pan to about 180°C/350°F. Gently place the fish into the hot oil 2 at a time. If you try to cook too many at once, the temperature of the oil will drop and your fish will not be crisp. After 4–5 minutes, the fish should be a lovely golden colour, remove with a slotted spoon and drain on kitchen paper.

When all the fish are cooked, place 2 fish side by side on each serving plate, place a tablespoon of tartare sauce by the side and serve with lemon wedges. I would eat nothing more than a salad of the season with this magnificent dish.

grilled Dover sole with lemon and caper dressing

Serves 2

2 Dover soles, about 450 g/1 lb each
25 g/1 oz/2 tbsp butter, melted
Sea salt and freshly ground black pepper

For the dressing:
100 ml/3½ fl oz/generous ⅓ cup good
 extra virgin olive oil
Splash of white wine vinegar
Finely grated zest of 2 lemons
Juice of 1 lemon
1 tbsp rinsed salted capers, roughly
 chopped
Small handful of fresh basil, finely chopped

AT THE FISHMONGER
Ask your fishmonger to skin the dark side, leaving the white side skin on, and to scale and remove the head if you wish.

It's probably only practical to cook this for two people as two fish will comfortably fit under most grills. The lemon and caper dressing is very easy to make, and is just a matter of stirring a few ingredients together. If you're short on time but want to indulge yourself with some luxury then this is the dish for you.

Preheat the grill to its highest setting.

Brush the white side of the fish with a little melted butter then lay on the grill pan. Brush the top of the fish with melted butter and season with salt and pepper. Cook under the grill for about 10–12 minutes, brushing occasionally with a little more melted butter so the fish takes on a wonderful crisp golden coating.

To make the dressing, mix the olive oil and vinegar together in a bowl, then taste to make sure you have a good acidity, the dressing should be quite piquant. Add the lemon zest, juice, capers and basil and stir to combine.

Place a fish on each serving plate and spoon over a little of the dressing, making sure there is plenty of caper, lemon zest and herbs going onto each fish. A fennel salad made by tossing finely sliced fennel with lemon juice, sea salt and parsley would make a lovely accompaniment.

thin-lipped grey mullet

Liza ramada

An underrated fish, which I think deserves more fans. Caught in early May when they come to the estuaries from the sea, this is when grey mullet taste their best and are most delicious. In Mediterranean cuisine they are a highly esteemed fish.

These are the wraith-like shoals of grey fish haunting harbours and shallow coastal lagoons in the summertime. Some mullet also move into estuarine areas going surprisingly far upstream, their grey dorsal fins occasionally cutting the surface film.

Thin-lipped grey mullet are streamlined and monochrome. Their blue-grey bodies with silvery sides are covered with faint grey lengthways stripes and there is a dark spot at the base of each pectoral fin. The small rather disapproving mouth is filled with tiny teeth, which are perfect for grazing on algae and organic matter in the mud. This frugal lifestyle means that they are slow-growing, but in time a fish can reach up to 60 cm/24 inches, although 20–40 cm/ 8–16 inches is more common. Grey mullet are pretty defenceless, but fortunately have a strong instinct for sensing danger, vanishing with remarkable speed, and if necessary leaping out of the water.

The thick-lipped grey mullet (*Chelon labrosus*) looks similar to the grey mullet apart from plumper lips and a slightly rounder body. Both spawn in spring around the Mediterranean and Iberian Peninsula, and you'll often see their offspring in lagoons there. The adults move north to spend the summer in British coastal waters or off the shores of France, Belgium and Holland.

Taste description

New leather and a deep, unrefined sweetness close to muscovado sugar are the predominant notes in the aroma. The flavour echoes some of this character, but instead of sweetness it's balanced by the muskiness of a newly cracked hazelnut shell, and a strong suggestion of grilled tomatoes. The flesh has a chewy texture.

Territory

Grey mullet prefers brackish coastal areas and lagoons with varying salinity. They are common throughout the Mediterranean and along the northwestern coast of the Black Sea, and are also found in the eastern Atlantic, from southern Norway to South Africa. They are a common summer visitor to southern British shores, sometimes extending into the North Sea.

Environmental issues

Pollution of coastal waters and the poor condition of many coastal lagoons potentially threaten this species.

Territory	Local Name
UK	*Thin-lipped grey mullet*
France	*Mulet porc*
Greece	*Mavráki*
Portugal	*Tainha*
Spain	*Morragute*
Italy	*(Cefalo) Botolo*
Germany	*Dünnlippige Meeräsche*

Health

Grey mullet has an iodine content 900 times that of best-grade beef, is rich in minerals and quite a good source of omega-3. Per 100 g/4 oz: 115 kcals, 4 g fat

Seasonality

Avoid during its spring (and sometimes autumn) spawning period.

Yield

1 kg/2¼ lb weight of grey mullet yields 50% edible fillet.

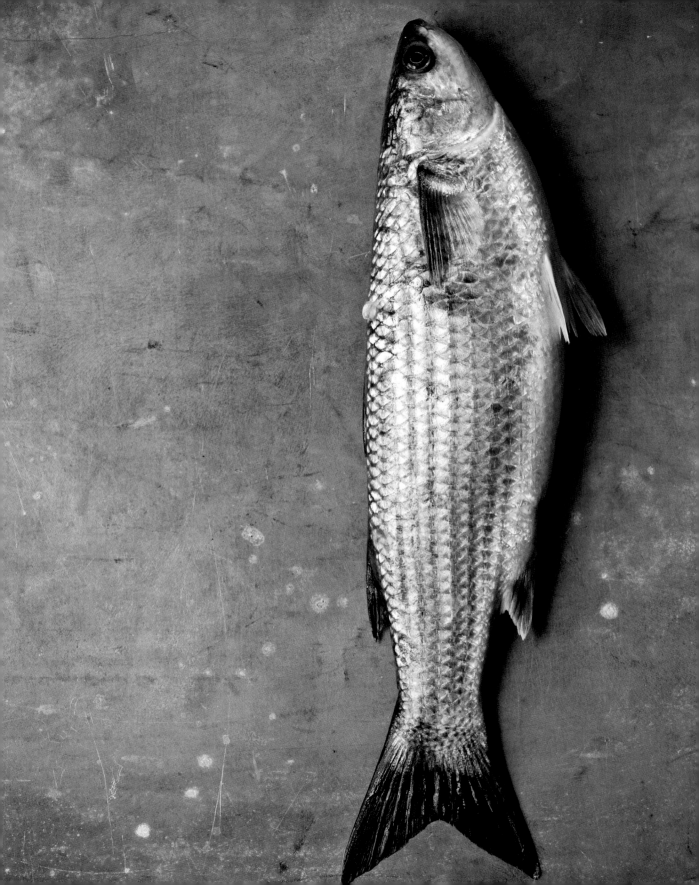

grey mullet with oyster stuffing

Serves 2

25 g/1 oz/2 tbsp butter, plus extra
 for greasing
1 small shallot, finely chopped
1 garlic clove
½ celery stick, finely chopped
2 rashers smoked bacon, rind removed
 and roughly chopped
150 g/5 oz cooked spinach
1 tbsp fresh mint, finely chopped
1 tbsp fresh parsley, finely chopped
50 g/2 oz/1 cup fresh white
 breadcrumbs
4 native oysters, shucked, reserving
 the juice
Sea salt and freshly ground black pepper
Dash of Worcestershire sauce, to taste
1 egg yolk
2 grey mullets, about 350 g/12 oz each,
 scaled and gutted
Olive oil, for rubbing

AT THE FISHMONGER
Ask your fishmonger to scale and
gut the fish.

The grey mullet gets bad press – it's true that they can be a little muddy in flavour when caught from estuarine locations, but when caught from the sea I find their flavour perfectly agreeable. Large fish can be filleted and then treated like bass – their flesh is similar in texture and there is that slight oiliness. I like to stuff the smaller fish with herbs, such as sage, rosemary and thyme, and simply roast them, but I like this Old English-inspired recipe for stuffing them with oysters.

Preheat the oven to 200°C/400°F/Gas Mark 6 and butter a roasting tray.

To make the stuffing, melt the butter in a frying pan, add the shallot, garlic and celery and fry gently until soft and golden.

Place the fried shallot mixture in a food processor with the bacon, spinach, herbs, breadcrumbs and juice from the oysters and pulse for a minute until a coarse stuffing mixture forms. Season with salt and pepper and add Worcestershire sauce to taste. Add the egg yolk and mix well. If the mixture is a little wet, add more breadcrumbs, but if it is a little dry just add a drop of water. Add the whole oysters to the stuffing and mix in.

Lay the fish on the prepared roasting tray and fill the belly cavity with the stuffing, making sure there are 2 oysters in each fish.

Season the fish and rub all over with olive oil then bake in the oven for 15–18 minutes. This is wonderful served with a salad of little gem lettuces dressed with red wine vinegar, oil and shallots.

baked grey mullet with dill and brandy

Serves 2

1 whole mullet, scaled and gutted or
 2 thick fillets, about 180 g/6½ oz
 each
A splash of white wine
1 tbsp brandy
Dash of olive oil
Pinch of ground cumin
Handful of fresh dill, finely chopped
Sea salt and freshly ground black pepper

To serve:
Squeeze of lemon (optional)

AT THE FISHMONGER
If you buy fillets, ask your
fishmonger for fillets from
a larger fish.

Dill and brandy are wonderful partners, and this very simple dish is all about the three main flavours working together, which they do very well cooked inside a bag.

Preheat the oven to 200°C/400°F/Gas Mark 6.

Place a sheet of foil, about 46 cm/18 inches square, or large enough to cover the fish, shiny side down on the work surface, and then lay a sheet of greaseproof paper on top. Fold in the edges, about 2.5 cm/1 inch, so both sheets are secured together. Using 2 layers helps to stop the foil being punctured.

Arrange the fish diagonally from corner to corner then fold up the sides. Mix the wine, brandy, olive oil and cumin together and pour over the fish. Sprinkle over the dill and season with salt and plenty of pepper.

Crimp all the edges together so that the fish is sealed inside and there are no leaks, then place in a roasting pan and cook in the oven for 15–18 minutes.

Serve by opening the bag at the table and adding a squeeze of lemon if you like. I love this dish with small buttered new potatoes.

grey mullet with mussels, roasted garlic and oregano

Serves 4

2 grey mullets, about 300–400 g/
 10–14 oz each, scaled and gutted
2 heads of garlic, unpeeled
150 ml/5 fl oz/⅔ cup good olive oil, plus
 a little extra for frying and drizzling
Sea salt
1 onion, finely chopped
1 celery stick, finely chopped
250 ml/8 fl oz/1 cup dry white wine
500 g/1 lb 2 oz ripe tomatoes,
 roughly chopped
Pinch of saffron strands
1 heaped tbsp dried oregano
10 live mussels, cleaned and
 beards removed

To garnish:
1 tbsp fresh parsley, finely chopped

AT THE FISHMONGER
Ask your fishmonger to scale and
gut the fish.

Oregano is one of my favourite herbs, as it is so evocative of the Mediterranean. I prefer oregano dried to fresh and always buy it on the branch, which is available in continental grocers. It's wonderful to sprinkle onto a sliced tomato that's dressed with a little good-quality red wine vinegar and served with any grilled fish. The roasted garlic and oregano work amazingly well in this light stew.

Preheat the oven to 120°C/250°F/Gas Mark ½.

Cut the heads from the fish and set aside, then chop the fish into chunks along the length of the fish about 5 cm/2 inches long. It's best to start about 7.5 cm/3 inches back from the tail and work your way to the head end, so you still make sure you get a nice tail piece.

First, roast the garlic. Cut off the top part so you can see the garlic cloves, then place on a baking sheet, drizzle with olive oil and season with a little salt. Roast in the oven for about 20 minutes or until the garlic is soft and can be easily squeezed out. Leave to cool then carefully peel the cloves and set aside.

Heat 2 tablespoons of olive oil in a pan, add the onion and celery and fry gently until softened. Add half of the wine and boil for a minute, then add the tomatoes and saffron. Cover the pan and cook gently for 30–40 minutes until the tomatoes are soft and stewed and really broken down. If the sauce is a bit dry add a splash of water. Pour the sauce through a conical strainer and press down with the back of a spoon to extract all the juice. Discard what's left in the strainer.

Pour the 150 ml/5 fl oz/⅔ cup olive oil into a hot roasting pan, add the garlic cloves and stir, mashing 6 or 7 of the cloves down. Add the remaining wine, boil for a minute, then add the tomato sauce and oregano and stir together. Add the fish.

Cover and bake in the oven for 12–14 minutes. Add the mussels and bake for a further 5 minutes until the mussels have opened. Remove from the oven, discard any mussels that are still closed, sprinkle with parsley and serve. I really like this dish with just plain boiled rice.

gurnard
Aspitrigla cuculus / Trigla lucerna / Eutrigla gurnardus

Gurnard belongs to the *Trigliadae* family, which are rather sweetly known as 'sea robins'.

There are three common varieties of gurnard. All have the same prehistoric fossil-like appearance with large bony heads covered in a protective scaly plate and a small cone-shaped body. The lower three rays of the pectoral fins are separated into finger-like sensory organs which the gurnard uses to feel for small fish and crustaceans living in the mud or sand of the seabed. Other than that the differences between the varieties are in colour and size.

The vibrant red gurnard (*Aspitrigla cuculus*), whose colouring is unmissable, is the smallest of the three varieties and reaches only up to 40–50cm/ 16–20 inches, while tub gurnard (*Trigla lucerna*) is the largest and grows up to 75 cm/30 inches. Despite its rather unflattering name, which is from the Old English word 'tubbot', meaning 'short and thick', these are beautiful fish with pink to red shading down the back. The large pectoral fins are edged like fans with an iridescent peacock blue and a reddish-orange outer edge.

Finally, the monochrome grey gurnard (*Eutrigla gurnardus*) reaches up to 40 cm/16 inches, and its grey body is speckled in pale grey or white flecks. Some have a slight flush of red and look like they have had too much to drink, hence their Spanish name of *borracho*, meaning 'drunkard'.

The gurnard's breeding season is a long one – it can start in February and go right through to August, although most spawning is done by June.

Gurnards are very gregarious and vocal fish, communicating with each other by producing audible grunts created by a special muscle in the airbladder, which in turn acts as a resonating chamber. The French call them *grondin*, meaning 'growler'. This has led to speculation about the origins of the sirens' song. Were sailors of old serenaded by a pack of grunting, growling fish under their boat, rather than a group of beautiful maidens? We'll never know.

Taste description

Gurnard shares the same firm, muscular texture as monkfish, and has a fairly neutral, understated aroma. That restrained character is echoed in the muted flavour, which carries notes of mussels and clams, as well as a just perceptible hint of almonds. The flesh tends towards dryness, but not unpleasantly so.

Territory	Local Name
UK	*Grey gurnard / Red gurnard / Tub gurnard*
USA	*Sea robins*
France	*Grondin gris / G. rouge / G. galinette, Galinette*
Germany	*Grauer Knurrhahn*
Holland	*Grauwe poon*
Denmark	*Grå knurhane*
Sweden	*Knorrhane, Knot*
Norway	*Knurr*
Spain	*Borracho, Perla / Arete / Bejel*
Italy	*Cappone gurno / C. coccio / C. gallinella*
Greece	*Capóni / Capóni / Capóni*

Health
Per 100 g/4 oz: No data available at time of publication.

Seasonality
Avoid gurnard during their breeding season: April to August for greys, June to August for reds, and May to July for tubs.

Yield
1 kg/2¼ lb weight of gurnard yields 32% edible fillet.

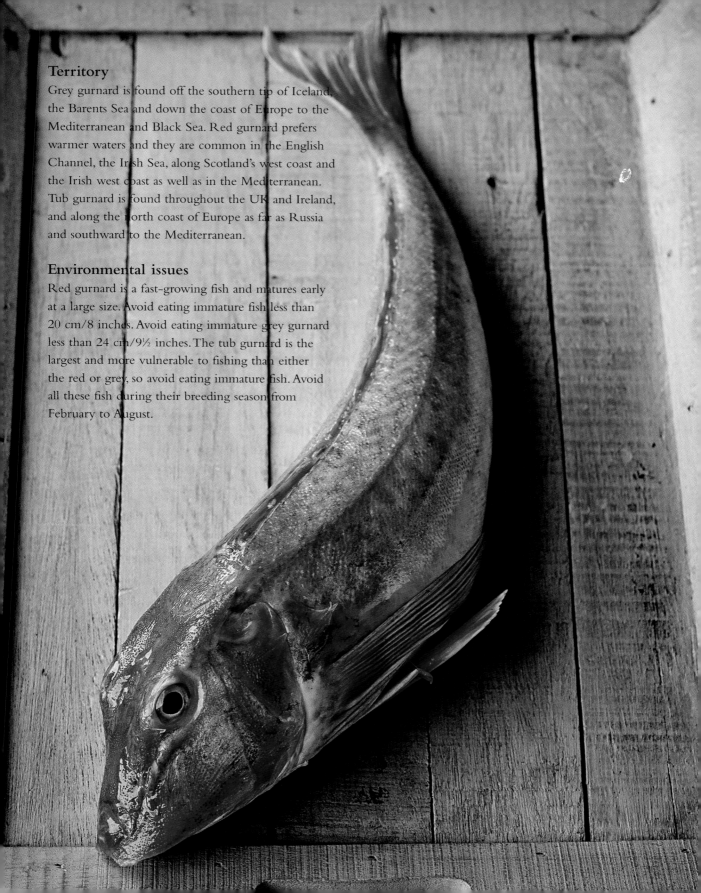

Territory

Grey gurnard is found off the southern tip of Iceland, the Barents Sea and down the coast of Europe to the Mediterranean and Black Sea. Red gurnard prefers warmer waters and they are common in the English Channel, the Irish Sea, along Scotland's west coast and the Irish west coast as well as in the Mediterranean. Tub gurnard is found throughout the UK and Ireland, and along the north coast of Europe as far as Russia and southward to the Mediterranean.

Environmental issues

Red gurnard is a fast-growing fish and matures early at a large size. Avoid eating immature fish less than 20 cm/8 inches. Avoid eating immature grey gurnard less than 24 cm/9½ inches. The tub gurnard is the largest and more vulnerable to fishing than either the red or grey, so avoid eating immature fish. Avoid all these fish during their breeding season from February to August.

gurnard fillet cooked in butter with lemon and parsley

Serves 2

Plain flour, for dusting
2 gurnard fillets, about 200 g/7 oz each
Sea salt and freshly ground black pepper
100 g/4 oz/8 tbsp butter
Small handful of fresh parsley
Squeeze of lemon, to taste

AT THE FISHMONGER
Ask your fishmonger to remove
the pin bones (the little bones that
protrude from the backbone out
into the fillet). It's an easy job
and they won't mind.

A treat for us on the market is to grab a fish from the auction and have it cooked for breakfast by Christine and her team at the local Fishermen's Mission. She cooks her fish just lightly floured and griddled to perfection. I like to treat this simple preparation with just some white pepper and vinegar and a mix of tomato ketchup and salad cream to make a sort of seafood sauce – it's great and I consider it a real treat. My great friend and fellow fish merchant Sean Perkes will often call me to join him for breakfast and he frequently brings tub gurnard fillets, even though he has the choice of magnificent sole, turbot, scallops or John Dory. He reckons 'tubs' are the best fish to eat on the market, and I totally agree with him now – they're delicious. I'm in on the secret – and I thought when I met him he was just being frugal!

This simple recipe keeps the flesh wonderfully moist and you can't beat fresh fish cooked in butter even though it's not the most healthy option. I'm sure it's okay once in a while.

Spread the flour out on large plate or work surface. Season the fish with salt and pepper and lightly flour the fish, shaking off any excess.

Melt three-quarters of the butter in a frying pan and wait until it just bubbles. Turn the heat down and add the fish. You are not trying to sear the fish but to cook it gently in the butter. Cook for 6–7 minutes, basting the fish with the butter on the pan, then turn it over, it should be wonderfully golden. Continue to cook and baste for a further 4–5 minutes.

Remove the fish from the frying pan and set aside on a plate. Add the remaining butter to the pan and turn the heat up slightly until the butter starts to bubble and smell nutty. Add the parsley and a good squeeze of lemon and spoon over the fish. I love to eat this with boiled potatoes and cabbage.

roasted gurnard with sage and pancetta

Serves 4

4 slices fatty pancetta
2 gurnard fillets, about 160 g/5½ oz
 each, skinned
6 fresh sage leaves
45 g/1½ oz/3 tbsp butter, melted
Sea salt and freshly ground black pepper

AT THE FISHMONGER
Ask your fishmonger to remove
the pin bones for you.

Gurnard is one of my favourite fish, but it is often relegated to cheaper lunchtime menus or stews in restaurants and is rarely eaten at home. This could be purely due to our lack of knowledge about this fish, but once acquainted with it, it becomes a real treat. This fish has always been eaten by families who work in the fishing industry and a traditional fisherman's dish in Brixham in Devon was a whole roasted gurnard wrapped in bacon – they used to call it a 'Brixham Ham'. Here's my modern-day version.

Lay some clingfilm on a work surface, about 40 cm/16 inches long. Applying pressure with the back of a heavy knife, stretch the slices of pancetta away from you, one by one, until they are stretched and thin, then cut them in half.

Lay 4 slices of pancetta on the clingfilm then arrange a gurnard fillet on top of the pancetta nearest to you. Place 2 sage leaves on top of the fish, brush with melted butter, and use the clingfilm to help you roll the pancetta around the fish, tucking the ends in as you go until you have a tight roll. Twist one end of the clingfilm away from you like a Christmas cracker and the other end towards you, then hold the 2 ends tightly and roll away from you a few times. You will feel the clingfilm tighten in from the ends to form a neat sausage shape. Repeat this with the other fillet then leave to chill in the refrigerator for 30 minutes.

Preheat the oven to 200°C/400°F/Gas Mark 6.

Remove the clingfilm and place the fish on a large baking sheet. Place a sage leaf on each fish and brush with a little melted butter. Season with pepper and roast in the oven for 10 minutes. This is wonderful served with a good old-fashioned parsley sauce and plenty of buttered peas.

risotto of gurnard and peas

Serves 4

2 tbsp olive oil

1 leek, finely chopped

2 celery sticks, finely chopped

2 garlic cloves, finely chopped

200 ml/7 fl oz/scant 1 cup dry white
 wine

1 kg/2¼ lb whole gurnards

150 g/5 oz small frozen Greenland
 prawns, unshelled

1 bay leaf

1 fresh thyme sprig

25 g/1 oz/2 tbsp butter

1 onion, finely chopped

400 g/14 oz/2 cups risotto rice, such as
 arborio or carnaroli

Sea salt and freshly ground black pepper

100 g/4 oz/1 cup fresh or frozen peas

To finish:

4–5 cubes of cold butter, about
 1 cm/½ inch in size

Small handful of fresh fennel herb or
 parsley, chopped

AT THE FISHMONGER
Ask your fishmonger to gut the
fish and remove the heads.

This recipe is inspired by one of my most favourite fish restaurants in the world, Al Gatto Nero on the island of Burano in the lagoon of Venice. Max, the owner's son, has become my friend. The food here is simple and beautifully cooked every time I visit, which I do twice a year if I can; it's a trip worth making. Ruggero and his wife Anna, who run the kitchen, totally respect the quality of the fresh seafood the fishermen bring them and instinctively know how to prepare each fish according to the season. They make a white risotto with a broth made from small goby fish they catch in the mud at low tide around the lagoon. I have made a version here with small gurnard and peas. It's delicious – I'm sure Ruggero, Anna and Max would approve.

First, make the stock. Heat the olive oil in a large heavy-based pan big enough to hold the fish, add the leek, celery and a garlic clove and fry gently for 3–4 minutes or until just softened but not browned. Add three-quarters of the wine, then the fish, prawns, bay leaf and thyme and pour in enough water to cover. Leave to simmer gently for 40 minutes until the fish is cooked and breaks up.

Place a conical strainer over another pan and ladle the contents of the stock pan into it, pressing down as hard as you can to squeeze any juice from the fish. Discard what's left in the strainer. Place the stock over a low heat.

To make the risotto, melt the butter in a wide pan, add the onion and other garlic clove and fry gently until softened. Add the rice and fry for 1–2 minutes or until the rice looks transparent around the edges. Add the remaining wine and when it has nearly evaporated add the hot stock, a ladle at a time, stirring the rice as you add it. Keep doing this, seasoning as you go, until the rice is cooked. The rice should have just a little bite to it.

Add the peas a few minutes before the risotto is cooked, then remove the pan from the heat and leave to rest for a few minutes.

To finish, whisk in the cubes of cold butter, add the fresh herbs, season and serve. I prefer a risotto slightly wet, so when you put a heap onto a plate and shake it backwards and forwards gently it falls into a comforting layer across the plate.

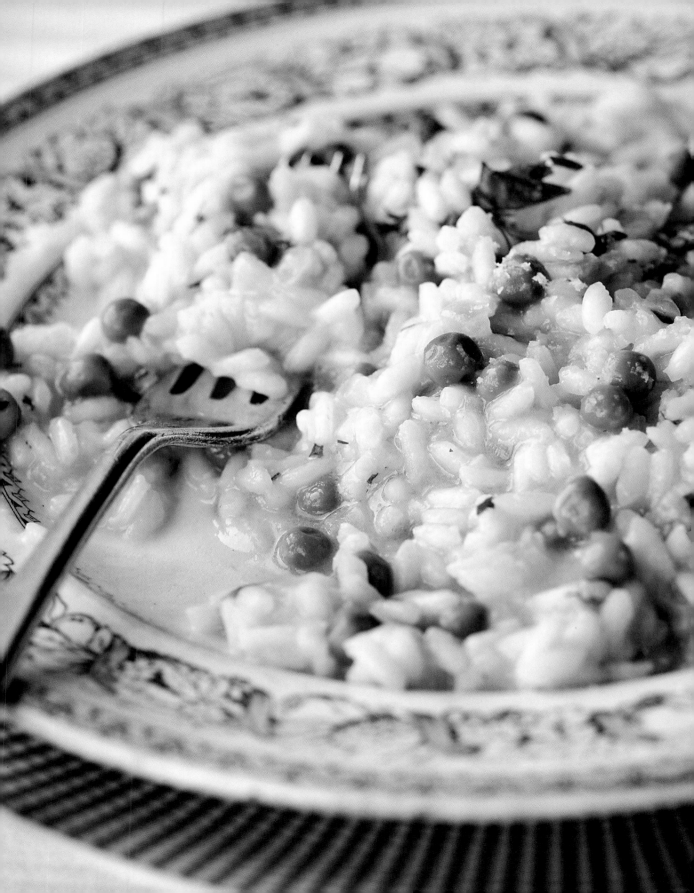

haddock *Melanogrammus aeglefinus*

The distinct black thumb- and fingerprint-like blotch above each pectoral fin identifies haddock – this is the mark of Saint Peter who is said to have plucked it out of the ocean!

Haddock are close relatives of cod, but are a little smaller, growing to 70–100 cm/27½–39 inches. They have a bluish-brown back, silvery flanks, a black curved lateral line and a sensitive chin barbel, which is used to feel around the dark ocean depths for food. They enjoy the cool waters of northern oceans and seas, coming inshore in summer to feed and going offshore to deeper waters in the winter to spawn. Most haddock reach maturity during their third year, and females often grow faster than males. They can live for more than 20 years.

Haddock spawn between February and June, with a peak between March to April. After spawning the haddock return to shallower waters where shoals of them feed on the seabed, eating shellfish, crustaceans, worms and sand eel.

A recent study in the North Sea has shown that some haddock have learnt to avoid nets using survival skills they gained as youngsters. Fish swim away from an approaching trawler and smaller fish can squeeze through the mesh. However, haddock taken by line fishing are in much better shape than those that have been trawled.

Taste description
Haddock has an ozone-like aroma that encapsulates the salt water from which it is fished – fresh with notes of seaweed and the tang of clean beach air. That oceanic character is followed through on the flavour, which is delicate with a suggestion of seashells and fresh spring greens. The texture is lean but succulent, the flakes of the spearmint-white flesh are compact but readily break apart. If possible, haddock should be bought and cooked skin-on – it's thin and easy to eat.

Territory
Haddock are widespread from the Arctic Circle through the Atlantic to UK waters, where they are most likely to be found in the North Sea.

Environmental issues
Stocks in the west of Scotland and in the combined areas of the North Sea, Kattegat and Skagerrak are at healthy or sustainable levels and are fished sustainably. While they are at sustainable levels, the fishing is too high on Icelandic and Faroese stocks. Stock in the northeast Arctic (Barents and Norwegian Sea) are healthy but the level of fishing mortality is unknown.

Territory	Local Name
UK	Haddock
USA	Haddock
France	Englefin
Sweden	Kolja
Holland	Schelvis
Norway	Hyse
Germany	Schellfisch
Denmark	Kuller
Italy	Eglefino

Health
Haddock is an excellent source of protein and contains vitamin B12 and selenium.
Per 100 g/4 oz: 81 kcals, 0.6 g fat

Seasonality
Avoid this fish during its spawning season from February to June.

Yield
1 kg/2¼ lb weight of haddock yields 50% edible fillet.

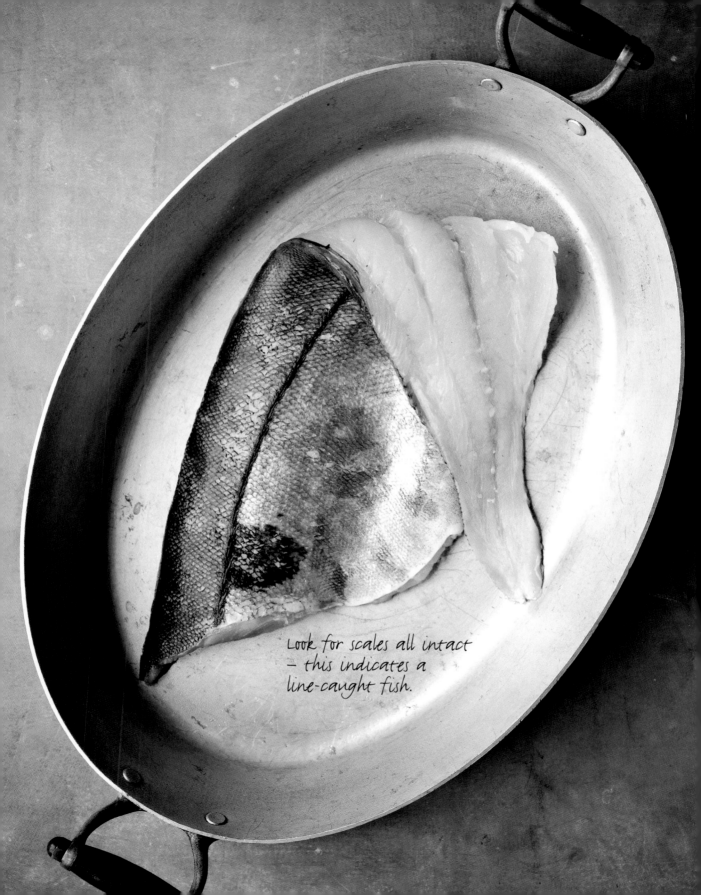

Look for scales all intact — this indicates a line-caught fish.

salted haddock with potato, red onion and chilli salad

Serves 2 as a starter

250 g/9 oz haddock fillet, skinned

150 g/5 oz rock salt

Extra virgin olive oil, for brushing

1 red onion, finely chopped

200 g/7 oz small cooked new potatoes,
 cut in half

For the mayonnaise:

1 tsp Dijon mustard

25 ml/1 fl oz/2 tbsp white wine vinegar

1 egg yolk

150 ml/5 fl oz/⅔ cup vegetable oil

Sea salt and freshly ground black pepper

1 tbsp extra virgin olive oil

1 tbsp fresh chives, finely chopped

1 tbsp capers, chopped

1 mild chilli, finely chopped

I love salted fish as it has a unique flavour. Cod is the main species that's salted and dried and is notably at the heart of Portuguese cuisine, but haddock takes salting well also. The principle of salting is to draw out moisture before drying so the fish is preserved. A piece of salted fish is wonderful cooked under the grill and then sprinkled with vinegar and served with a parsley and onion salad. In this recipe, I salt haddock overnight, cook it and make a salad – the results are excellent.

Place the fish on a large plate or in a shallow dish and cover with the salt. Cover and leave to chill in the refrigerator for at least 24 hours.

Preheat the grill to high.

When the fish is ready, pour off the liquid in the dish, then rinse the fish well and pat dry with kitchen paper.

Brush the fish with olive oil and place under the grill for 5 minutes until cooked. Leave to cool.

Meanwhile, make the mayonnaise. Whisk the mustard, vinegar and egg yolk together in a bowl. While whisking, slowly pour in the vegetable oil in a thin steady stream until you have a creamy mayonnaise. Season with salt and pepper, then stir in the olive oil, chives, capers and chilli.

In another bowl, combine the onion and potatoes. Flake in the fish, then mix in 1–2 tablespoons of the mayonnaise, just enough for the potatoes to be lightly coated. Serve with rye bread and a salad of baby leaves dressed with olive oil and lemon. Some asparagus in season would be great with this.

Thai fishcakes of haddock and prawns

Serves 4

300 g/10 oz raw king prawns, shelled

500 g/1 lb 2 oz haddock fillet

1 tbsp Thai red curry paste, to taste

½ tsp fresh root ginger, finely minced

2 shallots, finely chopped

Juice of 1 lime

10 fresh kaffir lime leaves, finely shredded

Splash of fish sauce

1 egg, beaten

150 g/5 oz green beans, chopped into
 5 mm/¼ inch pieces

3 tbsp plain flour

About 200–300 ml/7–10 fl oz/scant
 1–1¼ cups vegetable oil

AT THE FISHMONGER
Ask your fishmonger to skin
and remove any pin bones from
the fish.

Thai flavours are extremely fragrant and haddock, being a soft sweet flesh, lends itself perfectly to these fishcakes. The prawns add even more sweetness. I often serve these little fishcakes as an appetizer at barbecues.

I always find it a good idea, before I shape the whole batch of fishcakes, to make just one, cook it and taste it, to make sure I've got the balance of flavours right. If at this stage it is not to your taste you can always make adjustments.

The dipping sauce described below makes a delicious accompaniment or you could use ready-bought sweet chilli sauce, which is available in most supermarkets or Asian grocers.

Place the prawns and the haddock in a food processor, add the red curry paste, ginger, shallots, lime juice, lime leaves, fish sauce and the beaten egg and blitz together until smooth. Transfer to a mixing bowl and stir in the chopped green beans.

Using your hands, shape the mixture into small fishcakes, about 5 cm/ 2 in across and about 1 cm/½ in thick. Spread the flour out on a large plate and lightly flour the fishcakes.

Heat the vegetable oil in a large heavy-based frying pan and cook the fishcakes in batches for a few minutes on each side until golden. Drain on kitchen paper then serve.

You can make a very simple dipping sauce to go with these fishcakes by mixing the juice of 3 limes with a little sugar, then adding a couple of sticks of finely chopped lemongrass, a finely sliced shallot, 1–2 finely chopped red chillies, a dash of fish sauce and a little water together in a bowl.

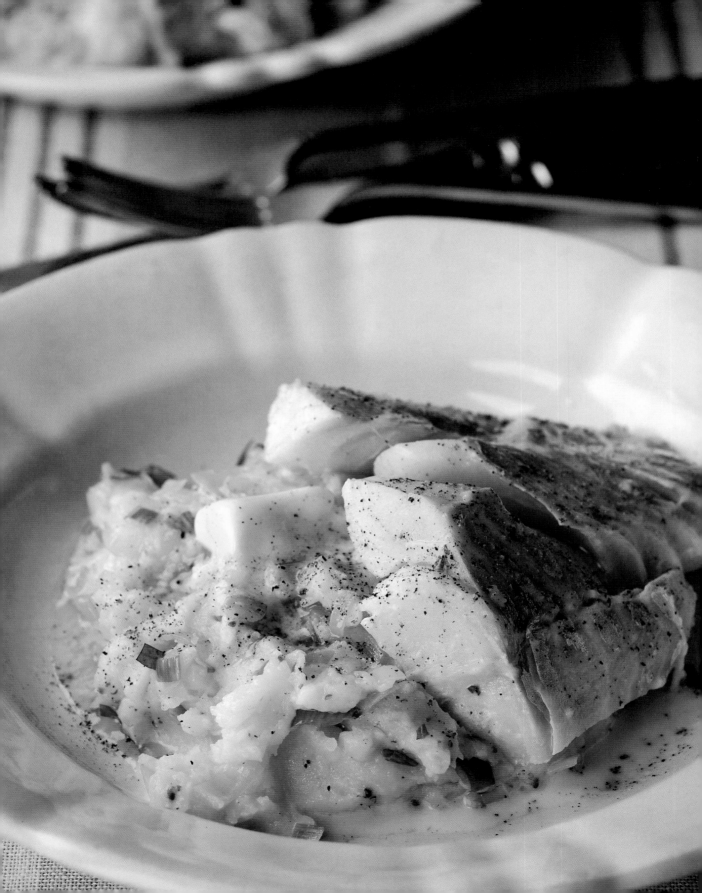

smoked haddock with mashed leeks and potatoes

Serves 2

500 ml/18 fl oz/2 cups milk

2 smoked haddock fillets, about
180 g/6½ oz each

2 bay leaves

1 leek, very finely shredded

About 400 g/14 oz potatoes, cooked
and mashed

1 tbsp wholegrain mustard

1 tsp fresh tarragon, finely chopped

Sea salt and freshly ground black pepper

If I had to name a perfect breakfast it would be smoked haddock. The best I have come across is from an old smoke house, Alfred Enderby, in Grimsby in the UK. They cure their fish in a traditional way and smoke them in old kilns which smell gorgeous from years of use, and I'm sure this helps the flavour – they use only large haddock and the result is a perfect balance of smoke and sweet fish. I can easily eat a whole fillet with a poached duck egg and plenty of black pepper.

Pour the milk into a large roasting pan and place the haddock flesh side down into the milk with the bay leaves. Bring to a gentle simmer on the hob, making sure the fish is submerged, and cook for about 6–7 minutes, after which time the skin should easily peel off.

While the fish is poaching, place the leek in a saucepan and without adding any liquid or water, gently cook until softened. Use this time also to prepare the mashed potato.

Stir the soft leek into the mashed potato with 1–2 spoonfuls of the milk the haddock was cooked in and continue to mix until you have a nice creamy consistency, adding more milk if necessary. Add the mustard and tarragon and season to taste with salt and pepper. Serve the fish with the mashed potato and plenty of pepper.

TIP
Make the mashed potato using the milk in which the haddock was poached for fantastic flavour.

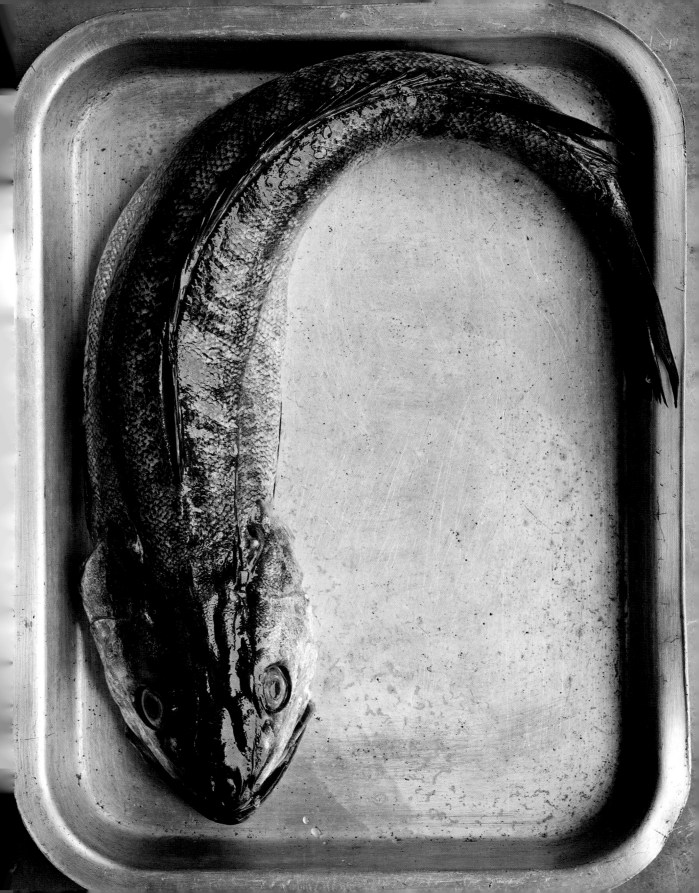

hake

European hake *Merluccius merluccius*
Cape hake *Merluccius capensis*

I love hake, though I rarely see it on British fish counters, largely because the demand in Spain is so very high. It's a real treat then to get hold of a chunk – its flesh is soft and delicious and a firm favourite of mine. Keep on the lookout for it in your fishmonger and snap it up when you can.

European hake

The European hake has beautifully sweet creamy white flakes, making it a Spanish, Portuguese, French and Italian passion. Unfortunately the hake's biology hasn't helped its chances of survival – males need to reach 3–4 years, when they are 29–50 cm/11½–20 inches long before they mature, while females mature at around 5–6 years old, when they are about 50 cm/20 inches long, so it's critical for them to be able to reach this stage to ensure the continuation of the species. Hake has a long, slender grey-black body with a large head and an impressive set of teeth inside its charcoal-grey mouth and can eventually reach up to 100–180 cm/39–71 inches in size. It's a voracious feeder, grouping together in hungry schools in the depths during the day and moving up to feed at night on squid and other fish. Hake spawns from February to July in northern waters.

Cape hake

Hake's near relative the Cape hake is found off the coast of South Africa in the deep waters of the continental shelf. It is similar in shape to its European cousin, but a little smaller, growing to a maximum length of 120 cm/47 inches, but usually found around 40–60 cm/16–24 inches. It is silvery in colour with a brownish back and a white belly. Females grow faster than males and reach sexual maturity when they are 45–60 cm/17¾–24 inches long. Spawning is from mid-spring to early summer, during October to December in the southern hemisphere. The hake migrates seasonally southward in the southern spring and northward in autumn. The youngsters eat small crustaceans and small deep-sea fishes, but need to keep out of the way of the adults who like to eat small hakes and jack mackerel.

(continues on page 104)

Territory	Local Name
UK/USA	*Hake*
France	*Merlu, Merluche*
Sweden	*Kummel*
Holland	*Heek*
Norway	*Lysing, Haeg*
Germany	*Seehecht*
Denmark	*Kolmuler*
Portugal	*Pescada*
Spain	*Merluza*
Italy	*Nasello*
Greece	*Bacaliáros*

Health
Per 100 g/4 oz: 92 kcals, 2.2 g fat

Seasonality
European hake: avoid during its spawning season from February to July.
Cape hake: avoid during its spawning season from October to December.

Yield
1 kg/2¼ lb weight of hake yields 75% edible steak.
1 kg/2¼ lb weight of hake yields 54% edible fillet.

Taste description

European hake

With the starchy aroma of baked or fried potatoes, European hake has a light but multi-layered flavour, featuring a soft lemon balm note, a warm vanilla sweetness and a green, fern-like element, as well as a suggestion of mushroomy earthiness. The milky grey/white flesh has a good level of juice, creating a yielding, melting mouth feel.

Cape hake

Smelling of a kind of starchy freshness, like clean washing or boiled new potatoes with the skin still on, Cape hake has a lush but uncomplicated taste, combining the sweet sleekness of double cream with a hint of salt. The texture is delicate – soft, like white bread soaked in milk – but without any mushiness, and the thin skin is very easy to eat. Such subtlety of flavour and richness of texture make it a good contender for light, dressing-like sauces.

Territory

European hake ranges from Norway to the Mediterranean. It is found all around the waters of the UK, but mainly on the western and northwest side of the UK. The Cape hake is found off the coast of southern and southwestern Africa.

Environmental issues

European hake

Avoid eating European hake from depleted stocks and immature fish below about 50 cm/20 inches and during their breeding season from February to July. Avoid eating generally until stocks have recovered.

Cape hake

The Cape Hake Fishery was recently certified by the Marine Stewardship Council as an environmentally responsible fishery, so choose Cape hake certified to the MSC standard.

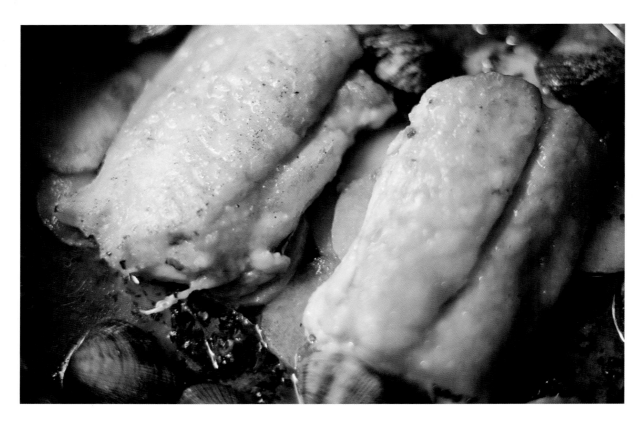

fried hake in oregano and chilli breadcrumbs

Serves 2

Vegetable oil, for deep-frying

4 tbsp plain flour

Sea salt and freshly ground black pepper

75 g/3 oz fresh fine breadcrumbs

1 tbsp dried oregano, ground to
 a powder

1 small dried bird's-eye chilli, ground
 to a powder

2 eggs, beaten

2 hake fillets, about 180 g/6½ oz each

To serve:

Lemon wedges

Mayonnaise (see page 286)

AT THE FISHMONGER
Ask your fishmonger for fillets
from the middle of a fish
weighing about 2 kg/4½ lb.

Every country has its version of fried fish and I would have to say that the flavour of fried breadcrumbs clinging to the outside of a moist fresh piece of fish seasoned with only a squeeze of lemon and maybe a little salt is extremely hard to beat. Any white fish like hake, cod or pollack is exceptional cooked in this way.

Oregano and chilli make a wonderful combination, but you can of course add your own favourite herbs and seasonings. Chips are a good accompaniment, but so is a simple tomato and onion salad with some fresh green lettuce leaves and a dollop of homemade mayonnaise (see page 286).

Heat the vegetable oil for deep-frying in a deep-fryer or suitable pan to 190°C/375°F (or until a breadcrumb rises to the surface of the oil).

Place the flour in a shallow dish and season with salt and pepper. Mix the breadcrumbs, oregano and chilli together thoroughly in another dish and place the beaten egg in a third dish.

Dip the fish first into the flour, then in the beaten egg and then into the breadcrumb mixture, making sure the fish is evenly coated. Carefully drop each piece of fish into the hot oil and deep-fry for 6–7 minutes until golden.

Serve with nothing more than a wedge of lemon and some homemade mayonnaise (see page 286) and enjoy this blissfully simple dish.

hake with parsley and creamed kale

Serves 2

½ onion

2 bay leaves

6 cloves

500 ml/18 fl oz/2 cups milk

350 g/12 oz kale

Sea salt and freshly ground black pepper

2 tbsp vegetable oil, for frying

2 hake fillets, about 180 g/6½ oz each

40 g/1½ oz/3 tbsp butter

40 g/1½ oz/3 tbsp plain flour

Small tsp capers, finely chopped

75 ml/3 fl oz/5 tbsp double cream

Small handful of fresh parsley, finely
 chopped

Squeeze of lemon, to taste

AT THE FISHMONGER
Ask your fishmonger for fillets,
preferably from a larger fish of
about 2 kg/4½ lb.

Kale reminds me of a sea vegetable and I think its fairly strong flavour works perfectly with most fish, but especially with the soft, slightly sweet flavour of hake. Kale is also very good eaten raw – it's full of vitamins, particularly vitamin C, and iron – and is very good tossed with capers, finely chopped onion and lemon juice and served with salmon.

Preheat the oven to 240°C/475°F/Gas Mark 9.

Using a sharp knife, make 2 slashes in the onion and insert the bay leaves into them, then press the cloves into the onion. Pour the milk into a saucepan and bring to a gentle simmer. Cook for 4–5 minutes, then turn the heat off and leave to infuse for about 30 minutes. Remove the onion.

Cook the kale in a large saucepan of boiling salted water for about 10 minutes, then drain and chop. Set aside.

Heat the vegetable oil in a frying pan that's suitable for the oven and when just starting to smoke, lightly season the hake fillets on the skin side with salt and pepper. Lay them in the pan skin side down and cook for 4–5 minutes until the skin is crispy and golden. Carefully turn the fish over and place the pan in the oven for a further 3–4 minutes. If your pan is not suitable for the oven, carefully transfer the fish to a roasting pan and continue to cook in the oven.

In another saucepan, melt the butter over a low heat. Stir in the flour until you have a creamy paste, then slowly pour in the milk while stirring. The sauce should be just thicker than double cream. Add the kale, capers, cream and parsley, taste and season with salt, pepper and just a squeeze of lemon. Place the creamed kale on serving plates and arrange the cooked fish on top. Serve immediately.

hake with green sauce and clams

Serves 4

Plain flour, for dusting

4 hake fillets, about 180 g/6½ oz each

Sea salt and freshly ground black pepper

100 ml/3½ fl oz/⅓ cup olive oil

2 garlic cloves

50 g/2 oz fresh parsley, very finely
 chopped

2 potatoes, very thinly sliced

Splash of dry white wine

1 dried bird's-eye chilli

1 bay leaf

200 g/7 oz fresh palourde or venus
 clams, cleaned, or live mussels,
 cleaned and beards removed

TIP
If you can't get fillets,
use the tail end of the
fish left on the bone.

I have seen this dish on countless menus on my regular trips to Barcelona, where I visit the fabulous Mercat St Josep, or the Boqueria, as it's more commonly known. I have had several versions of it and cooked it many times – the 'green sauce' comes from the amount of parsley used, and it's that classic Catalonian mix of garlic and parsley that makes it so enjoyable. The clams add a wonderful saltiness, and if done well you can just taste the sea. It is perfect served with a great Spanish wine such as Albariño or Cava.

Place the flour on a large plate or in a shallow dish. Flour the fish, shaking off any excess, and season well with salt and pepper.

Heat the olive oil in a casserole dish, add the garlic and fry for a minute then remove and set aside to cool. When the garlic is cooled, crush or pound it in a mortar with a pestle and mix it with the parsley. Try to make sure that the parsley is as finely chopped as possible.

Add the fish to the oil in the casserole dish and cook until browned on both sides. Remove from the pan and set aside. Add the potato slices to the casserole and cook until browned, then add a splash of wine. Arrange the fish on top of the potatoes, add the parsley and garlic mixture and pour in just enough water to cover the potatoes.

Add the chilli, bay leaf and clams or mussels to the casserole, then cover with a lid and cook gently for 7–8 minutes or until the clams or mussels open. (Discard any clams or mussels that have not opened.) The fish should be moist and cooked by this time and the thin slices of potato breaking up as you serve the fish from the pan. This dish needs pepper to season but there should be plenty of salt from the clams.

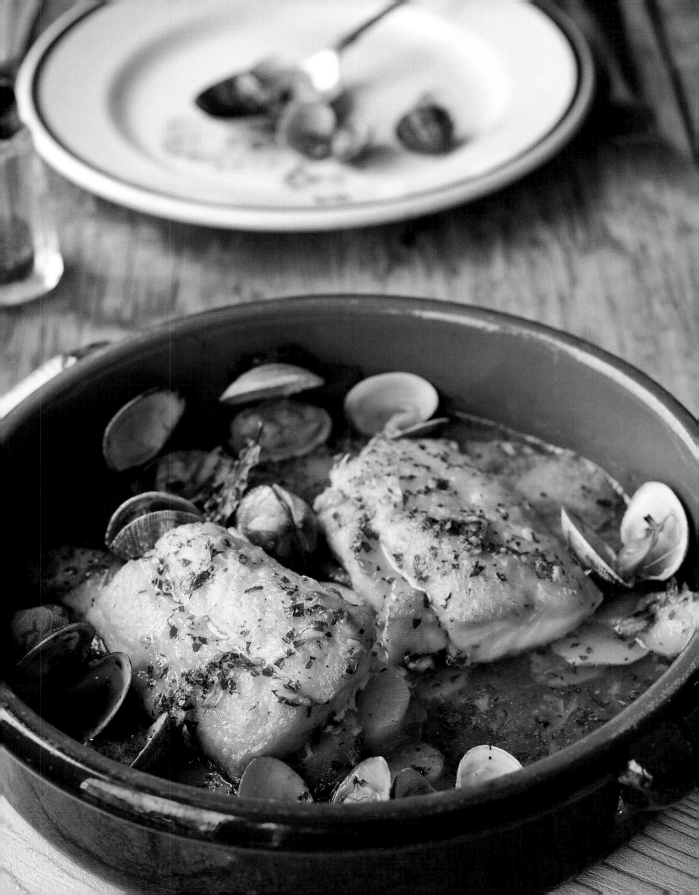

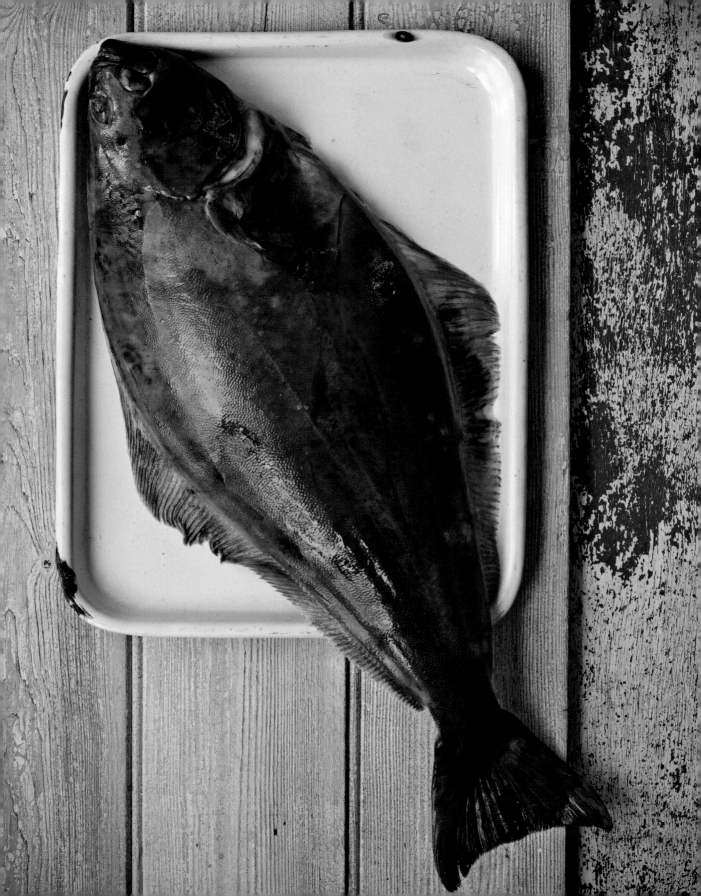

halibut

Hippoglossus hippoglossus / Hippoglossus stenolepsis

This firm-textured, mild flatfish belongs to the right-eyed *Pleuronectidae* family. It's a slow-growing fish living up to 50 years and can reach gigantic proportions. Norwegian commercial fisheries have reported Atlantic halibut of almost 4 m/13 ft and weighing about 300 kg/661 lb, and fishermen from halibut schooners of the 19th century talked of 'killer' halibut breaking men's legs and smashing up boats as they tried to land these formidable beasts.

Halibut have a thick-set, elongated body, which is dark greenish-brown in colour with a whitish underside. They have a voracious appetite and eat anything they can fit into their mouths.

Halibut was often eaten on fast days and at religious festivals, which may explain why it used to be spelled 'holibut' (in fact 'holy' forms part of its name in several languages). Despite this sacred reputation, by the 19th century it was a fish sold only when nothing else was available, but now, like brill, it has become highly esteemed. The good news is that its equally delicious cousin the Pacific halibut is being sustainably fished off the Pacific coast of Canada and the USA.

Taste description

Atlantic halibut

Although very clean and subtle in aroma, Atlantic halibut has an assertive flavour, reminiscent of a very good rare steak. The texture of the ivory flesh reinforces that steak-like nature – muscular and substantial, but with a delicate tenderness and a high level of moisture that provides a notably silky mouth feel. Atlantic halibut should be regarded with particular caution, owing to their critical stock status.

Pacific halibut

Much like the smell – a barely-there green note of steamed fresh soya beans – its flavour is quite unassuming with a light neutrality suggestive of sunflower oil. The texture is more unexpected: the bright white flakes appear big and succulent but, in the mouth, are smaller and closer, with a sticky rather than juicy quality, and break down slowly to give a long chew. It's a satisfying, if not rich, eat, and the texture and low-key flavour of the fish means that it handles the addition of punchy ingredients, such as citrus or fennel, as well as buttery sauces, very well. The skin is very fatty and best not eaten.

Territory

Halibut loves the cooler waters of the North Atlantic and the Arctic waters, and go as far down as New Jersey and Scotland.

(continues on page 112)

Territory	Local Name
UK	Halibut
USA	Halibut
France	Flétan
Holland	Heilbot
Germany	Heilbutt
Denmark	Helleflynder
Sweden	Hälleflundra
Norway	Kveite

Halibut are not found in the Mediterranean.

Health

Halibut is high in vitamins D and A and is a quite good source of omega-3 oil. Per 100 g/4 oz: 103 kcals, 1.9 g fat

Seasonality

Avoid halibut during its spawning season from late winter to early spring.

Yield

1 kg/2¼ lb weight of halibut yields 75% edible steak.
1 kg/2¼ lb weight of halibut yields 50% edible fillet.

Environmental issues

Fish labelled as 'halibut' is often Pacific halibut (*Hippoglossus stenolepis*). There is an immense fishery for Pacific and Californian halibut off the Pacific coast of Canada and the USA. The stocks are in good shape as they have a number of factors in their favour. Pacific halibut is sexually mature and able to reproduce earlier: at 5 years for males and 7 years for females.

The Pacific halibut stocks are well managed by the International Pacific Halibut Commission who apply strict harvesting conditions. Longline fisheries for Pacific halibut in the US waters of Alaska, Washington and Oregon were certified as environmentally friendly fisheries by the Marine Stewardship Council in April 2006. Longline fisheries for Pacific halibut in the Pacific waters of British Columbia and Canada are currently undergoing MSC assessment.

Farming halibut – a success story

I recently visited the Otter Ferry Halibut Farm in Scotland. It is a halibut hatchery and an amazing operation. The fish are reared in clear water pumped continously through the farm and production is about 200 tonnes a year from this farm alone. As farming of halibut becomes more popular, it is projected that 1,200 tonnes will be reared by 2010.

Halibut farming has a low impact on the environment as the fish convert their natural feed to flesh at a higher rate than many other farmed species. The fish I saw were muscular and look very 'happy' and elegant as they swam around their on-land environment. To cook and taste, the flesh was excellent and I have no hesitation in recommending it.

Aquaculture is a vital part of our future and it's great to see producers doing it so well and selling it locally, rather than importing the fish.

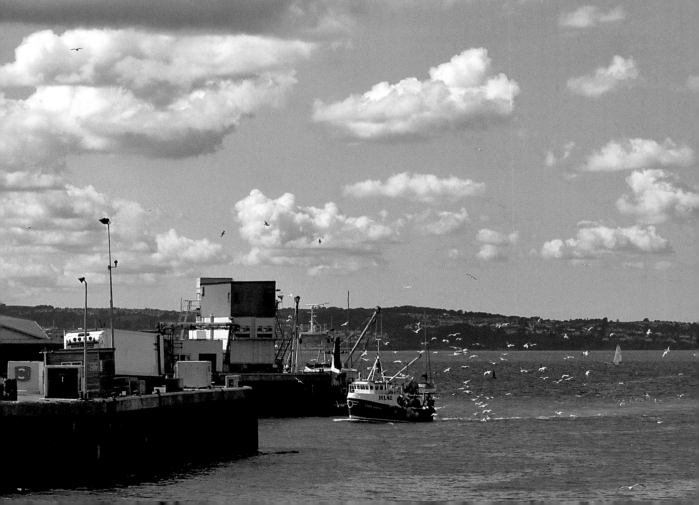

roasted halibut with broad beans and anchovies

Serves 4

Vegetable oil, for oiling
4 pieces of halibut fillet, about
 180 g/6½ oz each
20 g/¾ oz/1½ tbsp butter, melted
Sea salt and freshly ground black pepper
1 kg/2¼ lb fresh broad beans, podded
6 salted anchovy fillets
1 garlic clove
3–4 tbsp extra virgin olive oil
25 g/1 oz/¼ cup grated pecorino or
 Parmesan cheese
1 tbsp fresh mint, finely chopped
Squeeze of lemon

AT THE FISHMONGER
Buy the thickest piece of fillet you can – this will come from the head end of the fish. If your fishmonger only has small halibut, around the 4–5 kg/9–11 lb size, then ask for a steak cut across the fish.

Halibut has been held in high regard, I think because of its moist, creamy texture and because the fish yields good thick fillets. It has a delicate flavour and I like to partner it with just a simple salad or sauce. In spring and summer when the first broad beans are in abundance their wonderful sweetness with the addition of some garlic and anchovies and a little salty pecorino cheese make an excellent accompaniment to halibut. The consistency of this sauce is like a coarse pesto and it would work equally well with a roasted leg of lamb, a grilled piece of monkfish or roasted sea bass – these flavours are just so versatile.

Preheat the oven to 240°C/475°F/Gas Mark 9 and lightly oil a baking sheet.

Place the fish flesh side up on the prepared baking sheet and brush with melted butter. Sprinkle with salt and pepper and roast in the oven for 8–10 minutes.

Blanch the broad beans in a saucepan of boiling water for about a minute, then strain and leave to cool. When the broad beans are cool enough to handle, use the nail of your thumb and forefinger to pinch the end of each husk and squeeze out the bean. Set aside.

Grind the anchovies and garlic to a pulp in a mortar with a pestle, then add half the broad beans and work these to a pulp, adding the olive oil and grated cheese. Add the remaining broad beans and stir together until everything is combined. Stir in the fresh mint and a squeeze of lemon to taste, and serve a good spoonful alongside the roasted fish.

halibut with Béarnaise sauce

Serves 4

4 halibut fillets, about 190 g/7 oz each
Sea salt
2–3 tbsp vegetable oil

For the Béarnaise sauce:
1 heaped tbsp shallots, finely chopped
3 tbsp tarragon vinegar
Splash of white wine
3 egg yolks
Splash of water
200 g/7 oz butter, melted
Pinch of cayenne pepper
1 heaped tbsp dried tarragon
1 small handful of fresh tarragon,
 chopped
Lemon juice, to taste

AT THE FISHMONGER
You can buy halibut in steaks or
fillets – ideally you want flesh
from the head end of the fish.
For this recipe I am using fillets
taken from a 5–7 kg/11–15 lb fish,
as I think these are the best
eating size.

Good halibut is all about texture – its flesh has a luxurious soft juicy consistency. I have to confess that it is not one of my favourites, but I can easily see why people love it. It's not a fish you often find on menus these days and is more likely to be found in very traditional fish restaurants. Because of its delicate nature, it works really well with buttery sauces like hollandaise and, as in this recipe, Béarnaise. I quite often use a hollandaise sauce as a base and then flavour it with anchovy, garlic or other fresh herbs. I think that the tarragon of the Béarnaise sauce was made for big flatfish like halibut and turbot just as much as a good grilled steak.

When frying the fish, make sure the oil is hot otherwise the fish will stick to the base of the frying pan.

Preheat the oven to 240°C/475°F/Gas Mark 9. Season the fish with salt.

Heat the vegetable oil in a frying pan suitable for cooking in the oven. When hot, lay the fillets flesh side down in the pan and cook for 3–4 minutes until the fish is golden in colour. Turn the fish over and place the pan in the oven for a further 5–6 minutes to finish cooking. If you don't have a suitable frying pan, carefully transfer the fillets to a roasting pan instead.

Meanwhile, make the Béarnaise sauce. Place the shallots, vinegar and wine in a heavy-based saucepan and bring to the boil. Boil until you are left with about 2–3 tablespoons of liquid. Strain through a strainer and reserve the liquid.

Heat another pan of water until boiling. Place the egg yolks and water in a heatproof glass bowl and set the bowl over the pan of boiling water. Whisk, making sure that the yolks don't overcook and scramble but form a light frothy, almost double cream consistency. Remove the bowl from the heat and gradually, while whisking, pour in the melted butter in a steady stream as if you were making mayonnaise. The sauce should start to thicken. Add a pinch of cayenne, the reserved liquid and the dried and fresh tarragon. Mix well, taste and add enough lemon juice until you have a fresh acidity to the sauce. The final consistency should be thick double cream with a prominent tarragon flavour.

Place the halibut on serving plates and serve with a few tablespoons of the sauce, or serve the sauce in a small jug. I like to enjoy halibut with freshly cooked leeks, spinach or lightly boiled fennel.

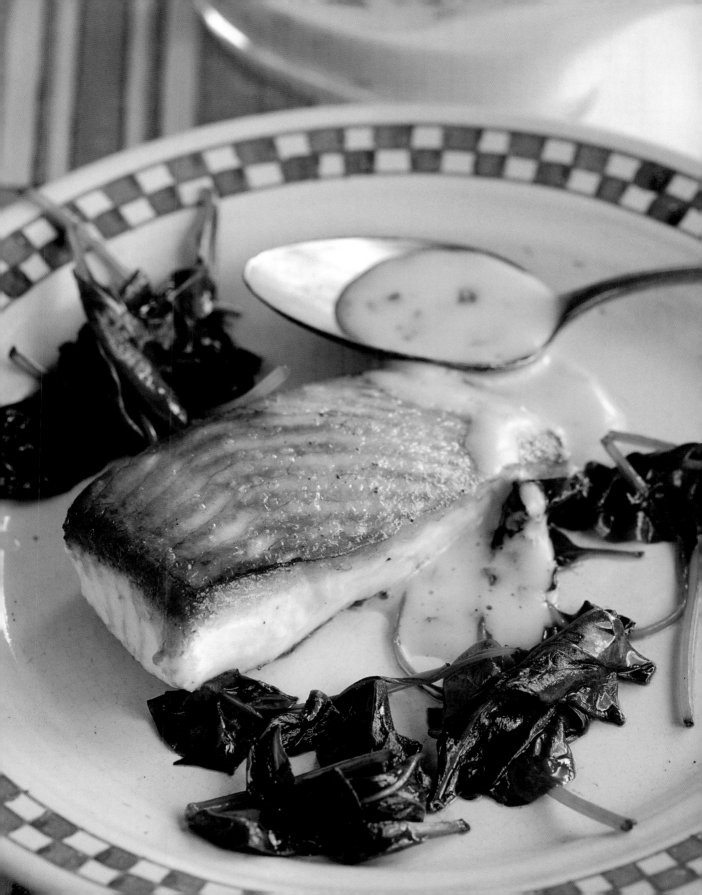

john dory *Zeus faber*

This fish is one of my favourites from my local market. I just pick up a few of these and take them over to the Fishermen's Mission where the ladies flour and fry them – one of the best breakfasts you can have.

This extraordinary-looking fish with its quiff-like spiny dorsal fin and miserable expression has the rather grand Latin name *Zeus faber*, as it was sacred to the god Zeus. It also carries the Christian name 'St Peter's Fish'. Gold-ringed dark spots on either side of its body are supposedly the thumb and fingerprints of St Peter, the apostle who pulled the fish out of the Sea of Galilee and removed a gold coin from its mouth to pay his overdue taxes. The fact that the Sea of Galilee has never seen a John Dory is a minor detail! John Dory's name is something of a mystery: 'Dory' may well have come from the French *dorée*, after its golden scales, and 'John' after the 18th century English actor John Quin who was a noted fan of eating it.

Sideways-on, John Dory's large compressed golden-brown body looks like an oval dinner plate, and if you look at it head-on it is barely visible, so it can sneak up on prey. Its down-turned tooth-filled mouth extends at surprising speed into a kind of suction tube, voraciously consuming small fish, cuttlefish and squid. John Dory can grow to over 60 cm/24 inches and weigh about 3 kg/6 lb 10 oz, but its enormous head and guts account for nearly two-thirds of its weight (see yield below) – the boneless fillets are highly prized, however.

Taste description

John Dory's aroma is very light with subtle hints of fresh seaweed and boiled potatoes. Its flavour is marginally more robust, featuring milky notes of plain omelette, most of which it owes to its thin, crunchy and easy-to-eat skin. The flesh is noticeably bland, but compensates with a very elegant texture – firm and smooth with discrete flakes and a pleasant, low-key stickiness.

Territory

John Dory are found in the warm regions of the eastern Atlantic, the coast of Europe and off the coast of southwest Africa, Southeast Asia and Australia. Its American counterpart is found between Nova Scotia and North Carolina.

Environmental issues

John Dory is not subject to quota restrictions and rarely targeted, generally taken as a very welcome and valuable by-catch in trawls. Because of this there is potential for landing and marketing of immature fish. Avoid immature fish under 35 cm/14 inches and during their breeding season from May to August.

What's your 'desert island' fish?
"Without a doubt John Dory because it's a really tasty fish – the flavour is excellent. Whenever I catch one of those it goes to one side for myself. Superb!"
Graham Perkes, third-generation trawler man from Brixham

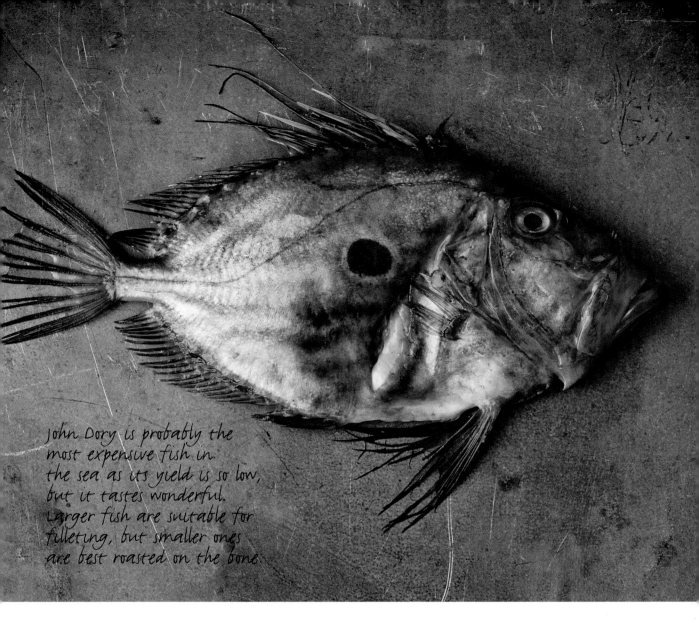

John Dory is probably the most expensive fish in the sea as its yield is so low, but it tastes wonderful. Larger fish are suitable for filleting, but smaller ones are best roasted on the bone.

Territory	Local Name
UK	*John Dory, Dory*
USA	*John Dory*
France	*Saint-Pierre, Doree, Poule de mer*
Italy	*Pesce San Pietro*
Spain	*Pez de San Pedro*
Germany	*Petersfisch*
Holland	*Zonnevis*
Denmark	*Sankt Peters-fisk*
Sweden	*Sankt Pers fisk*
Norway	*St Petersfisk*

Health
Per 100 g/4 oz: 89 kcals, 1.4 g fat

Seasonality
John Dory are available year round depending on which part of the world you are in. Avoid these fish during their spawning season – in the UK and Europe this is roughly May to August.

Yield
1 kg/2¼ lb weight of John Dory yields 33% edible fillet.

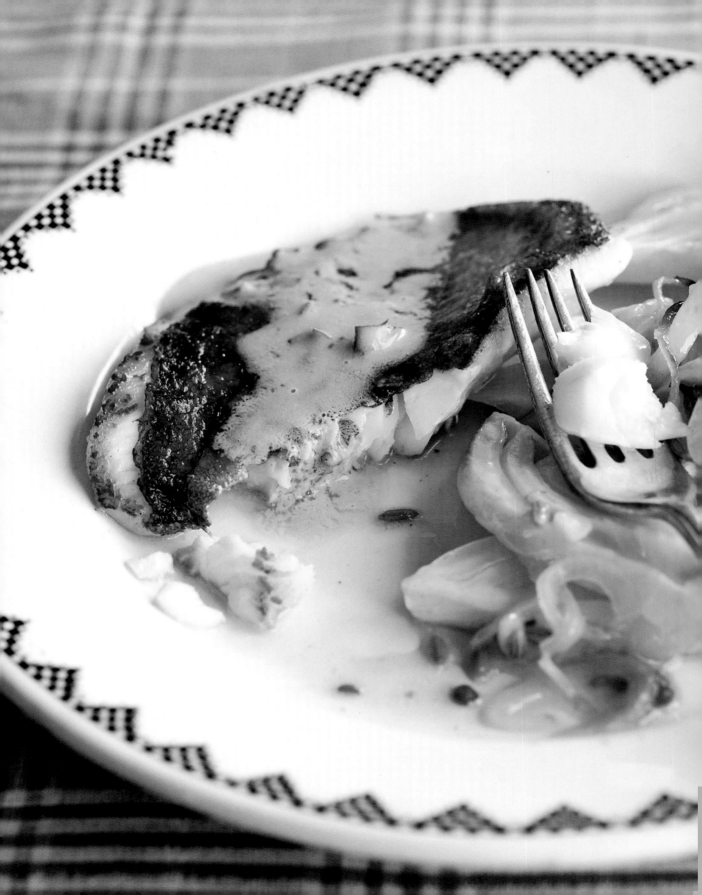

grilled dory with anchovy vinaigrette and braised fennel

Serves 4

150 ml/5 fl oz/⅔ cup olive oil, plus
 extra for brushing
150 ml/5 fl oz/⅔ cup white wine
 vinegar
150 ml/5 fl oz/⅔ cup white wine
2 bay leaves
1 tsp fennel seeds
1 tsp coriander seeds
1 lemon, sliced
1 small onion, finely sliced
3 garlic cloves, finely sliced
3 Florence fennel bulbs
John Dory fillets, about
 180 g/6½ oz per person
Sea salt

For the anchovy vinaigrette:

6 salted anchovy fillets
1 tsp Dijon mustard
3 tbsp white wine vinegar
100 ml/3½ fl oz/⅓ cup olive oil
100 ml/3½ fl oz/⅓ cup double cream
1 tbsp fresh parsley, finely chopped
Squeeze of lemon, to taste
Freshly ground black pepper

I use fennel and anchovies a lot in my cooking. They're a combination that were just made for seafood – if the flavours are good and they work together then keep using them, as they will support any piece of fish.

I serve the fennel at room temperature with this creamy vinaigrette and often enjoy it as a side dish with a lot of the fish I bring home. It even goes well with a roast leg of spring lamb.

Preheat the oven to 180°C/350°F/Gas Mark 4.

First, braise the fennel. Heat the olive oil, vinegar, wine, bay leaves, fennel seeds and coriander seeds in a casserole dish over a low heat. Add the sliced lemon, onion, garlic and fennel, then cover with a lid and cook in the oven for about 1 hour or until the fennel is tender. Leave the fennel to cool at room temperature in the braising liquid.

Preheat the grill to high.

To make the anchovy vinaigrette, pound the anchovy fillets in a mortar with a pestle. Place the mustard in a bowl, add the vinegar and whisk together, then slowly whisk in the olive oil until emulsified. Add the anchovy paste and gently whisk in the cream. Add the parsley, a squeeze of lemon and plenty of pepper.

Brush the John Dory fillets with a little olive oil and season with salt, then cook under the grill for 6–7 minutes until lightly golden.

To serve, place 2 or 3 chunks of braised fennel and onion mixture on serving plates, place the fish alongside and drizzle with the vinaigrette.

AT THE FISHMONGER
Ask your fishmonger to fillet the fish and trim the belly, then cut the fillets naturally in three – the fillet of a John Dory is actually made up of three small fillets that are very distinct and easy to see and are often separated before cooking.

roasted dory with creamy garlic potatoes and *salsa verde*

Serves 4

1 large John Dory, about
 1.5 kg/3 lb 5 oz in total
Sea salt and freshly ground black pepper
Olive oil, for rubbing and roasting
4 large heads of garlic
125 ml/4 fl oz/½ cup water
1 kg/2¼ lb potatoes, such as
 Maris Piper, peeled
200 g/7 oz/scant 1 cup butter, softened
Freshly grated nutmeg, to taste
Small handful of chives, finely chopped

For the *salsa verde*:

1 tsp Dijon mustard
100 ml/3 fl oz/generous ⅓ cup good-
 quality red wine vinegar
100 ml/3 fl oz/generous ⅓ cup good-
 quality extra virgin olive oil
Small handful each of fresh parsley, fresh
 tarragon, fresh basil and fresh mint,
 finely chopped
2 anchovy fillets, finely chopped
1 tbsp capers, finely chopped

AT THE FISHMONGER
Ask your fishmonger to remove the
head and trim the fins, including
the tail, from the fish.

This is a fine way to cook a single large fish and we will often eat this for a family Sunday lunch. It also works with brill, turbot or even lemon sole. The only other addition might be a plate of seasonal greens like sprout tops, kale or hispi cabbage, lightly boiled and finished with butter and black pepper.

Preheat the oven to 240°C/475°F/Gas Mark 9.

Slash the Dory diagonally to the bone on both sides, then sprinkle with salt and rub with a little olive oil to coat.

Separate the garlic into cloves but leave the cloves in their skins. Place in a small roasting pan with the water and a good drizzling of olive oil and roast in the oven for 15–20 minutes or until the garlic is easily squeezed from its skin. Leave to cool.

When the garlic is cool enough to handle, squeeze the flesh from the skins and set aside. The taste will be sweet and not as pungent as raw garlic.

Cook the potatoes in a saucepan of boiling salted water until they are falling apart. Drain and leave to steam dry.

Once the potatoes are dried, return them to a clean saucepan and give them an initial mash, gradually adding the butter, then season with salt, pepper and nutmeg. The consistency should be quite sloppy and almost like a purée. Add the chives and roasted garlic purée and mix to combine.

To make the *salsa verde*, place the mustard and vinegar in a bowl and gently whisk in the olive oil. Season with salt and pepper and add the herbs, anchovies and capers. If you feel the sauce is too thick, just add a little more olive oil. Season to taste.

Place the Dory in a large ovenproof baking dish and roast in the hot oven for about 25–30 minutes. When the fish is nearly cooked, you will notice a milky liquid coming from the slashes you have made in the fish, this is an indication that the fish is moist and ready.

Serve the fish in all its glory on a serving platter. Warm the potatoes through while beating with a wooden spoon and serve in a separate dish alongside the fish and a bowl of the *salsa verde*.

sautéed dory with artichokes and a tarragon sauce

Serves 4

8 small artichokes, trimmed and sliced
 top to bottom

Juice of ½ lemon

3–4 tbsp olive oil

1 onion, finely chopped

2 garlic cloves, finely chopped

Splash of water

750 g/1 lb 10 oz John Dory fillet (see
 yield table on page 117, you will
 see how expensive John Dory is!)

Sea salt and freshly ground black pepper

Pinch of dried oregano

70 ml/3 fl oz/⅓ cup dry white wine

100 ml/3 fl oz/generous ⅓ cup double
 cream

Small handful of fresh tarragon,
 finely chopped

AT THE FISHMONGER
Ask the fishmonger to fillet the
fish and trim the belly, then cut
the fillets naturally into three.

Gastronomically speaking, John Dory is held in as high regard as turbot, brill, Dover sole and sea bass. I would say that it has to be the most expensive fish in the sea and that the best fillets come from the larger fish. However, fillets from small Dory are wonderful as part of a plate of mixed fried fish and are also perfect alongside mussels, monkfish, clams and gurnard in a fish stew. Dory don't really have a season, they just turn up, so it's best not to plan this dish, rather take advantage of it when you find Dory in the market.

First, prepare the artichokes. I like to use young, small artichokes that can be cooked very quickly, however globe artichoke bottoms would work fine, as do some of the grilled artichokes in oil that are so readily available in many of our stores. Remember if you are preparing fresh artichokes to place them in water with a squeeze of lemon to stop them discolouring and turning black.

Heat 2 tablespoons of olive oil in a large sauté pan, add the onion and garlic and fry gently until softened but not coloured. Add the artichokes and a splash of water and cook for a further 4–5 minutes until tender. Remove from the pan and set aside.

Add 1–2 tablespoons of olive oil to the pan, and when hot, season the John Dory fillets with a little salt and pepper and fry for 3–4 minutes on each side until golden.

Add the artichoke, onion and garlic mixture and sprinkle in the oregano. Add the wine, then turn up the heat and allow the wine to reduce by at least half. Add the cream and tarragon, then season with salt and pepper and finish with a squeeze of lemon. The sauce should be quite thick.

I like to serve this dish with nothing else on the plate as I think the artichoke and Dory are a wonderful combination and make a fabulous lunch. If the season is right, I may add fresh peas or broad beans halfway through cooking.

lemon sole *Microstomus kitt*

The lemon sole is in fact not a sole at all, but a member of the *Pleuronectidae* family, the same family as halibut (see page 111) and plaice. Its name is something of a mystery, as it's not particularly lemon in colouring or indeed in flavour. Its other local names are equally mysterious, including 'Mary sole', 'smear dab' and 'sweet fluke'.

This oval-shaped fish comes in a variety of camouflage colours, depending on its surroundings and tends to be marbled reddish or greyish brown with flecks of yellow and orange, perfect for melting into the gravelly seabeds it favours. It has a smooth upper surface with a straight lateral line that curves above the pectoral fin and a white underside. Being a member of the flounder family, its eyes are on the right side of its head. Its head and mouth are also very small, hence its Latin name *Microstomus*, meaning 'small mouth'. It uses this petite tooth-filled mouth to feed on small crustaceans, worms and barnacles, for which it hunts at night.

Adult fish can reach up to 70 cm/27½ inches, but most are 20–30 cm/8–12 inches. Lemon sole can live up to 17 years, reaching sexual maturity at 3–4 years for males and 4–6 years in females. Spawning times vary between areas, but range from April to September.

Taste description
Although far less assertive in flavour than Dover sole, lemon sole has a distinct shellfish taste, particularly reminiscent of scallop and prawns, together with underlying oaty biscuit notes and a suggestion of sherry-like sweetness. The flesh is not overly juicy and the small flakes mean that the texture is quite close, but once in the mouth the fish takes on a melting, velvety softness with a faintly breadcrumb-like quality. Lightly dusted in flour, fried in butter and served with nothing more than a squeeze of lemon and some parsley, it makes a simply delicious meal.

Territory
Lemon sole are found all around the coastal banks of northern Europe, from Iceland and Norway to France as far as the Bay of Biscay. They are found northeast to the White Sea and northwest to Rockall and Faroe banks, around the Faroe Islands, northeast of Scotland. They are not found in the Mediterranean Sea.

Environmental issues
Avoid eating immature fish below 25 cm/10 inches. Lemon sole is largely unregulated as a fishery, only stocks in the Norwegian and North Seas are subject to quota restrictions. If possible choose fish landed in Cornwall where a minimum landing size (25 cm/10 in) allows it to reach sexual maturity and reproduce.

Territory	Local Name
UK/USA	*Lemon sole/English sole*
Spain	*Mendo limón*
France	*Sole limande*
Italy	*Sogliola Limanda*
Holland	*Tongschar*
Germany	*Rotzunge*
Norway	*Lomre, Bergflyndre*
Denmark	*Rødtunge*
Sweden	*Bergtunga, Bergskädda*

Health
Per 100 g/4 oz: 83 kcals, 1.5 g fat

Seasonality
Avoid this fish during its spawning season from April to September and just after, when it's out of condition. It is at its best in autumn and winter.

Yield
1 kg/2¼ lb weight of lemon sole yields 55% edible fillet.

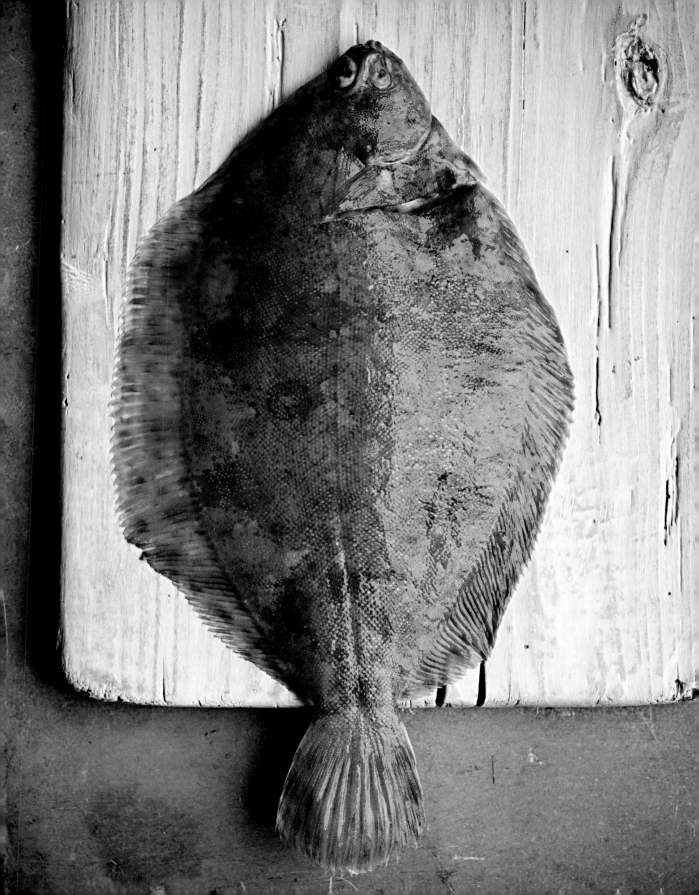

baked sole with courgettes

Serves 4

Vegetable oil, for oiling

4 x 450 g/1 lb lemon sole

Sea salt and freshly ground black pepper

20 g/¾ oz/1½ tbsp butter, melted

50 g/2 oz/4 tbsp butter

5–6 new season's courgettes, sliced thinly
 into rounds

1 dried bird's-eye chilli (optional)

Finely grated zest and juice of 1 lemon

Handful of fresh parsley, finely chopped

75 g/3 oz/1½ cups fresh breadcrumbs

75 g/3 oz/6 tbsp butter, cut into
 small cubes

To serve:

Lemon wedges

AT THE FISHMONGER

Ask your fishmonger to remove the head and skin from the fish and trim the fins tight to where the flesh ends. Your fishmonger may find it difficult to skin the lemon sole without a machine, if this is so, have the fish trimmed and leave the skin on; it is perfectly edible and enjoyable, but you may just want to ask him to rub a scaler over the fish.

Something I look forward to every year is picking my first courgette from the garden. I just slice it thinly and cook it in butter with lots of black pepper and lemon juice – I just love its soft texture and delicate flavour – something I might also say for lemon sole. I tried baking the two together with some breadcrumbs to give a lovely crisp texture and a final finishing of lemon juice; the results were delicious and here is my recipe.

This dish can easily be prepared for 4–6 people as the cooking is done in the oven and the fish are just served as they are with a large bowl of salad in the middle of the table.

Preheat the oven to 240°C/475°F/Gas Mark 9 and lightly oil a large baking sheet.

Lay the fish on the prepared baking sheet, season with salt and pepper and brush lightly with melted butter.

Melt the 50 g/2 oz/4 tbsp butter in a frying pan, add the courgettes and fry gently until softened. Crumble in the chilli, if using, plenty of pepper and enough salt to taste. Remove the pan from the heat and add the lemon zest, lemon juice and chopped parsley. Arrange the courgettes over the back of each fish, sprinkle lightly with breadcrumbs and dot the cubes of butter over the top.

Bake in the oven for 10 minutes until the breadcrumbs are crunchy and the fish is moist and soft with a little milky liquid starting to push out of it. This is when it is perfectly cooked.

Lift each fish off the baking sheet individually and serve completely unadorned with just lemon wedges.

goujons of lemon sole with fennel coleslaw

Serves 2

2 x 450 g/1 lb lemon sole, filleted

75 g/3 oz/½ cup plain flour

3 eggs, beaten

75 g/3 oz/1½ cups fine breadcrumbs

150 ml/5 fl oz/⅔ cup vegetable oil

Fine salt

For the coleslaw:

2 tbsp white wine vinegar

1 tsp Dijon mustard

1 tbsp caster sugar

2 egg yolks

200 ml/7 fl oz/scant 1 cup vegetable oil

Sea salt and freshly ground black pepper

¼ white cabbage, finely sliced

1 tbsp salt

1 fennel bulb, top and outer leaves
 removed, finely sliced across the bulb

1 small orange, peeled and cut into
 segments with pith removed

1 red onion, thinly sliced

AT THE FISHMONGER

Ask your fishmonger to fillet and skin the sole. The flesh from the dark side of the fish would always be the thickest and best. You'll be surprised how little fish is yielded, but this is normal as most of the fish is head, skin and bone.

Both Dover and lemon sole lend themselves to be made into goujons – small strips of fish which are coated in breadcrumbs and deep-fried. However, the Dover and lemon sole are quite different – Dover sole is firm while lemon sole is more soft and creamy in texture. This fennel coleslaw is a lovely crunchy flavoursome accompaniment to the hot, crisp, creamy fish.

First, make the coleslaw dressing. Mix the vinegar, mustard and sugar together, then add the egg yolks and, using a hand whisk, whisk until combined. While whisking, gradually drizzle in the vegetable oil in a steady stream until it is the consistency of double cream. Taste and adjust the seasoning to your liking. The dressing should be slightly sweet.

Sprinkle the finely sliced cabbage with 1 tablespoon of salt and leave to stand for 20 minutes, then wash off and dry.

Place the fennel, cabbage, orange and onion in a large bowl, add a few tablespoons of the dressing and mix together. Leave to chill in the refrigerator for 20–30 minutes to allow the flavours to develop.

Slice the lemon sole lengthways down the fillet, about the width of your middle finger. Place the flour, beaten egg and breadcrumbs on 3 separate plates or dishes. Dip the fish first in the flour, then the egg and finally the breadcrumbs until the fish is evenly coated.

Heat enough vegetable oil, about 5–7.5 cm/2–3 inches, in a deep-fryer or a large heavy-based frying pan to about 190°C/375°F. Add the goujons one by one to the hot oil, being careful that they do not stick together or attach themselves to the basket if using a deep-fryer. This is easily avoided by just shaking the basket slightly as each goujon is dropped in. Deep-fry for 3–4 minutes or until crisp and golden, then drain on kitchen paper and season with a little fine salt.

Serve the goujons with a spoonful of the coleslaw. Before putting the coleslaw on the serving plate, taste, and readjust the seasoning if necessary. I sometimes add a little chopped fresh tarragon, some lemon or lime juice, and even a few black olives depending on my whim.

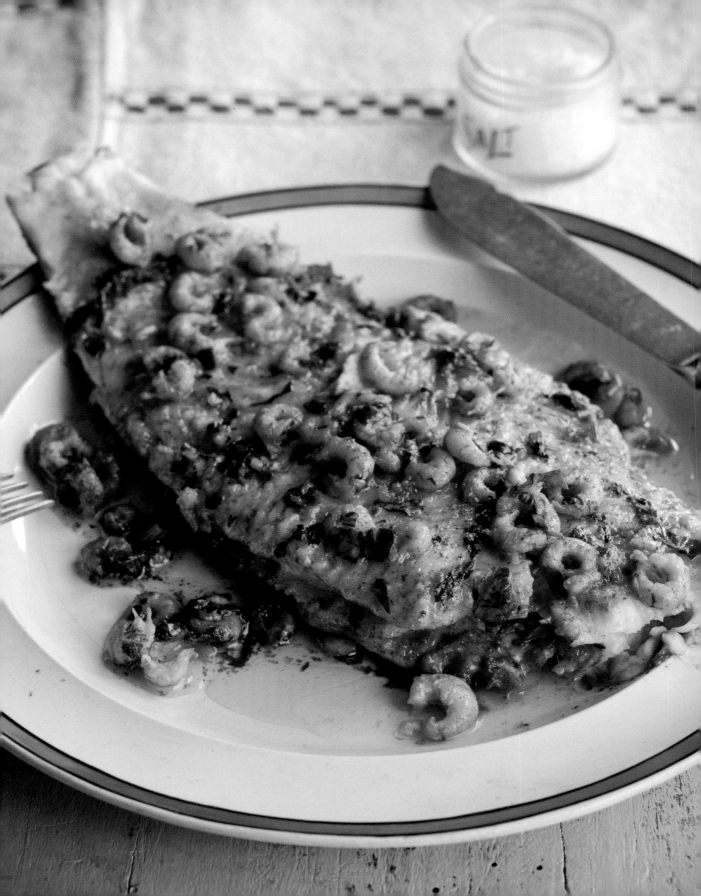

lemon sole cooked in butter with brown shrimps

Serves 2

2 tbsp olive oil

2 x 450 g/1 lb lemon sole

20 g/¾ oz plain flour

125 g/4½ oz/9 tbsp butter, cut into
 small cubes

Pinch of ground mace

Pinch of white pepper

75 g/3 oz peeled brown shrimps

Small handful of fresh parsley, very
 finely chopped

Squeeze of lemon

Sea salt and freshly ground black pepper

AT THE FISHMONGER
Ask your fishmonger to remove
the head and trim the fish so
that all the fins are removed
including the tail.

Lemon sole has quite a soft agreeable texture. Cooked in butter in the *meunière* style, where the fish is lightly dusted with flour and bathed in foaming butter during cooking, does it justice, but by adding the shrimps and a little mace this great fish becomes something magnificent and I think very British. It is a dish that we regularly serve in our restaurant and it sells out every time.

Heat the olive oil in a pan large enough to hold the 2 soles. Place the flour on a large plate and dip the fish into it, hold each fish in 2 fingers and give it a few taps to remove any excess flour, leaving only a light, even coating.

Lay the fish dark side down in the pan and fry for 1–2 minutes. Add 2 cubes of butter and cook for a further few minutes, then add the rest of the butter and turn the fish over. When the butter starts foaming and the bubbles are really small, add the mace and white pepper. Tip the pan towards you, and using a large spoon, baste the fish with the hot foaming butter for about 6–7 minutes.

Add the shrimps to the pan and continue basting for a further minute. Add the parsley and finish with lemon juice to taste. Season with pepper and just a little salt, then remove the fish from the pan and serve.

ling *Molva molva*

Ling is considered closest to cod in taste and texture and, as cod stocks are declining, now the spotlight has turned on this reluctant replacement.

Up on the British Yorkshire coast a small ling is known as a 'drizzle', which is a rather appropriate name for this morose member of the cod family. It's a loner that lurks in gloomy corners of shipwrecks and under rocky crevices, which offer good ambushing opportunities. Any fish or crustacean foolish enough to go exploring in its vicinity will end up inside its capacious tooth-filled mouth. It even looks crepuscular with a long, slender silvery-cream body, mottled with a seaweed brownish green along its back and flanks. Under its chin is a sensitive barbel, which is used to feel for hidden fish on the seabed. Ling are the largest-growing members of the cod family and can reach up to 2 m/79 inches long, and live for up to 25 years.

Ling is a large fish, but also a slow-growing one, males become sexually mature at 5–8 years old and about 80 cm/31 inches long, while females mature at 90–100 cm/35–39 inches. They come together to breed between March and August; the females are prolific spawners, producing up to 60 million eggs.

Taste description

Ling's bright white flesh has a texture that's firm but balanced by a marshmallow-like lightness, which is a consequence of the irregular pattern in which the flakes are arranged. The aroma has a sharp, malt vinegar tang with slight vanilla undertones, and a honeyed note is reflected in the flavour, which has a mild shortbread sweetness and a clean, rounded aftertaste. Although the skin is thick and clings to the flesh quite doggedly, it makes for good eating. Braises and soups are perfect ways in which to use ling as the flesh is robust enough not to fall apart during the cooking process.

Territory

Ling are found in the cooler climes of the Atlantic, around Iceland, the Nordic coast and occasionally around Newfoundland. They are also found off the western British Isles, especially around the southwest coast, and the western coasts of Ireland and Scotland.

Environmental issues

Ling often occupies habitats that are vulnerable to the impacts of trawling. Deepwater stocks appear to be over-fished and current management measures are not deemed sufficient to restore abundance. Avoid eating fish from deepwater stocks.

Territory	Local Name
UK	*Ling*
France	*Lingue, Julienne*
Holland	*Leng*
Germany	*Lengfisch*
Spain	*Maruca*
Italy	*Molva*
Greece	*Pentiki*
Sweden	*Långa*
Denmark	*Lange*
Norway	*Lange*

Health
Per 100 g/4 oz: 82 kcals, 0.7 g fat

Seasonality
Avoid ling during its spawning season from March to August and just after to allow it to get back into condition. It is at its best during the winter months.

Yield
1 kg/2¼ lb weight of ling yields 75% edible steak.
1 kg/2¼ lb weight of ling yields 50% edible fillet.

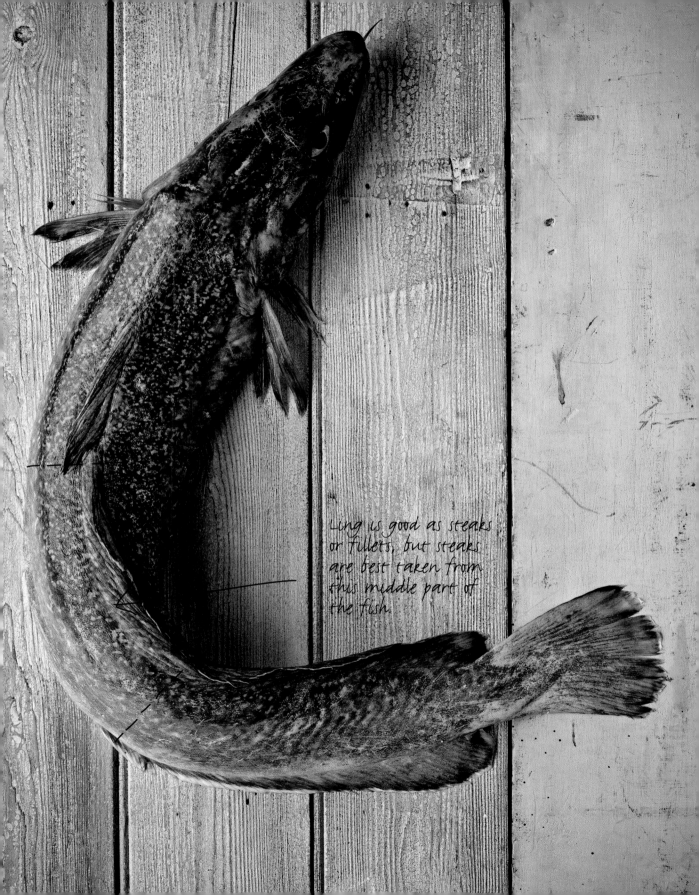

Ling is good as steaks or fillets, but steaks are best taken from this middle part of the fish.

ling and parsley fishcakes

Serves 4

300 ml/10 fl oz/1¼ cups milk

1 bay leaf

½ onion

A few parsley stalks

300 g/10 oz ling fillet

300 g/10 oz boiled potatoes, mashed

20 g/¾ oz/1½ tbsp butter

65 g/2½ oz/¼ cup plain flour, plus
 extra 2 tbsp

Small handful of fresh parsley, chopped

2 beaten eggs

85 g/3½ oz/⅓ cup breadcrumbs

Sea salt and freshly ground black pepper

Vegetable oil, for cooking

AT THE FISHMONGER
Ask your fishmonger for ling fillet,
skinned and pin-boned.

Ling lends itself perfectly to being made into fishcakes. I like my fishcakes to be simple – just the fish and potato mixed with a teaspoonful or two of béchamel sauce and a few herbs. The béchamel makes the fishcake very creamy and if ever I'm making fish in parsley sauce I always keep some back for fishcakes. I enjoy them with a salad of the season, dressed with an anchovy vinaigrette (see page 199) and some fresh mayonnaise (see page 286).

Place the milk, bay leaf, onion and parsley stalks into a small heavy-based saucepan and bring to a gentle simmer. Cut the fish into 2.5 cm/1 inch chunks, add to the pan and cook for a further 2–3 minutes. Remove the pan from the heat and leave to stand for 30 minutes. Remove the fish and flake into the mashed potatoes. Reserve the milk.

In another pan, melt the butter then stir in the 2 tablespoons of flour until you have a creamy paste. Slowly add some of the reserved milk in which the fish has been poached until you have a thick creamy sauce. Add a few tablespoons to the fish and potato mixture, then add the parsley, seasoning and mix together well. You should have a creamy dough which is not too wet and can be easily shaped. Keep the remaining sauce to serve with the fishcakes, if you wish, and add a squeeze of lemon just before serving.

Divide the mixture into 4 balls then flatten into rounds. I find a pastry cutter ideal for this job as it can be easily filled with the mixture and you get a consistent shape. Leave to chill in the refrigerator for 30 minutes before coating.

Place the beaten eggs in a shallow dish and place the flour and breadcrumbs on 2 separate plates. First dip each fishcake in the flour then the egg, and finally the breadcrumbs, making sure that the fishcakes are evenly coated.

You can shallow-fry the fishcakes in a little vegetable oil until golden on each side and then finish in the oven; however, my preference is to deep-fry them for 4–5 minutes in hot oil at a temperature of 190°C/375°F.

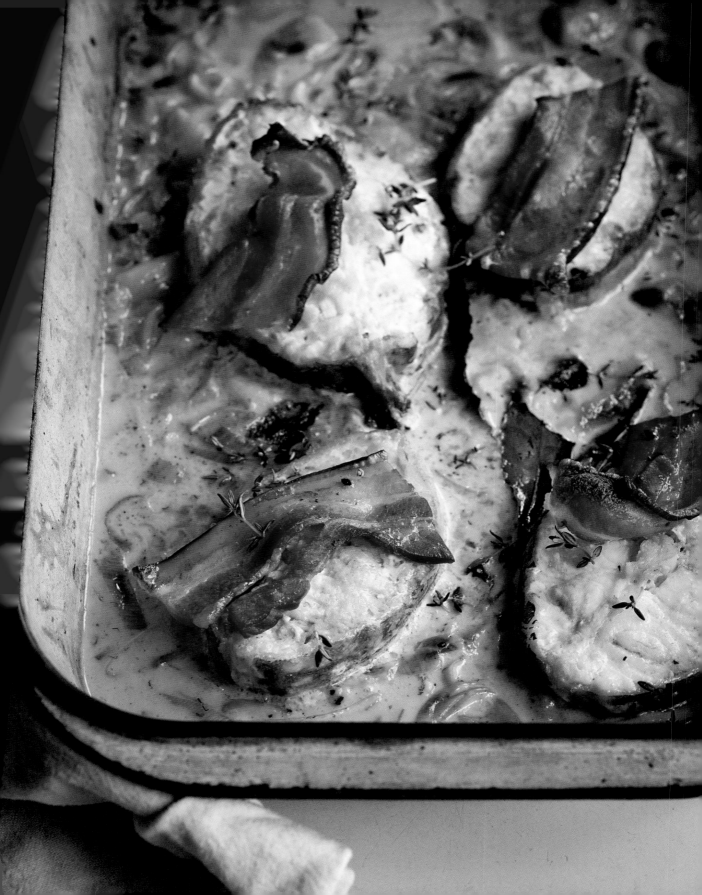

pot roast ling with bacon, leeks and stewed garlic

Serves 4

2 whole heads of garlic, peeled and
 broken into cloves
3–4 tbsp olive oil
Plain flour, for dusting
800 g/1 lb 12 oz ling fillet
1 small onion, finely chopped
1 celery stick, finely chopped
1 leek, finely sliced
4 thick rashers smoked streaky bacon,
 cut into chunks
Splash of white wine vinegar
Splash of vermouth
50 ml/2 fl oz/¼ cup white wine
50 ml/2 fl oz/¼ cup double cream
1 fresh thyme sprig
2 fresh bay leaves
Small handful of fresh parsley, chopped
Sea salt and freshly ground black pepper

AT THE FISHMONGER
Ask for steaks from the middle of
the fish, where they will be round
with no belly.

Ling braises well. I like to think of this dish as a winter comforter and it's fabulous served with creamy mashed potato or steamed kale.

Place the garlic cloves in a saucepan and pour in just enough water to cover. Bring to the boil, then turn the heat down and simmer for 5 minutes. Change the water and cook again until the cloves are soft but not breaking up.

Heat the olive oil in a casserole dish or large frying pan. When it is hot, spread the flour out on a large plate, dust the ling with flour, shaking off any excess, and fry until golden. Remove the fish from the pan and set aside.

Add the onion, celery, leek, bacon and soft garlic to the pan and cook until softened, then add the vinegar and boil for a minute. Add the vermouth and boil for a further minute, then the wine and boil for another minute.

Turn the heat down and add the cream, thyme sprig and bay leaves. Place the fish back in the pan, cover with the lid and leave to simmer for 8–10 minutes. Add the parsley and season to taste with salt and pepper. Half of the garlic should have melted into the sauce, if not mash up any whole cloves with a fork. Remove the bay leaves and thyme sprig and serve.

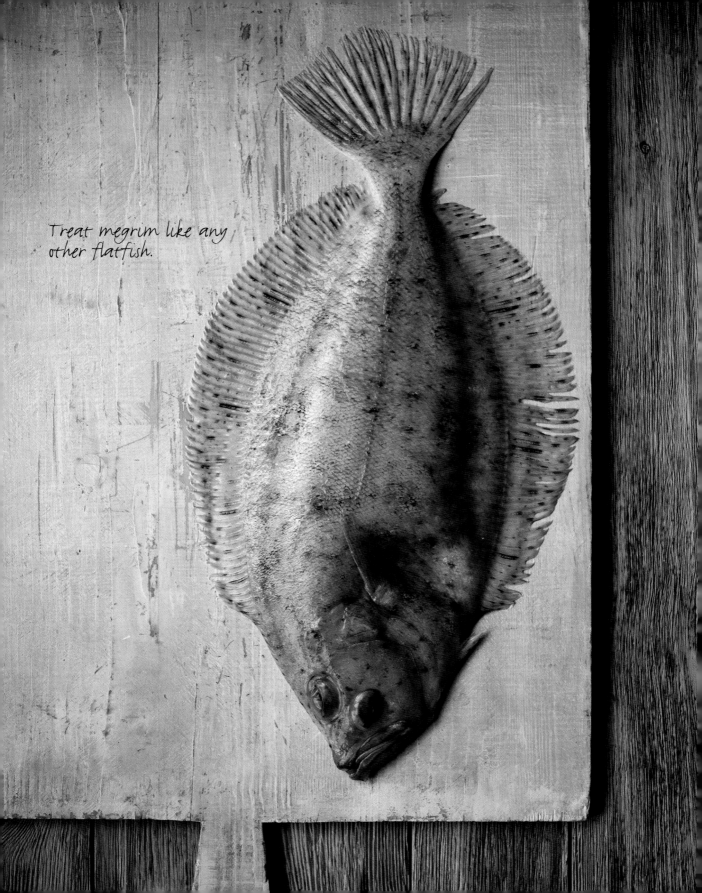

Treat megrim like any other flatfish.

megrim

Lepidorhombus whiffiagonis

This left-eyed flatfish has undergone something of a makeover recently, increasingly being found under the label 'Cornish sole', which is a much cooler name than megrim – another name for 'migraine' – or its nicknames of 'whiff' and 'fluke'. Insults continue to fly in other languages – fishermen in Boulogne in France call it *salope*, which is a pejorative term, yet it's very popular in France and Spain.

A great underrated fish, megrim are the less well-heeled relations of the turbot and brill family, usually growing to 35–45 cm/14–18 inches and weighing up to 1 kg/2¼ lb. Its yellowish-brown colouring allows it to blend beautifully with the soft sandy or muddy seabed in which it immerses itself, while its eyes keep a careful watch for any passing baby squid, fish or crustacean that could make a tasty supper.

Between January and April megrim move along the edge of the continental shelf to the southwest and west of the British Isles to spawn, they also spawn in spring in the deep waters off Iceland.

Taste description

Megrim is uniformly bright white in colour with a deeply savoury, vegetal taste. In common with many flatfish, this flavour is most pronounced on the bottom thinner fillet, which carries an additional earthy element. The flavour profile is reflected in the aroma too, which features notes of boiled leek or cabbage.

After an initial burst of moisture, the flesh gives a fairly dry mouth feel with a texture that is more fluffy and lightly fibrous than flaky. This is in marked contrast to the thin skin, which when cooked has a crunchy, bacon-rasher crispness, and a rounded, caramel sweetness.

Territory

Megrim flourishes off the Cornish coast and Irish Sea and is found in European seas between 100–700 m/358–2,296 ft, ranging throughout the northeast Atlantic from Iceland south and into the western Mediterranean.

Environmental issues

Stocks are generally good, so choose megrim that are otter-trawled from waters west of Ireland and the western Channel, where stock is classified as healthy. Beam trawlers catch much of the fish but stocks are well managed. Avoid eating immature fish less than 25 cm/10 inches and during the spawning season from January to April.

Territory	Local Name
UK	*Megrim, Cornish sole*
France	*Cardine*
Spain	*Lliseria, Gallo*
Italy	*Rombo giallo*
Germany	*Flügelbutt*
Sweden	*Glasvar*
Holland	*Scharretong*
Norway	*Glasvar*
Denmark	*Glashvarre*

Health
Per 100 g/4 oz: 79 kcals, 1.4 g fat

Seasonality
Megrim are at their plumpest and best in the autumn and into winter after a summer of feeding. Avoid this fish during their spawning season from January to April and after spawning, when they will be thin.

Yield
1 kg/2¼ lb weight of megrim yields 50% edible fillet.

grilled megrim with garlic, parsley and mint butter

Serves 2

50 g/2 oz/4 tbsp butter

2 megrim, about 500 g/1 lb 2 oz each

Sea salt and freshly ground black pepper

2 garlic cloves, finely chopped

Small handful of fresh parsley

Small handful of fresh mint

Squeeze of lemon

AT THE FISHMONGER
Ask your fishmonger to trim the fins, scale the fish and remove the head.

When I first ventured into the fish business in 1996, I was lucky enough to meet a man called Robert Wing, who has become a dear friend and is probably Cornwall's leading fish merchant. He introduced me to the market at Newlyn and many of the fishermen and buyers. I always used to ask Rob to buy the odd box of megrim and we would sell them in our restaurants; we would call them 'Scilly Isle soles' as this is where the fishing grounds are. My customers loved them.

Megrim's soft flesh is so delicious and, while not nearly as firm as the Dover sole, it is a perfectly acceptable alternative. We should try to eat more of this fantastic fish.

Preheat the grill to high.

Melt half the butter in a pan large enough to hold the fish and suitable for cooking under the grill. Add the fish white side down to the pan and cook gently for 4–5 minutes. Baste the fish with the butter then place the pan under the hot grill for 5–6 minutes until the thicker top side is starting to crisp and bubble. If you don't have a suitable pan then carefully transfer the fish to a roasting pan and cook under the grill. Season the fish with salt and pepper and place in a serving dish.

Add the remaining butter to the pan and heat. When the butter is foaming, add the garlic and fry for 1 minute or until it is just turning golden. Add the parsley and mint and finish with a squeeze of lemon, then spoon over the fish and serve.

Boiled potatoes sprinkled with just a little parsley are a perfect accompaniment and can mop up some of the wonderful garlicky butter on the plate. I also think the texture of the boiled potato and soft fish work well together.

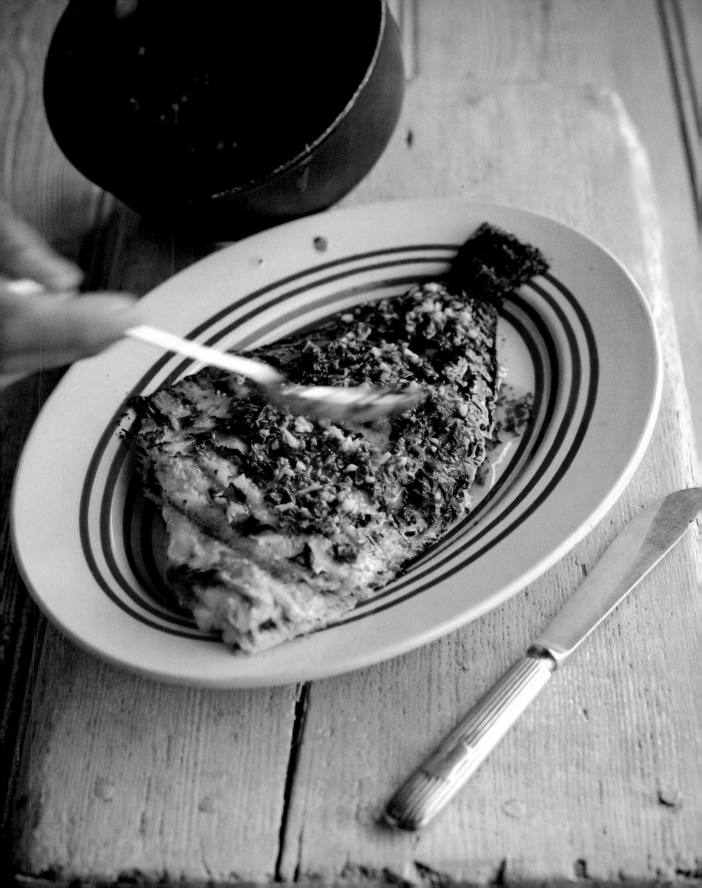

megrim baked with stewed garlic, cream and mussels

Serves 4

20 g/¾ oz/1½ tbsp butter, plus extra
 for greasing

4 megrim, about 500 g/1 lb 2 oz each
 before being trimmed

16–20 live mussels, cleaned and
 beards removed

Squeeze of lemon

Good handful of fresh parsley,
 roughly chopped

Freshly ground black pepper

For the garlic cream:

8 garlic cloves, unpeeled

400 ml/14 fl oz/1¾ cups double cream

Good pinch of cayenne pepper

Good pinch of nutmeg or mace

Pinch of white pepper

AT THE FISHMONGER

*Ask your fishmonger to trim the
fins, tail and head from the fish
and remove any scales.*

Cream, mussels and garlic are indeed a delicious combination and this idea of baking fish in cream came from a classic recipe by the food writer Eliza Acton, and I credit her for the inspiration here. What I love about this dish is the fact that it is so easy to cook and the flavours are so accessible. You can of course use this method for any flatfish including lemon sole, plaice, and the magnificent Dover sole.

Preheat the oven to 200°C/400°F/Gas Mark 6. Butter a large roasting dish.

First, make the garlic cream. Place the garlic cloves in a pan of water, then bring to the boil and cook for 10 minutes. Drain off the water and return the garlic to the pan. Cover with fresh water and simmer for 5–6 minutes until the garlic is soft. Drain and peel the garlic, then transfer to a food processor and blend with the cream, cayenne, nutmeg or mace and white pepper.

Place the fish side by side in the prepared roasting dish, pour over the garlic cream and bake in the oven for 8–10 minutes. Remove from the oven and add the mussels. Bake for a further 3–4 minutes or until the mussels have opened. Discard any mussels that remain closed.

Place the fish on serving plates and remove the empty shell from each mussel. Mix the mussel juice and cream together with a squeeze of lemon juice and the parsley. Season with black pepper to taste, spoon the creamy mussel and garlic sauce over each fish and serve.

fried megrim fillets with sauce Romesco

Serves 4

200 g/7 oz/scant 1½ cups plain flour

Sea salt and freshly ground black pepper

4 eggs, beaten

200 g/7 oz/4 cups fresh breadcrumbs

4 megrim, about 450 g/1 lb each before
 preparation

Vegetable oil, for deep-frying

For the sauce:

2 red peppers

1 or 2 mild fresh red chillies

150 ml/5 fl oz/⅔ cup good-quality olive
 oil, plus extra for drizzling

1 garlic clove

75 g/3 oz/⅓ cup blanched almonds

75 g/3 oz/⅓ cup walnuts

3 tomatoes, peeled and deseeded

4–5 tbsp good-quality red wine vinegar

Pinch of smoked paprika

40 g/1½ oz/scant 1 cup fresh
 breadcrumbs or one slice of stale
 bread, made into breadcrumbs

Small handful of fresh parsley, chopped

To serve:

4 lemon wedges

Small handful of parsley, finely chopped

AT THE FISHMONGER
Ask your fishmonger to scale and
fillet each fish.

The flesh of a megrim is rather thin and lends itself perfectly to being filleted and fried. As megrim is so popular in Spain, I thought I would pair it up with a traditional sauce Romesco. You will find this sauce featured in many dishes throughout Spain, where there are lots of regional variations, from creamy ones to searingly hot ones, all of which are delicious. It is generally made with almonds, soaked dried peppers, garlic, bread and vinegar and is served with meat and fish. It's extremely versatile and if you like it, then try it with grilled monkfish, roasted gurnard or mullet.

Preheat the oven to 240°C/475°F/Gas Mark 9.

To make the sauce, place the peppers and chillies in a roasting pan, drizzle with olive oil and roast in the oven for 25–30 minutes or until they are soft and blackened. Remove from the oven, place them in a plastic bag, seal the top and leave to stand for about 1 hour. The bag will have inflated and the peppers and chillies will have finished cooking in their own heat. Remove the peppers and chillies from the bag, peel off the skin and remove the seeds. Strain any liquid through a strainer and reserve.

Place the peppers, chillies and any liquid into a small food processor with the garlic, almonds, walnuts, tomatoes, vinegar, paprika, breadcrumbs and parsley and blitz together. With the motor running, slowly add the olive oil until the sauce starts to thicken. Season and set aside.

Place the flour on a large deep plate and season with salt and pepper, place the beaten eggs and breadcrumbs in 2 separate deep plates. Dip each piece of fish into the flour, making sure it is well coated, then into the egg and finally into the breadcrumbs, making sure the fish is evenly coated. Lay the fish side by side on a piece of greaseproof paper or clingfilm.

When all the fish are coated, heat enough vegetable oil for deep-frying in a deep-fryer or suitable pan to 190°C/375°F. When the oil is hot, carefully place the fillets into the oil and deep-fry 2 at a time until crisp, then drain on kitchen paper. Serve the fish topped with the sauce Romesco, accompanied by lemon wedges and a sprinkling of parsley.

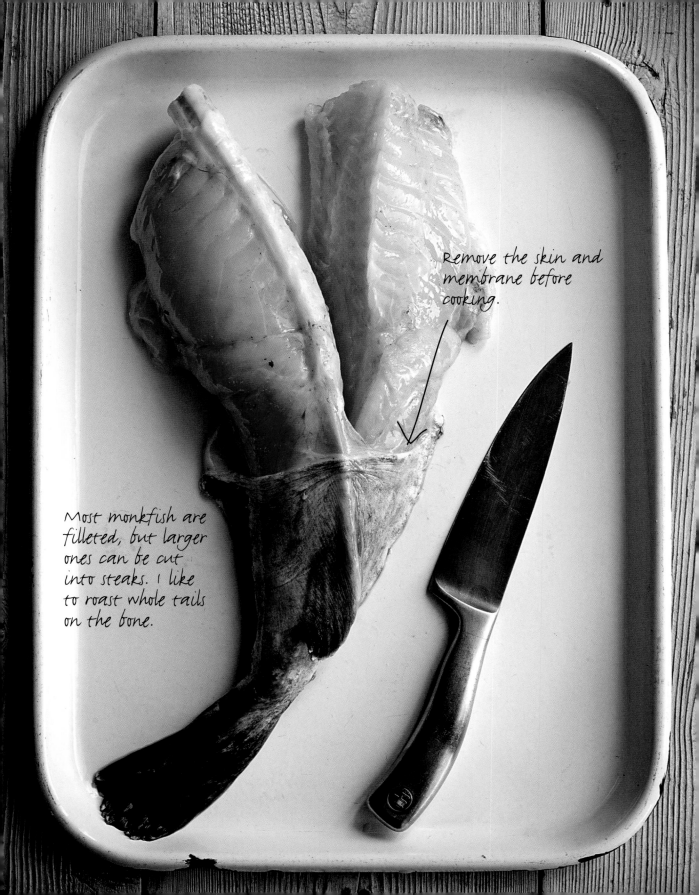

Remove the skin and membrane before cooking.

Most monkfish are filleted, but larger ones can be cut into steaks. I like to roast whole tails on the bone.

monkfish *Lophius piscatorius*

Firm textured and mild, monkfish is made for strong flavours. Often termed 'meaty', its flesh is less delicate and flaky than many white fish, making it perfect for barbecuing – try this fish with lemon on rosemary skewers.

The meaty, cone-shaped tail is all that ends up on the fishmonger's slab, while its enormous head and mouth are usually discarded at sea. Monkfish is a master of disguise, as its loose, scale-less mottled skin resembles a sandy or muddy seabed, and its body and mouth are fringed with seaweed-like fronds of skin. This fish is built to ambush, having hidden itself on the seabed it fishes for its supper, which is where its other name, 'anglerfish', comes from. On the end of its first dorsal spine is a fleshy 'lure', which it dangles in a tempting manner – some even contain chemical attractants or are luminous.

Monkfish are a long-lived species, living up to 24 years, and they are slow to reach sexual maturity. Females mature at 9–11 years, when they are 70–90 cm/27½–35 inches, while males mature at around 6 years, when they are 50 cm/20 inches. Females can reach 2 m/6½ ft, while males rarely grow beyond 1 m/3¼ ft. A buoyant, gelatinous ribbon or 'egg veil' is released during their spring and early summer spawning, which takes place in the deep waters off the edge of the continental shelf.

Taste description

Nutmeg, cinnamon, demerara sugar – the individual notes of monkfish's aroma give it a sweetly spicy character, a little like mulled wine. The flavour is much less forceful, being mild, slightly sweet and quite fleeting. But it's that shortness in taste that makes it one of the most versatile fish available and good for roasting, baking, frying and grilling. The muscular texture is another factor in its adaptability, as it's very forgiving, with a dense but juicy mouth feel and great consistency, delivering the same level of moisture and robustness in every bite.

Territory

Monkfish are found off the west coast of England, Wales and Scotland and the north, south and east coasts of Ireland. They are also found from the Mediterranean up to Iceland, and a similar species is found in American waters.

(continues on page 142)

Territory	Local Name
UK	*Monkfish, Anglerfish*
USA	*Monkfish, Anglerfish, Goosefish*
Greece	*Vatrachópsaro*
France	*Baudroie, Lotte*
Italy	*Coda di Rospo, Rana pescatrice*
Germany	*Seeteufel*
Spain	*Rape*
Holland	*Zeeduivel, Hozemond*
Portugal	*Peixe sapo, Ra do mar*
Denmark/Norway	*Bredflab, Havtask*
Sweden	*Marulk, Havspadda*

Health

Per 100 g/4 oz: 66 kcals, 0.4 g fat

Seasonality

Avoid monkfish during its breeding season from spring to early summer.

Yield

1 kg/2¼ lb weight of monkfish yields 80% edible steak.
1 kg/2¼ lb weight of monkfish yields 70% edible fillet.

Environmental issues

There are no size restrictions on monkfish landings due to its large head size and just the tail being of commercial value, and there are no measures to protect spawning stock. Avoid eating the fish from depleted stocks, such as the Scottish and Mediterranean stocks, or from stocks where information is lacking. The use of gill nets with larger meshes (22 cm/8½ inches) is a more selective method of fishing for this species than trawling. To help increase its sustainability, eat fish taken from healthy stocks like the southwest – the only stock in the northeast Atlantic assessed as having full reproductive capacity.

In New England, USA, a Fishery Management Plan was introduced in 1999 to rebuild monkfish (*L. americanus*) populations in 10 years. Although rebuilding targets have not yet been met (at the time of writing), monkfish in the two management areas are no longer considered over-fished, so the recovery plan is working. The stock is closely monitored and measures are in place to protect it, including enforcement of minimum landing sizes and spawning season closures.

In the UK, there is talk that Southwest fishermen claim to know where the monkfish 'nursery' areas are and are voluntarily not fishing them, so self-policing the stocks.

Only one-third of the fish is eaten – the rest is head...

...although the cheeks are delicious!

If you see monkfish liver on sale, buy it – it's the foie gras of the sea!

monkfish roasted with fifty garlic cloves, olives and basil

Serves 4

1 fennel bulb, very finely sliced

125 ml/4 fl oz/½ cup dry white wine

250 ml/8 fl oz/1 cup extra virgin
 olive oil

50 garlic cloves, unpeeled

2 tsp fennel seeds, finely ground

1 tbsp coriander seeds, lightly roasted
 and crushed

1 dried bird's-eye chilli

50 g/2 oz/¼ cup pitted black olives

6 tomatoes, cut in half

1 monkfish tail, about 1 kg/2¼ lb,
 prepared as above

Sea salt and freshly ground black pepper

Handful of fresh basil, finely chopped

AT THE FISHMONGER
Ask your fishmonger to remove
the skin and membrane but
leave the fish whole on the bone.

When planning a Sunday lunch, fish doesn't often get a look-in among all the meat choices; largely I think through tradition, but also because we aren't familiar with serving a whole fish on the table. It is a wonderful experience; a real sense of occasion and this dish is perfect for 4 or more people sharing lunch. Don't be put off by the 50 cloves of garlic, as the garlic loses its raw pungency and become incredibly sweet during the cooking. Part of the enjoyment of this dish is the squeezing out of the garlic cloves onto your plate and it makes a wonderful combination with the monkfish. The warm oil takes on all the flavours of the dish and is lovely spooned over creamy mashed potatoes or mashed squash.

Preheat the oven to 220°C/425°F/Gas Mark 7.

Spread the fennel over the base of a large roasting dish. Add the wine, olive oil and garlic and sprinkle in 1 teaspoon of ground fennel and the crushed coriander seeds. Crumble in the chilli and add the olives. Squeeze some juice from the tomatoes into the dish then add them.

Season the fish with salt and pepper and rub the remaining teaspoon of ground fennel all over. Arrange the fish on top of the vegetables and roast in the oven for 30–35 minutes. Remove from the oven and leave to rest for 4–5 minutes. There should be a white milky juice flowing from the fish as it rests, which is the protein in the fish naturally leaking out during cooking.

Stir in the basil, and after the oil has cooled slightly, season to taste before serving straight from the dish.

You can add a little lemon juice to the oil if you wish and you will find that the fish comes easily away from the bone as everyone helps themselves. I like to serve this dish with mashed potatoes and spinach or braised fennel.

monkfish cooked as *osso bucco*

Serves 4

3 large plump garlic cloves, finely
 chopped
Good handful of fresh flat leaf parsley,
 finely chopped
Finely grated zest of 2 lemons
4 large monkfish steaks, about
 200 g/7 oz each
2–3 tbsp olive oil
75 g/3 oz celery, finely chopped
1 shallot, finely chopped
1 tbsp fresh thyme leaves
1 small carrot, very finely chopped
1 tbsp tomato purée
1 tbsp anchovy paste
175 ml/6 fl oz/scant 1 cup dry
 white wine
4 fresh plum tomatoes, roughly chopped
125 ml/4 fl oz/½ cup water
Sea salt and freshly ground black pepper

AT THE FISHMONGER
Ask your fishmonger to skin
a large monkfish tail at least
1.5 kg/3 lb in weight and buy
steaks cut from the thick end of
the tail.

Osso bucco is a celebrated Italian dish made with veal shin, which is traditionally served with a saffron risotto finished with bone marrow and Parmesan; it's a wonderful dish and a favourite of mine. There are salted anchovies used in the preparation and the large slices of monkfish here are not dissimilar to veal slices, which is how the idea came about; I'm sure I'm not the first. These lovely flavours work really well with the monkfish and it is a firm family favourite. A simple saffron risotto would make a fine accompaniment.

Preheat the oven to 180°C/350°F/Gas Mark 4.

First, make the topping, which is called *gremolata*. Mix half of the chopped garlic, half of the chopped parsley and the lemon zest together in a bowl and set aside until needed.

Heat the olive oil in a large heavy-based pan that can hold the fish in a single layer and is suitable for the oven. When the oil is hot, season the monkfish with a little salt and sear until golden on one side then remove from the pan and set aside. Turn the heat down and add the celery, shallot, the remaining garlic, thyme and carrot and fry gently for about 6–7 minutes until softened. Add the tomato purée and cook for a further 1–2 minutes, then add the anchovy paste and wine. Allow the wine to boil for a minute, then add the fresh tomatoes.

Return the fish to the pan and add the water and a little of the remaining parsley. Cover and cook in the oven for about 15 minutes. If you don't have a suitable pan, carefully transfer to an ovenproof dish.

Place the fish on serving plates. If the sauce in the pan is not thick, then reduce down a little by boiling until it has thickened. Season and add the last of the parsley then spoon over the fish. Scatter over the *gremolata* and serve – fantastic!

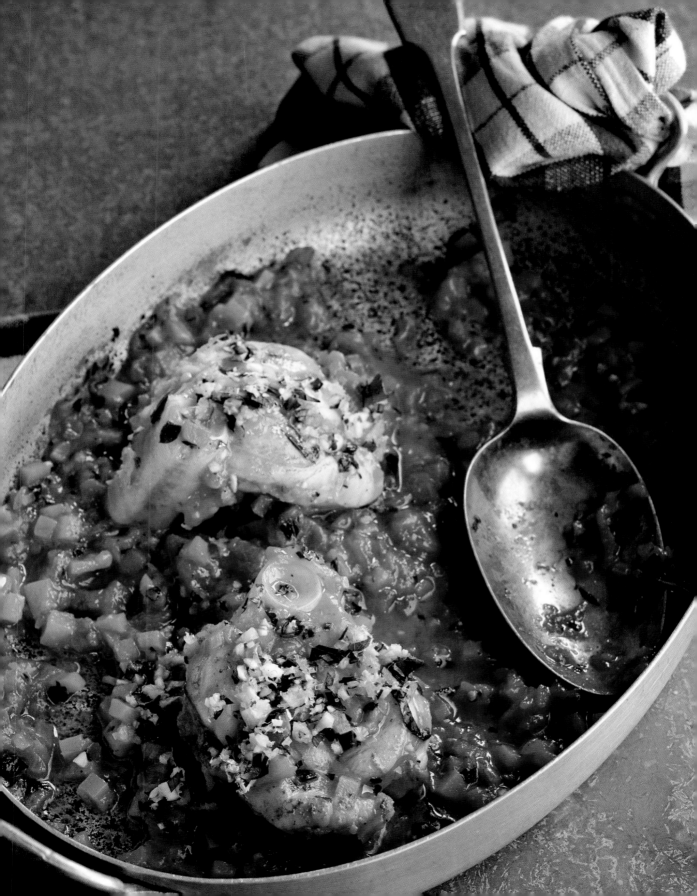

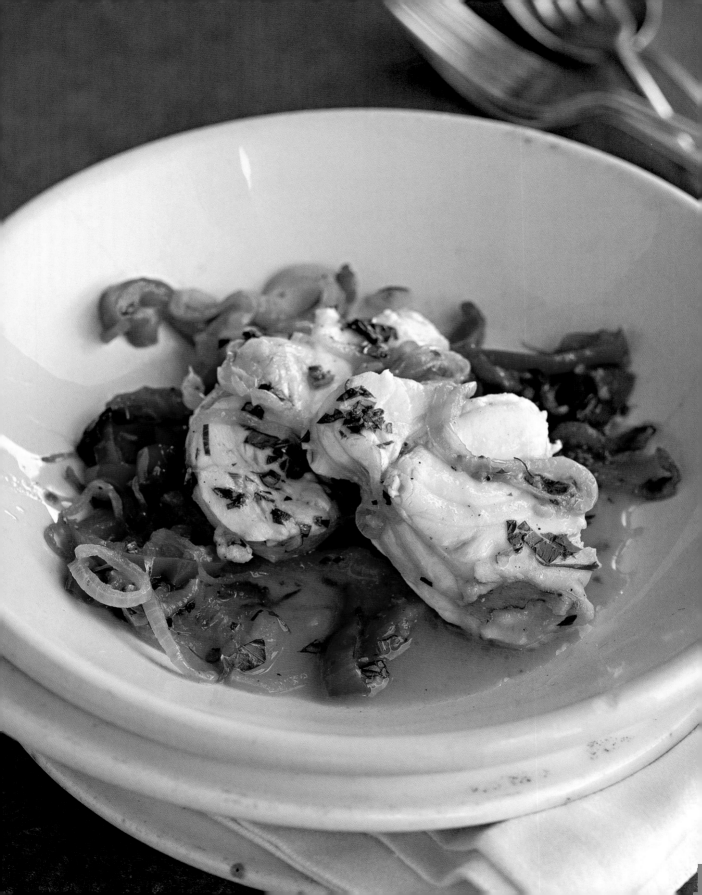

monkfish chunks cooked with onions, peppers and sherry

Serves 4

25 g/1 oz/2 tbsp butter

100 ml/3 fl oz/generous ⅓ cup olive oil

2 large onions, finely sliced

1 red pepper, deseeded and cut into
 2.5 cm/1 inch pieces

1 green pepper, deseeded and cut into
 2.5 cm/1 inch pieces

6 garlic cloves, finely chopped

Good pinch of saffron strands

400 ml/14 fl oz/1¾ cups dry sherry, such
 as Manzanilla or fino

750 g/1 lb 10 oz monkfish, cut into
 4 cm/1½ inch chunks

200 g/7 oz fresh palourde or venus clams
 or live mussels, cleaned and beards
 removed (optional)

Handful of fresh parsley, finely chopped

Sea salt and freshly ground black pepper

AT THE FISHMONGER
Ask your fishmonger to fillet the
monkfish and remove the skin
and membrane.

I love the cooking of Spain and Italy; in fact they have to be my favourite places to eat seafood. I think it's the simplicity of the dishes and that complete understanding they have when it comes to cooking fish that makes it so special — they just don't mess about with it. I ate a dish similar to this one in the excellent Café Belaer in Cuitadella on the island of Menorca. One of the other specialities was a local lobster cooked in sherry with plenty of onions; it was delicious, especially served with a bottle of Dom Pérignon champagne!

Heat the butter and olive oil together in a large heavy-based frying pan, add the onions, peppers, garlic and saffron and cook very slowly over a low heat for about 25 minutes until the onions are soft, light golden and nearly melted. You do not want any of the onions to be tinged by hot frying, as this will change the taste. This part is the most important part of the dish.

Add the sherry and monkfish, then cover with a lid and simmer gently for 10–12 minutes or until the fish is just cooked. If your fishmonger has a handful of clams or mussels, they are very good added 5 minutes before the end of the cooking time, but are not essential.

Add the parsley to the pan and season with salt and pepper, then serve.

This dish is great served with chicory that has been brushed with oil, seasoned with salt and lightly grilled — the enjoyable bitterness of the chicory works well with the sweetness of this dish.

pollack *Pollachius pollachius*

Pollack is rapidly increasing in popularity as a great alternative to cod and, like cod, pollack is a member of the *Gadidae* family. Pollack may not have the starry glamour of cod or haddock, but a light sprinkling of salt over its flesh 20 minutes before cooking improves the texture and makes this fish a worthy and sustainable successor to its famous cousin.

Pollack like rough ground, rocky coastlines and wrecks. It has a thick-set silvery body with a greenish-brown back (although this can vary according to its habitat) and its huge forward-pointing eyes are perfectly positioned for hunting crustaceans or molluscs. Larger pollack move into deeper water in search of herring and sand eel, or lurk near wrecks in the hope of catching a passing fish.

Loving its food, this fish can gain a lot of weight in its early years, and a well-fed pollack can grow up to 1.3 m/4¼ ft in length, although most are around 50 cm/20 inches. They become sexually mature around 4 years old and spawn in shallow water between January and April.

Taste description

Pollack has a fairly thick skin, the nutty Amaretto-like aroma of which is particularly highlighted when pan-fried. Compact in appearance, the white flesh breaks into discrete, delicate flakes, each one with a glossy sheen and a slippery mouth feel, thanks to a high moisture content. The taste is a perfect balance of the skin's faint bitterness and the flesh's carrot-water sweetness, which builds steadily in the mouth, leading to a distinctive aftertaste, reminiscent of marrowfat peas.

Territory

This species is found throughout the northeast Atlantic from Iceland and Norway right down to the Iberian Peninsula. It is also common around the coasts of Britain and Ireland. Pollack are not found in the Mediterranean.

Environmental issues

Pollack caught by hand line or rod and line is the best choice in terms of selectivity and sustainability. Avoid buying immature fish below 50 cm/20 inches.

Territory	Local Name
UK	*Pollack, Lythe*
France	*Lieu jaune*
Spain	*Abadejo*
Holland	*Witte koolvis, Pollak*
Germany	*Pollack*
Sweden	*Lyrtorsk, Bleka*
Denmark	*Lubbe*
Norway	*Lyr*

Health

Per 100 g/4 oz: 72 kcals, 0.6 g fat

Seasonality

Avoid pollack during its spawning season from January to April. It is at its best in summer and autumn when it's feeding voraciously and gaining a lot of weight.

Yield

1 kg/2¼ lb weight of pollack yields 75% edible steak.
1 kg/2¼ lb weight of pollack yields 65% edible fillet.

When buying, look for firm flesh of a pale pink colour and fillets of a good thickness.

roasted pollack with
salsa picante

Serves 4

25 g/1 oz pumpkin seeds
1 tsp sesame seeds
½ tsp cumin seeds
4 tomatoes, roasted
6 tbsp cider vinegar
Handful of fresh coriander
Juice of 1 lime
3 whole hot chillies, deseeded
1 tbsp dried oregano
4 garlic cloves
2 tbsp vegetable oil
4 pieces of pollack fillet, about
 150 g/5 oz each
Sea salt and freshly ground black pepper

To serve:
Lime wedges

This is a fantastic sauce that works well with a great piece of white fish – it's very zingy and there's a bit of heat from the chilli. I also like to eat it with grilled tuna and swordfish, and it's also delicious eaten with roasted shellfish.

Preheat the oven to 240°C/475°F/Gas Mark 9.

To make the *salsa*, place the seeds in a small dry frying pan and toast until golden. Add to a food processor with the tomatoes, vinegar, coriander, lime juice, chillies, oregano and garlic and whiz briefly until roughly chopped.

Heat the vegetable oil in a frying pan. When hot, season the fish with salt and pepper, lay flesh side down in the pan and cook for 2–3 minutes until golden. If your pan is capable of going into the oven, then place it on the top shelf and cook the fish for a further 6–7 minutes. If not, then transfer the fish to a roasting pan before completing the cooking.

Serve the fish with a spoonful of the sauce and a lime wedge. A bowl of boiled new potatoes would be the perfect accompaniment.

AT THE FISHMONGER
Try and buy the thick end of the fillet, like cod; you will get much more luxurious flakes.

salted pollack with garden salad

Serves 4

450 g/1 lb pollack fillet

250 g/9 oz coarse rock salt

100 ml/3 fl oz/generous ⅓ cup extra
 virgin olive oil, plus extra for oiling
 and brushing

1 garlic clove

4 little gem lettuces

4 very ripe tomatoes

1 red onion, finely sliced

1 green pepper, finely sliced

1 bunch radishes, finely sliced

1 small cucumber, finely sliced

Fine salt and freshly ground black pepper

50 ml/2 fl oz/¼ cup white wine vinegar

1 tbsp capers

Small handful of fresh flat leaf parsley,
 finely chopped

To serve:

Crusty bread

Good-quality olive oil

AT THE FISHMONGER
Try and buy the thick end from
a large pollack fillet. Ask your
fishmonger to remove all the skin
and bones.

Pollack, whether it be from Alaskan or UK waters, is a wonderful white-fleshed fish that is perfect for light salting, and by that I mean covering with rock salt for no more than 24 hours to draw out the moisture from the fish and really firm it up. The fish also takes on some saltiness after this time and I think it is the combination of the soft fish and gentle saltiness that works so well with crisp lettuce hearts, sweet tomatoes and piquant onions and capers. If I'm making a salad then this is my preferred choice.

The day before you are going to eat the salad, place the fish in a large ceramic dish and cover with the rock salt. Cover with clingfilm and leave to chill in the refrigerator for 24 hours. You will notice water building up in the dish after this time, which is the moisture that the salt has extracted from the fish. Wash the fish well and place in a bowl of cold water, then cover and leave to soak in the refrigerator for 1 hour before cooking.

Preheat the oven to 240°C/475°F/Gas Mark 9 and lightly oil a large roasting pan.

Place the fish into the prepared pan, brush with olive oil and cook in the oven for 6–7 minutes until the fish is just cooked. Leave to cool.

Cut the garlic clove in half and use to rub all around the inside of a large salad dish.

To prepare the lettuces, trim off the roots and remove the dark green outer leaves. Use only the sweet lighter-coloured leaves and the heart of the lettuce. Cut the tomatoes into quarters and toss together with the onion, green pepper, radishes and sliced cucumber. Sprinkle with a little fine salt.

Next, make the dressing. While whisking the 100 ml/3 fl oz/generous ⅓ cup olive oil in a bowl or jug, pour in the vinegar. Season with salt and pepper to taste, then lightly dress the salad. The remaining dressing can be served in a bowl at the table. Gently flake the fish on top of the salad then turn the salad once and finish with a sprinkling of capers and some chopped parsley. Fresh crusty bread and good olive oil are perfect with this salad.

Brixham pollack with parsley, caper and egg sauce

Serves 4

400 ml/14 fl oz/1¾ cups milk

800 g/1 lb 12 oz pollack fillet, skinned

50 g/2 oz/4 tbsp butter

1 onion, finely sliced

2½ tbsp plain flour

1 tsp English mustard

Good handful of fresh parsley, chopped

1 tbsp capers, finely chopped

2 hard-boiled eggs

Sea salt and freshly ground black pepper

This is a good old-fashioned recipe that my grandmother used to cook for me, although I'm not sure whether she ever used pollack. This dish works well with any white-fleshed fish so make use of whiting, haddock, even smoked haddock, gurnard and some of the other species that we are starting to see become more available. Everyone I've cooked this dish for absolutely loves it – it is pure comfort food and ideal for those who think they don't like fish.

Pour the milk into a large saucepan, add the pollack fillets and poach very gently for 6–7 minutes, then remove from the heat.

Melt the butter in another saucepan, add the onion and fry gently until soft and translucent. Add the flour and cook for a further 1–2 minutes. While stirring, slowly pour on the milk that the fish was poached in until the sauce is the consistency of double cream. Stir in the mustard, then add the parsley, capers and flake in the fish.

Shell and slice the boiled eggs, add them to the sauce, season with salt and pepper, and serve with creamy mashed potato and freshly cooked peas or broad beans. A nice little twist on this dish is to add a few bits of bacon.

TIP
To enjoy this dish as a fish pie, you can just top it with mashed potato and grill it for a few minutes until crisp on top.

red mullet *Mullus surmuletus*

Red mullet is my favourite fish, maybe for its stronger taste. This exotic fish is a member of the tropical goatfish family and is a sociable fish, swimming around in small shoals in warm shallow waters.

Red mullet is certainly a stunner and its colouring ranges from a rosy pink to bright red with three or four yellow stripes running lengthways along its flanks. These bands become more mottled at night, in fact its colouring can vary depending on the time of day, stress and age. It is no small wonder that the Roman Empire was swept by red mullet fever – the fish would be brought to the table in a glass jar, and its ruby colouring would fade as its life expired.

It has two rather dashing barbels under its chin, which are sensory organs to help it locate food by probing the mud for worms, molluscs and crustaceans. A relatively fast-growing species, red mullet can reach a maximum length of 45 cm/18 inches and becomes sexually mature at 2 years, when it is about 22 cm/8½ inches long. It spawns between May and July.

Taste description

A fish with an incredibly intense taste, red mullet has a deep, savoury aroma, a blend of roasted crustacean shells, particularly crab or lobster, along with a sweeter note of orange peel. Its concentrated flavour offers the earthiness of new Jersey Royal potatoes and an iodine freshness of seaweed and salt spray together with an edge of saffron-like spiciness, especially the dark meat. The skin adds another element, with the taste and crunchy texture of blistered chicken skin. This makes a great contrast to the soft but firm character of the clearly defined flakes, which are smooth and dense, like chicken oysters, but with a light oiliness that keeps the mouth feel luscious.

Territory

Red mullet is found throughout the Mediterranean, east North Atlantic Ocean and the Black Sea. It is also found as far north as Britain and Ireland, especially around the coasts of the south and west. Once it was just a summer visitor but increasingly it is being found all year round.

Environmental issues

Avoid immature fish less than 24 cm/9½ inches. Red mullet are subject to high fishing pressure in Mediterranean fisheries.

Territory	Local Name
UK/USA	*Red mullet*
France	*Rouget de roche*
Spain	*Salmonete de roca*
Portugal	*Salmonete*
Italy	*Triglia di scoglio*
Greece	*Barboúni*
Germany	*Meerbarbe*
Holland	*Mul*
Denmark/ Sweden/Norway	*Mulle*

Health

Red mullet is rich in vitamin B12 and selenium and is a moderate source of omega-3 oil.
Per 100 g/4 oz: 109 kcals, 3.8 g fat

Seasonality

Avoid this fish during their spawning season from May to July.

Yield

1 kg/2¼ lb weight of red mullet yields 50% edible fillet.

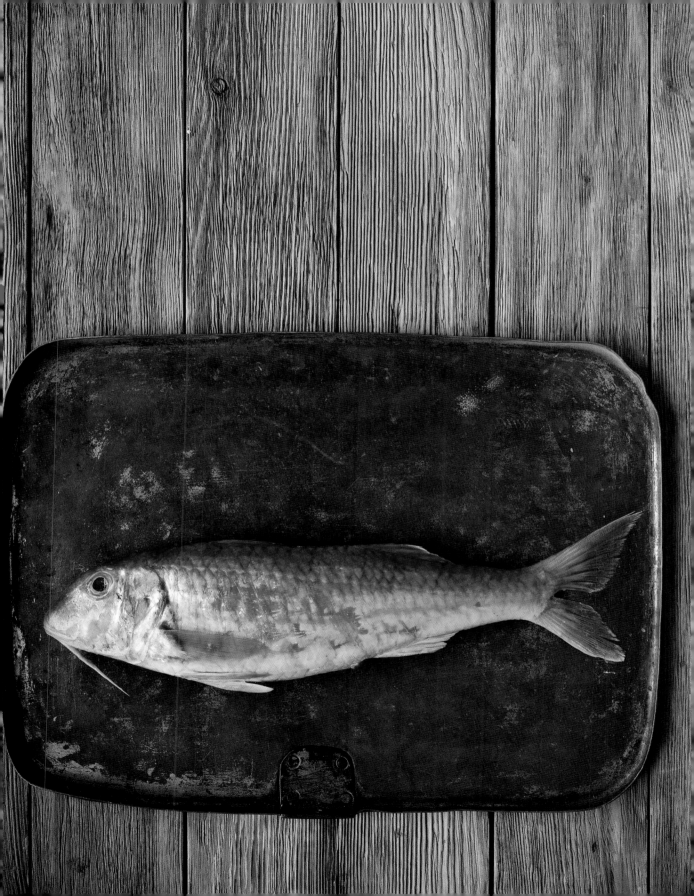

whole red mullet with Greek salad

Serves 2

2 red mullets, about 250 g/9 oz each
Good-quality olive oil, for brushing
A couple of sprigs of fresh rosemary
Sea salt and freshly ground black pepper

For the salad:

3 ripe tomatoes, cut into quarters
¼ whole cucumber, cut in half
 lengthways and sliced
1 small red onion, finely sliced
6 leaves from a round lettuce
1 tbsp fresh mint, chopped
½ handful of black olives, preferably
 Kalamata
100 g/3 oz good-quality feta cheese

For the dressing:

Splash of red wine vinegar
50 ml/2 fl oz/¼ cup olive oil
Good pinch of dried oregano (use Greek
 oregano if you can find it), plus extra
 for sprinkling

To serve:

Squeeze of lemon, to taste
Best-quality olive oil

The combination of red mullet and Greek salad is perfect. Red mullet when grilled has this wonderful almost 'shellfishy' saffron scent, which is just so beautiful. The secret of a great Greek salad is a good salty feta cheese and a sprinkling of real Greek mountain oregano.

Preheat the grill to its highest setting.

Brush the red mullets with olive oil, tuck a rosemary sprig into each belly cavity and cook under the grill for 4–5 minutes on each side.

Meanwhile, make the salad. Toss the tomatoes, cucumber, onion, lettuce, mint, olives and feta together.

To make the dressing, whisk the vinegar and olive oil together in a bowl. Season with salt and pepper, then crumble in the oregano. The dressing should taste quite acidic at this stage.

Liberally dress the salad with the dressing and toss together, then finish with a further sprinkling of oregano. Serve in a separate bowl alongside the grilled fish, which should be finished with a sprinkle of salt, a squeeze of lemon and a drizzle of your best olive oil.

AT THE FISHMONGER
Ask your fishmonger to just scale and gut the fish and ask him to save the livers if the mullet has any, as these are delicious grilled alongside the fish.

red mullet *escabeche* with basil, capers and tomato

Serves 2

150 ml/5 fl oz/⅔ cup milk

75 g/3 oz/½ cup plain flour

4 small red mullet fillets

3 tbsp vegetable oil, for frying

1 lemon

8 cherry tomatoes, thinly sliced

10–12 basil leaves

8–10 black olives, finely sliced

For the pickling mixture:

50 ml/2 fl oz/¼ cup red wine vinegar

1 tsp caster sugar

1 tsp fennel seeds, lightly ground

½ garlic clove, mashed to a fine paste
 in a mortar and pestle

50 ml/2 fl oz/¼ cup good-quality
 olive oil

1 shallot, finely sliced

1 tbsp capers

AT THE FISHMONGER

Ask your fishmonger for small fish weighing about 160 g/5½ oz each. Ask him to scale, fillet and remove the pin-bones from each fish for you.

Small red mullet fillets are delicious either fried or grilled whole or served pickled as in this recipe, which is known as *escabeche*. The flavours and fish can vary in an *escabeche*, but it's the pickling that makes this dish so delicious and distinctive. I often make this dish the day before I eat it so that the flavours can really develop. I then like to serve a big tray of pickled red mullet with some bread and wine as a starter or light lunch.

To make the pickling mixture, place the vinegar in a bowl, add the sugar and stir until it is dissolved. Add the ground fennel seeds, garlic, olive oil, shallot and capers and mix until combined.

Pour the milk into a shallow dish and spread the flour out on a plate. Dip each fish fillet first in the milk and then in the flour until evenly coated.

Heat the vegetable oil in a large frying pan and when sizzling hot, fry each fish until golden; the fish will have a rough crispy coating. Drain on kitchen paper, then place in a large ceramic dish, skin side facing upwards. Squeeze some lemon juice over each fish.

Lay the sliced tomatoes over each fish, then spoon over the pickling mixture. The fillets should be just covered to the level of the skin, if not, just simply make a little more mixture. Tear the basil leaves and sprinkle on liberally with the black olives and leave to stand for 20–30 minutes to allow the flavours to develop. You can also marinate the fish overnight so the flavours become stronger. Another nice addition to this dish are some segments of fresh orange.

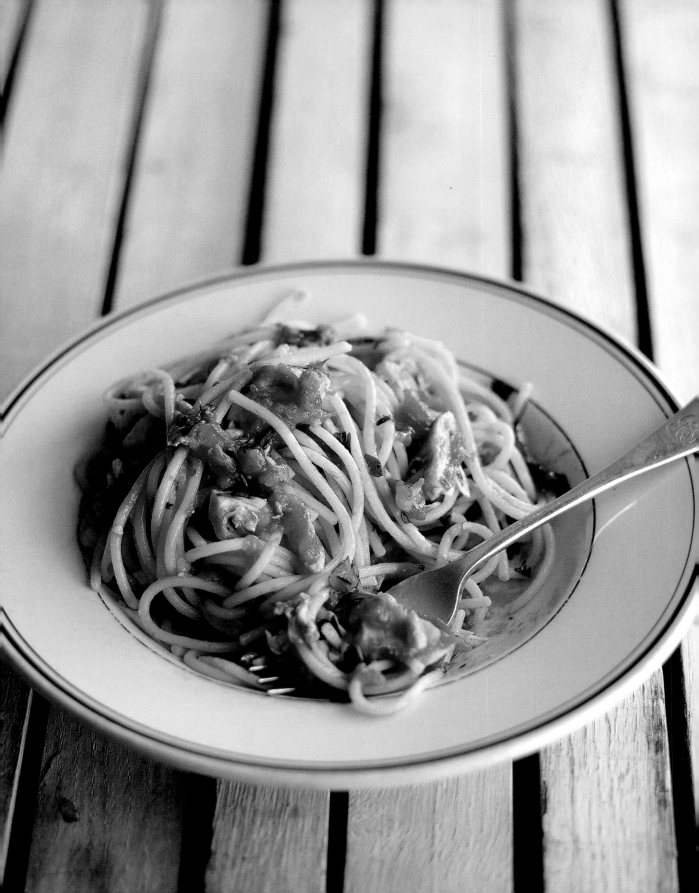

spaghetti with red mullet and tomato

Serves 4

200 g/7 oz dried spaghetti

Sea salt and freshly ground black pepper

4 tbsp good olive oil

1 garlic clove, finely chopped

6 tomatoes, peeled, deseeded and
 finely chopped

Pinch of saffron strands

Splash of white wine

4 red mullet fillets, about
 150 g/5 oz each

Small handful of fresh parsley, finely
 chopped, plus extra to serve

1 small dried bird's-eye chilli

Squeeze of lemon, to taste

To serve:

Lemon wedges

Small red mullets are often overlooked, with restaurants favouring the larger size of fish, which can be filleted and served whole. The small fish are just perfect for a *fritto misto* or as part of a sauce with pasta, as here. The other element that will make this dish a success is using the juiciest, ripest tomatoes. If you have the luxury of a few tomato plants, the tomatoes are superb picked from the vine and thrown straight into the pan, as I often do.

First, cook the spaghetti. Bring a large saucepan of lightly salted water to the boil, add the spaghetti and cook for 10 minutes or according to the packet instructions until tender but still firm to the bite.

Meanwhile, heat the olive oil in a frying pan large enough to hold the cooked pasta, add the garlic and fry gently for 1–2 minutes. Add the tomatoes, saffron, wine and red mullet and stir well together. Cook, gently stirring, until the tomatoes break down and the mullet is cooked. As you continue to stir, the fillets should break up into the sauce, taste and season frequently with salt and pepper. Add the parsley, then crumble in the chilli and add a squeeze of lemon juice to taste.

When the pasta is cooked, drain, reserving some of the cooking water, and add to the sauce with a little of the cooking water. Toss together until the pasta is coated in the sauce.

You can just serve this straight from the pan with a sprinkle of parsley and a few lemon wedges. If I can't find fresh tomatoes, then I use a good Italian brand of canned tomatoes.

AT THE FISHMONGER
Ask your fishmonger to scale,
fillet and remove the pin-bones
from the fish.

sea bass *Dicentrachus labrax*

A real favourite among fish lovers, the sea bass adorns our tables and menus with regularity, in part due to the fact that it farms so successfully.

An old name for bass was 'bares' from the Teutonic word 'bars' meaning 'bristle', and this fish certainly bristles with sharp spines from head to fin. Even its scales have minute spines on their edges. The French call it the 'wolf of the sea', an apt description for this formidable hunter with its powerful greenish-black body, silvery flanks and creamy belly. Bass hug the shoreline in the warmer months, feeding in the breaking surf on young fry and any other fish in the vicinity, a mackerel is a mere mouthful to a hungry adult bass.

The fact that they can reach 1 m/3 ft in length reflects their life expectancy, up to 25 years, rather than their growth rate. With their active lifestyle, food is used as energy rather than piling on the weight. Most females mature when they are 6 years old, at a length of 40–45 cm/16–18 inches, while the males mature when they are 5 years old and at a length of 31–35 cm/12½–14 inches.

Bass breed offshore from March to mid-June, then as inshore waters cool in October and November, bass move offshore to deeper waters. The smaller school bass are first to arrive inshore from February onwards – harbingers of the larger fish following on once they have spawned. By May the adults are prowling the surf once again.

Taste description
Wild sea bass
Notes of rocky earth and fresh, iodine-like sea air combine to give wild sea bass a complex aroma, and the taste in both skin and flesh is no less sophisticated; clean but intense, with elements of fresh seaweed and the ozone hit of rock pools just exposed by a retreating tide, with great length of flavour. The flakes are arranged in a distinctive snakeskin pattern, and their texture is substantial and fairly oily, with an initial burst of juice that disperses to give a satisfying chewy mouth feel.

Farmed sea bass
While its appearance (grey-white with a slight speckling) is fairly nondescript, at its best, farmed sea bass has a wonderfully multi-layered smell and flavour. The former is a mix of oceanic freshness, the green,

(continues on page 164)

Territory	Local Name
UK	*Sea bass, Salmon-bass*
France	*Bar, Loup (de mer)*
Spain	*Lubina*
Portugal	*Robala*
Italy	*Spigola*
Greece	*Lavráki*
Germany	*Seebarsch*
Holland	*Zeebaars*
Denmark	*Bars*
Norway	*Hav-åbor*
Sweden	*Havsabborre*

Health
Sea bass are a quite good source of omega-3 oils.
Per 100 g/4 oz: 100 kcals, 2.5 g fat

Seasonality
Avoid sea bass during their breeding season from March to mid-June.

Yield
1 kg/2¼ lb weight of sea bass yields 43% edible fillet.

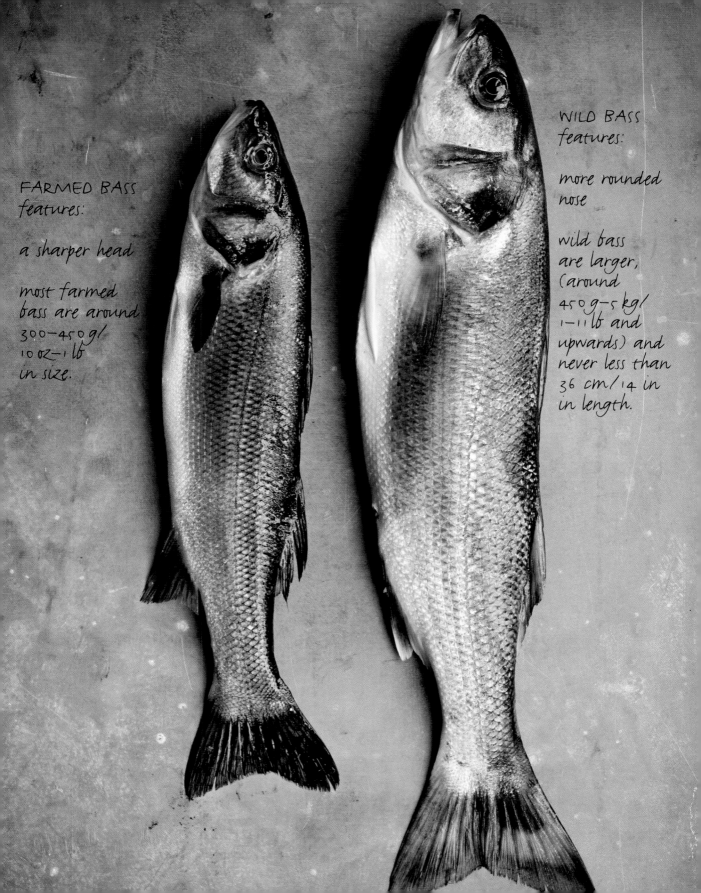

FARMED BASS
features:

a sharper head

most farmed
bass are around
300–450 g/
10 oz–1 lb
in size.

WILD BASS
features:

more rounded
nose

wild bass
are larger,
(around
450 g–5 kg/
1–11 lb and
upwards) and
never less than
36 cm/14 in
in length.

chlorophyll character of samphire or river reeds and a hint of mussel-like iodine balanced by a deeper nuttiness suggestive of roast chicken or sweet potatoes. The flavour, most of which is held in the skin, matches the aroma for complexity – a blend of the brininess of oysters and barnacles and the earthiness of potato skins, balanced by a spicy sweetness. Smooth, small flakes give the flesh a firm but delicate mouth feel.

Territory
Sea bass are found off the south and west coasts of Britain and Ireland and the Mediterranean where it is farmed.

Environmental issues
When eating wild bass choose line- or net-caught fish where possible in preference to trawled. Avoid fish under 40 cm/16 inches that have not bred yet and avoid during the breeding season March to June. A gill net fishery off the Holderness Coast (northeast England), managed by the North Eastern Sea Fisheries Committee (NESFC) is currently undergoing assessment by the Marine Stewardship Council (MSC). Sea bass are also farmed in Greece, Spain, France and Italy in open sea pens. Look out for organically grown sea bass – these have lower stocking densities and use more sustainable feed rather than wild fish.

The Line Caught Bass Campaign

Nathan de Rozarieux, Project Director Seafood Cornwall

Around 2002–4 we started to get a lot of negative stories in the local media in southwest England about dolphins being washed up on the beaches as a result of being caught in the nets of pair trawlers catching bass. A campaign was started against eating wild sea bass and the price of the wild bass collapsed. Even the hand liners who were fishing using traditional methods were affected. This was madness as they had no impact on the dolphin population and were catching bass in a sustainable and responsible way.

We needed to differentiate between the line-caught bass and bass caught by a pair trawler which may have had quite serious dolphin by-catch. We decided we should tag these line-caught fish, as the French had done before us, to show they were different, but we went that extra step by linking the tag to a web site where you could see who had caught your fish. This gave it greater traceability. Every fisherman had a number that you could check on the site and read all about the man or woman who had caught your bass.

We launched this with half a dozen fishermen in late 2005 at a restaurant in London, putting the word out about our tagged bass. Within two weeks, because we worked really hard at the other end of the chain with the consumers and the restaurateurs, there was a demand for our bass. It really captured people's imaginations, the idea that you could trace your fish from line to plate. People were contacting the Newlyn fish merchants asking when the next lot of tagged line-caught bass would be landed, and what a great idea it was!

We were lucky because we had done our homework – we knew that there was a market out there and we made sure they were aware of what we were doing. We started with 7 or 8 boats but once the market price for these fish started to go up significantly more boats joined in. Now there are 40 boats in the scheme. It's very low-tech, simple stuff.

One of the issues we are tackling with our fishermen is to make sure they understand that quality isn't determined by the day you land a fish. It's about how the fish is caught and cared for after it comes out of the water. We've done extensive shelf life studies and trials so we can tell the fishermen how to look after the fish to make sure that it retains premium quality, and the response from the fishermen has been very good. All the boats now go out with slush ice bins so they chill the fish down quickly. By handling the fish with care they land a premium product for a premium price. It's landed the same day and sold the next, so it will be two days old by the time it reaches a restaurant, but due to the care it's had since landing it's still in mint condition.

charcoal grilled sea bass with rosemary and thyme

Serves 2

1 sea bass, about 1 kg/2¼ lb
2 fresh rosemary sprigs
2 fresh thyme sprigs
Best-quality olive oil, for brushing
 and drizzling
Sea salt, for sprinkling

To serve:
Squeeze of lemon

AT THE FISHMONGER
Ask your fishmonger to scale and
gut the fish and remove the gills.

Sea bass is probably one of the most popular fish in restaurants and you see plenty of them at the fishmonger's as well. I think it is a fish for special occasions and certainly one that should be eaten as fresh as possible. I have been cooking sea bass with rosemary for years and it's probably one of my favourite dishes, especially when it is barbecued. At my restaurant, The Seahorse, local sea bass grilled over charcoal with just a sprig of rosemary tucked in the belly is one of our most popular dishes.

If you are using a barbecue, make sure your coals are nice and white or your grill plate is really hot; if the bars aren't hot then the fish will stick. This dish works perfectly well under a domestic grill, but make sure it is very hot.

Preheat the grill to its highest setting or light the barbecue.

Make 2 slashes down the side of the fish and tuck a piece of rosemary and a piece of thyme into each slash.

Brush the fish with olive oil, sprinkle with salt and grill for 7–8 minutes. Turn the fish over and cook for the same time on the other side. A great element of this dish is the crispy charred skin, so make sure your fish is crisping up well.

Serve the fish in all its glory with just a drizzle of your favourite olive oil, a little more salt and a squeeze of fresh lemon.

A Greek salad made with green lettuce, salty feta cheese, thinly sliced red onion, tomatoes and cucumber dressed with wild oregano, red wine vinegar and olive oil is a fantastic accompaniment.

sea bass baked with fennel and white wine

Serves 4

1 onion, finely sliced

3 garlic cloves, finely sliced

100 ml/3 fl oz/generous ⅓ cup olive oil,
 plus extra for brushing

4 fresh bay leaves

1 tbsp fennel seeds, lightly crushed

1 sea bass, about 2 kg/4½ lb

Sea salt

Good-sized handful of fennel herb,
 finely chopped

1 lemon, thinly sliced

150 ml/5 fl oz/⅔ cup dry white
 wine, such as a Muscadet or
 Sauvignon blanc

50 ml/2 fl oz/¼ cup Pernod or other
 aniseed-flavoured liqueur

AT THE FISHMONGER
This is a dish that warrants
a seriously fresh fish. Ask your
fishmonger to scale and gut it for
you and remove the gills. Make
sure all traces of blood are removed
from the belly cavity.

This recipe is suitable for cooking a large whole fish. It can be quite a celebration if you manage to buy a fish that is about 2 kg/4½ lb in weight. For me this is the perfect size. I like to cook the fish whole on the bone, and then the fillets can be easily removed (see the step-by-step photographs on pages 170–1 to see how it is done).

Preheat the oven to 240°C/475°F/Gas Mark 9.

Lay the onion and garlic in an ovenproof dish large enough to hold the fish. Pour in the olive oil and add the bay leaves and fennel seeds. Brush the fish lightly with a little olive oil, sprinkle with salt and rub half of the fennel herb all over the fish and in particular in the belly cavity. Lay the fish on top of the bed of vegetables, then arrange the sliced lemon on top of the fish in a line from the head to the tail.

Pour the white wine and Pernod around the fish and cook in the oven for 35–40 minutes, basting the fish frequently with the juices. If the dish starts to dry out, simply boil a little more wine and add it to the dish.

When the fish is cooked, carefully remove the layer of skin from the top of the fish and discard along with the lemon slices. Take a spoon and run it from the head to the tail down the middle of the fillet and push the fillet sideways off the bone. Using 2 spoons, place the flesh in a serving dish. Continue using the 2 spoons, lift away the fins, then hold the tail bone and lift it towards the head, it should come away easily. Lift out the bottom fillets, then spoon the pan juices and a sprinkling of fresh fennel herb over the plated fish and serve with boiled new potatoes with mint.

sea bass baked in salt and flamed with Pernod

Serves 1–2 as a light lunch

2 kg/4½ lb sea salt

1 sea bass, about 450–600 g/1–1⅓ lb

2–4 large fresh rosemary or thyme sprigs

2–3 tbsp water

2–3 tbsp Pernod

To serve:

Squeeze of lemon

AT THE FISHMONGER
Ask your fishmonger to scale
and gut the fish.

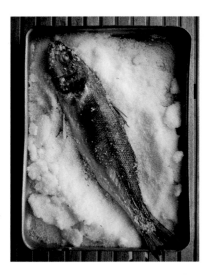

Fish cooked in salt works brilliantly, as the salt creates an oven within an oven and the fish cooks by steaming in its own juices. Probably the biggest single challenge is getting enough salt – you will need about 2 kg/4½ lb of salt for this dish. Fish that work best in salt are sea bass, grey mullet and red or black sea bream. It's best to avoid fish with a thin skin as the salt can penetrate, making the fish salty.

Preheat the oven to 220°C/425°F/Gas Mark 7.

Spread a layer of salt, about 13 cm/5 inches thick, on the base of a roasting pan or ovenproof dish that will hold the fish. Lay the fish on top of the salt and fill the belly cavity with the rosemary or thyme sprigs.

Cover the fish with the remaining salt, sprinkle over the water and cook in the oven for 25 minutes. When cooked, the salt will have formed a firm crust.

Remove from the oven, sprinkle over the Pernod and set it alight. When the flames die down, break the salt with the back of a spoon. It should come off in large chunks revealing the fish. When the fish is exposed, brush the salt away from it with a pastry brush, lift onto a serving plate and peel back the skin. (See the step-by-step photographs overleaf for how to serve.) Serve beautifully unadorned, with just a squeeze of lemon.

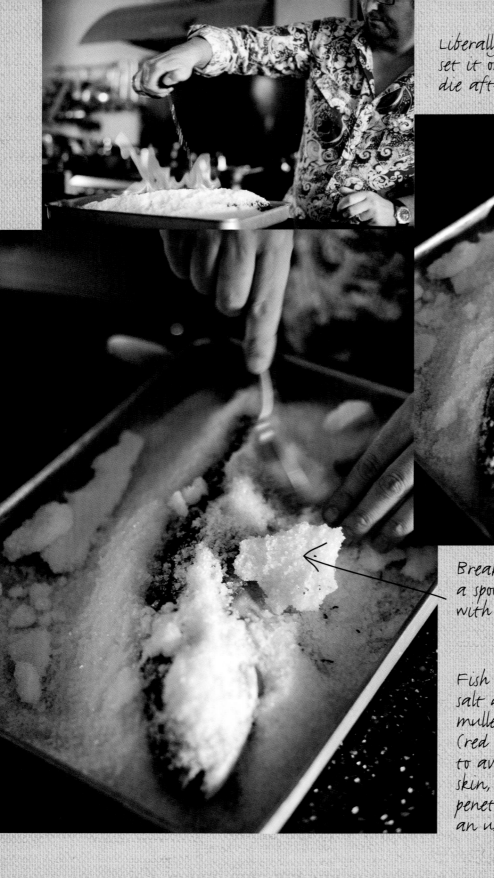

Liberally pour on Pernod and set it on fire. The flames will die after a few minutes.

Break away the salt with a spoon and dust off with a pastry brush.

Fish that work best in salt are sea bass, grey mullet and sea bream (red or black). It is best to avoid fish with a thin skin, as often the salt can penetrate this, adding an unwelcome saltiness.

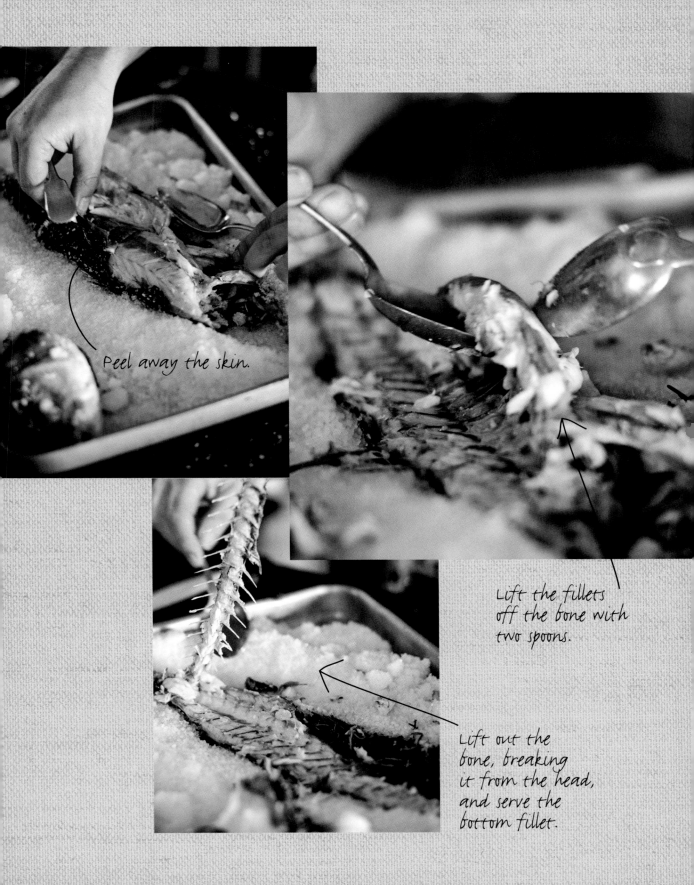

Peel away the skin.

Lift the fillets
off the bone with
two spoons.

Lift out the
bone, breaking
it from the head,
and serve the
bottom fillet.

skates and rays *Rajidae* family

The succulent taste and texture of this lovely white fish make it perfect for soups and stews, as it seems to soak up all the lovely flavours it is cooked in.

The wings of both skates and rays are sold under the name 'skate'. Like their close relative the shark, they have a cartilaginous skeleton and are a flattened kite shape with a tail. Large fins or wings allow them to glide gracefully over the seabed in search of crustaceans and small fish. They spend a lot of time half buried on the seabed – their understated colouring helps to camouflage them – and just their protruding eyes may be seen watching for prey.

Initially it was said that skates have a longer snout than rays, but this isn't strictly true. The key difference is that rays give birth to live young, as their eggs are fertilized and hatched within the body, whereas skates give birth to young in egg cases, which take 6–9 months to develop and then hatch as miniature adults. You often find the remains of these egg cases, or 'mermaids' purses', as they are sometimes called, on the beach. There are other differences, including curved thorn-like scales called bucklers found on skates, and rays have a whip-like tail usually with a stinging barb on it.

Skates and rays are slow-growing, taking 5–10 years to mature and producing few young (skates lay only about 40–150 eggs a year), and as a result of fishing pressure this has put many on the endangered list. Try to choose smaller, faster-growing species, such as starry, spotted and cuckoo rays.

Taste description

Very sweet in aroma with notes of freshly boiled potatoes, intense vanilla and the savoury warmth of boiled gammon, rays have an unusual shredded texture with long linear flakes that tear apart in the same way as a fresh mozzarella or spaghetti squash. In the mouth,

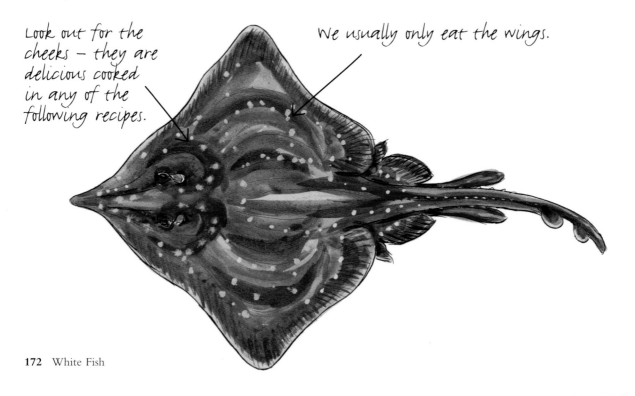

Look out for the cheeks – they are delicious cooked in any of the following recipes.

We usually only eat the wings.

the feel is soft, rich and melting with the controlled level of moisture leading to a very slight stickiness. The taste is delicate and clean with a suggestion of blanched asparagus as well as some of the depth of flavour of pork knuckle or the fat on a joint of bacon, leaving a very faint, pleasantly metallic aftertaste.

Territory

Spotted rays (*Raja montagui*) are found all around the coasts of Britain and Ireland (but not usually off the east coast of England). The cuckoo ray (*Raja naevus*) is relatively common and found all around the UK, although scarce in the lower North Sea. Starry rays (*Raja radiata*) range from the Mediterranean to Iceland and are most commonly found in British waters.

Environmental issues

Only the wings are sold by fishmongers, and the fish tends to be gutted and winged out at sea. This means it's hard to identify the variety of skate or ray you are buying. Skate and ray species are not separated for management or noted in official landing records, so, if you can, choose more sustainable species, such as spotted, cuckoo or starry rays. Avoid eating these species below the size at which they mature (54–57 cm/ 21–22 in for spotted rays, 54–59 cm/21–23 in for cuckoo rays, and around 40 cm/16 in for starry rays).

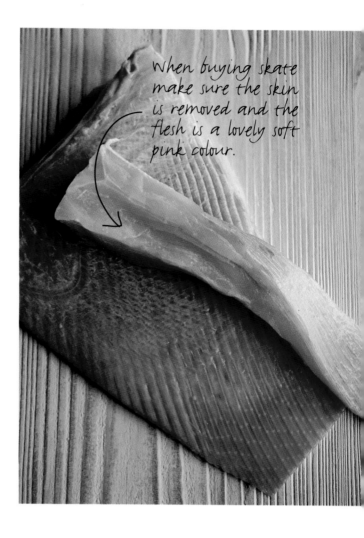

When buying skate make sure the skin is removed and the flesh is a lovely soft pink colour.

Territory	Local Name
UK	*Ray*
France	*Raie*
Spain	*Raya*
Italy	*Razza*
Portugal	*Raia*
Greece	*Seláchi*
Germany	*Rochen*
Holland	*Rog*
Denmark	*Rokke*
Norway	*Skate*
Sweden	*Rocka*

Health

Per 100 g/4 oz: 64 kcals, 0.4 g fat

Seasonality

Avoid during the breeding season, which is April to July for the spotted ray, summer and early autumn for the starry ray and December to May for the cuckoo ray.

Yield

1 'wing' yields 50% edible flesh.

stew of skate, mussels and chard

Serves 2

25 g/1 oz/2 tbsp butter

4 garlic cloves, finely chopped

1 shallot, finely chopped

100 ml/3 fl oz/generous ⅓ cup dry
 white wine

4 skate steaks, about 600 g/1⅓ lb in total

20 live mussels, cleaned and
 beards removed

3–4 chard leaves, with the central rib
 removed and finely shredded

1 small dried bird's-eye chilli

100 ml/3 fl oz/generous ⅓ cup double
 cream

50 ml/2 fl oz/¼ cup olive oil

75 g/3 oz/1½ cups coarse fresh
 breadcrumbs

Sea salt

Finely grated zest of 2 lemons

Small handful of fresh parsley,
 finely chopped

AT THE FISHMONGER
Ask your fishmonger to cut
the fish into steaks about
2.5 cm/1 inch wide; if possible
get these from a large wing,
preferably from the middle.

My good friend and long-time assistant Laura recalls enjoying skate for the first time when cooked in a stew with saffron, tomato and thyme. Stewing or poaching skate is a great way to cook it, as its silky flesh retains an incredible amount of moisture. This simple stew made with mussels and their juices and just a touch of cream ensures that the flavour is the very essence of the sea. The lemony garlic breadcrumb topping has a real zesty crunch and makes the whole thing utterly delicious.

Melt the butter in a pan large enough to hold the skate and mussels, add half of the garlic and the shallot and fry gently until softened. Pour in the wine and boil until the liquid is reduced by half. Add the skate, mussels and chard and crumble in the dried chilli. Pour in the cream, cover the pan with a lid and simmer gently for 5–6 minutes or until the mussels have opened and released their juices and the skate is cooked. Discard any mussels that remain closed.

Heat the olive oil in another pan until really hot, then add the remaining garlic and when it starts to brown, add the breadcrumbs and some salt and fry until the crumbs and garlic mixture are crisp. Add the lemon zest and a sprinkle of parsley and scatter the mixture liberally over the stew.

Mashed potatoes with plenty of black pepper, or just a loaf of bread, are wonderful served with this stew.

fried skate wing with caper mayonnaise

Serves 2

4 tbsp plain flour

3 eggs, beaten

100 g/4 oz/2 cups fine breadcrumbs

2 pieces of skate, about
 275 g/9½ oz each

About 200 ml/7 fl oz/scant 1 cup
 vegetable oil for deep-frying

For the caper mayonnaise:

2 egg yolks

2 tbsp white wine vinegar

1 tbsp Dijon mustard

100 ml/3 fl oz/generous ⅓ cup
 vegetable oil

50 g/2 oz/½ cup capers,
 roughly chopped

1 tbsp fresh parsley, finely chopped

Juice of ½ lemon

Fine salt and freshly ground black pepper

AT THE FISHMONGER
When buying skate make sure
the skin is removed and the flesh
is a lovely soft pink colour.

Skates' and rays' delicious flesh is wonderfully soft and they are free of spiky bones. I think they are the perfect starting point for anybody wanting to try more seafood.

I have heard many people say to me that they don't like skate because it tastes of ammonia, but this is definitely not the case with a fresh fish. This awful taste develops as the fish gets older, so if you've been told this story or even had this experience, do try again with a fresh piece of fish, you won't be disappointed. Fried skate is magnificent – you get a crisp outer coating and a soft moist middle. On smaller skate wings even the bones can be eaten.

First, make the caper mayonnaise. Place the egg yolks in a bowl with the vinegar and mustard and whisk together. While whisking, slowly pour in the vegetable oil in a steady stream until you have a thick creamy mayonnaise. Stir in the capers, parsley and half the lemon juice and season to taste with salt and pepper.

Place the flour, beaten egg and breadcrumbs into 3 separate deep plates. Dip the fish first in the flour then in the beaten egg and lastly in the breadcrumbs, making sure it is well coated.

Heat enough vegetable oil for deep-frying in a deep-fryer or suitable pan to 190°C/375°F. Deep-fry each piece of skate for 5–6 minutes until the outside is crisp and golden. Drain on kitchen paper, sprinkle with a little fine salt and the rest of the lemon juice and serve with a spoonful of caper mayonnaise. A bowl of chips and some pickled onions make the dish even more enjoyable.

skate fillet with leeks and clams

Serves 2

Splash of vegetable oil

50 g/2 oz/4 tbsp butter

2 skate fillets, about 200 g/7 oz each

1 garlic clove, very finely chopped

1 leek, cut into very fine matchsticks

180 g/6½ oz fresh palourde clams, rinsed

Splash of vermouth or dry white wine

150 ml/5 fl oz/⅔ cup double cream

Small handful of fresh tarragon or parsley,
very finely chopped

Sea salt and freshly ground black pepper

Skate is one of my favourites – it is perfect for anyone new to the world of seafood, as the meat is soft and sweet and the bones chewy and gelatinous rather than hard and spiky. Large skate or ray wings can be filleted and I think are quite a luxury. I like to use the thick top fillet of the skate wing for this dish, although the thinner one from the bottom is perfectly acceptable. It is also really delicious coated in breadcrumbs and deep-fried.

Heat a frying pan large enough to hold the skate wings. When very hot, add a splash of vegetable oil and half the butter, then add the skate wings and gently fry for 4–5 minutes on each side until golden. Once you have turned the skate, add the remaining butter and when it is foaming, tip the pan towards you and spoon the foaming butter over the golden-coloured fillets. Remove the skate from the pan and place in a hot serving dish.

Add the garlic and leeks to the pan and fry gently, adding a little more butter if necessary. Add the clams and toss together, then add the wine or vermouth and keep shaking the pan slightly until the heat pops the clams open. If you have any that are still closed, discard them. Add the cream and tarragon and bring to the boil. Season with salt and pepper and then spoon the sauce over the top of the skate. This is definitely a dish for the first of the season's new potatoes.

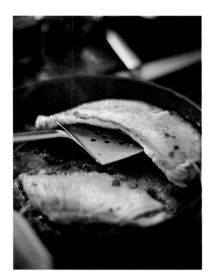

AT THE FISHMONGER
Look for large skate wings that weigh over 600–700 g/1⅓–1½ lb and ask your fishmonger to fillet them. The top fillet will always be thickest, and remember you won't have an option to just buy one, you will have to take the whole wing filleted.

snapper

The snapper is a gregarious, colourful tropical fish of the reef. There are many different species of snapper and most are very good eating. Pictured opposite is a five-line snapper, but the one you're most likely to come across is the red snapper (*Lutjanus campechanus*), also known as 'pargo', 'sow snapper', 'mule snapper' and 'chicken snapper'.

The red snapper, which can grow to about 50 cm/ 20 inches, has a light red body with a darker red back and sports a spiny dorsal fin. The long triangular-shaped face has a mouth packed with short, sharp, needle-like teeth that can crunch through small fish, shrimp, crab, worms, octopus and squid. Recent studies suggest their red colouring comes from the shrimp they eat.

Red snapper form large predatory schools of similar-sized fish that live hungrily around wrecks and reefs. The youngsters prefer shallow waters over a sandy or muddy bottom, which they can investigate.

Though their growth rate is slow, they are sexually mature around 2–5 years old, when males are 22 cm/8½ inches and females are 38 cm/ 15 inches. They are long-lived, reaching well over 20 years. Spawning is from June to October according to location.

Over recent years there has been a high demand for this delicious fish and diminishing stocks have led to fish fraud, with other reddish-coloured snapper being wrongly labelled. That's not to say that other snapper aren't delicious – look out for Caribbean red snapper, mutton, five-line, vermilion, mangrove and yellowtail. In fact, mutton snapper is being looked into as a possible candidate for offshore aquaculture, which could be good news for the hard-pressed red snapper stocks.

Taste description

Mildly gamey in aroma, red snapper has a springy elasticity, its well-defined and elongated flakes arranged in distinctive whorl patterns. The flesh is juicy and, in line with its smell, has a slight duck note, bolstered by a suggestion of roast chicken in the thick skin; for the best flavour the flesh and skin should be eaten together. The fish has a noticeable fat line, which means that, along with the milder white flesh, there is plenty of dark meat too, which contributes to its slightly metallic aftertaste.

Territory

Red snapper are found off the Atlantic and Pacific coasts from North Carolina to the Florida Keys and throughout the Gulf of Mexico to the Yucatan.

Environmental issues

There are two red snapper fisheries: the South Atlantic and the Gulf of Mexico. The South Atlantic red snapper fishery has been managed since 1983 through the Snapper-Grouper Fishery Management Plan (FMP).

In the Gulf of Mexico, the National Marine Fisheries Service (NMFS) has brought in a number of long-term regulations to address over-fishing and by-catch in the red snapper and shrimp fisheries. One of the main issues is the high mortality of juvenile red snapper caught in shrimp trawls as by-catch, which has hindered the rebuilding of the red snapper stock. To reduce this by-catch, fishery managers require fish by-catch reduction devices (BRDs) in shrimp trawls, which allow fish to exit the net while shrimp are retained. Gulf red snapper is currently under a rebuilding programme, with various measures in place to restore the stock by 2032.

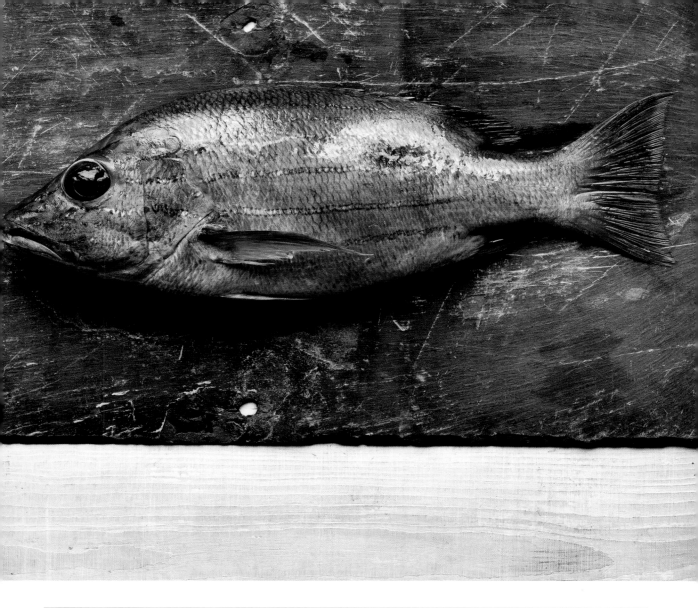

Territory	Local Name
UK	*Snapper*
USA	*Porgy, Snapper*
France	*Perche rouge*
Spain	*Pargo Jorobado*
Portugal	*Vermelho*
Italy	*Castagnola, Guarracino*
Greece	*Tsipoura*
Holland	*Kiekjesmaker*
Germany	*Schnapper*
Sweden	*Knäppare*
Denmark	*Pukkelsnapper*

Health

Snapper is low in saturated fat and sodium and a very good source of protein.

Per 100 g/4 oz: 90 kcals, 1.3 g fat

Seasonality

Avoid red snapper during their spawning period from June to October, and July through to September for fish off the southeastern USA.

Yield

1 kg/2¼ lb weight of snapper yields 47% edible fillet.

red snapper curry

Serves 2

1 tsp ground turmeric

1 tsp ground coriander

1 red snapper, about 600 g/1⅓ lb, filleted

Juice of 2 limes

6 tbsp vegetable oil

1 large onion, finely sliced

80 g/3¼ oz fresh root ginger, mashed
 to a paste in a mortar and pestle

4 garlic cloves, pasted

5 green cardamoms

4 cloves

10 black peppercorns

1 tsp chilli flakes

1 cinnamon stick

Handful of curry leaves

1 x 400 ml/14 fl oz can coconut milk

1 tbsp fish sauce, to taste

Good handful of fresh coriander,
 finely chopped

AT THE FISHMONGER

*Ask your fishmonger to scale, fillet
and remove the pin-bones from the
fish. Frozen red snapper works
perfectly well in this dish too.*

This wonderful recipe came to me from one of my old chefs and now spice guru, James Ransome. He will often send me a box or two of his latest spice mixes for me to play with, and fabulous they are too. This curry is an example of one of his spice combinations, and I have since used it with lobster, crab, monkfish, prawns, mussels and clams. You can see that it really is that versatile. If you would like to buy some spices from James, visit www.seasonsandspices.com. This curry is wonderful served for breakfast, just as they do in the Maldives and Sri Lanka, or as a main meal with some spring greens or rice.

First, mix the turmeric and ground coriander together, then rub half of this mixture into the fish fillets, especially on the flesh side. Squeeze the juice of a lime over fillets and leave to marinate in the refrigerator for about 40 minutes.

Meanwhile, heat the oil in a large pan big enough to hold the fish, add the onion and fry gently until softened. Add the ginger and garlic and fry for a further 3–4 minutes. Add the cardamoms, cloves, peppercorns, chilli flakes, cinnamon and curry leaves, and cook for a further minute. Add the remaining turmeric mixture to the pan, then pour in the coconut milk. Place the fish into this mixture flesh side down and simmer gently for 8–10 minutes.

Season with fish sauce and squeeze over the juice from the remaining lime, then finish with some finely chopped fresh coriander before serving.

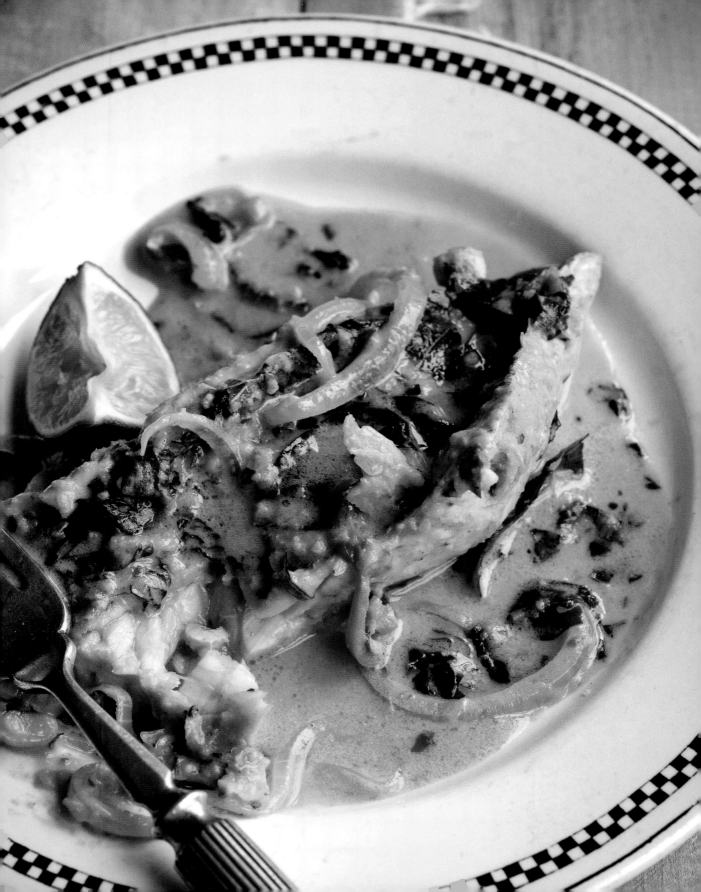

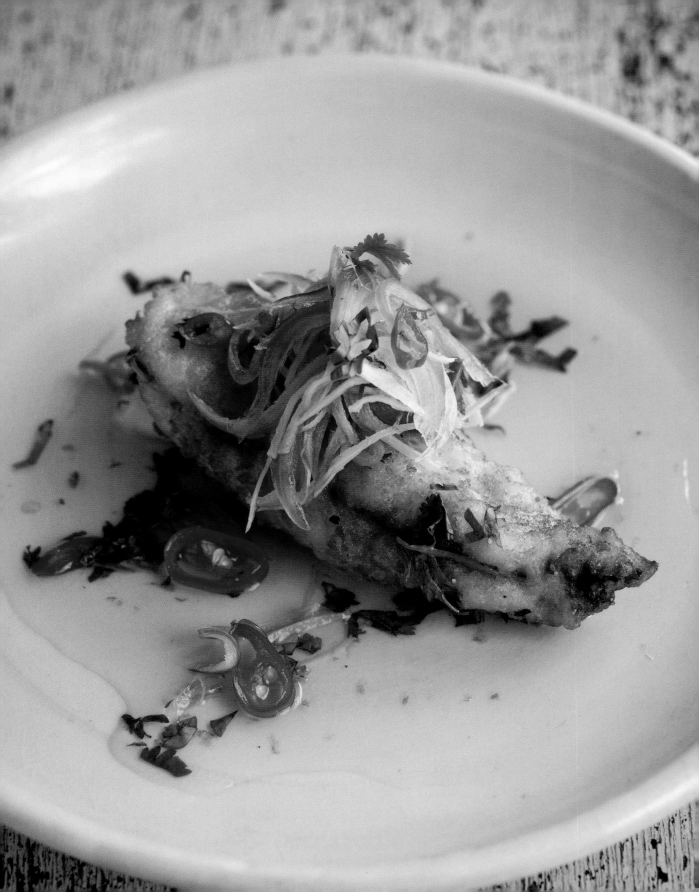

fried snapper with sweet chilli sauce

Serves 2

Vegetable oil, for deep-frying
20 g/¾ oz/¼ cup cornflour
Sea salt and freshly ground black pepper
2 x 250 g/9 oz snapper fillets

For the sauce:
100 ml/3 fl oz/generous ⅓ cup white
 wine vinegar
150 g/5 oz/¾ cup caster sugar
½ red onion, finely sliced
2.5 cm/1 inch piece fresh root ginger,
 peeled and cut into very fine
 matchsticks or grated
2 red chillies, finely sliced
Splash of fish sauce, to taste
Finely grated zest and juice of 1 lime
Small handful of fresh coriander,
 chopped

AT THE FISHMONGER
Ask your fishmonger to fillet,
scale and remove the pin-bones
from the fish.

The firmness of warm-water fish means they lend themselves well to being stewed or crisp fried, and snapper is excellent for this. This sauce is wonderful and is also fabulous with mussels or used to coat a lobster before roasting, so the outside goes wonderfully sweet, hot and sticky.

Heat the vegetable oil in a deep-fryer or in a suitable pan to 190°C/375°F.

Meanwhile, make the sauce. Place the vinegar and sugar in a saucepan and warm over a low heat until the sugar has dissolved, the flavour should be sweet and sour and it should be quite sticky. Add the onion, ginger and chillies and cook for a further 3–4 minutes; they should remain crunchy. Season the sauce with the fish sauce and the lime zest and juice.

Place the cornflour on a large plate or a clean work surface and season with salt and pepper. Coat the snapper in the cornflour, shaking off any excess, then deep-fry in the hot oil until crisp. Drain on kitchen paper.

Just before serving, stir the chopped coriander into the sauce, then spoon over the fish and serve. I like a cold noodle salad dressed with sesame oil, lime juice and ginger as an accompaniment.

turbot *Psetta maxima*

A thick chunk of turbot roasted and served with hollandaise is one of life's great pleasures. Gastronomically speaking, turbot rules the flatfish kingdom. It's the larger cousin of the brill, and has been loved by mankind for over 2,000 years. Despite its less classy Scottish nickname of *bannock fluke*, which means 'left-eyed oat cake', make no mistake this is a fish for very special occasions.

Reaching 50–80 cm/20–31 inches long, with the occasional 1 m/3 ft monster, turbot can live up to 25 years. It has a large distinctly diamond-shaped body and a scale-less skin with a scattering of bony tubercles over the surface. Nineteenth-century diners were urged to eat the skin, and the fins were also considered something of a delicacy. Turbot like a sandy, gravelly or shell-covered seabed where they can blend into their surroundings, as the topside of their whole body, including the fins and tail, is covered in tiny speckles of brown, black and green. Their underside is white.

Females tend to be larger than the males, becoming sexually mature around 35 cm/14 inches, while the males are mature when they are 30 cm/12 inches, at about 5 years old. They spawn from April to August and their young may be found in rock pools or estuary mouths. Turbot enjoy feasting on small bottom-dwelling fish as well as shellfish and crustaceans.

Taste description
Wild turbot
Most of the turbot's subtle aroma, which features notes of potato skin and pork crackling, is concentrated in its skin, and is matched by an equally delicate seawater flavour balanced by a faint hint of sweetness. But although the flavour is appealing, it is its superb texture that has won it its 'King of Fish' reputation. Firm and substantial with a juicy elasticity, the white flesh breaks into large, even flakes with a silky, gelatinous character. The result is a luscious, almost sticky, pork trotter-like mouth feel.

Farmed turbot
Farmed turbot's aroma features a starchy sweetness, like sugary popcorn or fries from a fast-food outlet. Carrying through that sugared fragrance, the flavour has a caramel-like lactose character similar to burnt milk. The texture is short and very smooth with a tendency to break into large segments, a little like blancmange. The starchiness that is evident in the aroma is also a factor in the mouth feel, giving the teeth a slightly furry coating.

Territory
Turbot are mainly found close to shore in sandy shallow waters throughout the Mediterranean, the Baltic Sea, the Black Sea and the North Atlantic to the Arctic Circle. They are also found along the northern European coasts including Britain and Ireland, where it is most common in the south. Its main fishery is the sandbanks of the North Sea.

Environmental issues
Where possible choose line-caught fish or day-boat fish. However, most turbot is acceptably caught by beam trawlers. Throughout Cornwall Sea Fisheries District it is prohibited to land turbot below 30 cm/ 12 inches in size.

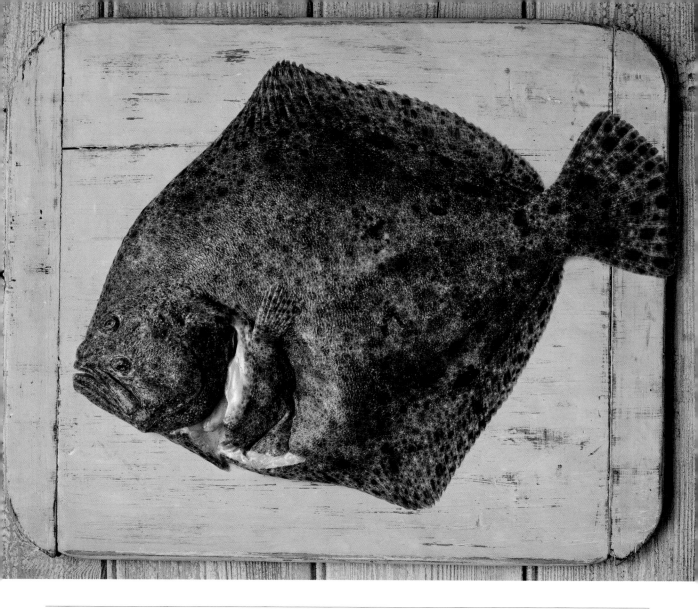

Territory	Local Name
UK/USA	*Turbot*
France	*Turbot*
Spain	*Rodaballo*
Portugal	*Rodovalho*
Italy	*Rombo (Chiodato)*
Greece	*Kalkáni*
Holland	*Tarbot*
Germany	*Steinbutt*
Sweden/Norway	*Piggvar*
Denmark	*Pighvarre*

Health

Turbot is a very good source of protein, and vitamins B3 and B12. It also contains the minerals selenium, magnesium and phosphorous. Per 100 g/4 oz: 95 kcals, 2.7 g fat

Seasonality

Avoid turbot during its breeding season from April to August. It is at its peak during autumn and winter.

Yield

1 kg/2¼ lb weight of turbot yields 50% edible steak.
1 kg/2¼ lb weight of turbot yields 33% edible fillet.

turbot with caper and parsley sauce

Serves 2

2 turbot steaks, about 350 g/12 oz each

2 tbsp olive oil

Sea salt and freshly ground black pepper

400 ml/14 fl oz/1¾ cups milk

1 onion

8 cloves

2 bay leaves

40 g/1½ oz/3 tbsp butter

3 tbsp plain flour

3 tbsp capers, finely chopped

3 tbsp fresh parsley, finely chopped

Squeeze of lemon, to taste

AT THE FISHMONGER

Try and buy big chunky steaks
cut right across the fish, or if the
fish is larger enough, from
the right-hand side of the fish
up near the head, this is where
the meat will be at its best.

This is another one of my favourite dishes – a thick turbot steak pan-roasted and swimming in velvety caper and parsley sauce. I like to serve it by putting the pan in the middle of the table and allowing my guests to help themselves. It is fabulous and a great way to eat this fish.

Preheat the oven to 240°C/475°F/Gas Mark 9.

Brush the turbot steaks with the olive oil and season with salt and pepper, then place in a large roasting dish and cook in the oven for 12–15 minutes.

Meanwhile, make the sauce. Pour the milk into a large saucepan. Cut the onion in half and insert the cloves, then make a couple of slashes in the onion halves and insert the bay leaves. Place the studded onions into the milk, bring to the boil, then reduce the heat and simmer for 6–7 minutes. Remove the pan from the heat and leave to infuse for a further 10 minutes. Remove the onions.

Melt half the butter in another saucepan over a low heat and stir in the flour until you have a smooth, creamy paste. Slowly pour in the milk while gently whisking until the sauce is smooth and is the consistency of double cream. Season with a little salt and pepper, add the capers and parsley and lastly a squeeze of lemon.

Place the turbot in a serving dish, remove the skin, which should come away easily, and spoon over lashings of the delicious sauce. Freshly cooked spinach, chard or purple sprouting broccoli would make a delicious accompaniment.

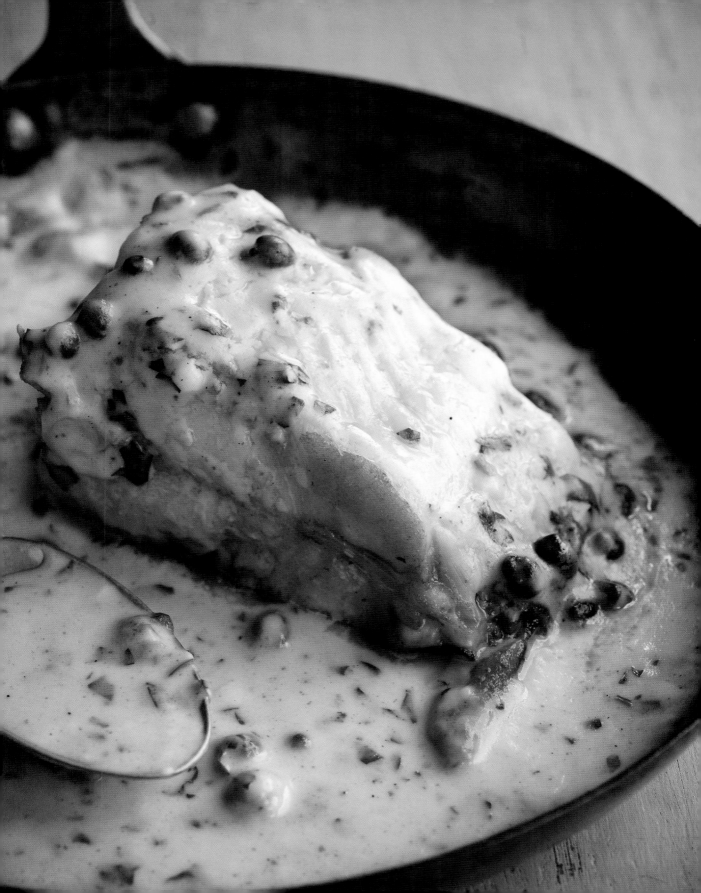

grilled turbot steak with tartare sauce

Serves 2

2 turbot steaks, about 300 g/10 oz each
Olive oil, for brushing
Sea salt and freshly ground black pepper

For the tartare sauce:
2 egg yolks
1 tbsp white wine vinegar
1 tsp Dijon mustard
250 ml/8 fl oz/1 cup vegetable oil
1 tbsp capers, finely chopped
1 tbsp fresh tarragon, finely chopped
1 tbsp shallots, finely chopped
1 tbsp gherkins, finely chopped
Few drops of lemon juice, to taste

To serve:
Lemon wedges

AT THE FISHMONGER
Ask your fishmonger for a steak
cut through the middle of
the fish; the bigger the fish, the
better the eating experience.

Turbot comes pretty much top in the hierarchy of fish and its wonderful texture and flavour mean that the best way of cooking it is without doubt the simplest. A simple sauce such as hollandaise, Béarnaise or even just melted butter with lemon juice and parsley is about all you need. I like to enjoy the delicate flavours of fish contrasted with sharp piquant flavours and I think tartare sauce is perfect with a grilled piece of turbot.

Preheat the oven to 240°C/475°F/Gas Mark 9.

Brush the turbot steaks with olive oil and season with salt and pepper. Place the fish steaks in a roasting dish and cook in the oven for 12 minutes. You will notice the white milky liquid coming from the centre of the fish where the bone is, which indicates that the fish is cooking. The liquid is merely the protein oozing from the bones.

Meanwhile, make the tartare sauce. Whisk the egg yolks, vinegar and mustard together in a small bowl. While whisking, slowly pour in the vegetable oil in a steady stream until you have a creamy mayonnaise. Add the capers, tarragon, shallots and the gherkins and stir together. Season to taste and add a few drops of lemon juice.

Serve the roasted fish with a good tablespoon of the tartare sauce, lemon wedges and a salad of the season.

poached turbot with mint and cucumber

Serves 4 as a starter

125 ml/4 fl oz/½ cup white wine

250 ml/8 fl oz/generous 1 cup water

Small handful of fresh parsley leaves and
 parsley stalks

6 bay leaves

1 onion, chopped

1 tbsp rock salt

8 black peppercorns

400 g/14 oz thick turbot fillet

100 g/4 oz/½ cup crème fraîche

1 tbsp fresh mint, finely chopped

Juice of 1 lemon

4 tbsp cucumber, skinned and finely
 chopped

Sea salt and freshly ground black pepper

To serve:

Few handfuls of watercress

Extra-virgin olive oil

AT THE FISHMONGER
Buy a fillet of turbot from the
biggest fish the fishmonger has –
a piece of fillet from a fish over
5 kg/11 lb would be fabulous but
rare. Ask your fishmonger to skin
the fillet for you.

Turbot has special qualities, its flesh is wonderfully firm and especially good served cold just like poached salmon. Turbot can be very expensive – in fact, it is one of the most expensive fish in the sea – so serving it as an appetizer means you can enjoy the experience of this lovely fish without breaking the bank.

Place the wine, water, parsley leaves and stalks, bay leaves, onion, rock salt and peppercorns in a wide pan large enough to hold the turbot. Place the fish into this mixture, making sure it is fully covered. If you need more liquid, just add more water. Bring the pan to the boil, then reduce the heat and simmer for 2–3 minutes. Remove the pan from the heat and set aside. The fish will cook in the remaining heat from the water and will be ready after an hour or so.

Mix the crème fraîche, mint, lemon juice and cucumber together in a bowl, then season with salt and pepper.

When ready to eat, break the turbot into 4 pieces, serve with a tablespoon of sauce and a handful of peppery watercress leaves dressed with salt and olive oil.

"Turbot has a deeper flavour than most fish – it holds particularly well when cooked and has a good texture, almost like a fillet steak. It doesn't require much doing to it – it's easy to cook. For these reasons it's been highly prized for centuries. It is without doubt the fish of kings."

Martin Purnell, fish buyer

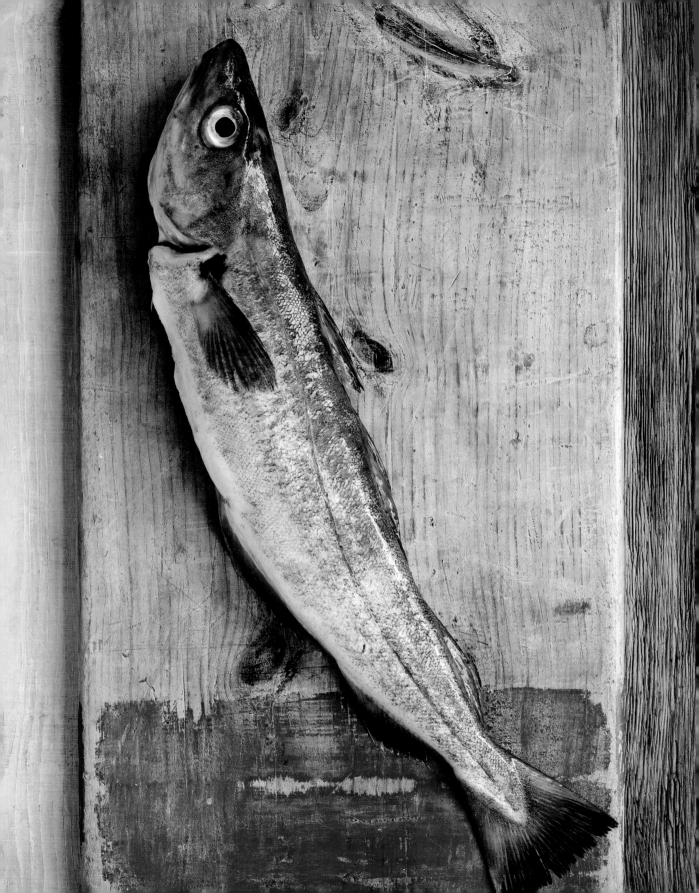

whiting *Merlangius merlangus*

This delicately flavoured member of the cod family hasn't enjoyed rave reviews for its culinary performance over the years, but with our greater awareness of sustainability now is the time to give whiting a second look.

Like all members of the cod family, it's intrinsically lazy and greedy, and this lack of exercise and voracious appetite provides us with delicious firm flakes of pearly white flesh to eat. Unlike its more ocean-going cousins, whiting prefer to swim around in predatory shoals in shallower inshore waters. Most whiting on the fishmonger's slab will be around 30–40 cm/ 12–16 inches, although the occasional one of 70 cm/ 27½ inches, tipping the scales at 3 kg/7 lb, does turn up.

Whiting is very sensitive to rough treatment, even more so than mackerel, so it must be as fresh as possible and treated with kindness. The whiting's more slender cod-like shape has no barbel under the chin, it has a dark blue-green back, dazzling silvery-white sides and belly, and a distinct dark spot on the base of its pectoral fins.

Taste description
Both sharp and savoury, the strong aroma of whiting is much like putting your nose in a bag of salted and vinegared battered fish and chips. The flavour is of full-cream milk – intense at first, but very fleeting, and the texture is soft yet crumbly, like muesli or a flapjack.

Territory
Whiting are widespread over the North Atlantic, from the Arctic Circle south to the Mediterranean and the Black Sea.

Environmental issues
Stocks are healthy. Avoid eating immature fish under 30 cm/12 inches and fish caught during the main spawning season from March to April.

Territory	Local Name
UK	*Whiting*
USA	*Whiting, Silver hake*
France	*Merlan*
Spain	*Merlán*
Portugal	*Badejo*
Italy	*Merlano*
Germany	*Wittling*
Sweden	*Vitling*
Norway	*Kviting*
Holland	*Wijting*
Denmark	*Hvitting*

Health
Per 100 g/4 oz: 81 kcals, 0.7 g fat

Seasonality
Whiting are best from November to February when they are most prevalent in inshore waters and prior to spawning so are in peak condition.

Yield
1 kg/2¼ lb weight of whiting yields 45% edible fillet.

grilled whiting with caper butter

Serves 2

350 g/12 oz whiting fillet
2 tbsp capers
Finely grated zest of 1 lemon
1 tbsp fresh parsley, finely chopped
100 g/4 oz/8 tbsp butter, softened
Sea salt

AT THE FISHMONGER
Try and buy as large a fish as
you possibly can and ask your
fishmonger to fillet and pin-bone
the fish for you.

Whiting is an incredibly underrated fish. It has soft flesh with lovely small flakes and a very delicate flavour. This fish is a delight if coated in breadcrumbs, fried and served with tartare sauce, or simply grilled with butter and capers as in this recipe.

Preheat the grill to its highest setting.

Blitz the capers, lemon zest, parsley and butter together in a food processor until the mixture is almost smooth.

Brush the fish fillets with the butter mixture and place under the grill for 4–5 minutes until cooked. Season with salt to taste and serve with a simple green or tomato salad.

grilled whiting with onion and rosemary sauce

Serves 4

150 g/5 oz/⅔ cup butter, softened
2 onions, finely sliced
1 garlic clove, finely sliced
1 ½ tbsp white wine vinegar
75 ml/3 fl oz/⅓ cup dry white wine
250 ml/8 ½ fl oz/1 cup whipping cream
Sprig of rosemary
2 bay leaves
Sea salt and freshly ground black pepper
Handful of fresh parsley, finely chopped
4 x 165 g/6 oz whiting fillets

AT THE FISHMONGER
Try to buy as large a fish as
possible and ask your fishmonger
to remove the head and butterfly
fillet it. This will mean the tail is
left, but the fillets are still joined
together down the back, which
makes for attractive presentation.

Whiting's soft flesh can lack a little in flavour, but there is lots and lots of it out there and, eaten very fresh, it can be delicious, especially when grilled with a little butter and served with this wonderful sauce.

First make your sauce. Melt 100 g/3 ½ oz/scant ½ cup of the butter in a heavy based pan over a low heat. Add the sliced onions and garlic and cook very gently for about 10 minutes, ensuring that the onions do not catch or become coloured. When they are stewed sufficiently, add the white wine vinegar and cook for a further 3–4 minutes, until the vinegar has completely evaporated. Then add the white wine and continue to cook. When there is just a little moisture left, add the cream, rosemary and bay leaves. Season with a little black pepper and cook for at least another 15 minutes. Remove the bay leaves and rosemary and purée until smooth (there should be no lumps of onion). Return the puréed sauce to the saucepan and stir in the finely chopped parsley.

Preheat the grill. Brush the whiting fillets with the remaining butter, season and grill, skin side up, until the skin becomes crisp.

Serve with a few tablespoons of sauce and some fresh new potatoes.

oily fish

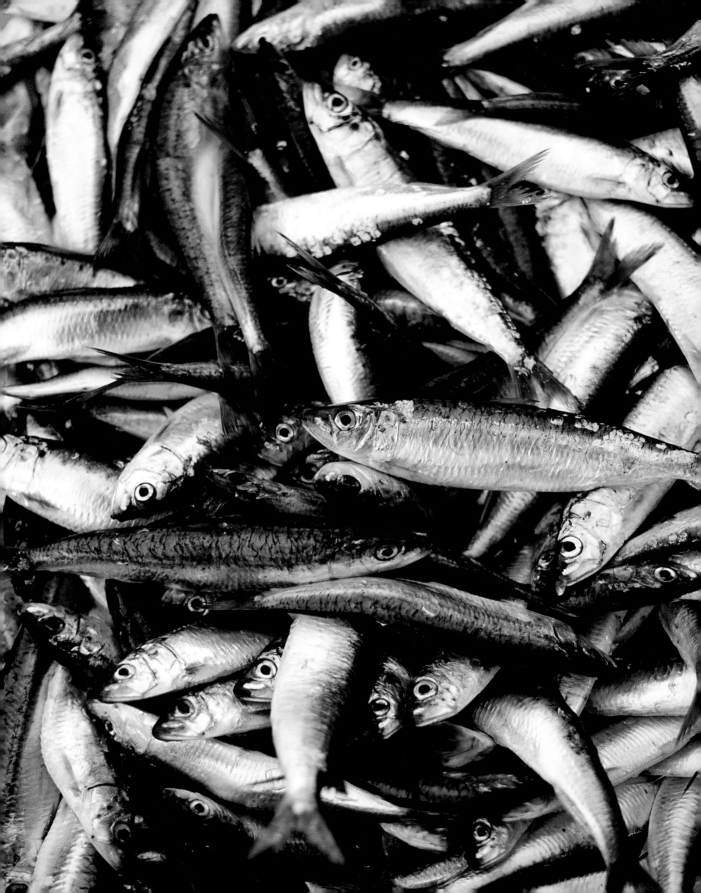

anchovy *Engraulis encrasicolus*

I'm a great fan of this tasty little relation to the herring; it has amazing potential to be used in so many different ways. Fresh anchovies are easily marinated and sit proudly as the star in a plate of cold mixed *antipasti*. The preserved salted anchovy is used to add real punch and piquancy to pasta dishes, salads and sauces, and is most famously incorporated in Worcestershire sauce and Elsenham's closely guarded recipe for their *Patum Pepererium* (Gentleman's Relish).

The anchovy lives a brief but action-packed existence. A plankton-eating fish at the bottom of the food chain, it uses the 'safety in numbers' approach to survival by hanging out in large schools – a sensible idea when everything in or even on the ocean is after you for supper. During the summer months it moves from the deep waters of the open sea to spawn inshore. Anchovies can grow up to 20 cm/8 inches, but most are 12–15 cm/4½–6 inches in length, and resemble sprats: silver in colour with a forked tail and single dorsal fin, but the body is more round in shape and slender in profile. Most anchovies end up stacked in a barrel, with salt between each layer. They are left for a few weeks and then bottled or canned in olive oil.

Taste description

Fresh anchovies when fried are not dissimilar to sardines – oily and fresh-tasting. However, most people will have eaten anchovies in salted form. The flesh appears dark brown (or the finest Cantabrian anchovies can appear a light pink colour) and texturally the salted anchovy is like biting through a slice of soft pear. You will get an immediate pungency from the salt – good salted anchovies should leave your mouth with the salty tang of the sea.

Territory

Anchovies are chiefly caught in the Mediterranean and Black Sea area, also along the coast of West Africa to Angola, eastern Central Africa and the northeast and central Atlantic. They are regularly caught on the coasts of Greece, Sicily, Turkey, Bulgaria, Russia, Ukraine, Italy, France and Spain. The range of the species also extends along the Atlantic coast of Europe to the south of Norway. In winter they are sometimes caught off Devon and Cornwall in the UK.

(continues on page 198)

Territory	Local Name
UK	*Anchovy*
France	*Anchois*
Greece	*Gávros*
Italy	*Acciuga, Alice*
Spain	*Anchoa, Boquerón*
Portugal	*Anchova, Biqueirão*
Germany	*Sardelle*
Holland	*Ansjos*
Tunisia	*Anshouwa*
Turkey	*Hamsi*

Health

Good source of calcium, iron and phosphorus, and a very good source of protein, niacin, selenium and omega-3.
Canned in oil: per 100 g/4 oz: 210 kcals, 5 g fat
Fresh fish: per 100 g/4 oz: 131 kcals, 4.8 g fat

Seasonality

Avoid fresh anchovies during their summer spawning, which is from April to September in the Mediterranean and June to August in the southern North Sea and the Channel. They are at their best in the winter months.

Yield

1 kg/2¼ lb weight of anchovy yields 55% edible fillet.

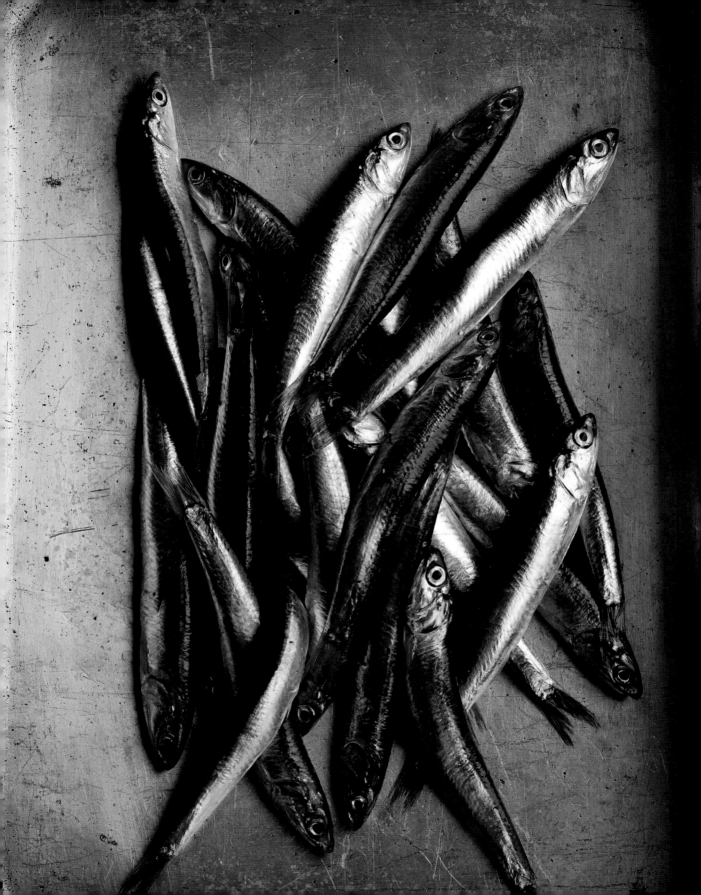

Environmental issues

The European anchovy may be small but it is in great demand. The *premier cru* of anchovies are found in the Bay of Biscay, off the coast of northwest Spain and France, Portugal and the Mediterranean Sea. Increasingly effective technology to find the schools, improved catching methods and the seemingly insatiable demand for fresh anchovies means that these fish have been pursued nearly all year round. Now quotas are being carefully monitored in order to manage the remaining stocks. Buy and eat outside of their spawning times if eating fresh, as with all fish.

Abundant anchovies

In 2007, a huge school of anchovies appeared in Brixham. It was a wonderful thing – lorries from the continent were lined up as small boats were landing up to 30 tonnes of anchovies a day. At a price of £2000 per ton, it was a great month for the port and for the fishermen.

Similar incidents have occurred when an abundance of anchovies has appeared; for example, in November 1890, a thousand fish were caught in two days from the pilchard boats fishing near Plymouth.

Frank Buckland in his *History of British Fishes* talks of a report sent to him by Mr Matthias Dunn of Mevagissey, Cornwall, in November 1871. He says, "It is seldom anchovies come so close to shore as these did, though countless quantities of them hang on our coast from December till February, and in some dark nights give a beautiful phosphorescent light to the depths of the ocean."

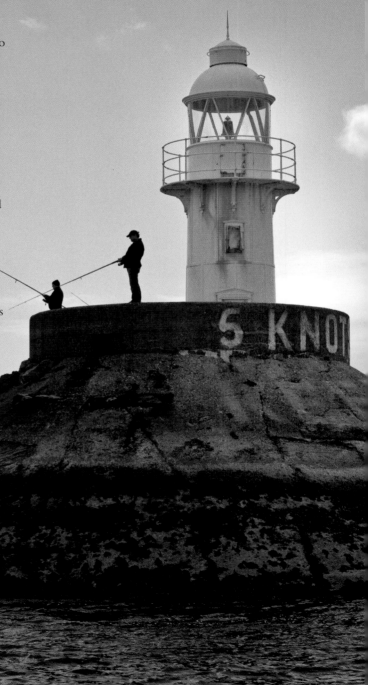

celery, anchovy and pine nut salad

Serves 2

1 tbsp sultanas

6 or 7 salted anchovy fillets

¼ garlic clove, crushed

Small handful of fresh basil

Dash of red wine vinegar

1 tbsp crème fraîche

100 ml/3½ fl oz/generous ⅓ cup
 olive oil

25 g/1 oz Parmesan cheese, finely grated

Squeeze of lemon juice

Finely grated zest of 1 lemon

Dash of Worcestershire sauce, to taste

3 celery sticks, thinly sliced

1 small red onion, cut in half and
 finely sliced

1 tbsp pine nuts, toasted

To garnish:

Torn fresh basil leaves

This fresh salad is very simple to prepare. Good salted anchovies are a real taste of the Mediterranean and the clean, fresh taste of celery with sweet sultanas and pine nuts is a great mix, especially with this creamy garlic and basil dressing. A nice twist to this dish is mixing in a tablespoon or two of sweet caramelized onions.

First, soak the sultanas in a small bowl of water for 20 minutes or until they are plumped up.

To make the dressing, chop 2 of the anchovy fillets finely and crush in a mortar with a pestle. Add the garlic and basil and give it a good bash, then transfer the mixture to a bowl and add the vinegar and crème fraîche. Whisk in the olive oil, then add half the Parmesan, the lemon juice and zest and Worcestershire sauce to taste, and continue to whisk until the dressing is the consistency of double cream.

To make the salad, mix the celery, red onion, toasted pine nuts, soaked sultanas and remaining anchovies together. Pour over the dressing and mix well. Sprinkle the rest of the grated Parmesan over the top, garnish with some torn basil leaves and serve.

TIP
It is wrong to think fresh anchovies are salty – they're not. It's the process of preserving them that gives them that flavour. Salted anchovies have a unique flavour that is essential to many dishes.

home-cured anchovies with oregano and chilli

Serves 4 as a starter

1 kg/2¼ lb anchovies, filleted

5 tbsp rock salt

300 ml/10 fl oz/generous ⅓ cup
 white wine

300 ml/10 fl oz/generous ⅓ cup water

25 g/1 oz dried oregano

1 dried bird's-eye chilli

1 red onion, sliced

Sea salt and freshly ground black pepper

100 ml/3½ fl oz/generous ⅓ cup
 olive oil

2 tbsp red wine vinegar

To garnish:

Fresh basil leaves

AT THE FISHMONGER
Ask your fishmonger to butterfly
fillet the anchovies – this is where
the head and the backbone are
removed, but the tail remains on
and the two fillets remain joined
down the back.

Curing fish is great fun, really easy and quite rewarding. I like to have a few kilner jars of cured anchovies and sprats in the kitchen, as they really add to salads and sauces, and there's nothing quite so moreish than a plate of cured anchovies, especially with an ice-cold glass of dry sherry.

Place the anchovies in a shallow dish and rub the salt onto the fish. Cover and leave to stand in the refrigerator for 1 hour. Wash the salt off and pat dry with kitchen paper. Place the fish in a clean shallow dish.

Mix the wine and water together and pour over the anchovies. Cover and leave to chill in the refrigerator for 24 hours.

Drain the anchovies and lay them out on a large plate or in another shallow dish.

Using a mortar and pestle, pound the oregano and chilli together and sprinkle over the fish. Sprinkle over the red onion and season with salt and pepper.

Mix the olive oil and vinegar together and pour over the anchovies, then sprinkle basil leaves over the top and serve.

The anchovies will keep for a week in the refrigerator.

grilled fresh anchovies with capers and olives

Serves 2

Allow 250 g/9 oz fresh anchovies
 per person
Good pinch of sea salt
2–3 tbsp olive oil, plus a little extra for
 drizzling and frying (optional)
1 tsp dried oregano
Small handful of fresh parsley, chopped
1 garlic clove, finely chopped
10 fresh basil leaves, shredded
1 tsp capers, chopped
Finely grated zest and juice of 1 lemon
½ tsp fennel seeds, ground
10 ripe cherry tomatoes
1 tbsp green olives, chopped

To garnish:
Fresh basil leaves

AT THE FISHMONGER
Ask your fishmonger to gut the
anchovies and wash (you can leave
the heads on if you prefer).

This very simple dish is full of Mediterranean flavours and relies on the great combination of basil, tomatoes, garlic and lemons to really show the fish off. You can make it with sardines and mackerel or even salmon fillets, if you like.

If you can, save this dish for the barbecue as there's nothing like that wonderful aromatic grilled flavour with fresh oily fish. While your fish is grilling, if you have a rosemary or thyme bush that needs a prune, chop off a few branches and put them on the smouldering coals, and you'll be amazed how they help the flavour of the fish as it becomes engulfed in gorgeous herby smoke.

Lay the anchovies on a board and rub them inside and out with salt, olive oil and oregano. Cook on a stovetop grill pan for 5–6 minutes or fry them gently in olive oil.

Mix the parsley, garlic, basil, capers, lemon zest and juice, ground fennel seeds, tomatoes and olives together and moisten with a little olive oil. Spoon the thick dressing over the fish, garnish with basil leaves and serve.

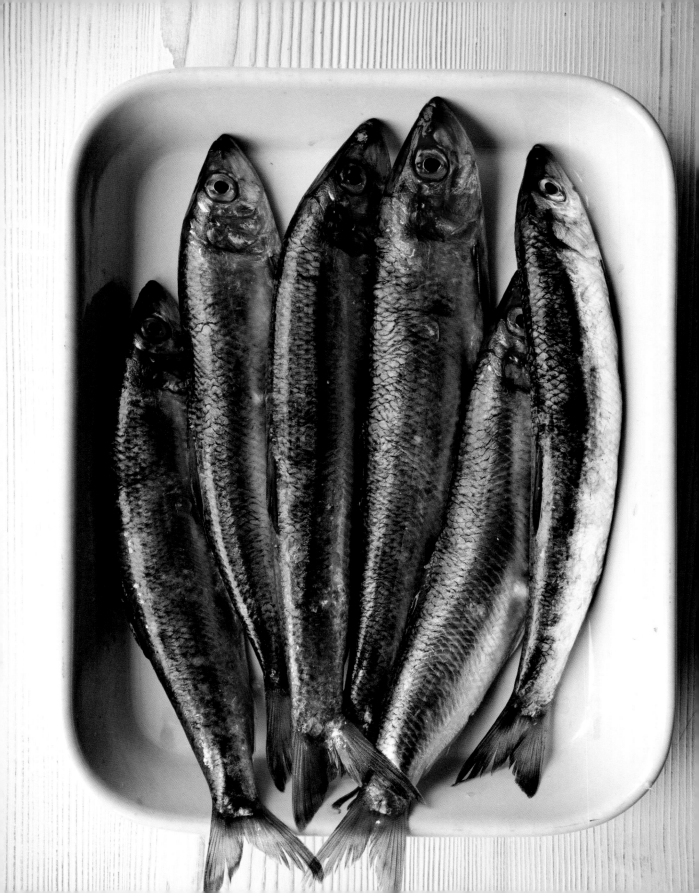

herring *Clupea harengus*

I love the common name of 'silver darlings' for these oil-rich bite-sized fish. Not only is the fish delicious, but the roes make a luxurious and cheap lunch.

Plankton-eating herring play a vital role in the marine food chain. So important have they been to us that over the centuries we created an enormous number of herring cures to preserve them, ranging from British kippers to Scandinavian rollmops.

Herring are members of the *Clupeidae* family which includes mackerel and sardines. From their head to the tip of their deeply forked tail they are predominantly silver with a blue-green back, allowing them to melt into their watery environment when viewed from above.

There are several different varieties of herring with distinct breeding populations with subtle variations. They can reach up to 40 cm/16 inches long, but are more usually 25–30 cm/10–12 inches. They follow an annual migration cycle – shoals move from feeding grounds to spawning grounds and back. After a spring and summer of feeding, they are lusciously plump and perfect for smoking. They are sexually mature at 3–9 years old, and their spawning time depends on which population they are from. They gather in large shoals of a similar age and move into shallow bays to spawn.

Taste description
Herring's high oil content is responsible for its pungent aroma, which has a distinctively petrol-like, resinous character, together with a strong tannic note. That same oiliness contributes a fresh anchovy-like saltiness to the fish's flavour, which, combined with the delicate seawater character of the skin and the mild, white pepper spiciness of the flesh, makes for a complex taste. The texture is unctuous and lush and, although small, filament-like bones are liberally distributed through the flesh, they are so fine and pliable that they can be eaten without concern. Good flavour matches are anything with a piquant character.

Territory
Herrings are found throughout the North Atlantic, as well as in the North Sea.

Environmental issues
The largest single fishery is for Atlantic herring, which is fished throughout much of the North Atlantic. In European waters, the North Sea autumn-spawning stock and drift net fisheries in Thames Blackwater and the eastern English Channel are certified as environmentally responsible fisheries by the MSC. Herring stocks in the Norwegian Sea (spring spawners), eastern Baltic and the Gulf of Riga are also assessed as being healthy and harvested sustainably.

Territory	Local Name
UK	*Herring*
USA	*Herring*
Sweden	*Sill, Strömming*
Denmark/	
Norway	*Sild*
France	*Hareng*
Germany	*Hering*
Holland	*Haring*

Herring is not found in the Mediterranean.

Health
Herrings are a good source of omega-3.
Per 100 g/4 oz: 190 kcals, 13 g fat

Seasonality
Herrings are at their very best in the autumn, but can be eaten all year round. Thames Estuary herring is best in the spring.

Yield
1 kg/2¼ lb weight of herring yields 50% edible fillet.

grilled herring with devilled butter

Serves 2

4 good-sized herrings

Sea salt

Olive oil, for brushing

100 g/4 oz/8 tbsp butter, softened

½ tsp cayenne pepper

1 heaped tbsp fresh parsley,
 finely chopped

½ tsp ground white pepper

½ tsp ground ginger

½ tsp curry powder

Squeeze of lemon

AT THE FISHMONGER
Ask your fishmonger to scale
and gut the fish and remove
the heads if they bother you.

This is a very English recipe and I am assuming the word 'devilled' comes from the fact that it can be hot and spicy – I can just hear somebody describing it as 'devilishly hot'. But spices and herbs work exceptionally well with oily fish including mackerel, a plate of sprats, or even a nice roasted piece of cod or John Dory.

Preheat the grill to its highest setting.

Sprinkle the herrings with a little salt and brush with olive oil. Cook under the grill for 5–6 minutes until the skin starts to crisp and bubble.

To make the butter, combine the remaining ingredients to your taste. When the herrings are cooked, remove from the grill then dot the devilled butter over the hot fish and allow it to melt. This dish is wonderful eaten with a bowl of boiled minted new potatoes and a squeeze of lemon.

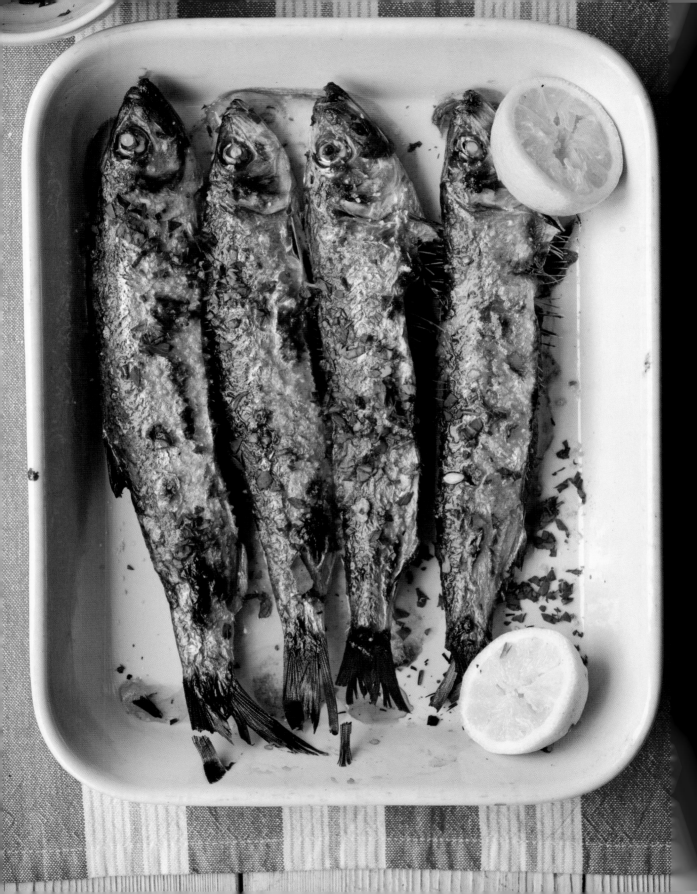

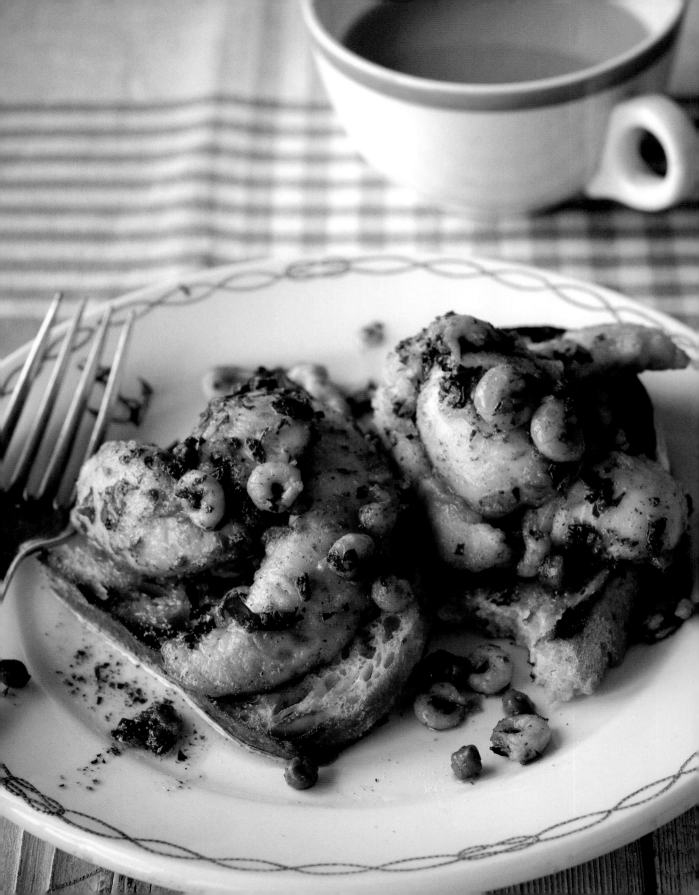

fried herring roes with brown shrimp, capers and lemon

Serves 4 for a light lunch

Plain flour, for dusting
Sea salt and freshly ground black pepper
600 g/1⅓ lb herring roe
125 g/4½ oz/9 tbsp butter
Small handful of fresh parsley
Small handful of capers
100 g/4 oz brown shrimp
Good squeeze of lemon

To serve:
4 thick slices of bread, toasted

I consider herring roes a luxury and can only seem to buy them frozen these days, as they are a by-product of the catch of the large commercial pelagic trawlers which target these magnificent fish at certain times of the year. The roes are often taken from the fish and processed on board. I think myself very lucky if I am able to walk over to the market and find a few fat herrings that yield lovely creamy roes when I prepare the fish in my kitchen. The best eating roe I think comes from the male fish, which are known as 'milts' and are very creamy in texture, while the female roe as you'd expect, has the texture of very fine eggs. My wife disagrees with me as she enjoys the female roe, so it is just a matter of personal taste.

Apart from this very simple lunch recipe, roes can also be served on toast which has been spread thickly with salted anchovy butter, or they can even be coated in breadcrumbs and fried until crisp and served with a wonderful piquant tartare sauce. My grandmother would often cook this dish for me and I would enjoy wonderful conversations with her about cooking while enjoying the herring roes and a pot of tea.

Place the flour in a shallow dish and season with salt and pepper. Lightly dust the roes with the seasoned flour, shaking off any excess.

Melt half the butter in a frying pan large enough to hold the roes. When the butter starts to bubble, add the roes and cook gently for about 4 minutes until they start turning golden. Turn them over carefully with a spoon and break up the remaining butter in the pan. Turn the heat up slightly and, as the butter starts to bubble, baste the roes with the butter. After a few minutes, add the parsley, capers, shrimp and lastly a squeeze of lemon. Spoon the roes on to hot toast, making sure that the bread soaks up any spare butter that may be in the pan.

yellowtail kingfish _Seriola lalandi_

Packed with fish oils, yellowtail kingfish is a great choice for those of us interested in good health. They are voracious carnivores with sleek, solid, torpedo-shaped bodies built for speed. Their tremendous power makes them hugely popular with game anglers who enjoy the fight they put up, with the possible outcome of a tasty supper if the angler wins!

Kingfish are handsome beasts with dark blue-green backs, a silvery belly, a yellow 'go faster' stripe running down the length of their body and distinctive yellow tail fins. They can grow up to 2.4 m/8 ft and weigh around 65 kg/143 lb, although a more normal size is around 100–180 cm/39–71 inches. Yellowtail kingfish inhabit inshore waters either in small groups or as lone fish haunting rocky shores, reefs and jetties, where they often circle other schools of fish looking for stragglers or chase bait fish to the surface, where the sea boils with their feeding frenzy. Increasingly efficient traps saw wild stocks fall over the last 50 years until catches became small and unpredictable. Fortunately, with its rapacious appetite and penchant for eating local species, kingfish are ideal for farming in Australian waters and have become one of the great aquaculture success stories over the last decade.

Kingfish are particularly good when eaten raw, the Japanese call it _hiramasa_ or _buri_ depending on size, and winter kingfish with its high fat content, especially on the belly flap, is highly regarded by sashimi connoisseurs.

Taste description

Very high in omega-3 oils and wonderfully soft and oily, it has a better flavour when eaten raw.

Territory

Yellowtail kingfish are found in the cool temperate waters of the Pacific and Indian Oceans off South Africa, Japan, southern Australia and the USA.

Environmental issues

Stocks plummeted at the end of the 20th century due to increasingly efficient traps and catching methods.

Now commercially raised kingfish have taken the pressure off wild stocks. There is also a bag limit for recreational anglers wanting to catch them. They are sometimes caught in the snapper hand-line fishery and also caught using surface or sub-surface traps, trolling, bottom-set long lines, poling and bottom-set traps, hand lines, drop lines, long lines and bottom-set gill nets.

Farming the fish

The company Clean Seas Aquaculture, based in Port Lincoln in South Australia, are champions of farming yellowtail kingfish. They had wanted to master the art of propagating a pelagic species of fish from eggs produced in a hatchery, with the idea of using this knowledge to breed the highly prized southern bluefin tuna in captivity. So, they started this experiment with yellowtail kingfish, which became a commercial success in its own right within a few years.

Marcus Stehr is Managing Director of Clean Seas Aquaculture: "We've been successfully breeding and spawning yellowtail kingfish over the last five years. It takes 50 days to get them from an egg to a 5 g/⅛ oz fingerling, once the fish are around 5–7 g/⅛–¼ oz, we use a helicopter to transfer them from the hatchery to sea cages in both Arno Bay and further up the Spencer Gulf at Fitzgerald Bay some 150 km/93 miles north, where they take a further 15 months to grow into 4 kg/8 lb 13 oz fish. Our ultimate long-term objective is to replicate this same process in captivity with the southern bluefin tuna."

Chef Neil Perry, of Sydney's famous seafood restaurant Rockpool Fish, is a huge fan: "I have yet to try a farmed fish that eats as well as the yellowtail kingfish from South Australia," he says.

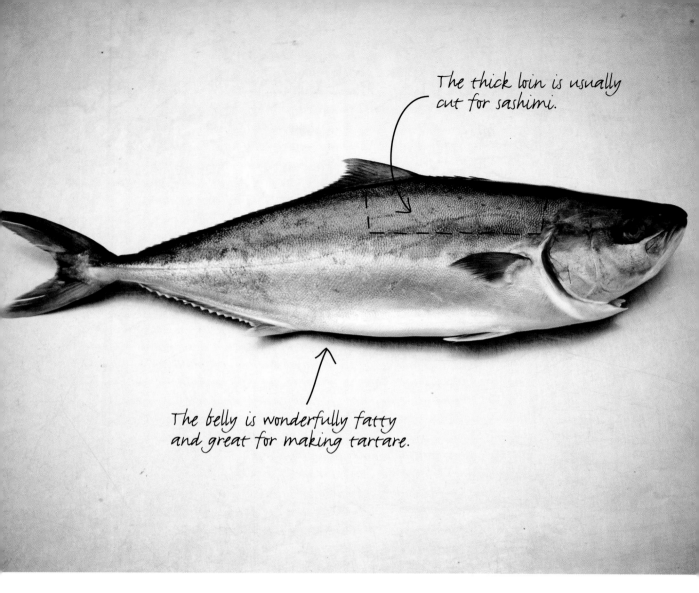

The thick loin is usually cut for sashimi.

The belly is wonderfully fatty and great for making tartare.

Territory	Local Name
UK/Australia/	
New Zealand	*Yellowtail kingfish, Northern kingfish*
USA	*Amberjack, Yellowtail*
Greece	*Magiatiko*
France	*Seriole*
Italy	*Ricciola*
Germany	*Gelbschwanz*
Spain	*Pez de limon, Medregal*
Holland	*Makreel*
Japan	*Buri*
Portugal	*Charuteiro*

Health

Kingfish is a very good source of omega-3 oils.
Per 100 g/4oz: 309 kcals, 7.8 g fat

Seasonality

This fish is best from January to May. The higher fat content of fish caught in winter (towards May in the southern hemisphere) makes excellent sashimi.

Yield

1 kg/2¼ lb weight of kingfish yields 75% edible steak.
1 kg/2¼ lb weight of kingfish yields 60% edible fillet.

kingfish tartare

Serves 4 as a starter

200 g/7 oz kingfish, finely chopped
2 shallots, finely chopped
75 g/3 oz gherkins, finely chopped
50 g/2 oz/½ cup capers, finely chopped
1 tbsp fresh parsley, finely chopped
Sea salt and freshly ground black pepper
Squeeze of lemon, to taste

AT THE FISHMONGER
Ask your fishmonger for either
a tail piece or a fillet from the
middle of the fish. Make sure all
the bones and skin are removed.

Oily fish like kingfish and mackerel are wonderful for a fish tartare, and capers, gherkins, and shallots work amazingly well with the lovely soft fish oils. Make sure your fish are really fresh for this dish.

Simply mix the fish together with the shallots, gherkins, capers and parsley in a large bowl. Season with salt and pepper, then add a squeeze of lemon to taste and serve immediately on individual serving plates with crisp lettuce leaves.

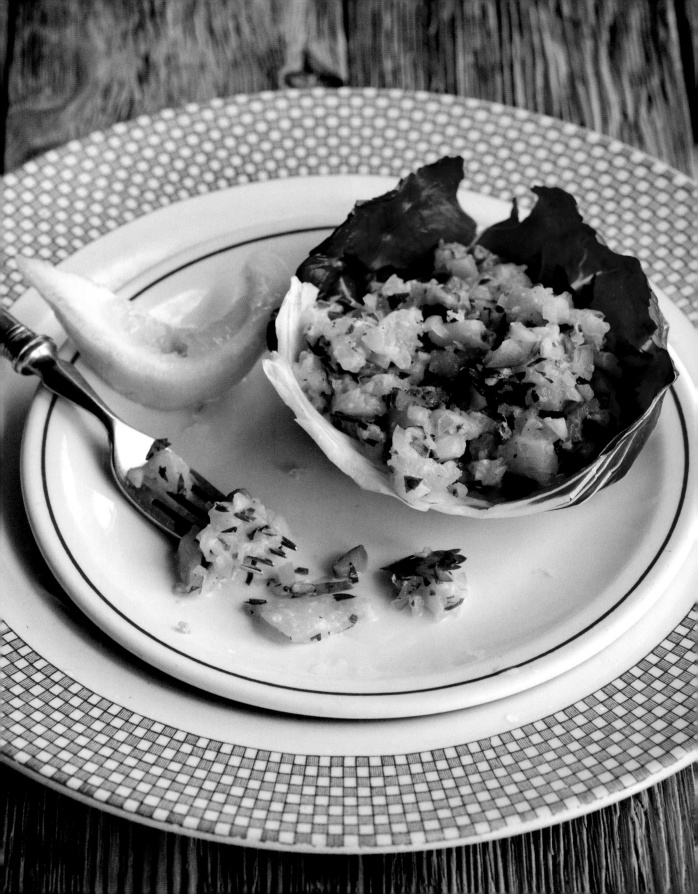

mackerel *Scomber scombrus*

Plentiful, cheap, fabulous to eat and good for you … surely too good to be true? The mackerel is quite a star and a fish that takes to barbecuing, poaching, baking and grilling, works well with strong flavours and stands up alone with nothing but a squeeze of lemon juice.

It's a very ritzy-looking fish with its metallic green-blue sheen scattered with a mass of black scribbles or bars on its back, pale green flanks and scales that sparkle with a myriad hues. A member of the *Scombridae* family, the mackerel typifies the fast swimming predators such as tuna and bonito that also belong to this group. Its tapered body is streamlined from tip to tail, its small fins fold into grooves to reduce drag, and even the eyes sockets are flush to the head. Everything is designed to achieve maximum speed, which they use to great effect by hunting shallow coastal waters during the summer for young fry. All this greed results in a fish that can reach up to 70 cm/27½ inches, living for more than 20 years if it dodges nets and lines.

Mackerel are sexually mature by 3 years old, when they spawn in the sea's warmer upper layers from March to July. The voracious youngsters pile on the weight at an incredible speed, reaching 22 cm/8½ inches after just 1 year and 30 cm/12 inches after 2 years. During the winter, mackerel move to deeper water, going into a state of near hibernation, fasting and waiting for the spring.

Mackerel are exceptionally perishable, so eat them really fresh. Since the 17th century, special laws in the UK permitted mackerel to be sold before and after divine service on a Sunday. This act has never been repealed, but changes in Sunday trading in the 21st century mean that mackerel has lost its sabbatical advantage.

Taste description

Mackerel is a fish that particularly repays being eaten very fresh before its high oil content starts to spoil. Its aroma is light and oceanic, reminiscent of fine green seaweed, and its predominantly pink flesh is succulent, with discrete flakes that are almost chicken-like in texture. Although there's a high level of oil, it's balanced by generous amounts of juice, which helps disperse it in the mouth. The flavour is delicate with a low-key pleasant mineral-like taste.

(continues on page 216)

Territory	Local Name
UK	*Atlantic mackerel*
USA	*Atlantic mackerel*
Greece	*Scoumbri*
France	*Macquereau*
Italy	*Maccarello, Sgombro*
Germany	*Makrele*
Spain	*Caballa*
Holland	*Makreel*
Portugal	*Sarda, Cavala*
Denmark	*Makrel*
Sweden	*Mackrill*
Norway	*Makrell*

Health

Mackerel is a very good source of omega-3.
Per 100 g/4 oz: 220 kcals, 16 g fat

Seasonality

Avoid mackerel during its breeding season from March to July. It is at its very best towards the end of summer and into autumn.

Yield

1 kg/2¼ lb weight of mackerel yields 50% edible fillet.

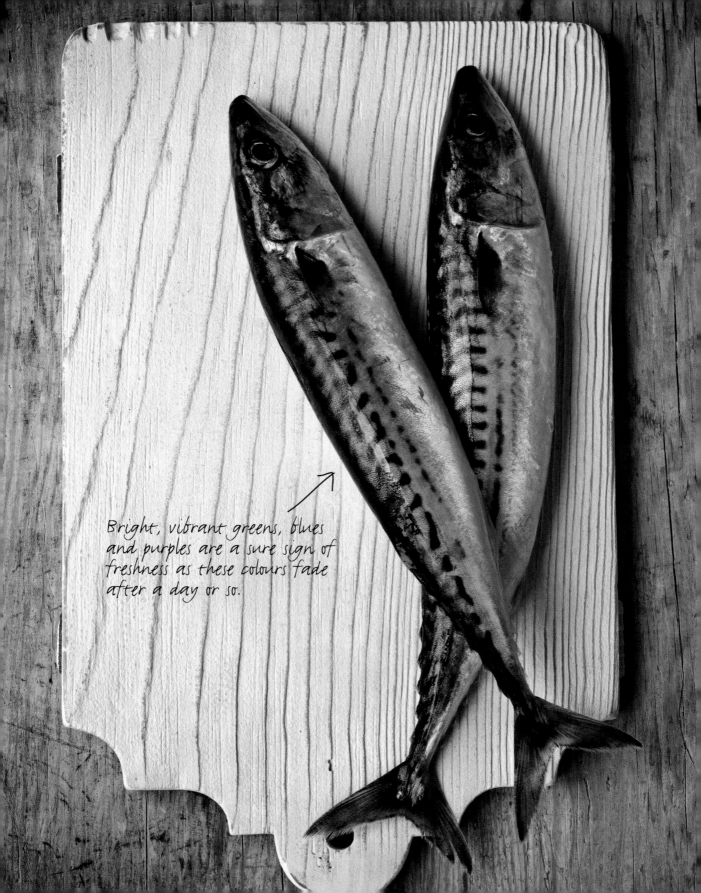

Bright, vibrant greens, blues
and purples are a sure sign of
freshness as these colours fade
after a day or so.

Territory

Mackerel have an extensive range from the Mediterranean to Iceland and throughout the Atlantic Ocean.

Environmental issues

Mackerel don't take kindly to rough handling, so increase the quality of your fish and help with sustainability by choosing line- or net-caught fish from fisheries certified by the Marine Stewardship Council (MSC).

The Southwest handliners

Located off the southwest coast of England, from Start Point to Hartland Point, is an area known as the 'Southwest Mackerel Box', where only handliners are permitted to target mackerel. The area was set up to protect the juvenile mackerel, as the area is a well-known nursery, and is widely held to be a success in contributing to the good existing stock levels.

The handline method uses either braided twine or strong nylon lines to which hooks are attached. Coloured plastic or feathers are attached to these hooks to attract fish and the line is weighted with lead. Each handline has 25–30 hooks. Fishermen are not permitted to catch fish below the minimum landing size of 20 cm/8 inches.

The handline mackerel fishery was one of the first in the world to go for Marine Stewardship Council (MSC) certification, and had its first MSC certification in 1997, so it was well ahead of the game. It was an easy fishery to certify – 100 boats spread over the southwest region fishing with hook and line, 20–30 hooks per man, jigging up and down. They've been fishing that way for 50 or 60 years. The annual mackerel catch for the whole country is about 180 thousand tonnes; the handliners catch 2,000 tonnes, so it's scratching the surface, yet it provides jobs for hundreds.

Brendan May, Chief Executive of the MSC, said at the time of certification: "These community-based fisherman care about the marine environment and are willing to stand up to independent scrutiny. We hope that market forces will demonstrate to other fishermen targeting the stock, that there is commercial advantage and distinction between mackerel from this handline fishery – which will now be discernible to consumers."

roasted mackerel with North African spices

Serves 4

3 tbsp ground cumin or whole
 cumin seeds
2 tsp ground coriander or whole
 coriander seeds
6 large garlic cloves
1 large bunch of fresh coriander
1 large bunch of fresh parsley
Small handful of fresh mint, chopped
300 ml/10 fl oz/1¼ cups olive oil
1 tbsp paprika
Good pinch of cayenne pepper
Juice of 2 lemons
Sea salt
4 mackerel, about 300 g/10 oz each

To serve:
Lime juice (optional)
Squeeze of lemon

AT THE FISHMONGER
Ask your fishmonger to gut the
fish, clean thoroughly and remove
the heads.

Oily fish just love big, bold flavours and this mix of fresh spices and herbs are typical of the flavours of Morocco. This particular mix is called *chermoula* and forms the base of many dishes. It's worth making up a quantity in the summer and storing it in a kilner or jam jar, as it's so versatile; rub it onto a nice slice of fresh swordfish before grilling over a fire — it's fantastic!

For maximum flavour, use whole cumin and coriander seeds and roast them yourself in a dry frying pan to get the natural aromas and oils really going, then grind to a fine paste in a mortar and pestle or spice grinder.

Place the garlic and herbs in a food processor and blend until smooth, adding a little of the olive oil if it is too thick. Scrape out into a bowl and add the paprika, cayenne, ground coriander and cumin and the rest of the olive oil, and mix until you have a paste. Add the lemon juice and salt to taste.

Make 2 or 3 slashes down the side of the mackerel and rub the spice mixture in well, making sure it gets right inside the slashes. Place the fish in a shallow dish or on a large plate, cover and leave to marinate in the refrigerator for about 1 hour.

Preheat the oven to 220°C/425°F/Gas Mark 7.

Roast the fish in the oven for 8–10 minutes until cooked.

The mackerel can be dressed with lime juice before serving. Serve with a good squeeze of lemon and a green salad with plenty of sliced red onion in it.

poached mackerel salad with horseradish dressing

Serves 4

4 mackerel, about 300 g/10 oz each
 when whole

For poaching:

2 bay leaves

1 tbsp peppercorns

100 ml/3 fl oz/generous ⅓ cup red
 wine vinegar

1 fresh thyme sprig

125 ml/4 fl oz/½ cup dry white wine

1 small onion, sliced

For the salad:

4 lettuce hearts or little gems

2 small red onions, finely sliced

250 g/9 oz ripe cherry tomatoes, halved

8 salted anchovy fillets

1 tbsp capers

For the dressing:

1 tsp Dijon mustard

50 ml/2 fl oz/¼ cup white wine vinegar

150 ml/5 fl oz/⅔ cup vegetable oil

1 tbsp crème fraîche

1 tbsp fresh tarragon, finely chopped

1 tbsp horseradish

Sea salt and freshly ground black pepper

AT THE FISHMONGER
Ask your fishmonger to gut the
fish, clean thoroughly and remove
the heads.

Mackerel is a fish that everyone is familiar with – so many people have a story of an encounter with mackerel, whether it be eating it or catching it. I recall one summer waking up to the water 'boiling' in front of our house where huge mackerel shoals had chased the sprats inshore to the harbour; there were fish jumping everywhere as the poor sprats were cornered. My friend Noel and I often wait in the harbour during the summer months drinking a few cold beers and waiting for the mackerel to come in on the evening's rising tide. A bag can be filled in about half an hour. I love it – a fresh grilled fish for supper and soused and smoked mackerel in the refrigerator for the next few days.

This quick uncomplicated salad is lovely for the summer, it's so easy to prepare and mackerel is just wonderfully moist when poached. Sliced red onions, sweet lettuce hearts and a creamy horseradish dressing are a great combination.

Make sure the mackerel are thoroughly cleaned, then mix together all the ingredients for the poaching liquor in a large pan and bring to the boil. Place the mackerel into the liquid, turn off the heat and leave to cool for 40 minutes.

Remove the fish from the pan and carefully peel off the skin. Using your hands, remove the 2 fillets from the fish. You will be able to feel small bones called pin-bones in the fillets near the head end, remove these and leave the fish in nice big chunks.

To make the salad, cut the lettuce hearts into quarters then eighths through the root and arrange in a salad bowl. Liberally sprinkle over the onions, tomatoes, anchovies, capers and the chunks of lovely mackerel.

To make the dressing, place the mustard and vinegar together in a bowl and while whisking them together slowly add a small stream of vegetable oil until you have a thick emulsion. While whisking, add the crème fraîche, tarragon and horseradish until you have a creamy dressing that can be easily poured. Season with salt and pepper and drizzle over the salad. Serve the rest in a sauceboat next to the salad.

grilled mackerel skewers with teriyaki and spring onions

Serves 4

4 mackerel, about 300 g/10 oz each
 before preparation
12 spring onions, trimmed
Small handful of fresh coriander,
 chopped

For the marinade:
6 tbsp light soy sauce
3 tbsp mirin
3 tbsp sake
2 tbsp caster sugar
25 g/1 oz very finely grated fresh
 root ginger

For the sauce:
4 tbsp light soy sauce
2 tbsp sake
2 tbsp mirin

AT THE FISHMONGER
Ask your fishmonger to fillet the
fish and remove the pin-bones.

These fabulous little skewers are perfect for the barbecue or cooked under a grill. You can even make them up at home then take them to the beach or park and grill over a disposable or other portable barbecue.

Teriyaki is a popular Japanese marinade that's used with meat and fish, particularly oily fish, as it gives it a wonderfully sticky, sweet glaze. It is very versatile. I have baked sole fillets and cod in parcels with a splash of teriyaki. I also think it is wonderful brushed on lobsters and large prawns.

Soak 8 wooden skewers in a bowl of cold water for 30 minutes before using to prevent them burning during cooking.

Cut each mackerel fillet into 3 chunks across each fillet. Cut the spring onions into the same length as the pieces of fish.

Push a wooden skewer through the end of a piece of spring onion then push another skewer through the other end so you have a rugby post shape. Thread the mackerel fillets through at either end with the skin side facing you and push onto the skewers. Thread on another piece of spring onion, then another piece of fish, until there are 3 pieces of mackerel and 3 pieces of spring onion on each pair of skewers. Lay the skewers in a large ceramic dish or plastic container.

Mix all the marinade ingredients together and pour over the fish. Cover and leave to marinate in the refrigerator or a cool place for 2 hours.

Preheat the grill to its highest setting or light a barbecue.

Remove the fish from the marinade, reserving the marinade and lay the skewers on a baking sheet. When the grill is hot or the barbecue is ready, grill the fish for 4–5 minutes until the skin is starting to blister, brushing the fish with the remaining marinade during cooking. Set aside.

To make the sauce, mix all the sauce ingredients together and spoon a little over each skewer before serving. Sprinkle over the coriander and serve.

This is delicious with a salad of sliced onion, chestnut mushrooms, sesame seeds and beansprouts dressed with a little pouring sauce and lime juice.

mackerel tagine

Serves 2

2–3 tsp olive oil

2.5 cm/1 inch piece fresh root ginger, chopped

½ red pepper, chopped

4 cherry tomatoes, chopped

2 garlic cloves, chopped

1 onion, chopped

1 mackerel, about 350 g/12 oz, gutted and chopped into 5 cm/2 inch chunks (small fish can be left whole)

Sea salt

Handful of fresh coriander, finely chopped

40 g/1¼ oz/¼ cup black olives

Squeeze of lemon, to taste

For the spice mix:

1 tbsp ground allspice

1½ tbsp ground coriander

2 tbsp paprika

1 tbsp turmeric

2 tsp ground cassia

1 tsp ground cardamom

1 tsp chilli flakes

A day at the beach can be extra special if you take a fishing rod, a barbecue or portable stove and some basic ingredients. Catch your own fish, make this delicious tagine and watch the sun go down.

Mix all the ingredients for the spice mixture together and store in an airtight jar.

Heat the olive oil in a large frying pan, add the ginger, peppers, tomatoes, garlic and onion and fry gently for 4–5 minutes, then add 1 teaspoon of your spice mixture. Add the chunks of mackerel, cover with water and leave to simmer for 7–8 minutes.

Before serving, season with plenty of salt, then add the coriander, olives and a squeeze of lemon juice to taste.

A few hours' fishing are good for the soul, and catching your own fish invokes a celebration!

Just being on the water and around the coast is a wonderful experience.

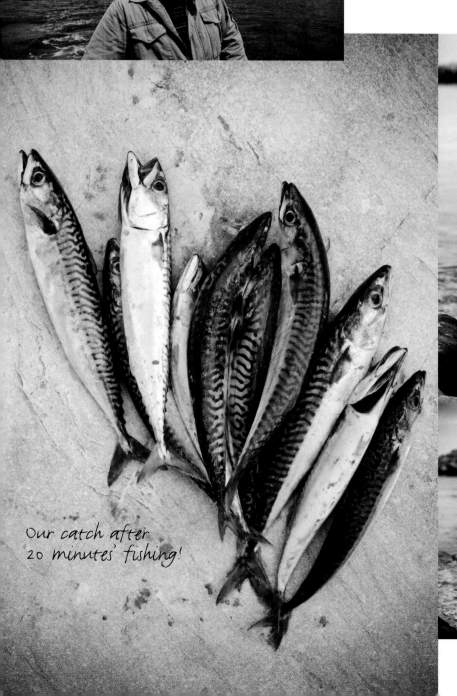

Our catch after 20 minutes' fishing!

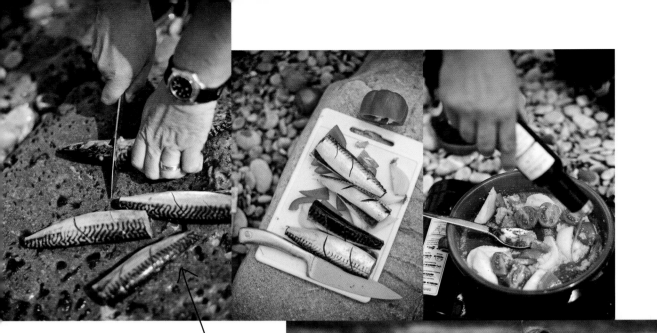

Make some cuts in the flesh and rub with a few spices.

A simple camping stove is all you need – your knives and ingredients will fit into a small plastic box.

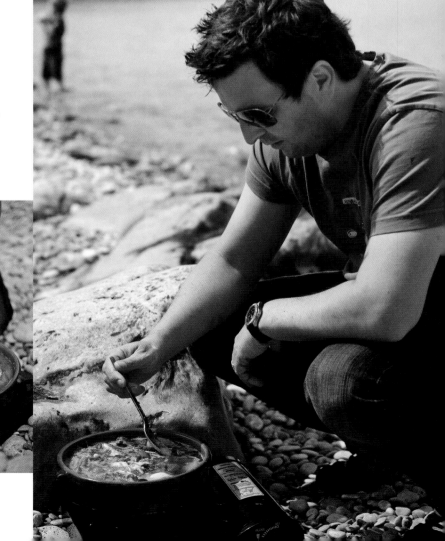

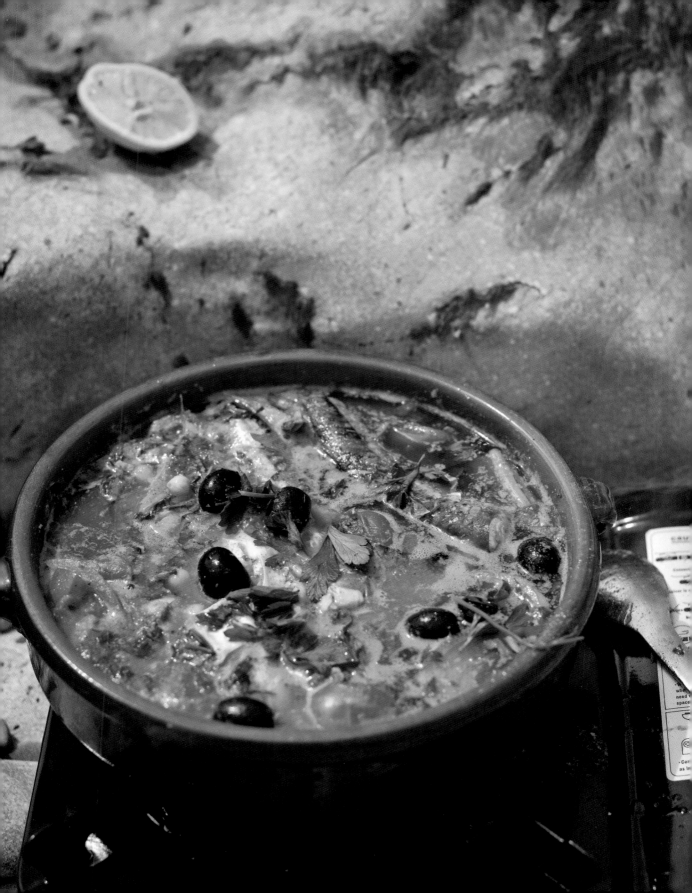

salmon _Salmo salar_

Atlantic salmon is one of the most popular species for eating, probably in part due to the fact that it farms so well. These fish are extraordinary as they are able to return to the river where they were born with pinpoint accuracy years after they went to sea, and it's believed that a number of navigation aids including the stars, differences in the earth's magnetic field and ocean currents guide them. Once they get close to the coast, salmon literally smell their way home, guided by a chemical memory of what their river smelt and tasted like.

Life for an Atlantic salmon starts some time in November or December in the shallows of a fast-flowing river or stream. The eggs are deposited in a shallow excavation called a redd, they are fertilized by the male, then covered with gravel. In the spring the eggs hatch, and after 1–4 years the young salmon migrate downstream where their bodies become more elongated and silvery and they turn into smolts, which then head off to the deep ocean, where they feed on protein-rich food like herring, sand eels, sprats and prawns. Salmon stay at sea from 1–4 years, becoming bigger and bigger, and some reach over 30 kg/66 lb before returning back to the river where they were born to spawn the next generation and the cycle starts all over again.

Taste description
Wild salmon
There's no mistaking Atlantic salmon's unique flavour – rich, savoury/sweet but clean, its high oil content giving it a rich, satisfying, juicy mouth feel and a skin that crisps nicely when pan-fried. The aroma carries piquant notes of orange peel, something that is coincidentally mirrored in the warm colour of the flesh. Separating easily, the discrete, curved flakes have a luscious, silky quality towards their centre; this high moisture content is most apparent when the fish is cooked through, which causes the fat membrane that separates each flake to melt back into the flesh. The flakes break down easily in the mouth and the oil disperses quite quickly to a leave a drier-textured flake.

Organic farmed salmon
Strikingly bright apricot in colour, the flesh of organic salmon has a dense, compact texture, with an initial juiciness that gives way to a pleasantly crumbly mouth feel. The aroma has an earthy intensity, like fallen autumn leaves, and the flavour is similarly autumnal in nature, with rounded mellow notes of chestnuts balanced by some mild, orange-peel acidity.

(continues on page 228)

Territory	Local Name
UK/USA	_Salmon_
France	_Saumon_
Spain	_Salmón_
Portugal	_Salmào_
Sweden	_Lax_
Denmark/	
Norway	_Laks_
Holland	_Zalm_
Germany	_Lachs_

Health
Salmon are a good source of omega-3 oils.
Per 100 g/4 oz: 180 kcals, 11 g fat

Seasonality
Avoid Atlantic salmon during their spawning season from November to December and just after.

Yield
1 kg/2¼ lb weight of salmon yields 55% edible fillet.

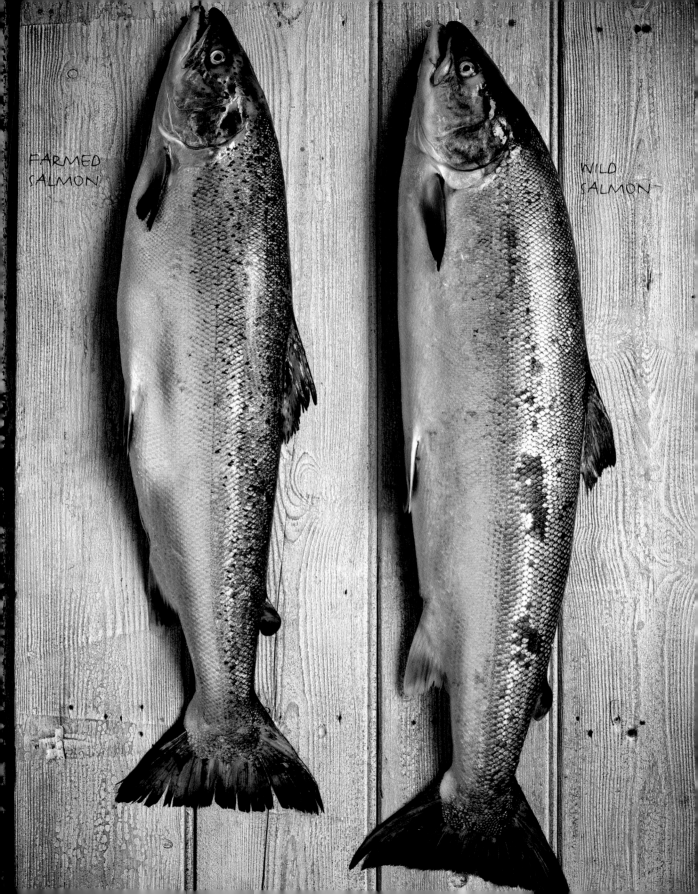

Territory

Atlantic salmon are found in varying quantities in the following countries: Canada, Denmark, England and Wales, Faroes, Finland, France, Greenland, Iceland, Ireland, Norway, Poland, Portugal, Russia, Scotland, Spain, Sweden, and the United States. There are no salmon in the Mediterranean Sea.

Environmental issues

Industrial impacts such as pollution, physical barriers to migration, netting, physical degradation of spawning and nursery habitat, and increased marine mortality has meant that populations of wild Atlantic salmon have declined by 67% in the past 30 years. Salmon farming, once seen as the solution for cheaper fish, has had its own issues over the years, and in turn has affected the wild stocks by infecting them with sea lice. Though conditions have improved with better siting of salmon cages, and there are now RSPCA-monitored farms and Soil Association-certified organic salmon farms, one still can't get away from the fact that it takes 3 kg/6 lb of wild caught fish to produce 1 kg/2¼ lb of edible salmon, and 12 kg/26 lb of fish to produce 1 kg/2¼ lb of fish oil. Both are crucial in the diet of a farmed salmon. You can always try its tasty cousin the Pacific salmon, of which there are 6 species: pink, chum, chinook, coho, sockeye and masou.

"People have gone through a huge learning process with salmon farming. It's getting better all the time as the science has helped to improve how we raise the fish and reduce the impact on the environment. We can certainly manage our wild fisheries better, but to meet world demand you're going to have to have a lot more farmed fish, which is why we are seeing farmed species like tilapia, bream and bass coming onto the market. There is a huge variation in quality in farmed fish – the same could be said for a piece of beef."

Wynne Griffiths,
former CEO of Young's and fishmonger

grilled salmon with spiced new potato salad

Serves 4

700 g/1½ lb new potatoes

Sea salt and freshly ground black pepper

3 tsp cracked coriander seeds

3 tsp sesame seeds

1 tsp cracked black peppercorns

3–4 tbsp olive oil, plus extra for oiling
 and brushing

1 tsp ground turmeric

1 tsp ground cumin

1 tsp sweet paprika

150 g/5 oz/⅔ cup plain yoghurt

3–4 tbsp water

Small handful of fresh mint, finely
 chopped

Squeeze of lemon, to taste

4 pieces of salmon fillet, about
 180 g/6½ oz each

To serve:

Lemon wedges

AT THE FISHMONGER
I prefer a cut of salmon from the middle of the fish. The further towards the head you go, the fattier the cut will become, as most of the fat is in the salmon's belly. However, if you prefer your fish oily, then ask for a cut from the thicker end of the fillet.

Salmon has become one of our most popular fish; it is readily available and farms well. It is quite oily and works brilliantly with spices as well as fairly strong flavours like capers, onions, peppery watercress, lemon and chilli. This new potato salad uses plenty of spices and would be great eaten with mackerel, sardines and indeed tuna. Use a mortar and pestle to crack or lightly crush the coriander seeds and peppercorns.

First, make the salad. Cook the potatoes in a pan of boiling salted water until softened, then drain and leave to cool. When they are cool, cut them in half and set aside.

Toast the coriander seeds, sesame seeds and peppercorns in a small dry frying pan, shaking it all the time to allow the spices to lightly toast and release their aroma. Set aside.

Heat the olive oil in another pan and add the turmeric, cumin and paprika, a good pinch of salt, the potatoes and the roasted spices. Give the pan a good mix, being careful not to break up the potatoes but making sure they are really well coated in the spices. Remove from the pan and place in a serving dish.

To make a dressing for the potatoes, mix the yoghurt, water, a good handful of finely chopped mint and a squeeze of lemon together until it is the consistency of double cream. Set some aside and spoon the rest of the dressing over the potatoes.

Preheat the grill to high and lightly oil a large baking sheet.

Place the salmon on the prepared baking sheet, season with a little salt and pepper, brush with olive oil and cook under the grill for 6–7 minutes.

Serve the salmon on individual serving plates with just a little more of the yoghurt dressing spooned over the fish, accompanied by a lemon wedge and the potato salad.

grilled salmon with watercress, capers and mint

Serves 2

2 x 200 g/7 oz salmon fillets
Melted butter, for brushing

For the sauce:
1 tbsp capers
Small handful of fresh mint,
 finely chopped
Small handful of watercress leaves
100 g/4 oz/½ cup crème fraîche
Finely grated zest of 1 lemon
Sea salt and freshly ground black pepper

AT THE FISHMONGER
Ask your fishmonger for a cut
from a salmon fillet from the
middle of the fish. If you like your
salmon more oily, ask for pieces cut
from the head end of the fillet.

Farmed salmon is a staple these days, and I accept that aquaculture is a firm part of our future if we are to feed our growing population. This is an excellent recipe, especially with the larger, fattier salmon you can buy, as the crème fraîche, lemon and the freshness of the mint cut through those lovely fish oils.

Preheat the grill to its highest setting.

Brush the salmon with melted butter and cook under the grill for 5–6 minutes.

Meanwhile, make the sauce. Place the capers, mint and watercress in a food processor and pulse until smooth, then simply mix into the crème fraîche with the lemon zest. Season with salt and plenty of pepper and serve alongside the hot grilled fish – delicious.

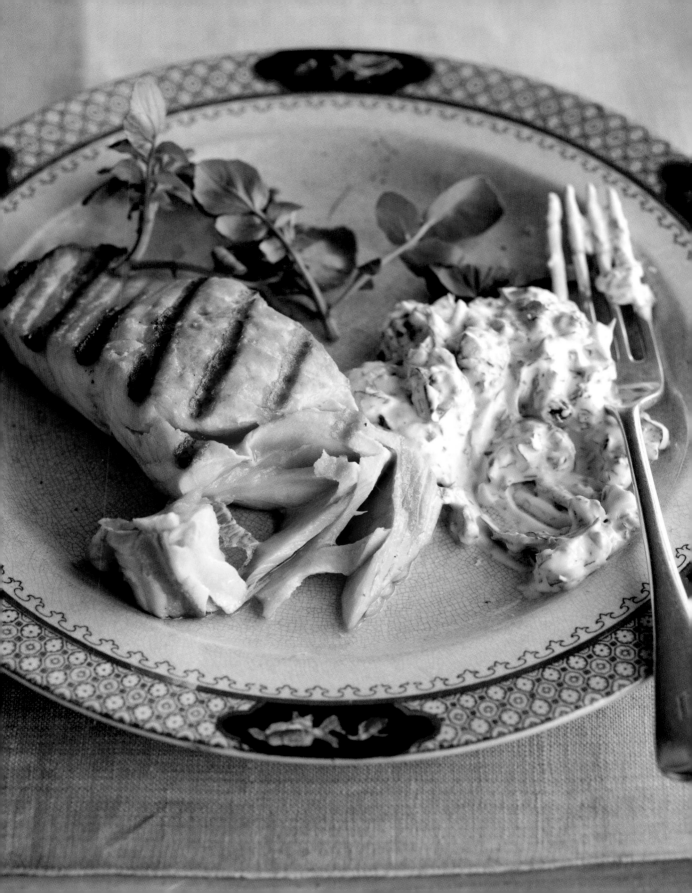

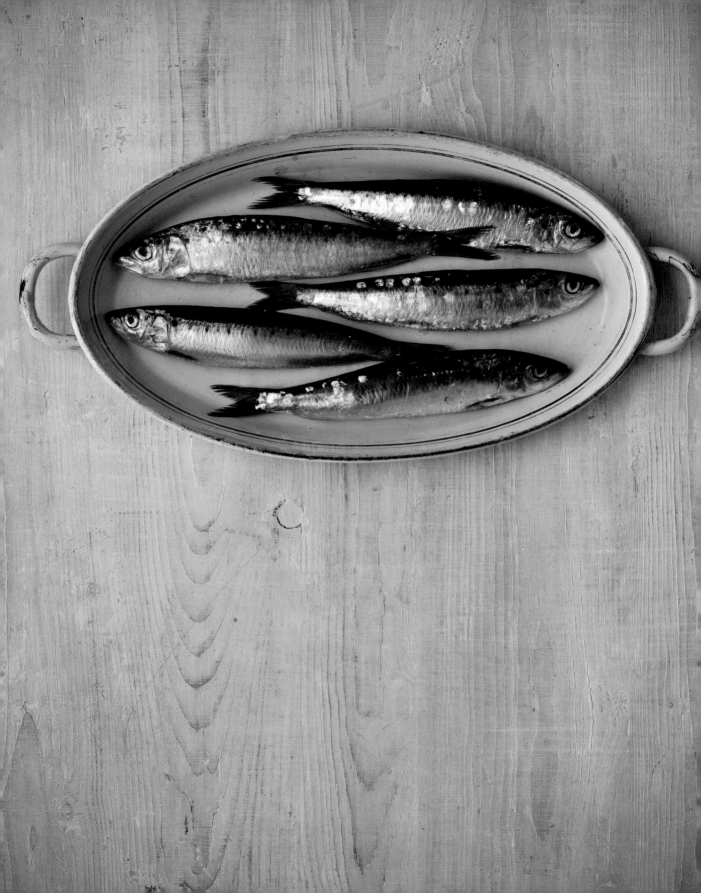

sardine *Sardina pilchardus*

This fish always makes me think of the summer. A juicy sardine sizzling on the barbecue, with a few herbs thrown in to add to the wonderful aromatic smell, is perfect just scooped up and served with crisp lettuce leaves, some sea salt, a good squeeze of lemon and plenty of sunshine.

Sardines are a pelagic shoaling member of the *Clupeoid* family, which includes herrings and sprats. It has a silvery body with a greenish back and two spots on each side near the head. Sardines grow slower and live longer in more northerly waters – the maximum length it can reach is 25 cm/10 inches and it can live to 15 years old. When sardines are 2 years old and over 15 cm/6 inches they are no longer a sardine but a pilchard.

Sardines prefer to feed at night, nervously nibbling on planktonic crustaceans. They spawn in spring and summer in the open sea or near the coast, after which they migrate northwards to their feeding grounds. They are often found inshore in coastal waters, and in winter they migrate southwards. A moment of panic can turn these sardine schools into the bait balls you see on wildlife programmes. Off the coast of South Africa the annual sardine run in June and July is followed by a plethora of sea birds, sharks, dolphins, fish and fishermen.

Taste description
Despite their very high oil content, much of which is held in the skin, sardines don't give an overly slick mouth feel – most of the oil is released on the first bite, dissipating quickly to leave a pleasantly dry, crumbly texture. The aroma has a cool metallic note, as well as a suggestion of aubergine. This is carried through in the flesh, which has an intense sesame nuttiness (the result of all that oil) along with a smoky aubergine note, reminiscent of Middle Eastern dishes such as *baba ganoush*. The flesh can be light or dark and, although plenty of small bones are distributed throughout, they are filament-thin so are scarcely noticeable when eaten.

Territory
Sardines are widely distributed in European seas, reaching the northward limit of its range in the vicinity of the British Isles on the southern coasts of England and Ireland, in the northeast Atlantic: Iceland (rare) and North Sea, southward to Bay de Gorée, Senegal. They are also common in the western part of the Mediterranean and Adriatic Seas, as well as in the Sea of Marmara and the Black Sea.

Environmental issues
The good news is that pilchard or sardine numbers are at healthy levels and are caught in coastal waters off southwest England using traditional drift or ring nets.

Territory	Local Name
UK/USA/	
France/Germany	*Sardine*
Italy/Spain	*Sardella, Sardina*
Portugal	*Sardina, Sardinopa*
Greece	*Sardélla*
Holland	*Pelser, Sardien*
Sweden	*Sardiner*
Norway/	
Denmark	*Sardin*

Health
Sardines are a very good source of omega-3 and -6 oils.
Per 100 g/4 oz: 165 kcals, 9.2 g fat

Seasonality
Sardines are found globally so are available year round, but ought to be eaten as fresh as possible (July–November in the UK).

Yield
1 kg/2¼ lb weight of sardine yields 50% edible fillet.

grilled sardine, walnut and olive salad

Serves 2

6 sardines, filleted
200 ml/7 fl oz/scant 1 cup olive oil,
 plus extra for brushing
1 tbsp dried oregano
1 egg yolk
½ garlic clove, peeled
1 tsp Dijon mustard
Good splash of white wine vinegar
1 anchovy fillet
Splash of water
Sea salt and freshly ground black pepper
Worcestershire sauce, to taste (optional)

For the salad:

1 red onion, finely sliced
6 ripe tomatoes
10 black or green olives
1 round lettuce
Good pinch of dried oregano
1 cucumber, halved and deseeded
Small handful walnuts

AT THE FISHMONGER
Look for sardines that have hues
of gun-metal green and purple on
their backs and avoid any with
red heads or split bellies. Larger
sardines, which have become
pilchards, will not be as oily as
the smaller fish.

Rich, oily sardines are wonderful combined with crisp salad ingredients. I particularly like the flavour of the walnuts with this fish and the olives have a distinct saltiness that seems to bring the whole dish together. This is definitely one I recommend you try.

Heat a stovetop grill pan until hot or a traditional grill to its highest setting.

Brush the sardines with olive oil and rub over some of the oregano, then grill skin side down for 4–5 minutes until crisp and cooked.

Meanwhile, make the dressing. Place the egg yolk in a small food processor with the garlic, the rest of the oregano, mustard, vinegar and anchovy fillet and blitz briefly. With the motor running, gradually add the olive oil until the mixture is thickened, then loosen with a splash of water until it is a pouring consistency. Taste the dressing and season with salt and pepper and Worcestershire sauce, if you like.

Simply mix all the salad ingredients together, then season with salt and toss with the dressing. Lay the sardines on top of the salad or break up and toss through, then serve.

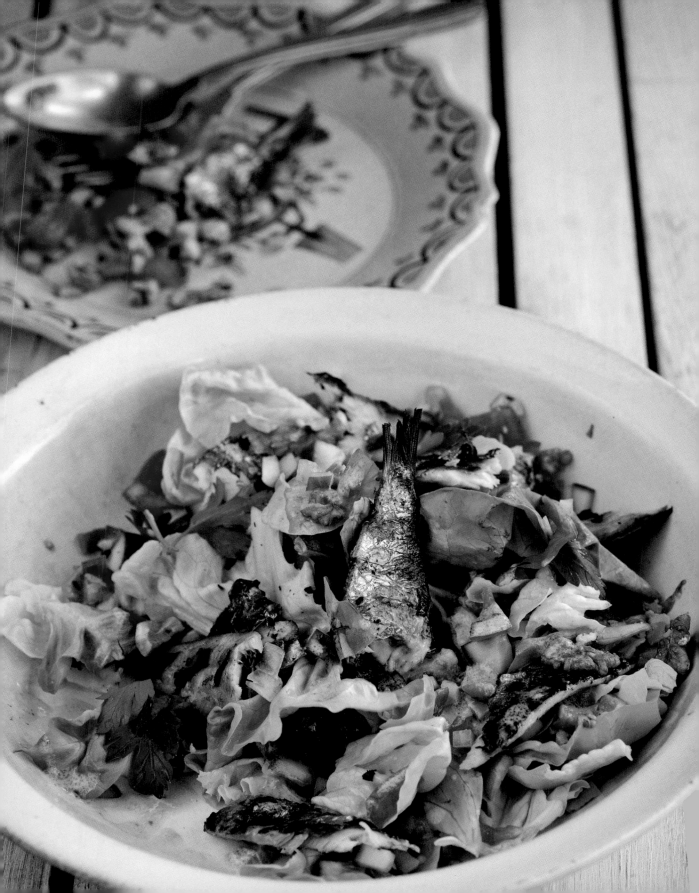

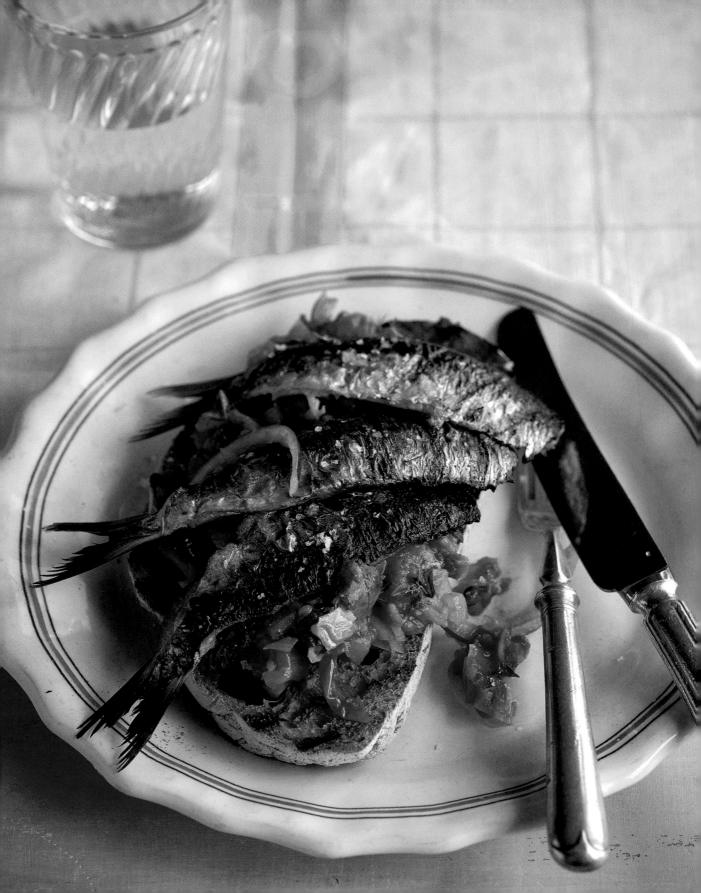

sardines on toast

Serves 4

2–3 sardines per person,
 about 250 g/9 oz each,
 or 2 x 125 g/4½ oz cans sardines

For the sauce:
1 onion, chopped
2–3 garlic cloves, chopped
3 tbsp olive oil
Pinch of saffron strands
Splash of white wine
Small handful of fresh parsley, chopped
6 ripe tomatoes, or 1 x 400 g/14 oz can
 good Italian plum tomatoes
Small handful of fresh fennel herb,
 chopped
Small handful of fresh basil, chopped
Sea salt and freshly ground black pepper

To serve:
Sourdough bread, toasted

AT THE FISHMONGER
Ask your fishmonger to scale and
fillet the fish, removing any pin-
bones from the larger fish.

What I love about this dish is that something so simple can be absolutely delicious. I use fresh sardines, but if you can't get fresh, you can make this with canned ones instead.

Preheat the oven to 200°C/400°F/Gas Mark 6.

First, make the tomato sauce. Heat the olive oil in a saucepan over a low heat, add the onion and garlic, and cook very gently until softened. Add the saffron, wine and parsley. Chop the tomatoes roughly into quarters then squeeze them to release their juices as you add them to the pan. Add the chopped fennel and cook very slowly for 8–10 minutes, then add the basil and season with salt and pepper.

Pour the sauce into an ovenproof dish and lay the sardines on top. Cook in the oven for 6–7 minutes until the fish are cooked. Serve on toast.

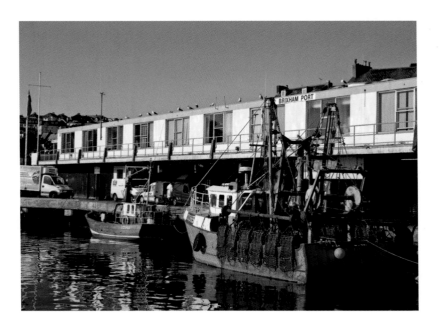

sprat *Sprattus sprattus*

The best way to eat the delicious sprat is floured, fried and eaten really hot with a squeeze of lemon – fabulous. It is a diminutive relative of the herring family and swims around in vast swirling silvery shoals, and its delicious omega-oil-rich flesh is hunted down by everything from minke whales and mackerel to seagulls and humans.

Sprats are a seasonal migratory fish, spawning in late spring and summer, moving inshore during autumn and winter to feed on plankton. There's an autumnal feeding frenzy on the sprat from the top to the bottom of the food chain.

Sprats are similar looking to the herring though smaller, growing to around 12 cm/4½ inches and with a snugger nose. Victorian fishery expert Frank Buckland said the smell of a sprat burning on a fire is more savoury and appetizing than a herring and can be smelt over a longer distance as there is more oil in a sprat than a herring.

In fact, in Victorian times sprats were so abundant that they were used for manure. Sadly these days many a sprat ends up with an equally unglamorous fate, as they are often processed into fishmeal. However, I'd like to put the sprat firmly back on the menu as it's a real seasonal treat.

Taste description

With a light, marine freshness of aroma, sprats have a very delicate flavour, which is characterized by slightly spicy notes of mustard cress and cumin, along with a sweet, sesame taste that derives from their oil content. Their small size and the softness of their white flesh means that the latter can be easily peeled away (skin still attached) from the spine to be eaten, or the whole fish can be eaten ungutted, head and bones included.

Territory

Sprats are found in the northeast Atlantic – North Sea and Baltic, and south to Morocco. They are also found in the Mediterranean, Adriatic and Black Seas.

Environmental issues

The sprat fishery in the North Sea is reported to be in good condition.

Territory	Local Name
UK/USA	Sprat
Greece/Italy	Papalina
France	Sprat, Esprot
Spain	Espadin
Portugal	Espadilha, Lavadilha
Holland	Sprot
Norway	Brisling
Germany	Sprotte, Sprot
Denmark	Brisling
Sweden	Skarpsill, Vassbuk

Health

Sprats are a good source of omega-3 oils.
Per 100 g/4 oz: 172 kcals, 11 g fat

Seasonality

Sprats are at their very best from early autumn to Christmas.

Yield

100% – the whole sprat is edible.

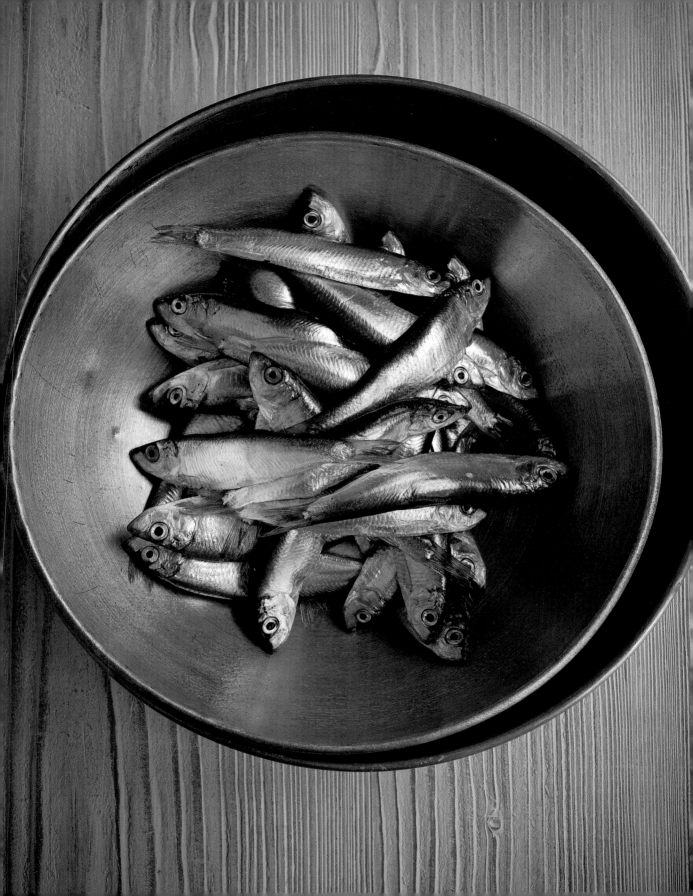

David Hurford — the oily fish specialist

David has been fishing out of Brixham all his life. Oily fish are his forte —
he targets sprats, herring, sardines and anchovies with the occasional by-catch
of mackerel in his 15-metre boat 'Constant Friend', a multi-purpose vessel
that can go stern trawling, mid-water trawling and scallop dredging.

When is the sprat season?

The sprat season starts around the first week of August.
If you start earlier the fish are usually full of feed and
their bellies split during processing. Also they can be
a bit too oily, so it's got to be pitched right.

Where do the sprats go that you land?

When we pull up a catch, its iced straight away, and
when we return to port this is unloaded straight into
bins of slush ice and taken by refrigerated lorries to
the factory, where they are blast-frozen into 20 kilo
blocks. It's really important with oily fish that they
are looked after from the moment they leave the sea.
All our fish are dealt with overnight, so by the next
morning when we are setting out to sea again, the
previous day's catch has been processed and is on its
way to markets on the Continent. The other, much
smaller, market is the fresh sprat market. The fish go
into 6 kilo boxes which are iced and then sent around
the country to the fish markets. Out of the average
20 to 25 tonnes of sprats we land in a day, only
1 or 2 tonnes will go to this market.

Who eats your sprats?

If we catch large sprats and they're going to Sweden
they don't have it frozen, instead they like it barrelled
in brine with spices. These barrels then go over to
Sweden, where they won't start eating them until the
following season. Then they fillet the sprats, which is
why they like the larger fish. Denmark does the same
thing. But the German and Dutch markets prefer their
sprats frozen. There is a little bit of smoking done,
but not as much as there used to be, which is a shame

as smoked sprats are really nice if done properly.
I would say that 95% is going abroad — it's the market
forces. Even though the Swedes, Danes, Dutch and
Germans want our sprats, the Brits don't … it's
madness, total madness!

What's your favourite oily fish to eat?

I'd just as sooner eat a sprat any day if it's cooked
right. Sprinkle the sprats with a little salt and leave for
half an hour or more. Flour your sprats, then a smear
of bog-standard olive oil in a pan, not the virgin stuff.
Fry them in a very hot pan and don't crowd the pan.
They go nice and crisp and proper. That, with some
fresh bread, takes some beating and it's cheap! We eat
them on the boat like that when we're steaming home.
We've got to have our omega-3!

grilled sprats with oregano and chilli

Serves 2

A few dried bird's-eye chillies
Pinch of fine salt
1 tbsp dried oregano
3 tbsp olive oil
At least 200 g/7 oz sprats

To serve:
Squeeze of lemon, to taste

These fish are best cooked over a barbecue and a handful of sprats make a fabulous appetizer.

Light a barbecue.

Crumble the dried chillies in a bowl, add the salt, oregano and olive oil and mix to combine.

Lay the sprats on a baking sheet, brush liberally with the olive oil mixture and cook on the barbecue for about 2 minutes until crisp.

Simply hand round the fish in a napkin as they are cooked and invite your guests to squeeze over a little lemon and then devour the whole fish one by one.

devilled sprats

Serves 4

Vegetable oil, for deep-frying
1 tsp cayenne pepper
½ tsp mustard powder
250 g/9 oz/1¾ cups plain flour
1 tsp salt
1 kg/2/14 lb sprats
300 ml/10 fl oz/1¼ cups milk

To serve:
Lemon wedges
Mayonnaise (see page 286)

There's nothing better you can do with a sprat than to simply fry it until crisp and then enjoy it with some buttered bread and a squeeze of lemon. The only addition I like to make is mixing a little mustard powder and a good pinch of cayenne into the flour so the sprats become devilishly hot and spicy.

Heat enough vegetable oil for deep-frying in a deep-fryer or suitable pan to 190°C/375°F.

Mix the cayenne, mustard powder, flour and salt together in a shallow dish and pour the milk into a separate dish.

Dip the fish first in the milk, then toss in the flour and deep-fry for 2–3 minutes until crisp. Drain on kitchen paper and serve with lemon wedges and a pot of homemade mayonnaise.

salt-cured sprats

Serves 4

1 kg/2¼ lb whole sprats
2 good handfuls of fine sea salt
1 kg/2¼ lb rock salt
4–5 fresh bay leaves

In August, when the local boats in my home town of Brixham start sprat fishing, the fish are delicious and their oil content is just right for salting. A few pounds' worth of sprats will fill several kilner jars and give you an alternative to salted anchovies (see page 200) throughout the year. The salted sprats will keep in kilner jars in the refrigerator for two months.

Lay the sprats in a single layer in a large colander or bowl, sprinkle with fine sea salt and leave to stand for 1 hour. This helps to draw the moisture from the fish, which is essential in the salt curing process. After an hour, wipe the fish with kitchen paper to remove any moisture and salt.

Sprinkle a layer of rock salt, about 10 cm/4 inches thick, in a large plastic container, then arrange the sprats in a single layer on top. Add a couple of bay leaves, then another layer of salt. Repeat the sprat and salt layers until all the sprats are completely covered in rock salt. Take a piece of cardboard that will just fit inside the container, wrap it in foil and place on top of the fish with some heavy cans on top and leave in the refrigerator for a week. The weight will help to press the fish and every few days you will need to tip the moisture out of the container.

After a week, the sprats will be ready to use in any dish that calls for salted anchovies. They are especially good filleted and tossed in salads or mixed with garlic and olive oil and tossed with spaghetti.

TIP
To decant into a jar, layer
the fish with fresh salt
until the jar is filled, then
seal tightly.

swordfish *Xiphias gladius*

With its distinctive sword-like bill and fierce temperament, swordfish has few predators apart from humans. Its flesh is arranged in a distinctive whorl pattern (the larger the fish, the larger the whorl) similar to that of tuna and the skin has the lightly textured appearance of linen.

This highly migratory species and only member of the *Xiphias* family moves from cooler temperate waters in summer to feed, returning to warmer waters to spawn. In the Atlantic this takes place in spring (in the southern Sargasso Sea); in spring and summer in the Pacific; and from June to August in the Mediterranean off the coast of Italy, where it has been harvested on its way to its spawning grounds for centuries.

These awesome fish can reach up 650 kg/1,433 lb and 4.5 m/14 ft, although 450 cm/177 inches and 150 kg/330 lb is more usual. Their streamlined, scale-free bodies cut through the water at tremendous speed in pursuit of schools of small tuna, dorado, mackerel or squid.

Taste description

In terms of its aroma, it has more in common with meat than fish, with a strong suggestion of properly hung beef. There's a marked difference between the meat at the whorled centre of a fillet and that at the edges. The former is pale, with a juicy, yielding character, and a lactic astringency that's suggestive of Greek yoghurt. In contrast, the flesh around the skin is softer, the wood-like grain exchanged for a soft, pressed tofu consistency. The flavour is more intense and there's a sourish note.

Territory

Swordfish are found in the Pacific, the Atlantic Ocean from northern Norway to Newfoundland, throughout the Mediterranean and into the Black Sea.

Environmental issues

Swordfish were harvested by a variety of methods on a small scale until the global expansion of long-line fishing. Long-line gear can target specific species, but the by-catch of endangered species like marine turtles is still a significant problem. Swordfish has low resilience and is subject to high fishing pressure and most stocks are classed as vulnerable. Swordfish caught in the North or South Atlantic would be the most sustainable choice for consumers, in particular from USA- and Brazilian-managed waters where extra measures are being taken for the avoidance of turtle by-catch.

Territory	Local Name
UK/USA	Swordfish
France	Espadon
Spain	Pez espada
Portugal	Espadarte, Agulha
Italy	Pesce spada
Greece	Xiphiós
Holland	Zwaardvis
Germany	Schwertfisch
Norway	Svaerdfisk
Denmark	Svaerdfisk
Sweden	Svärdfisk

Health

Swordfish are a quite good source of omega-3 oils.
Per 100 g/4 oz: 139 kcals, 5.2 g fat

Seasonality

Swordfish are available all year round, depending which part of the world the fish is from. Avoid during its spawning season, which is in spring in the Atlantic, spring and summer in the Pacific, and June to August in the Mediterranean.

Yield

1 kg/2¼ lb weight of swordfish yields 75% edible steak.
1 kg/2¼ lb weight of swordfish yields 60% edible fillet.

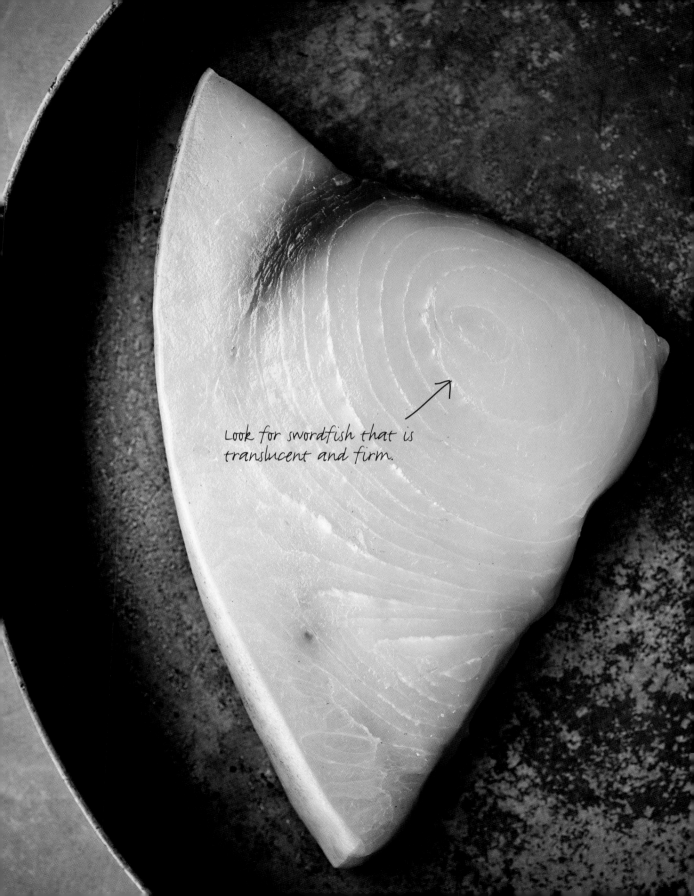

Look for swordfish that is
translucent and firm.

grilled swordfish with oregano

Serves 2

2 tbsp dried oregano
1 garlic clove
Finely grated zest and juice of 1 lemon
4–5 tbsp olive oil
2 x 160 g/5½ oz swordfish per person
1 tomato, chopped
1 tbsp black olives

To finish:
Sea salt
Squeeze of lemon, to taste

AT THE FISHMONGER
Try and buy slices from the
middle of the fish where the steaks
will be wider.

Grilling chunky fish like swordfish and tuna on the barbecue or under a conventional grill couldn't be easier. Swordfish and tuna are a substantial meal on their own and a single salad or lightly cooked vegetable is often enough.

Preheat the barbecue or grill to its highest setting.

Pound the oregano, garlic, lemon zest and juice and olive oil together in a mortar with a pestle until you have a thick, fragrant sauce. Brush the swordfish steaks with the mixture and cook on the barbecue or under the grill, continually basting with the sauce, for 3–4 minutes on each side until cooked.

Add the tomatoes and olives to the remaining sauce and spoon over the fish. Finish with a sprinkle of sea salt and a squeeze of lemon to taste.

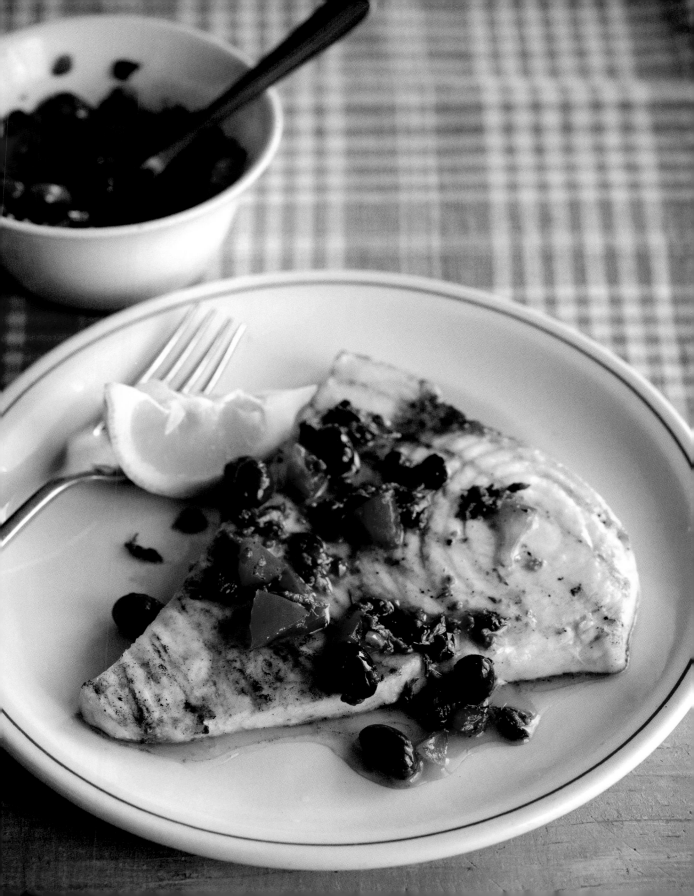

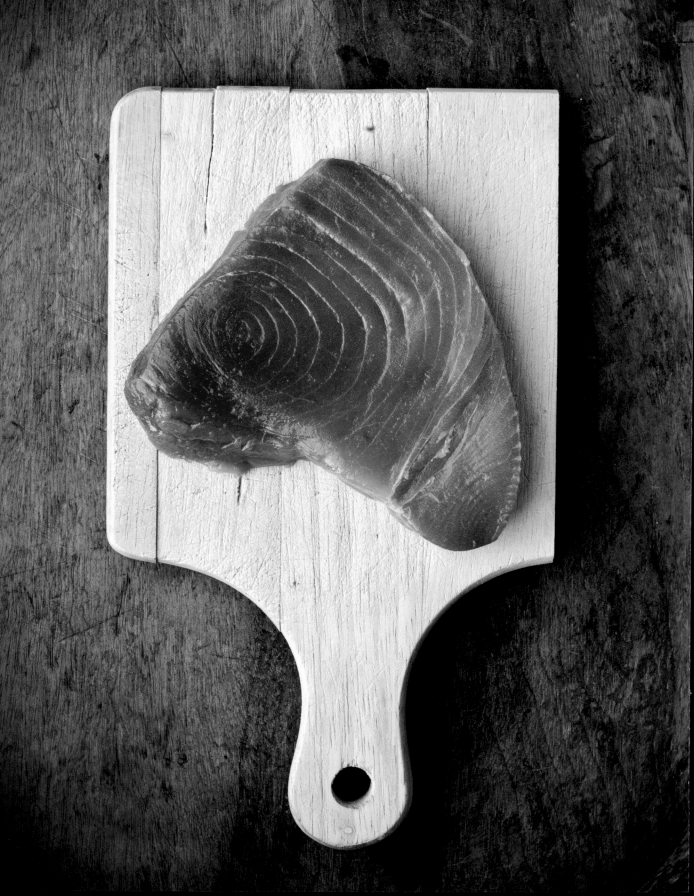

tuna *Thunnus thynnus*

Tuna is fabulous and its popularity exploded during the 1990s. It is versatile and ideal for those eating fish for the first time, as its meaty texture often appeals.

Tuna are large, oceanic fish capable of covering vast distances in their seasonal migrations. They are also fearsome predators, with the sharpest sight of any bony fish and phenomenal speed. They often form mixed schools of several tuna species, such as albacore, skipjack and bluefin, and hungrily launch into schools of herring, mackerel and anchovy or hunt down squid or other crustaceans.

The word 'tuna' comes from a Greek word meaning 'to rush', and this fish is certainly built for speed. Its hydro-dynamic torpedo shape, retractable side fins, eyes set flush to the body and crescent-shaped tail create as little drag as possible. The Atlantic bluefin tuna can reach sprinting speeds of up to 100 km per hour/62 miles per hour and cruises at between 2.8 and 7.4 km per hour/1–4 miles per hour. In order to survive, tuna have to keep moving, as their rigid heads mean they can't pump water over their gills, instead they must continuously swim with their mouths open.

Bluefin tuna is exceptional because its specialized circulation system allows it to retain heat generated by its muscles and gives its flesh that blood-infused red colour. It is slow to grow and slow to mature, so the lethal combination of improved fishing technology and increased demand has put this top predator's stocks into sharp decline. However, exciting new developments in aquaculture in Australia could see the first captivity-bred bluefin tuna taking pressure off the wild stocks.

Taste description

Yellowfin (*Thunnus albacares*)

Displaying the typical tuna characteristics of very firm flesh arranged in distinctive whorls, like knots in wood, the texture of yellowfin is firm and juicy, its large flakes reminiscent of pork crackling, with an underlying suggestion of the nuttiness of baked bread or brown butter. Some of these qualities are reflected in the taste, which is similar to roast pork or dark turkey meat. It is best cooked by briefly searing on both sides – the exterior should take on a pale, toasted oatmeal brown, while the interior should remain a rosy pink.

(continues on page 250)

Territory	Local Name
UK	*Tuna, Tunny*
USA	*Tuna*
France	*Thon rouge*
Spain	*Atún*
Portugal	*Atum*
Italy	*Tonno*
Greece	*Tónnos*
Germany	*Thunfisch, Roter Thun*
Holland	*Tonijn*
Denmark	*Tunfisk*
Norway	*Makrellstørje*
Sweden	*Tonfisk*

Health
Per 100 g/4 oz: 128 kcals, 2.7 g fat

Seasonality
Albacore, skipjack and yellowfin tuna are available all year round.

Yield
1 kg/2¼ lb weight of tuna yields 75% edible steak.
1 kg/2¼ lb weight of tuna yields 60% edible fillet.

Albacore (*Thunnus alalunga*)

Like all tuna, albacore has much in common with meat, and is an excellent entry level choice for those wary of fish. The flesh is even in texture with a moderate amount of moisture that flees quite quickly. The aroma is reminiscent of roast pork chop, to which some sweetness is added by the caramelization on the surface of the cooked fish. That pork chop note is also strongly present in the flavour, together with a citrus acidic element that, just like rhubarb, causes the sensation of a tacky 'fur' on the teeth, as well as stimulating the production of saliva.

Territory

Atlantic bluefin tuna are found throughout the Atlantic and spawn in Gulf of Mexico and near the Straits of Gibraltar in spring/summer. Albacore tuna are found throughout the world's temperate, sub-tropical and tropical oceans. Skipjack tuna are found throughout the world's tropical and warm temperate waters and yellowfin tuna are found throughout the world's tropical and subtropical seas, except the Mediterranean.

Environmental issues

Tuna is a universally popular fish – as our demand increases so its stocks decline. Some stocks are in better shape than others, it really depends on their rate of growth and when they become sexually mature –
the bigger slower growing species are in the worst state, so avoid Northern bluefin, Pacific bluefin and Southern bluefin. The ones which are in the best shape are the faster growing and maturing varieties, such as albacore, skipjack and yellowfin. Increase the sustainability of the tuna you eat from these areas by choosing line- (pole and line- or hand-line) or troll-caught 'dolphin-friendly' fish.

Sustainably caught tuna

For generations the French and Spanish have fished the vast fishing grounds of the Atlantic albacore tuna using traditional hook and line techniques. However, over the last couple of years, two British Cornish boats – *Charisma*, skippered by John Walsh, and *Nova Spero*, skippered by Shaun Edwards – have travelled to join the three or four hundred French and Spanish boats in the Bay of Biscay for the season. Because the Atlantic albacore troll fishery is a relatively low production fishery, hundreds rather than thousands of fish are landed.

"There's a huge demand for tuna, especially when caught in this low impact way, and landed locally rather than flown in. Also the fish can be traced back to the fisherman who caught it. The fishermen handle the tuna carefully from the moment it lands on the deck right through until it's back in port 7 days later," explains Nathan de Rozariaux, Project Director of Seafood Cornwall.

Free-range tuna farming in Australia – the future of aquaculture?

The Southern bluefin tuna is an endangered species and subject to a strict quota, with just over 5,000 tonnes allowed to be exported each year by Australia. Currently they are 'ranched' by capturing the fish in the wild and towing them back to Port Lincoln, Australia, in cages where they are kept in pens to be fattened up for overseas markets such as Japan and the US. Back in the early 1990s, the fishermen of Port Lincoln were catching these same tuna and canning them for sandwiches and cat food – now they have become a star fish, fetching a premium price. But ranching is not a sustainable method of farming by any means.

Australian company Clean Seas, owned by Marcus Stehr, has become the first company in the world to create an artificial breeding program for the Southern bluefin tuna, in an attempt to rescue wild stocks.

To get the fish into a breeding condition, scientists had to mimic the temperature and oxygen content of the waters from the Antarctic to the southern Indian Ocean through which the fish migrate. They've even used artificial sunlight and moonlight and reproduced underwater currents to trick the fish into thinking they are in the wild.

Marcus Stehr: "We were able to get fertilized eggs and these hatched into larvae that started to feed. We are now doing tests on these and hopefully growing them onto fingerlings. We'll certainly be looking to go into full-stage production within the year or so. To complete this life cycle of the Southern bluefin is the holy grail of the fish world, it's not a question of *if* but *when* we can grow on the fingerlings to adult tuna, as we have done already with the kingfish. In the wild, Southern bluefin tuna are an ever-depleting resource, so we need to think of its future and the propagation of hatchery-bred tuna is the way to go."

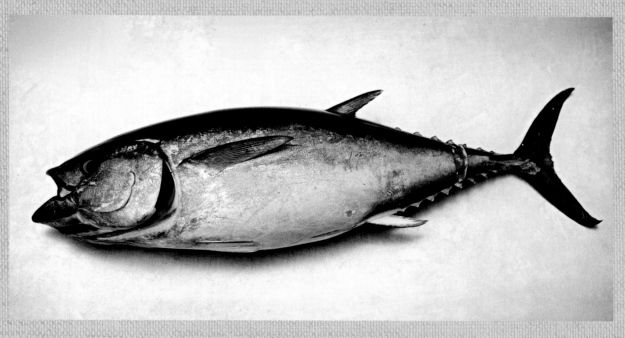

tuna with crisp breadcrumbs, parsley and lemon

Serves 2

7 tbsp olive oil, plus extra to serve

Sea salt and freshly ground black pepper

2 tuna steaks, about 200 g/7 oz each

1 garlic clove, very finely chopped

75 g/3 oz/1½ cups coarse fresh
 breadcrumbs that are not too dry

Finely grated zest of 2 lemons

Small handful of fresh parsley,
 finely chopped

Squeeze of lemon, to taste

AT THE FISHMONGER
Tuna is mainly imported in
loins, and you should look for tuna
which is a vibrant deep red; avoid
tuna that's dark brown.

Tuna is a magnificent fish, and is wonderful eaten raw, fabulous cooked over a fire and fantastic just fried in olive oil. I like my tuna to be either well cooked or raw, not a bit of each, and you often find chefs searing tuna steaks and leaving them completely raw in the centre. While this may look pretty when cut through, I think tuna is taken to another level when it is cooked pink and the fat and membrane is allowed to melt down between the flakes.

This is a very simple recipe, and the combination of crisp breadcrumbs with moist tuna is delicious.

Preheat the oven to 240°C/475°F/Gas Mark 9.

Heat a large heavy-based frying pan that is suitable for cooking in the oven until hot and add 3 tablespoons of olive oil. Sprinkle a little salt over the tuna steaks and add them to the hot pan. Leave them to sizzle for 1–2 minutes on either side, then pop into the oven for a further minute to get some heat to the centre of the fish. Place the tuna steaks on serving plates. The flakes of the tuna should be easily separated and if you pull a steak apart with your fingers you will see that it is wonderfully moist and pink and not raw in the centre.

Add the rest of the olive oil to the hot pan, then add the garlic and, just as the garlic starts to brown, add the breadcrumbs and continue to fry until they are crisp. Add the lemon zest and parsley and spoon over the top of the tuna steaks, finishing with just a squeeze of lemon and a little olive oil. Enjoy this simple preparation with a rocket and tomato salad.

tuna carpaccio
with capers and anchovies

Serves 2

200 g/7 oz very fresh tuna

2 egg yolks

1 tsp Dijon mustard

1 tbsp white wine vinegar

8 salted anchovy fillets

½ garlic clove

Splash of Worcestershire sauce

1 tsp capers

100 ml/3½ fl oz/generous ⅓ cup
 vegetable oil

1 tbsp Parmesan cheese, finely grated

Freshly ground black pepper

Squeeze of lemon, to taste

1 tsp fresh parsley, finely chopped

1 shallot, finely chopped

AT THE FISHMONGER
I won't have to even explain to
you what fresh tuna looks like;
when you see it you will know.
You can use the tail end of the
tuna for this dish as its smaller
in diameter and can be easier
to slice.

If I spot really red fresh tuna in the fishmonger's then this is a dish that I would certainly make. Don't buy your tuna and leave it in the refrigerator hoping to do it in a few days! This dish is just a simple assembly of ingredients that takes advantage of the freshest fish.

Place the tuna in the freezer for 20–30 minutes to firm up. This will help you when slicing it thinly.

To make the dressing, place the egg yolks, mustard, vinegar, 3 of the anchovy fillets, garlic, Worcestershire sauce and half the capers into a small food processor and blitz to a paste. While the motor is running, drizzle in the vegetable oil until the sauce is the consistency of double cream. Add the Parmesan, pepper, parsley and a squeeze of lemon and stir to combine.

Using a very sharp knife, slice the tuna into thin slices no more than 5 mm/¼ inch thick and lay on a cool plate. Liberally sprinkle over the remaining capers, anchovy fillets and the chopped onion, then spoon the dressing in a thin stream over the tuna and serve.

grilled tuna with pepperonata

Serves 2

2 x 160 g/5½ oz fresh tuna steaks
Rock salt, for sprinkling
Olive oil, for brushing

For the pepperonata:

100 ml/3 fl oz/generous ⅓ cup olive oil
1 large onion, very finely sliced
2 garlic cloves, mashed to a paste in a
 mortar and pestle
1 red pepper, deseeded, cut in half and
 thinly sliced lengthways
1 yellow pepper, deseeded, cut in half
 and thinly sliced lengthways
½ tsp ground cumin
1 dried bird's-eye chilli
50 ml/2 fl oz/¼ cup red wine vinegar
Fine salt and freshly ground black pepper
1 tbsp fresh basil leaves, shredded

To serve:

Rock salt
Squeeze of lemon, to taste

Tuna is becoming a luxury – the world's catch is highly controlled by quotas and the fish is constantly in demand, as chefs have embraced its wonderful eating qualities. Some of the best tuna I have eaten, with the exception of Japan, has been around the Mediterranean, where I have had it braised, grilled, seared and barbecued. It is delicious with this sweet stew of peppers – typical of Italy.

Preheat the oven to 240°C/475°F/Gas Mark 9.

First, make the pepperonata. Heat the olive oil in a large saucepan over a very low heat, add the onion and fry very gently for 20 minutes until it melts and starts to become sticky and golden. Add the garlic, peppers and cumin and continue to stew until the peppers have softened and melted. Crumble in the chilli, add the vinegar and cook for a further minute. Season with salt and pepper to taste, then add the shredded basil. The stew should be slightly sweet from the peppers and at the same time sour from the vinegar.

Meanwhile, heat a ridged stovetop grill pan until hot. When the oil is smoking, season the tuna steak with fine salt, brush with olive oil, add to the pan and cook for 1½–2 minutes on each side. Transfer the tuna to a roasting dish and cook in the oven for a further minute or so. This will ensure that the all-round heat of the oven gets to the centre of the fish without drying the outside surfaces of the tuna steak. The tuna is done when the flakes just pull apart and the centre is a gorgeous juicy pink rather like medium-cooked lamb would be.

Place the tuna in a large serving dish, sprinkle over a little rock salt and a squeeze of lemon, and serve with a large spoonful of the pepperonata.

AT THE FISHMONGER
Look for tuna that is a vibrant deep red and avoid brown tuna or any with a pearlescent look. Preferably, the steak should come from the top end of the loin rather than the thinner end near the tail. Depending on the width of the loin, the best thickness for a tuna steak is about 20 cm/8 inches.

shellfish

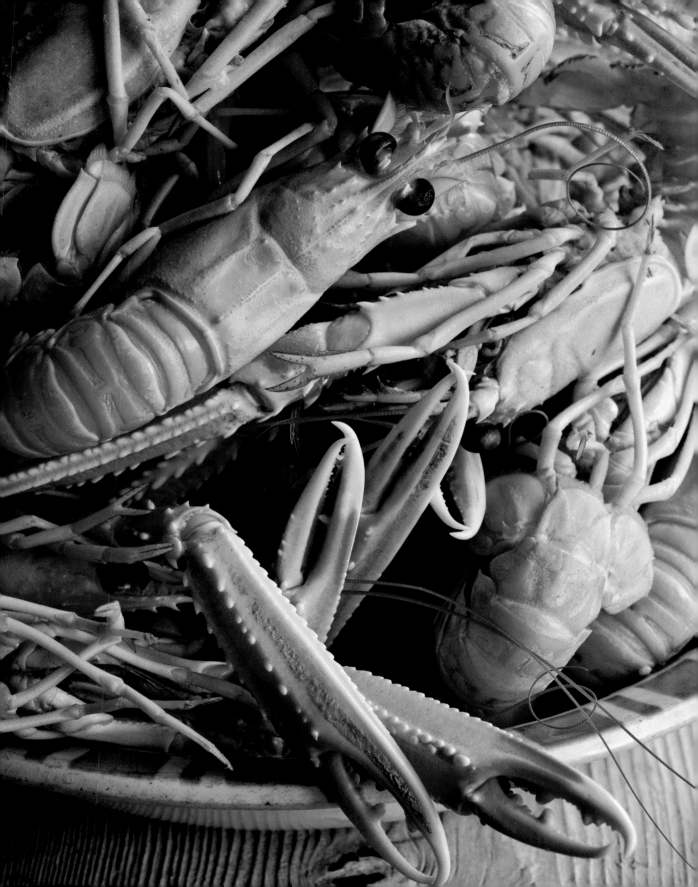

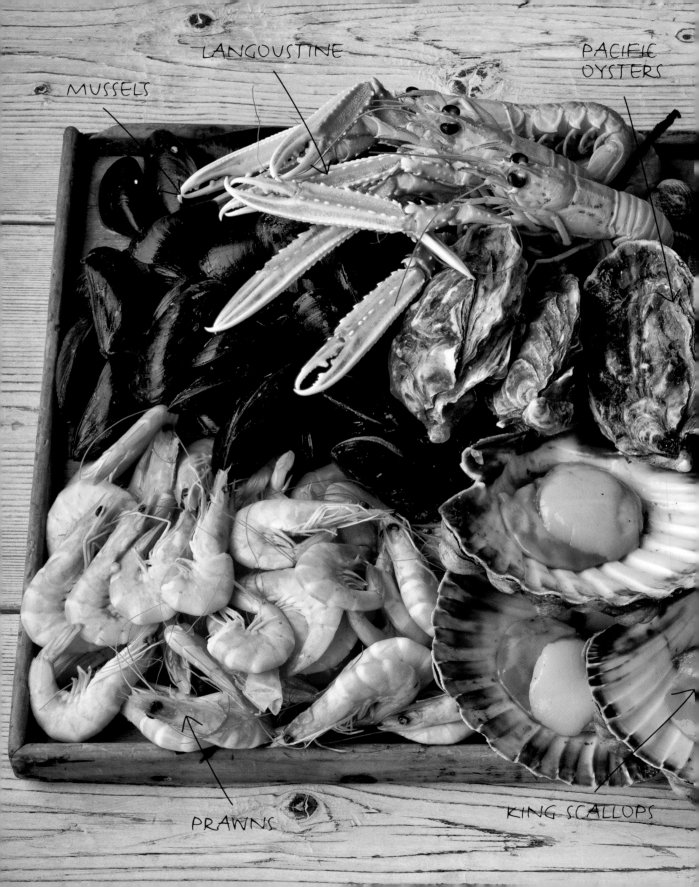

MUSSELS

LANGOUSTINE

PACIFIC OYSTERS

PRAWNS

KING SCALLOPS

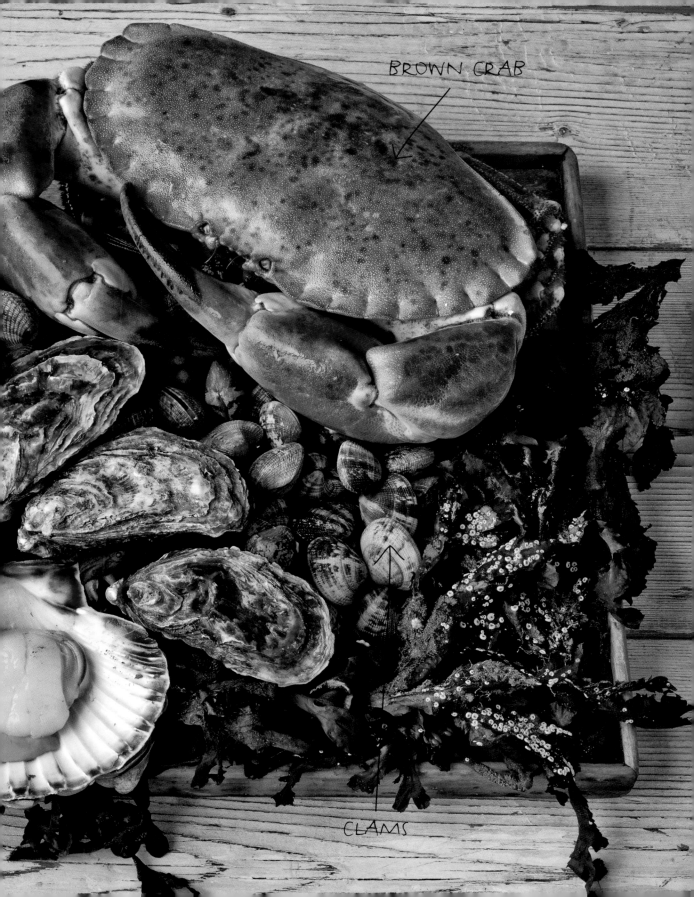

BROWN CRAB

CLAMS

roast shellfish platter with garlic, tomato and herbs

Place 2 halves of lobster, 6 live razor clams, a handful of live mussels, a handful of fresh clams, a few scallops and some prawns in a large bowl with a glug of olive oil, a few sprigs of fresh thyme, a few sprigs of fresh rosemary, a little salt, a couple of crumbled dried chillies, 10 unpeeled garlic cloves, and 10 or 20 small cherry tomatoes. Using your hands, mix everything together, then tip into a roasting pan and spread evenly. Roast in an oven preheated to 240°C/475°F/Gas Mark 9 for about 10 minutes. (I use my wood oven for a smoky flavour, but a conventional oven is just as good.) Remove, sprinkle with a few breadcrumbs and cook for a further 2 minutes. Squeeze over some lemon to taste, then serve just as it is.

my favourite seafood stew

Serves 2

4 tbsp olive oil

1 shallot, finely chopped

2 garlic cloves, chopped

2 tomatoes, roasted

Pinch of saffron strands

3–4 fresh thyme sprigs

Splash of Pernod

200 ml/7 fl oz/scant 1 cup white wine

Selection of fish and seafood (see right)

About 200 ml/7 fl oz/scant 1 cup water
 (or fish stock if wished)

Sea salt

Fresh parsley or basil, chopped, for
 sprinkling

To serve:

Fresh bread

I have been cooking this dish for a number of years in my restaurant, and the only slight change we've made is to add a few ladlefuls of shellfish stock. This stew has clean wonderful flavours that come from the simple marriage of great ingredients, and what's more it is extremely easy to make. Ask your fishmonger for advice on buying fish in season and which are sustainable species. I like to include lobster, clams, mussels, chunks of skate, steaks of Cape hake, gurnard and pollack. You need to buy enough seafood to fill a large pan packed tightly in a single layer.

Heat the olive oil a large pan, add the shallot and garlic and sweat gently until softened. Add the tomatoes, saffron and thyme sprigs and stir together. Add the Pernod and tip the pan away from you, allowing it to catch alight. Pour in the wine and simmer gently for 2 minutes. Add the fish and add enough fish stock (or water) to just cover, then leave to simmer for 8–10 minutes. Lastly, add the mussels and clams and allow them to steam open.

Remove the thyme and season with salt. Finally sprinkle over the chopped herbs and serve with plenty of bread to mop up the delicious juices.

TIPS

Make sure you use mussels, clams or cockles in this dish as their salty juices are wonderful in the broth.

When serving, you can give your guests an empty bowl with just a slice of toasted bread in it, topped by a spoonful of aïoli. You ladle in the broth first, allowing the crouton to soak it up, then spoon in the fish. A great occasion.

clams

palourde clam *Ruditapes decussates*
razor clam *Solen marginatus* and *Ensis ensis*

The palourde or 'carpet shell' clam gets its name from the stunning carpet-like pattern of dark brown streaks on its pale shell. These shellfish, which grow to around 8 cm/3 inches are found near the high water mark at low tide – two holes in the sand giving their presence away. Although palourde clams are eaten by the French, Spanish and Portuguese, they seem to have disappeared off the British menu, which is a surprise as the Victorians were very enthusiastic about them. They called them 'butter fish' because they thought they were richer and sweeter than cockles.

Another underrated bivalve from the tide line is the razor clam, or 'spoot' as it's known in Scotland, where the passion for hunting them is known as 'spooting'. Their glossy brown shells grow to 12–15 cm/4½–6 inches depending on the species, and are similar in shape to a cut-throat razor. This clam has a siphon at one end for filter feeding when the tide is in and a long powerful foot at the other end, which burrows through wet sand at surprising speed. Often the only sign of a razor clam being in the vicinity is

the small spout of water it spits out as it melts down into the sand. Unlike other clams, razor clams permanently gape open at both ends, a quick tickle of its foot, which should retract straight away, will tell you if it's alive.

Taste description

Palourde clams

The aroma of a beach in high summer – hot rocks, beached seaweed slowly drying to brittle crispness along the tide line – defines the smell of palourde clams, although that strong savoury character is underpinned with a faint suggestion of mustiness. Take a mouthful and there's a slight sensation of sliminess, which rapidly passes to reveal a chewy texture at the front of the flesh, while the meat towards the back of the shell has a softer more yielding quality. From first bite to last bite, there's a generous amount of juice, the strong saltiness is balanced by the flavour of the meat, which has a lobster- or scallop-like sweetness.

Territory	Local Name
UK	*Razor clam, Spoot/ Palourde, Carpet shell*
France	*Couteaucourbe/Palourde*
Italy	*Cannolicchio/Vongola nera, Vongola verace*
Spain	*Navaja/Almeja fina*
Greece	*Solína/Chávaro*
Holland	*Scheermes*
Norway	*Knivskjell*
Germany	*Schwertmuschel/Venusmuschel*
Denmark	*Knivmusling*
Sweden	*Knivmussla*

Health

Clams are a quite good source of omega-3.
Per 100 g/4 oz: 74 kcals, 1 g fat

Seasonality

Avoid palourde clams during their spawning period from April to June and avoid razor clams during their spawning season from mid-May to early August.

Razor clams

Razors also have a smell evocative of the aromas of a sun-baked beach. Their long, linear shape gives them the appearance of mini squid and, at their foot, the meat is noticeably chewy with an abrasive, sandy feel. Towards the centre of their length, that rubbery, gritty quality lessens; the flesh becomes tinged with green and the flavour takes on a shellfish-like sweetness. At the tip, where the flesh is at its whitest, the texture is softer still – smooth and yielding like a lychee – and the flavour has a sharp tang, a little like sour cabbage.

Territory

Palourde clams are found throughout Britain, especially in the south, and down to the Mediterranean. Razor clams are found throughout European waters from as far north as Scotland down to the Mediterranean and also along the east coast of North America and Canada.

Environmental issues

Choose clams harvested in the wild by sustainable methods or buy farmed ones.

spaghetti with carpet shell clams, chilli and parsley

Serves 2

150 g/5 oz dried spaghetti

Sea salt

6 tbsp olive oil

1 garlic clove, finely chopped

50 ml/2 fl oz/¼ cup white wine

300 g/10 oz fresh clams

2 tbsp fresh parsley, finely chopped

1 small dried bird's-eye chilli

AT THE FISHMONGER
I particularly like carpet shell clams but you can use any small clam like the venus or lupine. Make sure the shells are tightly closed and that they smell fresh.

This is an incredibly simple but delicious dish. I like to make a big plate for everyone to share. The only other addition I sometimes make to this dish is 3–4 tablespoons of fresh tomato passata or roughly chopped very ripe tomatoes.

Cook the spaghetti in a large saucepan of boiling salted water according to the packet instructions until just tender but still firm to the bite. Drain.

Heat the olive oil in a frying pan, add the garlic and when sizzling, add the wine, clams and a little of the parsley. Crumble in the chilli and move the pan in a circular motion so you agitate the clams and their shells are coated in the pan juices.

When the clams have opened, keep moving the pan until the juices are about 6 tablespoonfuls, then add the spaghetti, sprinkle in the remaining parsley, toss together well and serve.

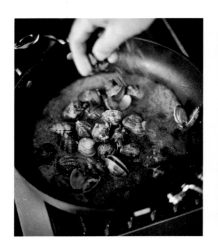

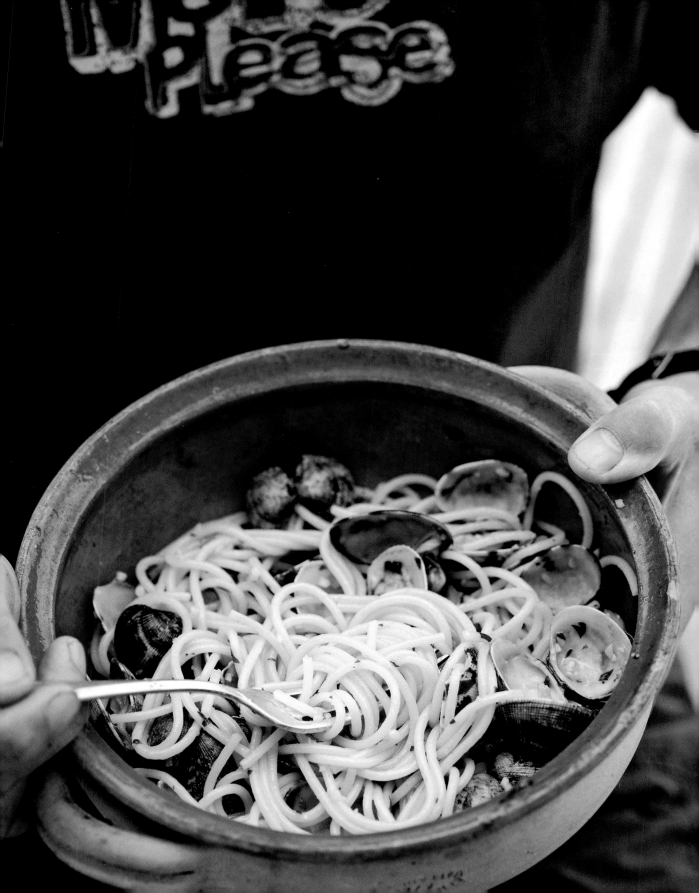

grilled razor clams with garlic breadcrumbs

Serves 4

75 g/3 oz/1½ cups fine breadcrumbs

50 ml/2 fl oz/¼ cup olive oil, plus
 extra for brushing and drizzling

Finely grated zest of 2 lemons

2 garlic cloves, finely chopped

Splash of Tabasco

Good handful of fresh parsley,
 finely chopped

18 live razor clams

Fine salt

AT THE FISHMONGER

Look for razor clams that are tightly closed, they shouldn't be gaping open, and they should have a sweet smell. It is normal for them to hang out of the end of their shells and wave around, but when they are touched they should instantly retract. Razor clams should always be live when you cook them.

Razor clams are a wonderful shellfish. The small ones can be added to stews or indeed spaghetti with clams, while the larger ones are perfect for grilling. One of my favourite Chinese restaurants steams them with garlic, ginger and soy sauce. I have recreated this recipe successfully by placing the razor clams in a foil bag with some soy sauce, water, shredded ginger, spring onions, garlic and coriander, then cooked for 6–7 minutes in the oven and the results are excellent. They can also be paired up with chorizo, and I recall an excellent dish cooked by Mark Hix at The Ivy for my wedding party. The spicy oil in the chorizo worked beautifully with the sweet, soft texture of the clams. This recipe is one that I cooked with Mark recently – I love it, it's so simple and so good.

Preheat the grill to high.

Mix the breadcrumbs, olive oil, lemon zest, garlic, Tabasco and parsley together in a bowl. You should have a loose moist crumb.

Place the razor clams in a large roasting dish, sprinkle with fine salt, brush with olive oil and cook under the grill for 3–4 minutes until the clams pop open. Sprinkle the stuffing mixture into each clam, drizzle with a little more olive oil and grill for a further minute or so until the crumbs are crisp and have soaked up all the clam juices.

Serve beautifully unadorned. This makes a wonderful appetizer.

cockles *Cerastoderma edule*

Eating pickled cockles that my grandmother made is one my earliest memories of food. Since Roman times, cockles have been an important part of coastal larders.

The name 'cockle' comes from the Greek and Latin word for 'shell' and these bivalves are members of the *Cardidae* family, which means 'heart-shaped'. Cockles have distinct raised ribs radiating over the length of their shells, which help them to grip the sand when they leap; they do this by using a large powerful muscular foot within the shell. By bending this foot backwards beneath the shell and then straightening it, the cockle hops forward. It also uses this foot to burrow into the sand or mud, where it spends the majority of its time filtering tiny organisms from shallow coastal waters and estuaries. The colour of the shell varies according to its surroundings and ranges from brown through to a pale yellow or grubby white.

If conditions are right, cockles can grow from the size of an orange pip to a tasty 6 cm/2½ inches within 18 months and their typical lifespan is 2–4 years. If the conditions are not good, then cockle beds have been known to hop off *en masse* to find richer pickings.

Taste description

Fairly tooth-resistant in texture, cockles have an underlying grittiness at their core that gives the smooth flesh a little more bite. The scent is mild, with an ozone-like freshness that's close to the smell of raw cod, plus a deeper note suggestive of the burnt wood aroma of an extinguished match. There is a hint of dilute, almost floral sweetness to the flavour, but it's extremely mild – this seafood definitely requires other, more dominant ingredients to give it some character.

Territory

The common cockle (*Cerastoderma edule*) is found as far north as the Barents Sea and Baltic Sea and as far south as the Mediterranean. However, in the Mediterranean it's more common to find its slightly smaller cockle cousin, *Cerastoderma glaucum*.

Environmental issues

Avoid overexploited cockle beds where mechanical harvesting and dredging causes damage to stocks, disturbance of seabed or estuary and depletion of prey species for birds and other marine life. The Burry Inlet fishery in Wales is certified as an environmentally responsible fishery by the Marine Stewardship Council (MSC).

Territory	Local Name
UK	*Cockles*
France	*Coque, Bucard*
Holland	*Kokkel, Kokhaan*
Germany	*Herzmuschel*
Spain	*Berberecho*
Portugal	*Berbigão*
Greece	*Kydóni*
Italy	*Cuore edule, Cocciola*
Norway	*Saueskjell, Hjertemusling*
Denmark	*Hjertemusling*
Sweden	*Hjartmussla*

Health

Per 100 g/4 oz of meat: 53 kcals, 0.6 g fat

Seasonality

Avoid cockles during their spawning season from May to August.

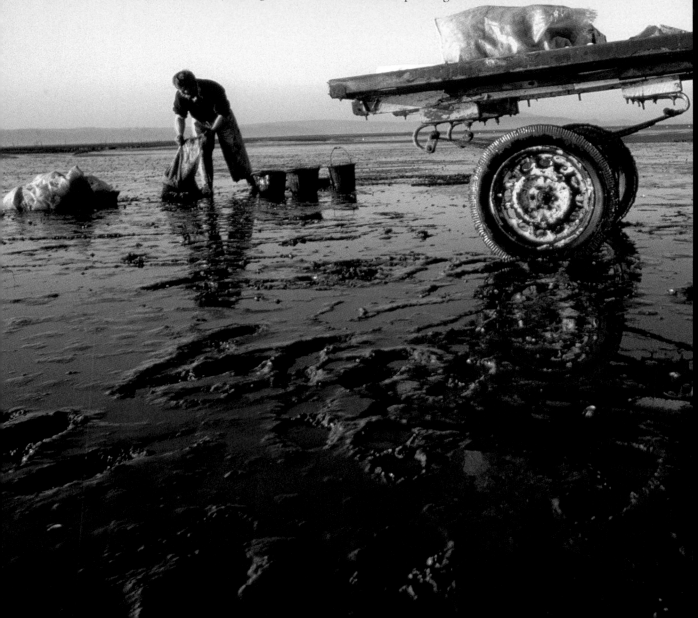

The Burry Inlet cockle fishery

What began 60 years ago as a family affair now sells Welsh cockles all over the world. The Burry Inlet is the estuary of the River Loughor. The cockle industry has largely existed in the same way since the 1800s. Originally fished by women using donkeys, they were displaced by men who left heavy industry and used horse and cart. Throughout the history of the fishery, only hand raking has been allowed, although access is now allowed by vehicle rather than restricted to horse and cart or donkey. Effective fishery management measures are in place and the stock is said to be very consistent between years and in an excellent condition. Fishery effort is tightly controlled via the issue of cockle licences and daily quotas. A limited number of licences are issued each year for the hand raking of cockles only. Gathering takes place all week, except on Sundays, to an individual daily quota of 300–600 kg/0.3–0.6 tonnes per person per day. Minimum cockle sizes are set via riddle size (a hand-held measurement device) to allow the survival of sufficient spawning stock.

pickled cockles

Serves 2

2 kg/4½ lb fresh cockles, in the shell

100 ml/3½ fl oz/generous ⅓ cup water

White wine or malt vinegar

50 ml/2 fl oz/¼ cup sherry or brandy

2–3 blades of mace

1 bay leaf

A few sliced onions (optional)

A few slices carrot or celery (optional)

To garnish:

Handful of fresh parsley (optional)

To serve:

Freshly ground white pepper

I enjoyed some fantastic cockles recently in Wales, sitting outside a café in Milford Haven – they were firm, meaty and tasted of the sea. I think cockles are one of those things you either love or hate. I am a cockle lover and like to pickle my own and enjoy them with sticks of celery, plenty of white pepper and thick-cut sourdough bread generously spread with butter. These pickled cockles are very easy to do and a jar of your own will be a wonderful pleasure.

Place the cockles in a large saucepan with the water. Cover them with a cloth, put a lid on the pan and allow them to steam open, shaking the pan from time to time. This will take only 3–4 minutes. Discard any cockles that remain closed. Strain the juice through a strainer, reserving the juice, then pick the cockles from their shells and set aside.

Add roughly the same quantity of vinegar to the pan as there is reserved liquid. Then add 50 ml/2 fl oz/¼ cup sherry or brandy per 575 ml/ 20 fl oz/2 cups of liquid, or proportion thereof (1:10). Add the mace and bay leaf and leave to simmer for 5–6 minutes.

Remove the spices, then pour the liquid over the cockles and leave to cool. A nice addition is to add a few sliced onions or thin slices of carrot or celery to the cockles. Always serve with plenty of white pepper. A final sprinkle of parsley will transform this humble dish into one good enough for any dinner party.

crab

brown crab *Cancer pagurus* ## spider crab *Maia squinado*

A crab sandwich in hand, made from a thick crusty white loaf, a great dollop of creamy mayonnaise and the buttery richness of a mixture of brown and white crabmeat, and you can't help but imagine sitting in your deckchair with the sand between your toes.

Brown crab

With its formidably large black-tipped serrated pincers and rusty oval-shaped shell with pie crust edging, the brown or common crab is the heavyweight armour-plated tank of the seabed. Two claws, the smaller one for grabbing, cutting or prising, and a larger crushing claw, which is the crab's biggest muscle, ensure that no one messes with this grumpy scavenger.

In order to grow, crabs swell up and burst out of their old shell revealing a vulnerable soft new one underneath, which has to harden. So, until they are battlefield ready again, they hide away. During the first years of a crab's life, moulting (shedding of the shell) takes place frequently, but only every two years after it is fully grown. Females or hen crabs are sexually mature when they are about 12.7 cm/5 inches, while males or cock crabs mature at 11 cm/4¼ inches. It is possible for the crab to grow to 30 cm/12 inches across the carapace, but a more modest 15–20 cm/6–8 inches is usual.

Spider crab

Looking like something out of *War of the Worlds*, we rarely give these crabs with their long spidery legs and spiky orange carapace a second glance. Sweeter than their common cousins, I would highly recommend them and stocks are plentiful. These are summer visitors to our shores, and their Latin name *Maia* gives a clue to their arrival. They migrate inshore from deeper waters from May onwards, resulting in a mass breeding frenzy in July and August, which can only be described as a great party with mounds of males swarming over the females. They hang around in shallow warm waters as late as December before returning to the depths. The spider crab is greatly prized in Europe.

Taste description

Savoury, with a slightly acid tang of canned tomato, the aroma of brown crabmeat is rounded and deep.

Territory	Local Name
UK	*Edible crab, Brown crab / Spider crab, Spiny crab, King crab*
France	*Tourteau, Dormeur / Araignée (de mer)*
Italy	*Granciporro / Grancevola, Granzeola*
Spain	*Buey / Centolla*
Greece	*Siderokávouras / Kavouromána*
Holland	*Noordzeekrab / Augustinuskrab*
Norway	*Krabbe, Taskekrabbe*
Germany	*Taschenkrebs / Troldkrabbe*
Denmark	*Taskekrabbe / Troldkrabbe*
Sweden	*Krabba, Krabbtaska / Spindelkrabba*

Health

Crabs are rich in vitamins and minerals like iron, potassium, selenium and zinc. Crabmeat is also low in fat and a good source of omega-3.
Per 100 g/4 oz: 128 kcals, 5.5 g fat

Seasonality

The brown crab gives the best meat yield from April to November. Avoid it during its breeding season in the winter from January to March. Avoid the spider crab during its spawning season from April to July.

The flavour is sweet at first, with a very delicate saltiness before a rich, piquant note of baked cabbage begins to emerge. The creaminess of the soft, wet texture is given a little edge by a slight granular quality.

The aroma of white crabmeat is all about starch – first the damp coolness of cold batter on fried fish, then, as the smell has time to develop a little, a strong, sugary, suggestion of canned sweetcorn. The taste is multi-layered – an initial fleeting burst of sweetness as the flesh releases its copious juice, followed successively by a bland neutrality and a faintly metallic, butter note that lingers on as an aftertaste. Short and crumbly, the meat has a fragile fibrous texture, falling apart in the mouth easily.

Territory

Brown crab

Brown crabs are found along the coastlines of northwest Europe as far as Norway, and are very common around the coastline of Britain. The conditions in the UK are near perfect for producing the best crab in the world. They are not found in the USA.

Spider crab

The spider crab's range extends from France and Spain where it is commonly harvested. It is also a summer visitor to Britain and is found as far north as the west coast of Wales.

Environmental issues

All pregnant females must be returned to the water by law. There is a minimum landing size for crabs, which is 12–14 cm/4½–5½ inches across (depending on the local area), and this ensures that crabs can reach breeding size. Potting is the most sustainable method of catching crab, as there is no by-catch of non-target species and small crabs may be returned to the sea alive. At the time of writing, crab stocks are well managed and healthy.

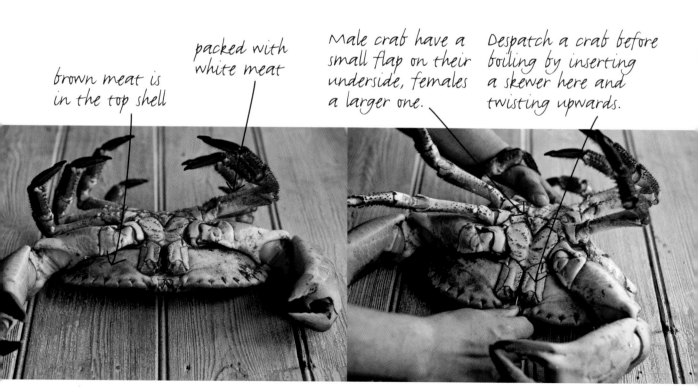

brown meat is in the top shell

packed with white meat

Male crab have a small flap on their underside, females a larger one.

Despatch a crab before boiling by inserting a skewer here and twisting upwards.

dressed crab

I am one of those people who prefer crab to lobster. I will often gather on the beach with friends, fill a large drum with seawater and boil a few dozen crabs. We then tip this over onto the pebbles, allow the crab to cool for an hour while we drink some beer, and sit with our feet in the water happily cracking the crab with stones and eating them with spoonfuls of mayonnaise and bread. We simply allow the tide to do the washing up!

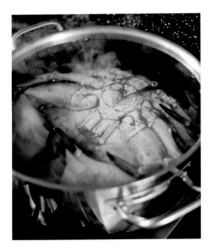

First bring a large pot of well-salted water to the boil. Add the crab to the pan and boil for 20-30 minutes. Remove from the water and stand on its nose to allow the water to drain away as the crab cools.

To prepare the cooked, cooled crab, first remove the legs and claws by pulling them off from the body. Place the crab on its back (hard shell-side down), put your hands under the edge of the crab and push upwards until you hear it break. Lever the crab apart. Remove the spongy 'dead men's fingers' and discard. Remove the stomach sac and hard membranes inside the shell. Use a spoon to remove the brown meat from the shell and any soft shell that has formed. Place it into a clean bowl and mash with a fork.

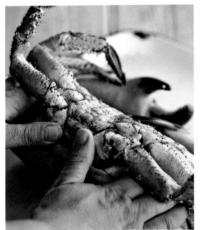

Break each claw in half and scrape the white meat out of the thick end of the claw. Place into a separate clean bowl. Use the back of a heavy-bladed knife to crack open the remaining claw and the pincers. Remove all the white meat and flake into the bowl. Remove the piece of cartilage inside each of the claws, pick off the meat and discard the cartilage.

To remove the meat from the body of the crab, take a sharp knife and cut the crab body in half then in half again. Pick out the meat using your fingers. Run your fingers through the white meat in the bowl to break up the meat and to pick out any remaining bits of shell.

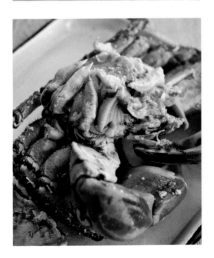

Once you have taken the meat from your crab, all you need to do is to make some good mayonnaise (see Boiled Langoustines with Mayonnaise on page 286), slice some cucumber and wash some fresh salad leaves.

Another fine way of enjoying crab is a simple crab sandwich. To make this, spread some mayonnaise onto a piece of good brown bread, place some brown crabmeat on top, then add a layer of chunky white crabmeat, some sliced cucumber and a sprinkling of cayenne pepper and lemon juice and sandwich between the other piece of bread – fantastic!

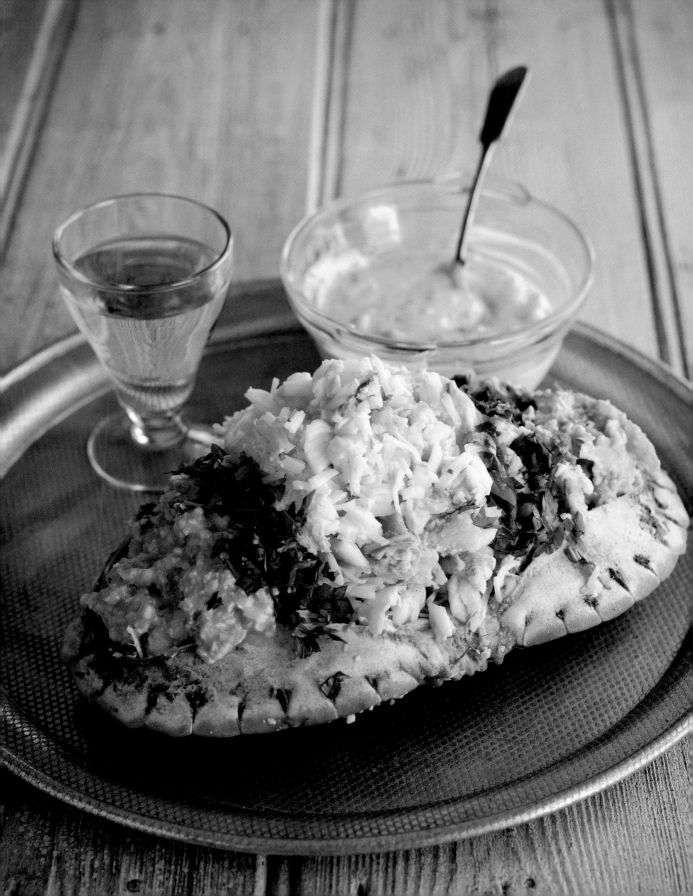

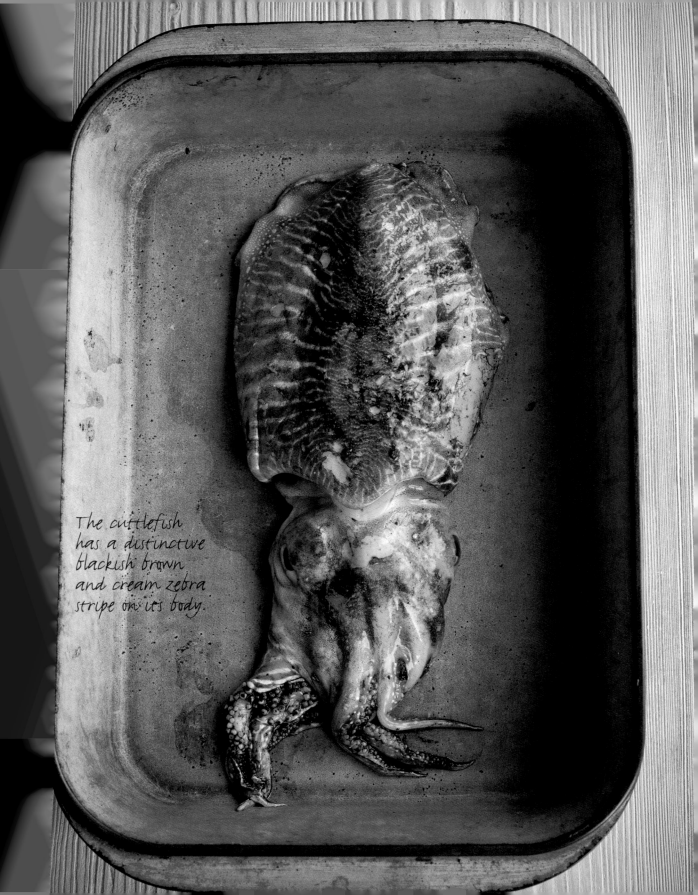

The cuttlefish
has a distinctive
blackish brown
and cream zebra
stripe on its body.

cuttlefish *Sepia officinalis*

A favourite of the Spanish and Italians, the cuttlefish is a highly intelligent, charismatic, jet-powered cephalopod. With three hearts and blue-green blood, it's a weird yet handsome beast.

The main body houses an internal shell called a cuttlebone that has tiny chambers, which are filled or emptied of gas, so it can move up and down. It has two large eyes, a beak-like jaw, and trailing from the body are eight arms and two longer tentacles, which shoot out to capture its prey, usually crustaceans, small fish and even other cuttlefish. It lives for two years, reaching a usual body length of 30 cm/12 inches.

This chameleon of the sea has a large number of specialized pigment cells that allow it to change colour and texture with lightening speed. They use these to communicate with other cuttlefish or to blend into the background. If this disappearing act doesn't fool the enemy then a well-directed squirt from their internal ink sac allows them to sneak off. Once used in early photographic processes, this sepia ink is used to colour pasta or rice black and is considered a delicacy, especially in Venetian cooking.

During the spring and summer cuttlefish move inshore to breed. Females die soon after, having attached their inky-coloured eggs, known as 'sea grapes', to seaweed, debris and even the very pots they are caught in. The final remains of this extraordinary creature wash up on the shore as snowy-white cuttlebones.

Taste description

Lightly sweet in aroma, with a suggestion of grilled bacon, cuttlefish has the same slightly tooth-resistant character as squid – the exterior of its flesh is very firm, like well-cooked egg white, becoming more creamily silky towards the centre. The flavour has a delicate note of saffron, plus a suggestion of woody herbs like thyme, underpinned by a lingering, prawn-shell richness.

Territory

Cuttlefish are found throughout the eastern Atlantic from the Baltic and North Seas to South Africa. They are also found in the Mediterranean and the English Channel, especially around the southwest coast. Cuttlefish are not found in any of the Americas.

Environmental issues

Where possible, look for cuttlefish from areas where measures have been put in place to protect cuttlefish eggs, such as leaving the egg-encrusted traps in sheltered areas until the eggs have hatched, or using a removable surface on the trap. They do this in Brittany, France, for example. It is caught in abundance in Brixham, UK. Cuttlefish is not controlled by quota.

Territory	Local Name
UK	*Cuttlefish, Inkfish*
Greece	*Soupiá*
France	*Seiche*
Spain	*Jibia*
Italy	*Seppia*
Germany	*Tintenfisch*
Holland	*Zeekat*
Denmark	*Blæksprutte*
Norway	*Blekksprut*
Sweden	*Bläckfiskar*

Health

Per 100 g/4 oz: 71 kcals, 0.7 g fat

Seasonality

With warming waters they seem to be available year round.

cuttlefish with artichokes, lemon and peas

Serves 2

1 tbsp good-quality extra virgin olive oil
 for frying, plus 100 ml/3 fl oz/
 generous ⅓ cup for covering the fish
2 small onions, finely sliced
1 garlic clove
125 ml/4 fl oz/½ cup dry white wine
1 medium cuttlefish, about 250 g/9 oz,
 cleaned and cut into strips
1–2 fresh thyme sprigs
1 small dried bird's-eye chilli
1 lemon
4 small artichokes, trimmed
100 g/4 oz/¾ cup fresh podded peas, or
 frozen if out of season
1 tbsp fresh tarragon, finely chopped
1 tbsp fresh mint, finely chopped
Sea salt and freshly ground black pepper

AT THE FISHMONGER
Ask your fishmonger to clean
the cuttlefish for you.

This dish is really a combination of all my favourite ingredients. I like to make it with small baby artichokes cut into thin slices, but it works equally well with globe artichoke bottoms and the grilled preserved artichokes in oil that you can buy in most delicatessens and supermarkets.

Preheat the oven to 150°C/300°F/Gas Mark 2.

Heat the 1 tablespoon of olive oil in a casserole dish over a low heat, add the onions and garlic and sweat gently until softened but not browned.

Pour in the wine and boil for a minute, then add the cuttlefish and pour in the rest of the olive oil to cover the fish. Add the thyme and chilli and cook in the oven for 1 hour or until the cuttlefish is tender. Leave to cool.

Cut the lemon into quarters and remove the skin, then remove the pips and pith and chop the flesh.

Remove the thyme from the cuttlefish and pour off half of the oil. Add the artichokes and peas and heat gently on top of the hob until warmed through. Add the lemon, tarragon and mint, taste and season with salt and pepper, then serve.

I like to eat this dish as it is at room temperature. If you are lucky enough to have a vegetable garden, you will have infinite possibilities for using your produce in this dish – broad beans, new potatoes and runner beans all work wonderfully well.

chargrilled cuttlefish with wet polenta

Serves 2

Juice of 1 lemon

2 garlic cloves, chopped

75 ml/3 fl oz/⅓ cup olive oil

Sea salt

1 or 2 cuttlefish, about 700 g/1 lb 9 oz
in total, cleaned and cut into strips

250 g/9 oz/1¾ cups polenta

50 g/2 oz/½ cup freshly grated
Parmesan cheese

30 g/1 oz/2 tbsp butter

Small handful of fresh parsley,
finely chopped

AT THE FISHMONGER

Ask your fishmonger to clean and skin the cuttlefish but retain the tentacles – you should be left with pieces of pure white meat similar in texture to squid.

I ate this dish in Venice some years ago. It is popular throughout the city and I think the combination of sweet cuttlefish and creamy, slightly cheesy polenta is delicious. The Venetians use a white polenta, which can be bought from some Italian food shops, but the yellow polenta more commonly available is fine. I also find it easier and more convenient to use the instant polenta when I am cooking at home.

Mix the lemon juice, garlic, olive oil and a pinch of salt together in a shallow dish. Add the cuttlefish and leave to marinate for an hour.

Preheat the grill to its highest setting.

Cook the polenta in a saucepan of boiling water according to the packet instructions for 10–15 minutes. Remove from the heat and add the Parmesan, butter and parsley.

Grill the cuttlefish on either side for 3–4 minutes and serve immediately with a spoonful of the warm polenta.

cuttlefish in ink sauce

Serves 2

2 tbsp olive oil

2 garlic cloves, finely chopped

1 small onion, finely chopped

1 kg/2¼ lb cuttlefish, cleaned and cut
 into strips

125 ml/4 fl oz/½ cup white wine

Sea salt and freshly ground black pepper

3 tbsp tomato purée

8 tomatoes, roughly chopped

125 ml/4 fl oz/½ cup water (optional)

Small handful of fresh parsley

4 sachets of cuttlefish or squid ink

To serve:

Lemon wedges

Crusty bread

AT THE FISHMONGER
Ask your fishmonger to clean all
the ink off, wash the tentacles
thoroughly and remove the skin.

Cooking cuttlefish in its own ink is extremely good and you should not be put off by the colour – it won't stain you! I cook this at my restaurant The Seahorse and everyone absolutely loves it – even those who were a little concerned at first.

Cuttlefish has such a good flavour, better than squid I think. It's definitely a fish for the future as it grows very quickly and is landed in large amounts. Cuttlefish can be cooked just like squid, and my favourite way of eating it is braised or slow cooked.

Heat the olive oil in a casserole dish, add the garlic and onion and fry gently until lightly golden. Add the cuttlefish and fry for a further 1–2 minutes. Season with salt, then add the wine and allow it to reduce by half.

Add the tomato purée, chopped tomatoes, some water if you feel the pan is too dry (the cuttlefish will release liquid as it cooks), half the parsley and lastly the ink. Stir together to combine, then bring to a gentle simmer. Cover with a lid and cook gently for about 45–50 minutes or until the cuttlefish is really tender when you insert a knife into it.

If you have lots of liquid left in the pan, just ladle most of it out into another saucepan and boil to reduce it, then add it back to the stew. The final texture should be thick so that when you spoon it onto serving plates the juice doesn't run everywhere. Sprinkle with the remaining parsley and serve with lemon wedges and crusty bread.

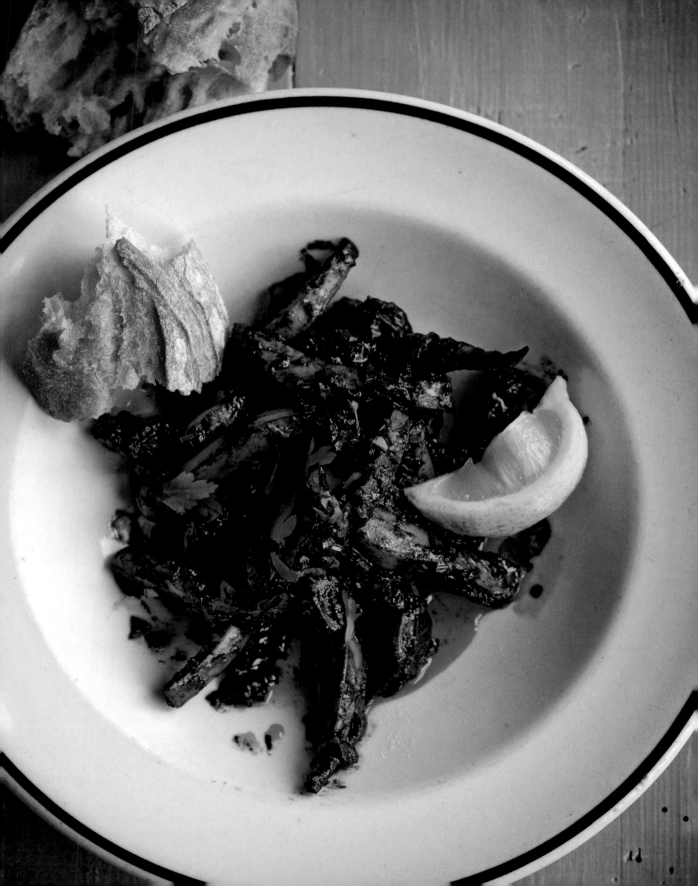

langoustine *Nephrops norvegicus*

This amazing shellfish is hugely popular in France, Spain and Italy, yet still some people consider it to be too fiddly and not worth the effort. If you can get past this, and I think it is worth the effort, then you are in for a real treat. Even if only a few mouthfuls are had from each langoustine, it's hard to beat the juicy sweet flesh.

This beautiful pale pink lobster with its red and white striped claws loves muddy seabeds where it can dig a snug burrow to hunker down in, emerging at night in search of worms and smaller crustaceans. Their burrow is home for the first 2 to 3 years of their life and they can grow to about 24 cm/9½ inches and live for over 10 years.

This diminutive shellfish was also the unlikely saviour of the Scottish fishing industry. In the 1960s, trawlers in search of cod and haddock threw langoustine overboard as rubbish. They were called 'Dublin Bay prawns' because they were sold as unwanted by-catch by Dublin street vendors. But as white fish catches declined, the fried breaded tails of langoustine were becoming increasingly popular as scampi. Suddenly they became a highly lucrative and valuable catch for the fleet, no longer thrown overboard, but lovingly graded into their own little compartments and sent to Spain and France, where they are worshipped as a luxury seafood.

Taste description

The langoustine's slender body and claws means that it yields up comparatively little flesh, but the flavour more than repays the labour-intensive business of shelling them. The aroma carries echoes of lobster along with the marine, spumy freshness of a windswept beach and an underlying starchiness, not unlike clean washing just taken off the clothesline. Smooth and velvety in texture, the flesh has a rounded, elegantly sweet and rich taste, with notes of Jerusalem artichoke, and the flavour is released steadily with no peaks or troughs and there is no aftertaste to speak of.

Territory

Langoustines are found throughout the northeastern Atlantic and North Sea as far north as Iceland and northern Norway, and as far south as Portugal. They are also found in the northern Adriatic Sea.

Environmental issues

Langoustines are caught mainly in nets trawled across the muddy sea floor, although a small number are trapped in individual creels. You can increase the sustainability of the scampi or langoustines you eat by choosing pot- or creel-caught rather than trawled, although this can be hard to find as most are exported. The Loch Torridon creel fishery has been certified as an environmentally responsible fishery by the MSC, but the catch is shipped weekly to Spain. Avoid eating scampi from stocks off the north and northwest Spanish and Portuguese coasts, as these stocks are depleted, hence the exporting of our stock to Spain.

Douglas Neil has been studying the life cycle of the langoustine in order to find out ways to catch it, store it and preserve its delicate flesh both for export and for local use, and in a responsible, sustainable manner. For several years, Neil's team, working in partnership with one of the seafood industry's giants, Young's Bluecrest, have been testing langoustines. They have concluded that stress can have a major impact on quality of flesh and can affect prices and catches, so they are trying to find out how best to treat them when they are first caught. If they can find out how to deal with the issue of stress, they will be on to a real winner.

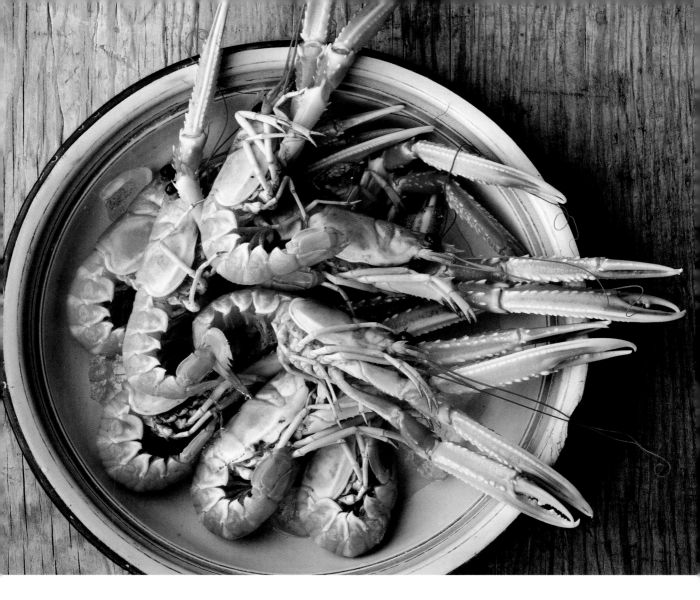

Territory	Local Name
UK	*Langoustine, Dublin Bay prawn, Norway prawn*
USA	*Langoustine*
France	*Langoustine*
Italy	*Scampo, Scampi (plural)*
Spain	*Cigala*
Portugal	*Lagostim*
Greece	*Karavida*
Holland	*Noorse kreeft*
Germany	*Kaisergranat*
Sweden	*Havskräfta*
Denmark	*Jomfruhummer*
Norway	*Sjøkreps, Bokstavhummer*

Health

Per 100 g/4 oz: 92 kcals, 0.8 g fat

Seasonality

Avoid fresh langoustine in April and May when the females are moulting (shedding their hard shells) and the flesh becomes watery.

boiled langoustines with mayonnaise

Serves 2

1 kg/2¼ lb langoustines
Sea salt and freshly ground black pepper

For the mayonnaise:

3 egg yolks
1 tbsp Dijon mustard
2 tbsp white wine vinegar
300 ml/10 fl oz/1¼ cups vegetable oil
Squeeze of lemon, to taste

To serve:

Lemon wedges
Fresh bread

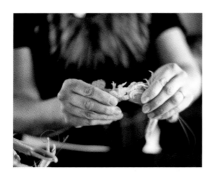

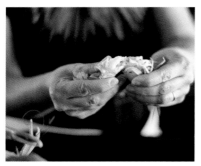

Langoustines are one of the sweetest shellfish. They can be bought live, chilled or frozen. Many chefs have the view that a live langoustine has the best texture and flavour, and I'm sure this is the case, *if* they are cooked straight from the water. However, I spent some time on a research vessel a few years back where the langoustine was being studied in great detail for environmental reasons. What was discovered was how the effect of stress affects the balance of sugars within the animal and how this ultimately affects the flavour. If a live langoustine is put into a tube, then into a box and posted, it is likely that it will undergo a great deal of stress, whereas a langoustine that had been brought to the surface slowly and chilled immediately in ice until it dies will suffer less stress and have better flavour. I did a taste test and, much to my amazement, it was true.

As langoustines have so much flavour, they are wonderful just eaten freshly boiled and cooled and served with creamy mayonnaise. When eating langoustines, don't forget the lovely meat from inside the head. Your first point of attack when eating them should be to twist the head from the tail and suck out the glorious meat from the head.

To cook the langoustines, bring a large pan of water to the boil and add a handful of salt. When the salt has dissolved, drop in the langoustines and cook for about 4–5 minutes. Drain and leave to cool.

To make the mayonnaise, whisk the egg yolks, mustard and vinegar together in a bowl. While whisking, slowly pour in the vegetable oil in a steady stream until you have creamy mayonnaise. Season to taste with salt, pepper and a squeeze of lemon.

Serve the langoustines in a pile with a bowl of mayonnaise, some lemon wedges and bread.

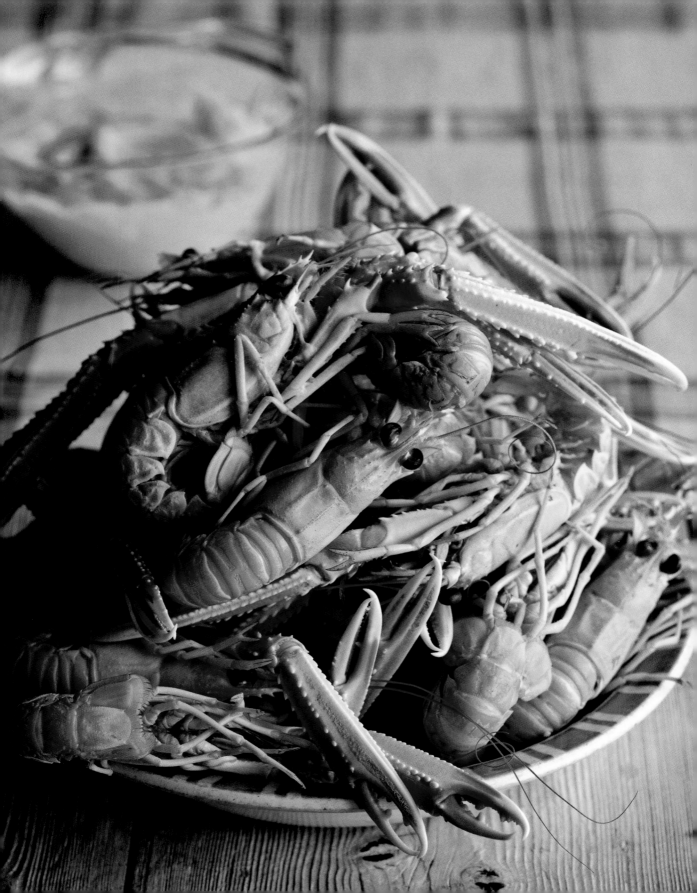

lobster

Homarus gammarus and *Homarus americanus*

Thought such a treat, it is often difficult to convince yourself to have something as simple and tasty as a lobster and mayonnaise sandwich, but I would heartily recommend it with an ice-cold beer on a hot summer's day.

Lobsters are well equipped for fighting, with a large crushing claw and a thinner one for cutting, and a hard protective carapace covering their head and thorax. Their stalked eyes keep a careful watch from the solitary rocky hollow where they live and flick out a pair of mini-antennae that are packed with receptors to smell passing prey, such as sea urchin, starfish or crab. These creatures can live up to 50 years.

The female carries her eggs under her tail for 11 months and she is protected by law. A few weeks after hatching, the larvae fall to the seabed where they dig a burrow and live for a couple of years before moving to a rocky hollow. The European lobster takes 5–7 years to reach 87 mm/3¼ inches – a minimum landing size set by the European Union (EU), although many local bylaws set this at 90 mm/3½ inches.

When alive, the European lobster is a beautiful dappled dark blue colour, while its American cousin is brown, but both turn red when cooked.

Taste description

Lobster claw, tail and brown meat all have different characteristics. The brown meat is very rich, with a creamy consistency similar to foie gras and a pronounced flavour of crustacean, as well as a subtle suggestion of saffron. In contrast, the tail flesh is much more compact with a mouth feel of firm calves' liver and a slight tooth resistance, but releasing plenty of juice at first bite. The aroma is reminiscent of steamed cabbage or seaweed, but the flavour is powerfully mineral. The green cabbage aroma is given off by the claw meat, too, but in a lighter cleaner way, and the flavour has the intense sweetness of a well sugared cup of tea. Its smooth liver-like texture intensifies towards the tip.

Territory

The European clawed common lobster (*Homarus gammarus*) is found in the Eastern Atlantic waters from the Arctic Circle to the Mediterranean; the British Isles is at the very centre of its territory. Its very closely related cousin, the American lobster (*Homarus americanus*), prefers the western side of the Atlantic.

Environmental issues

Avoid lobsters below the legal minimum landing size (87 mm/3½ in in the EU), egg-bearing or large animals (females), which contribute to the breeding stock. Lobster potting is the most selective fishing method.

Territory	Local Name
UK/USA	*Lobster*
Italy	*Astice, Elefante di mare*
France	*Homard*
Holland	*Kreeft, Zeekreeft*
Spain	*Bogavante*
Portugal	*Lavagante*
Greece	*Astakós, Karavida megáli*
Sweden/Denmark/ Norway/Germany	*Hummer*

Health

Per 100 g/4 oz: 103 kcals, 1.6 g fat

Seasonality

Lobsters are at their poorest after spawning in June and at their very best early spring or late autumn. Their season runs from April or May to October. The sweetest-tasting lobsters are around 450–675 g/1–1½ lb when they are 9–12 years old.

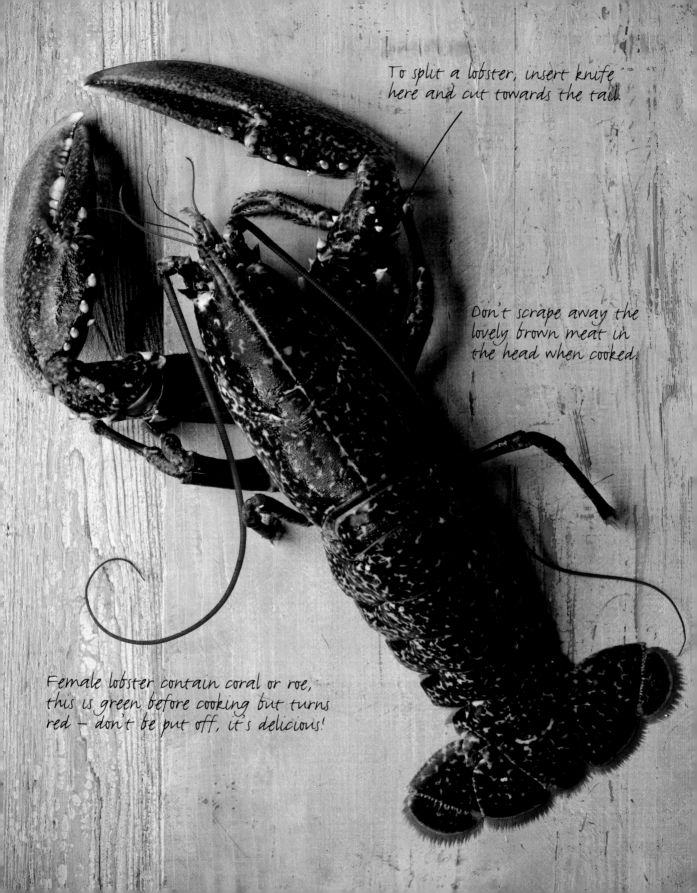

To split a lobster, insert knife here and cut towards the tail.

Don't scrape away the lovely brown meat in the head when cooked.

Female lobster contain coral or roe, this is green before cooking but turns red – don't be put off, it's delicious!

rock lobster *Panulirus cygnus*

The Western Australian Rock Lobster (WARL), also
known as the crayfish, has the standard issue lobster
body encased in a dark purplish-brown carapace,
which grows to about 8–10 cm/3–5 inches. The
youngsters live in caves and reefs in shallow water
up to 30 m/98 ft, adults up to 60 m/197 ft deep.
The lobster likes to live in its own rocky crevice,
coming out at night to hunt pretty much anything,
including other lobsters.

They are sexually mature around 6 or 7 years old,
spawning between August and January. In the first 3 years
youngsters grow 4 cm/1½ inches a year, reaching full
size at around 10 years, and can live for around 30 years.

Taste description

Characterized by beachy iodine-laced notes of seaweed
and sea spray, the aroma of freshly cooked rock lobster
is fleeting, although it does develop a suggestion of
almond as it cools. The flavour is rich, especially in the
flesh closest to the shell with elements of saffron and a
slightly bitter, metallic note that's balanced by a nutty
depth and a gradually released sweetness. Initially juicy
but firm, with a slight crunch reminiscent of a ripe
apple or pear, the texture of the pure white flesh
becomes increasingly tender as it's chewed.

Territory

WARL are restricted primarily to the west coast of
Australia between the Northwest Cape and Hamelin
Harbour in the Indo-West Pacific Ocean region.

Environmental issues

The WARL fishery has been practising responsible
management since 1963 and was one of the first in
the world to be certified ecologically sustainable by
the Marine Stewardship Council, in 2000. Lobsters are
harvested using baited pots, and these pots are required
to have escape gaps. There can be a small by-catch
of other fish and octopus species using this method.

By limiting the fishing season, having a minimum
size requirement for the caught lobsters, protecting
breeding females, limiting how many lobsters can be
caught, and restricting the size of the lobster pots, this
fishery is thriving and sustainable.

Territory	Local Name
UK	*Rock lobster*
Australia/	
New Zealand	*Crayfish, Rock lobster*
USA	*Southern rock lobster*
Holland	*Langoesten*
France	*Langouste*
Germany	*Panzerkrebse*
Greece	*Astakos*
Italy	*Aragosta*
Spain	*Langosta*

Health

Per 100 g/4 oz: 112 kcals, 1.5 g fat

Seasonality

Fishing is done off the coast of Western Australia between
November and June every year. But frozen tails can be eaten
all year round.

lobster cooked 'Fornells-style'

Serves 2

1 live lobster, about 750 g/1½ lb

Sea salt

1 red pepper

1 green pepper

3 garlic cloves

50 ml/2 fl oz/¼ cup olive oil

Splash of brandy

125 ml/4 fl oz/½ cup white wine

Pinch of saffron strands

1 small dried bird's-eye chilli

4 tomatoes, finely chopped

450 ml/15 fl oz/generous 1¾ cups fish
 soup or shellfish stock

300 ml/7 fl oz/scant 1 cup water

Handful of fresh parsley, finely chopped

In the north of the magical island of Menorca is a village called Fornells, famed for its lobster fishery and indeed a local lobster stew called *Calderetta*. Anyone who has been there will reminisce about the wonderful rich flavour of the sauce and the sublime texture of the lobster that tastes so good enjoyed out in the open in the warm Mediterranean air. I can say my first bowl of it was a milestone in my culinary education and it is a flavour I won't forget – that amazing unique crustacean taste left me literally licking the bowl. I could almost taste the sea, and with a few glasses of cold crisp wine, it was just perfect.

The lobsters in Menorca are different, they are in fact crawfish and have no claws, the meat is pure white and firm, and the flavour extremely rich. Somehow the shell of the fish does flavour the sauce in a way that nothing else can. However, I have made this successfully with my local lobster. I have also cheated a little by using a jar of bisque or fish soup in place of shellfish stock.

First, blanch the lobster in a large pan of boiling salted water for 5 minutes, then leave to cool.

Place the peppers and garlic in a food processor and blitz until finely chopped. Remove the claws from the lobster and crack open to remove the brown meat and reserve. Split the rest of the lobster in half and into chunks, leaving the meat in the shell.

Heat the olive oil in a large pan, add the chopped peppers and garlic and fry gently for 5 minutes. Add the lobster chunks and cook for a further 5 minutes. Add the brandy and boil for about a minute, then add the wine and boil for another minute. Add the saffron, crumble in the chilli and add the tomatoes, 175 ml/6 fl oz/¾ cup fish soup or shellfish stock, the water and half of the parsley. Cover with a lid and cook gently for 10 minutes.

Next, add the reserved brown meat from the lobster and cook for a further 10 minutes, uncovered. Sprinkle over the remaining parsley and serve.

lobster thermidor

Serves 4

4 live lobsters
Sea salt and freshly ground black pepper
1 onion
1 bay leaf
8 whole black peppercorns
200 ml/7 fl oz/scant 1 cup milk
25 g/1 oz/2 tbsp unsalted butter
1 tbsp plain flour
1 tsp English mustard
2 garlic cloves, crushed
25 ml/1 fl oz/2 tbsp brandy
Handful of fresh tarragon leaves, chopped
1 tbsp finely grated Parmesan cheese

AT THE FISHMONGER
Buy lobsters live and either cook
them yourself or ask your
fishmonger to do this for you.

I think lobster thermidor represents luxury. It is a dish known to most people, and although I haven't been a great fan in the past, I must admit there is something very comforting and indulgent about it. Cooked well it can be delicious.

To cook the lobsters, bring a large saucepan of salted water to the boil, add the lobsters and cook for 8–10 minutes. Remove the lobsters from the water and leave to cool, then cut in half lengthways from the head to the tail and remove all the meat, separating the dark and coral from the white meat, and pick all the meat from the claws. Reserve the shells for serving.

Make a slash in the onion and insert the bay leaf, then stud the onion with the peppercorns and place in a large saucepan with the milk. Bring to the boil, reduce the heat and simmer for 2–3 minutes. Remove the pan from the heat and leave for about 10 minutes to infuse. Remove the onion and discard.

Melt half the butter in another pan over a low heat. Stir in the flour until you have a creamy paste, then take the pan off the heat and slowly add the milk, stirring all the time until the sauce is thick and there are no lumps. Return to the heat and gently warm for 2–3 minutes until the sauce thickens. Stir in the mustard and set aside.

Preheat the grill to high.

Melt the rest of the butter in a large saucepan, add the garlic and fry gently for 1–2 minutes, allowing the butter to become well flavoured. Add the lobster meat, stirring it around so that it becomes coated in the garlic and butter, then pour in the brandy and set alight. Pour the reserved sauce into the pan and add the tarragon. Stir and season to taste with salt and pepper. Place this mixture back in the reserved lobster shells, sprinkle over the Parmesan cheese and place under the grill for 1–2 minutes until golden on top. Serve, accompanied by rice or salad if wished.

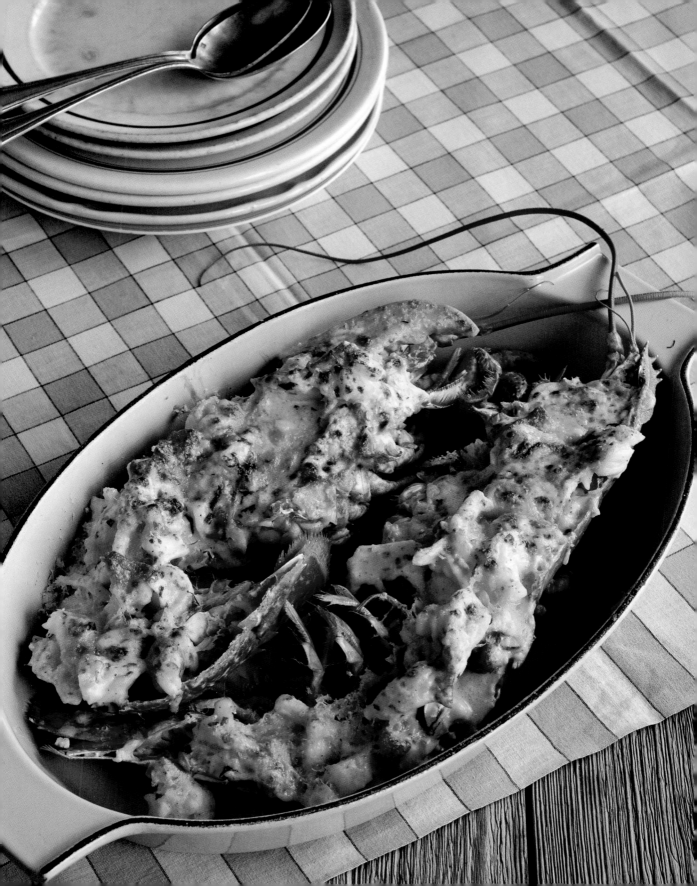

mussels *Mytilus edulis*

Plump, tender, sweet and arriving in a variety of sizes, the mussel is a mainstay of French cuisine, with *moules et frites* occupying many a French menu. Cheap, readily available and a good source of protein, I love them raw with a squeeze of lemon, grilled with garlic, breadcrumbs and parsley, or steamed and served in a sweet and sour chilli sauce.

Mussels are stunning bivalves with rich turmeric-coloured flesh contained within a purplish blue-black shell sculpted with concentric lines. They may vary in size and colour, depending where they are from, and can reach up to 13 cm/5½ inches long, but are more usually 5–8 cm/2–3 inches. The name 'mussel' comes from the Latin and Greek word *mus* meaning 'mouse', and looking at it sideways you can see a mouse-like profile.

Mussels live in clusters or mussel beds in coastal zones. The largest mussels settle in the food-rich tidal zone, while the smaller ones live in less turbulent deep water. Mussels are filter feeders working like efficient pumping stations drawing out nutrients and oxygen from the seawater – a medium-sized mussel pumps over 1 litre/1¾ pints of water an hour.

Mussels use a fine strong thread, the size of a human hair, called a byssus, to attach themselves to structures or other mussels. This is produced by a gland near the foot and is made of keratin and other proteins. They also use this thread to move around and in time come to rest on the seabed, often attaching themselves to fellow mussels or to rocks, poles, pier struts or the underside of a boat, which may take them to other parts of the world.

Taste description

If any one seafood distils the essential nature of the sea, it's the mussel. That oceanic character is especially pronounced in its aroma – a blend of surf and fresh seaweed with an underlying saffron-like spicy note. The initial mouth feel is silky, the exterior of the mussel having a smooth texture like a rich mousse. Bite in, and the feel shifts to a rich, almost egg-yolk-like liquidity, releasing flavour notes of fennel seed and a mild brininess. The interior is firmer, with a chewiness comparable to bacon rind.

Territory

This species has an extensive range from the southern Arctic, throughout the North Atlantic, down to North

Territory	Local Name
UK	*Mussel*
USA	*Blue mussel*
France	*Moule*
Italy	*Cozza*
Spain	*Mejillón*
Portugal	*Mexilhão*
Greece	*Mydi*
Denmark	*Blåmusling*
Norway	*Blåskjell*
Sweden	*Blåmussla*
Germany	*Miesmuschel*
Holland	*Mossel*

Health

Mussels are a good source of selenium, vitamin B12, zinc, folic acid, iron, calcium and omega-3 oil.
Per 100 g/4 oz: 74 kcals, 1.8 g fat

Seasonality

Mussels are only in season when there is an 'R' in the month, so September to April. Avoid mussels when they are spawning from May to August.

Carolina, the North Sea and Baltic Sea, and right down to the Mediterranean. They are common all around the coast of the British Isles, with large commercial beds in the Wash, Morecambe Bay, Conway Bay and the estuaries of southwest England, north Wales and west Scotland.

Environmental issues

Mussels are widely cultivated in the UK, France, Spain and Holland and stocks are generally considered to be under-exploited. The main methods of harvesting wild and farmed mussels are dredging and hand gathering. Choose mussels that have been harvested in the wild by hand gathering or go for farmed mussels.

Mussel farming

Shellfish aquaculture is a very sustainable way of farming. Rope-grown mussels are probably the most sustainable form of this. You dangle a rope in the sea from a buoy or raft and the mussel spat that's naturally in the water will settle on it, forming large colonies that require no feeding or antibiotics and are fully organic. After a few years, you pull the rope out of the water, pluck the mussels off and put the rope back into the water.

In New Zealand they have a vast open-water mussel farm just a couple of miles offshore, where the ocean water sweeps through the farm. It's not an easy option as there are access problems and weather conditions limit when they can harvest, but there is great potential to supply the consumer with a premium product from Grade A waters. The other huge plus factor is that these ropes act in the same way as reefs – they attract all sorts of marine life and fish into the area.

If a mussel is open, give it a tap – a live one should close, if it doesn't throw it away. Similarly, if a mussel doesn't open during cooking, discard it. This simple rule also applies to cockles and clams.

steamed mussels with wine and parsley

Serves 4

50 g/2 oz/4 tbsp butter

3 garlic cloves, finely chopped

2 shallots, finely chopped

Good handful of fresh parsley,
 finely chopped

100 ml/3½ fl oz/generous ⅓ cup dry
 white wine

2 kg/4½ lb live mussels

To serve:

Crusty bread

AT THE FISHMONGER
Make sure the mussels you are
buying are tightly closed. Avoid
mussels that are covered in mud.
If you have any mussels that are
open by the time you get them
home, give them a tap and they
should close, if not discard them.
Mussels can be stored at the
bottom of the refrigerator covered
in damp newspaper for up to
24 hours.

I have eaten a number of preparations for mussels but nothing works quite as well as a simple *marinière*; it's all down to the quality of the mussels. The only other flavour I do like with mussels is fresh tomato and chilli. At home during the summer months, I bottle my own glut of tomatoes and they will often find their way squeezed into a nice bowl of steaming mussels.

Melt the butter in a saucepan, add the garlic and shallots and gently fry until softened. Add a little bit of parsley then the wine and boil for just a minute or so. Add the mussels and, using a large spoon, turn the mussels so that they are covered with the parsley and juices. Cover with a lid, give the pan a shake and allow the mussels to steam open, about 4 minutes. Discard any mussels that remain closed.

Add the remaining parsley, then using a large spoon, turn the mussels, making sure that each one gets coated in the buttery garlicky juices.

Serve immediately in large bowls with crusty bread.

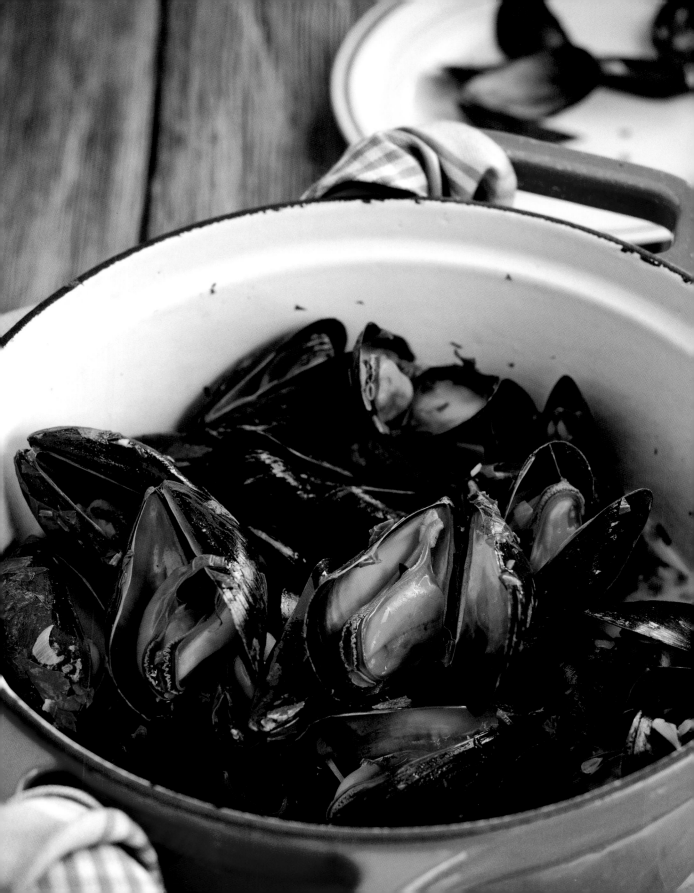

oysters *Ostrea edulis* and *Crassostrea gigas*

Oysters are best consumed direct from the shell or using an oyster fork. Don't just swallow your oysters, be sure to chew and properly taste the flesh. Popular accompaniments are a squeeze of lemon, a dash of Tabasco or finely chopped shallots in vinegar.

The oyster's natural habitat is estuarine and shallow coastal water with a firm muddy seabed. The almost pear-shaped shell is off-white to cream with rough, scaly concentric bands in a bluish or brown hue. An elastic ligament hinged to the lower, bowl-shaped shell attaches the flat upper shell and the inside is pearly white or bluish-grey. Oysters filter 1–6 litres/1¾–10½ pints of seawater an hour, drawing their nutrition and oxygen from it. Spawning begins in March or April depending on the water temperature.

Oysters have always been linked with love. Aphrodite, the Greek goddess of love, emerged from the sea on an oyster shell and promptly gave birth to Eros and the word 'aphrodisiac' was born. There may be some basis for their aphrodisiacal association because of the zinc they contain, which is required for the production of testosterone in humans. The French recently discovered that the *nacre*, or mother of pearl, that oysters produce may be used to stimulate bone growth in humans just as it does for a cracked oyster shell.

Taste description

Native oysters (*Ostrea edulis*)

While native oysters have the same overall oceanic smell and taste of Pacific oysters, their character is more complex with flavour notes of fresh seaweed as well as the suggestion of citrus-like and faintly metallic elements. Although the texture isn't quite as creamy or juicy as that of the Pacific oyster, this multi-layered, fine flavour means that they are considered to be the superior of the two types.

Pacific and rock oysters (*Crassostrea gigas*)

With a large, long, deeply cupped shell, Pacific oysters have a flavour and aroma that sums up the sea, like the ozone-like tang of ocean spray or the briny freshness of newly exposed rock pools. Take a first sip of the juice in which the oyster sits, and the taste is slightly salty; take a second, and it's much purer and lighter – this is the fluid held within the folds of the oyster itself. When chewed the meat is unctuous and sweet.

Territory	Local Name
UK	*European or Native oyster*
USA	*Pacific or Rock oyster*
France	*Huître, Huître plate*
Holland	*Oester*
Spain	*Ostra*
Italy	*Ostrica*
Portugal	*Ostra plana*
Greece	*Stridi*
Sweden	*Ostron*
Denmark/Norway	*Østers*
Germany	*Auster*

Health

Oysters are high in protein and low in fat. They are rich in zinc and contain many other minerals such as calcium, iron, copper, iodine, magnesium and selenium. They are also a good source of omega-3 oil. Per 100 g/4 oz: 65 kcals, 1.3 g fat

Seasonality

As natives are a protected species, they may only be harvested outside their spawning season, which runs from the start of May to the end of August. Eat them when there is an 'R' in the month. Native oysters eaten close to the spawning season can be 'milky' with a cloudy juice, a softer, pulpier texture and a less fine flavour, so late September to late March ensures you get the best of the season. Pacific oysters are available all year round.

Territory

Oysters are found throughout European waters and around the whole of the UK from the Thames estuary to the Northern Isles, and Ireland. The Solent is the UK's largest native wild oyster fishery. The Pacific oyster is found from southeast Alaska to Baja, California.

Environmental issues

In the UK, the wild native oyster is listed as threatened and declining in the North Sea and English Channel; the same is true throughout most of the European waters. The Solent in Hampshire is one of the few wild native oyster-producing areas in the UK, and also the largest. While these oysters are spawning, from 14 May–4 August (1 May–31 October in Sussex Sea Fisheries District), the season is closed in order to protect them. The native oyster is the subject of a Species Action Plan, which aims to maintain and expand its distribution in UK waters. Seeded oyster fisheries are generally privately owned and managed. They have a low impact on the surrounding environment, as high water quality standards are required for cultivation of shellfish for human consumption.

When buying oysters, make sure that the shells are tightly closed just as you would with mussels and clams. It is important that the oyster remains alive in its shell and its own water – once this leaks the oyster will die and could be unsafe to eat. The two main types of oysters at the fishmonger are the native European oyster, which is round and flat and the meat is firm and sweet, and the Pacific or rock oyster, which has a deep bottom or cup and a flat top shell with a pointed end. The preferred provenance of an oyster is a personal choice and they can be quite different in flavour depending on where they are grown. You either love oysters or you hate them, I don't think there is anything in between! I am an oyster fan and I love to eat them just as they are. However, if this is not for you, try these two great ways of preparing oysters – they are both delicious.

oyster tartare

Finely chop a shallot, a tablespoon of capers and a tablespoon of gherkins. Mix them together with a few drops of Tabasco, then sprinkle this mixture over the top of your freshly shucked oyster with a squeeze of lemon to taste.

grilled oysters with bacon

Open your oysters, sprinkle on some very finely sliced smoked bacon, a splash of Worcestershire sauce, a teaspoon of cream and a fine sprinkle of Parmesan, then grill for 3–4 minutes.

prawns/shrimp

common prawn *Palaemon serratus*
brown shrimp *Crangon crangon*

Prawns, it seems, are enduringly popular, maybe because they are sweet and don't taste too strong. They will take on some powerful flavours and work especially well with hot, spicy Thai flavourings or the smoky charcoal of the barbecue.

The brown shrimp is a rather drab creature before it is cooked – a semi-translucent riot of mottled sandy brown, which is perfect for blending into the sandy or muddy flats of the shallow bays and inlets it frequents. It lives in a burrow, emerging at night to feed on small molluscs and tiny fish, and grows to around 8.5 cm/3⅓ inches.

Its similar-sized cousin, the common prawn, shares many of the same features. Both have five pairs of legs, two pairs of antenna and compound eyes on stalks. The front pair of legs have nippers, which are larger in shrimps, and finally five pairs of swimming legs flutter away at the rear of the body. They can also snap their abdomen and flick their fan-shaped tail to shoot backwards at speed, but one distinctive difference is the prawn's head is extended in front to form a spike. The prawn is virtually translucent with a dappling of brown, blue or yellow, which turns to a stunning coral pink when cooked – the French call them *bouquet rose*. This is a shellfish you can catch yourself in rock pools in early autumn, when they are at their plumpest. Populations move offshore in winter, returning in spring.

There is another prawn worth mentioning and this is the larger northern or deep-water prawn (*Pandalus borealis*), which can grow to 15 cm/6 inches. They are trawled in large quantities in Norwegian waters and cooked at sea – their tails a familiar ingredient for the famous prawn cocktail.

Taste description
Common prawn
Common prawn shells are so thin that they can be left on for eating, adding a pleasantly crunchy counterpoint

Territory	Local Name
UK	*Common prawn/Brown shrimp*
USA	*Shrimp/Brown shrimp*
France	*Crevette rose/Crevette grise*
Denmark	*Roskildereje/Hestereje, Sandhest*
Germany	*Sägegarnele/Garnele, Krabbe*
Holland	*Steurgarnaal/Garnaal*
Norway	*Strandreke/Hestereke*
Italy	*Gamberello/Gamberetto grigio, Gambero della sabbia*
Sweden	*Tångräka/Sandräka*
Spain	*Camarón, Gamba/Quisquilla gris*
Greece	*Garidáki/Psili garida*
Portugal	*Camarão branco/Camarão negro*

Health
Brown shrimps are a good source of omega-3.
Per 100 g/4 oz of prawns: 96 kcals, 0.5 g fat
Per 100 g/4 oz of shrimps: 68 kcals, 1.4 g fat

Seasonality
Brown shrimps are available all year round. Avoid the common prawn during its spawning period from November to June, and they are at their very best from August to October. The northern prawns are best avoided during their summer and autumn spawning season.

to the firm flesh, which is resistant to the bite at first, then yielding. The aroma is intensely oceanic – sweet, salty and fresh – and the flavour is reminiscent of potted shrimps, honeyed and buttery with a subtle suggestion of spice and a rich, lingering aftertaste. Their flavour and texture means that they are perfect to use in the recipe 'a pint of prawns' or to briefly deep-fry with their shells on.

Brown shrimp

Smelling sweetly of an oceanic blast of fresh sea air, brown shrimp pack a lot of flavour into their small forms with notes of salted caramel and the mild acidity of the flesh of a green apple that has browned on exposure to the air. The texture is juicy and soft, a little like the tender inner leaves of cooked sweet cabbage with the tooth-packing character of chicken breast. The sugared flavour and yielding texture pair up well with spaghetti with garlic and parsley.

Territory

Brown shrimps are found on sand and muddy bottoms in shallow inshore waters from Norway down to the Mediterranean. Their American equivalent is found from Baffin Bay to Florida. Common prawns are found in shallow inshore water from Norway down to the Mediterranean and northern or deep-water prawns are found in deep offshore waters from Greenland down to Martha's Vineyard (an island off the US east coast) in the west and Britain in the east.

Environmental issues

Shrimp fisheries are an important part of the European Union's fishing industry. However, the fine-meshed trawl nets used to capture brown shrimp also catch high levels of non-target species, including juveniles of other commercial species like flatfish, cod and haddock. Brown shrimp fisheries have caused losses of up to 16% of the North Sea spawning stock of plaice. This incidental capture can be reduced through the use of 'by-catch reduction devices' (BRDs), which retain shrimp, but allow more fish to escape from nets unharmed. BRDs have been used very successfully to reduce by-catch in the cold water shrimp fisheries of Canada, Iceland and Norway.

Choose brown shrimps caught in trawls fitted with veil nets and separators, which reduce the by-catch of non-target and juvenile fish and shrimps, or use the tractor-caught shrimp from Morecambe Bay. Increase the sustainability of the fish you eat by choosing only prawns taken in fisheries using sorting grids to reduce the by-catch of non-target species.

Prawn fishing in South Australia

Andy Puglisi fishes for western king prawns in the Spencer Gulf. This is probably one of the most well-managed and sustainable prawn fisheries in the world:

"Each season we identify the areas to trawl, we also restrict the size of vessel, the power they tow with and the size of net they are allowed. Instead of having a quota that can be abused, we restrict the time you can fish. We go out and catch fish between the last quarter of the moon and the first quarter of the moon. Prawns come out at night so we do 50-minute trawls continuously from sundown to sunrise. We also have real time management. A committee of fishermen – we call them the 'Committee at Sea' – monitor the prawns on an hourly basis. If we go into an area and find that small prawns are turning up, we report this and our Committee at Sea will shut that area. It's closed officially within an hour by the government.

Over time we have focused on the spawning cycles of the prawns. We wait until the majority have spawned before we start fishing. When my father was fishing they trawled for 200 nights a year; we've reduced that down to between 55 and 60 nights and yet we're still catching the same amount of prawns. We have deck machinery on board that returns our by-catch back to sea within minutes of hitting the sorting tables, so 95% of our by-catch is returned alive.

For our fishery the key is to fish for a set period of time, but every fishery will have a means of sustainable harvest. The difficult part is to get fishermen to realize this. It's the fishery that needs to be looked after."

spaghetti with garlic, parsley and fresh prawns

Serves 4

300 g/10 oz dried spaghetti

75 ml/3 fl oz/⅓ cup olive oil

600 g/1⅓ lb prawns, shelled but reserve the shells and heads

2 garlic cloves, finely sliced

50 ml/2 fl oz/¼ cup dry white wine

100 ml/3½ fl oz/generous ⅓ cup good-quality passata or roughly chopped fresh ripe tomatoes

2 tbsp fresh parsley, finely chopped

Sea salt and freshly ground black pepper

AT THE FISHMONGER
Look for prawns whose heads are firmly attached to the body with no sign of blackening in the head. This is the effect of what is known as melanosis as the prawn deteriorates in quality since defrosting or being caught.

Unless you actually live near a prawn fishery, the likelihood is you will not be able to buy fresh prawns. Often on my holidays in the Balearics I will buy fresh prawns from the fishermen as they land their catch in the evening, I consider this an incredible treat as the catches are so small, but the flavour of the Mediterranean prawn is, in my eyes, unrivalled and I will spend the year looking forward to being able to buy some. In between times I use frozen prawns. In the main they are caught and frozen at sea or at the farm and then sold defrosted in their chilled state, or more often as a frozen prawn. I like to buy wild-caught prawns where possible but I'm happy to use good-quality farmed prawns when these are not available.

Cook the spaghetti in a large saucepan of boiling salted water according to the packet instructions until just tender but still firm to the bite. Drain.

Meanwhile, heat the olive oil in a frying pan, add the reserved prawn shells, heads and garlic and fry for 4–5 minutes until the garlic is golden and crisp and the shells have imparted their flavour into the olive oil.

Using a slotted spoon, remove the shells and garlic, then add the raw shelled prawns and cook for 3–4 minutes. Add the wine and boil for 2–3 minutes, then add the passata or tomatoes and cook for a further minute. Add the parsley and spaghetti and toss together. Season with salt and pepper and serve.

shrimps on toast

Serves 2

Thick bread, for toasting
75 g/3 oz/6 tbsp butter
150 g/5 oz shelled brown shrimps
Pinch of ground mace
Sea salt and freshly ground white pepper
1 tbsp fresh parsley, very finely chopped
Cayenne pepper, for sprinkling (optional)

To serve:
Lemon wedges

AT THE FISHMONGER
Luckily you can buy shelled brown
shrimps, otherwise it is a lengthy
process to peel your own. You will
always buy them cooked as this is
done on board the boat.

Small brown shrimps caught around Morecambe and Silloth in the UK are absolutely superb. I like to buy them in quantity and pot them in butter to spread on hot thick toast. At the restaurant there is always debate as to whether potted shrimps should be served at room temperature or warm. When I visited Ray's shrimp fishery in Silloth in Cumbria, one of the oldest shrimp producers there, they were fairly adamant that potted shrimps should be served melted and then spooned on toast. I have to say I like them both ways and I also like them gently warmed in melted butter with just a few spices and poured over thick toast – the toast absorbs the wonderful butter and the shrimps remain beautifully firm, as in this recipe.

First, toast the bread. Melt the butter in a saucepan with the mace and salt and plenty of white pepper for a minute or so. Add the shrimps and heat through. Add the parsley and spoon the mixture over the toast. The dish can be spiced up a little by a sprinkling of cayenne pepper, if you like.

king and queen scallop

Pecten maximus and *Chlamys operculis*

The scallop is unable to completely shut its shell, so it keeps watch with 50 green-ringed blue eyes embedded at the base of a frill of short sensory tentacles, which run along the outer edges of its upper and lower shells, and allow it to sense shadow and movement. When it senses danger it rapidly opens and closes its shell with a single, over-sized adductor muscle, the jet of water that results propels it through the water and out of trouble. Scallops are the only bivalve that can swim and they migrate in large schools throughout the year, moving to deeper waters in winter or to better feeding grounds where they filter feed.

Tiny scallops attach themselves to seaweed or rocks, setting themselves free when bigger to snap around the ocean. The off-white to pinkish ribbed shell can grow to around 15 cm/6 inches in a king scallop, which can live to 20 years, and 10 cm/4 inches in the queen, which can live for up to 4 years – their ages are reflected in the concentric rings of their shells.

Taste description

King scallop (*Pecten maximus*)

Milkily transculent when raw, pure opaque white when cooked, king scallops have a unique texture, with long, thin, soft but densely packed fibres that give each one a striated appearance. The mouth feel is melting with a creamy, almost foamy quality, a bit like a marshmallow. The aroma has a caramel sweetness; that mellowness is carried through on the flavour, but is given an added layer of complexity with a hint of ozone-like seaweedy freshness. The roe (sometimes called the coral, on account of its warm orange colour) has a distinctively iodine-like, piscine taste, and a slippery, elastic texture; the bigger the roe, the silkier the mouth feel, though the bitterness can be quite pronounced in larger examples.

Queen scallop (*Chlamys operculis*)

In contrast to the caramel sweetness of king scallops, queens have a milder, more vanilla-like, honeyed aroma and a full-bodied sugared flavour with a slight hazelnut note. The texture is firmer, with a long-lasting, rich mouth feel and a more obviously stranded structure.

Territory	Local Name
UK	*Scallop, Great scallop / Queen scallop, Queenies*
France	*Coquille Saint-Jacques / Vanneau*
Spain	*Vieira, Concha de peregrino / Volandeira*
Italy	*Ventaglio*
Portugal	*Vieira / Vieira*
Greece	*Kténi*
Denmark	*Kammusling / Kammusling*
Germany	*Jakobsmuschel*
Holland	*St Jacobsschelp / Kammosel*
Norway	*Kamskjell / Harpeskjell*
Sweden	*Kammussla / Kammussla*

Health

Scallops are rich in protein and a very good source of omega-3 oils. They are also high in Vitamin B12, and a good source of key minerals, such as copper, iron, manganese, phosphorus, selenium and zinc.
Per 100 g/4 oz: 92 kcals, 0.5 g fat

Seasonality

Avoid scallops during their spawning period from June to August. They take a while to recover from this process so steer clear from mid-September to early December when they will be back to their plump best.

Territory

Scallops range from Norway to the Iberian peninsula. Some of the best scallop farms are off the west coast of Scotland. Queens are usually found in deeper waters than the great or king scallop.

Environmental issues

Hand-dived scallops are generally better quality and larger than scallops dredged off the seabed. It's a more selective method which causes no damage to the seabed compared with scallop dredging (though not without its own issues – see below). Diving is restricted to 30 m/98 ft depth, creating a natural 'refuge' for wild populations to regenerate. Farmed scallops are dredged from cultivated beds in much the same way as they are dredged from wild or natural beds. Choose scallops from responsibly managed farms.

Scallops – to dredge or not to dredge?

Dr Tom Pickerell

Dredging for scallops is a high-impact method of fishing. The big issue is: does high impact mean destructive if you're dredging over a muddy gravel or sand bank? Dredging stirs the seabed up but if there are no corals or complex biological structures there, it doesn't have the same sort of impact. Could there be areas where dredging for scallops would be accepted by conservation groups?

Dr Tom Pickerell, of the Shellfish Association of Great Britain, comments:

"If one totally banned all dredging then the only scallops on sale would be diver-caught ones. That simply will not meet the demands of the market. We would have to source our scallops from other countries and this would have a social-economic effect on our own fishing fleet, as well as clocking up food miles and raising questions about how those countries manage their fisheries. There's no question that diver-caught scallops tend to be better quality than dredged ones. But the system is open to abuse. Scallops are not a species regulated by quota so divers can take as many as they like. For example, if you have a crevasse with scallops in it, dredgers can't get at these, but divers can. If they gathered all the scallops there, they'd wipe out the localized population, which may itself be seeding a much larger fishery. Also divers tend to gather the bigger scallops that are genetically more successful – the larger you are, the higher your reproductive success. So it's fair to say that diver-caught scallops have their own issues, as do dredged ones."

scallops Seahorse-style

Serves 2

2 garlic cloves

Handful of fresh parsley leaves

2 salted anchovy fillets

Splash of Tabasco

100 g/4 oz/8 tbsp butter

6 fresh scallops

1 tsp fresh tarragon, finely chopped

6 tbsp white wine

6 tbsp olive oil

Sea salt

6 tbsp fine breadcrumbs

AT THE FISHMONGER
Buy scallops that are still in the
shell and ask your fishmonger to
clean them for you, reserving the
cut half of the shell. Leave the rose
on, as these are delicious. Do not
buy scallops that look milky or are
sitting in a puddle of water, as
these will undoubtedly have been
soaked and their flavour and
texture will be poor.

The Seahorse is the latest restaurant I have opened with my chef and great friend Mat Prowse and old school friend Mark Ely. It is a relaxed sort of place that gives you the impression it has been there for years; it's nice and comfortable just as a restaurant should be. We do serve some local meat, but in the main the restaurant is known for its great seafood, which is cooked over charcoal or just prepared simply according to the seasons and served unadorned, so our guests can appreciate the fabulous seafood that's caught just outside our door. This scallop dish is a favourite with our diners.

Preheat the oven to 240°C/475°F/Gas Mark 9.

First, make the garlic butter. Place the garlic, parsley, anchovy fillets and butter in a food processor with a splash of Tabasco and blitz until smooth.

Place a scallop in each shell, keeping the rose on. Sprinkle each one with a little tarragon, then add 1 tablespoon of wine to each scallop and 1 tablespoon of olive oil. Season with a little salt, then place a teaspoon of garlic butter on the top of each scallop. Sprinkle breadcrumbs over each one.

Place the scallops in a roasting dish and cook in the oven for 5 minutes. The breadcrumbs should be nicely browned, the scallops firmed up and the olive oil, garlic butter and wine all bubbling together. Serve 3 scallops to a plate or one plate of 6 to share and get stuck in.

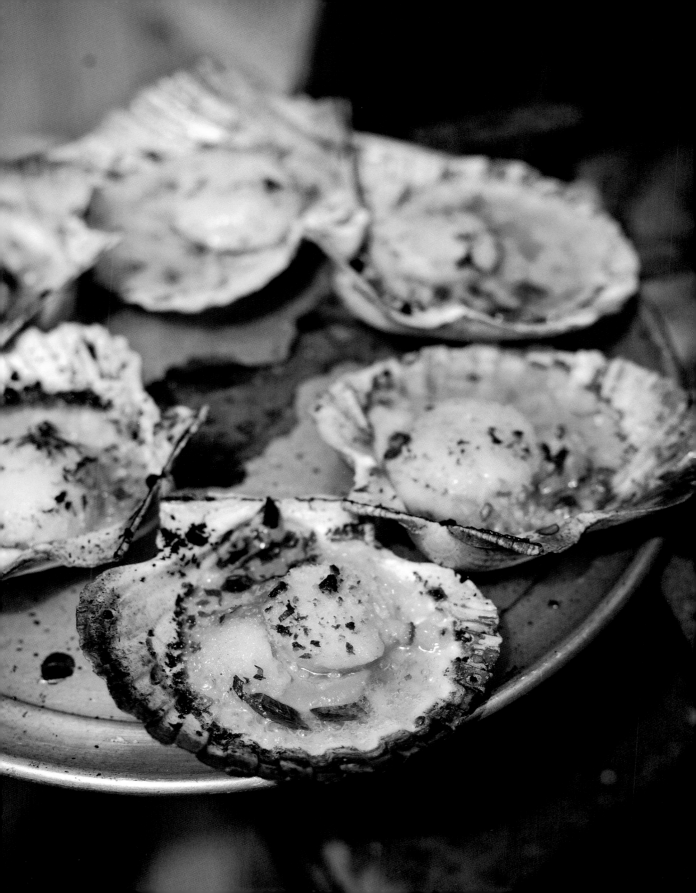

squid

Loligo forbesi and *Loligo vulgaris*

With eyes that focus like a camera, and three pale green hearts, the squid is a highly intelligent lethal predator – not to be messed with. Giant squid reach up to 13 m/42 ft, but the particular species we are more familiar with and found on the fishmonger's slab is a more modest 40–60 cm/ 16–24 inches. The ubiquitous dish of squid, deep-fried for a few seconds in light crisp batter, is better known and adored in Europe by its Spanish and Greek name, *Calamari*.

The squid's cylindrical body has triangular fins either side, but its main source of propulsion is jet power. Water is sucked into the body cavity and expelled at speed through a siphon, which can even be directed to change the direction of travel. If it wants to sneak up on unsuspecting prey or to vanish, colour-changing cells in its skin enable it to blend into its surroundings. If all else fails then it squirts black ink straight at its pursuer. By the time it has cleared the squid is long gone. With eight arms ably assisted by two longer feeding tentacles, catching a passing fish, or indeed a fellow squid, is easy.

Loligo forbesi has a very short one-year life cycle with a single breeding season from December to May.

Taste description

Pan-frying is one of the best ways to bring out the flavour of squid. Cooked that way, it takes on a distinctly sweet aroma of toasted hazelnuts and toffee praline. Those sweet, nutty elements are echoed in the taste, which features intense notes of caramel and chocolate and condensed milk with a slight oceanic saltiness. When cut with a knife, the pure white flesh yields like soft rubber. However, none of that rubbery quality is evident in the mouth – instead, it has the texture of a firm *panna cotta* and, although the characteristic squeak that it makes against the teeth would suggest a dry texture, it gives out a considerable amount of juice.

Territory

Loligo forbesi is widespread throughout the northeast Atlantic as far south as the English Channel. Further south, and in the Mediterranean, it is replaced by the very closely related *Loligo vulgaris*.

Environmental issues

Annual breeding and a fast life cycle have meant squid has remained pretty good on the sustainability front. However, avoid eating squid taken in industrial or large-scale commercial fisheries that remove large quantities of squid at the base of the food chain.

Territory	Local Name
UK	*Squid, Inks*
USA	*Squid, Calamari*
France	*Encornet*
Spain	*Calamar*
Italy	*Calamaro*
Greece	*Kalámari*
Germany	*Kalmar*
Holland	*Pijlinktvis*
Denmark	*Blæksprutter*
Norway	*Blekkspruter*
Sweden	*Kalmar, Bläckfisk*

Health

Squid are a quite good source of omega-3 oils.

Per 100 g/4 oz: 81 kcals, 1.7 g fat

Seasonality

Avoid squid during its breeding season from December to May.

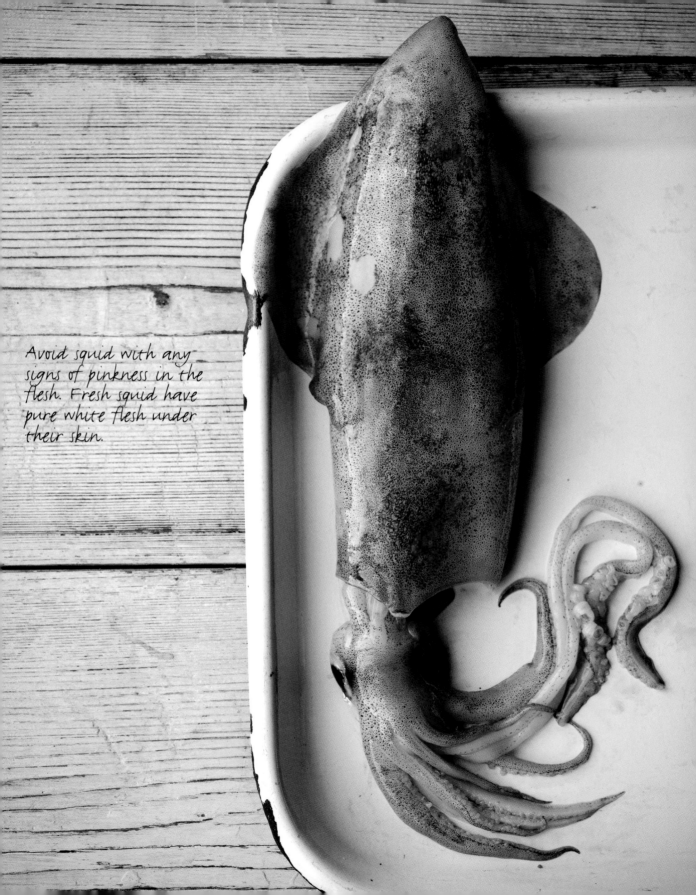

Avoid squid with any signs of pinkness in the flesh. Fresh squid have pure white flesh under their skin.

grilled squid with garlic, chilli and parsley

Serves 2 as a starter

2 squid, about 150 g/5 oz each
Olive oil, for brushing

For the dressing:

8 tbsp olive oil
2 garlic cloves, finely chopped
Sea salt and freshly ground black pepper
Pinch of ground cumin
Juice of 1 lemon
Small handful of fresh parsley,
 finely chopped
1 dried bird's-eye chilli

AT THE FISHMONGER
Ask your fishmonger to clean the
squid, and remove the gut, skin
and membrane.

Squid is increasing in popularity as more and more chefs choose to use it. I've eaten some wonderful braised squid dishes and it's gorgeous paired with Asian flavours. Squid is hard to beat dipped in milk then floured and deep-fried until crisp and golden, but cooked over a hot fire, as we do at my restaurant, it is absolutely wonderful. It maintains its incredible sweetness, which is so nice with the aromatic taste of charcoal.

Preheat the grill to its highest setting or light the barbecue.

First, make the dressing. Heat the olive oil in a pan, add the garlic, pinch of salt and the cumin and when the garlic starts to brown, squeeze in the lemon juice. Add the parsley and crumble in the chilli, then taste and season with salt and pepper.

When the grill is hot or the coals are nice and white, brush the squid with olive oil and salt, not forgetting the tentacles, and cook for 5–6 minutes on either side.

Place the squid on a large plate, putting the tentacles at the bottom, just as if you were putting it back together. Taste the dressing and spoon over the squid, then serve.

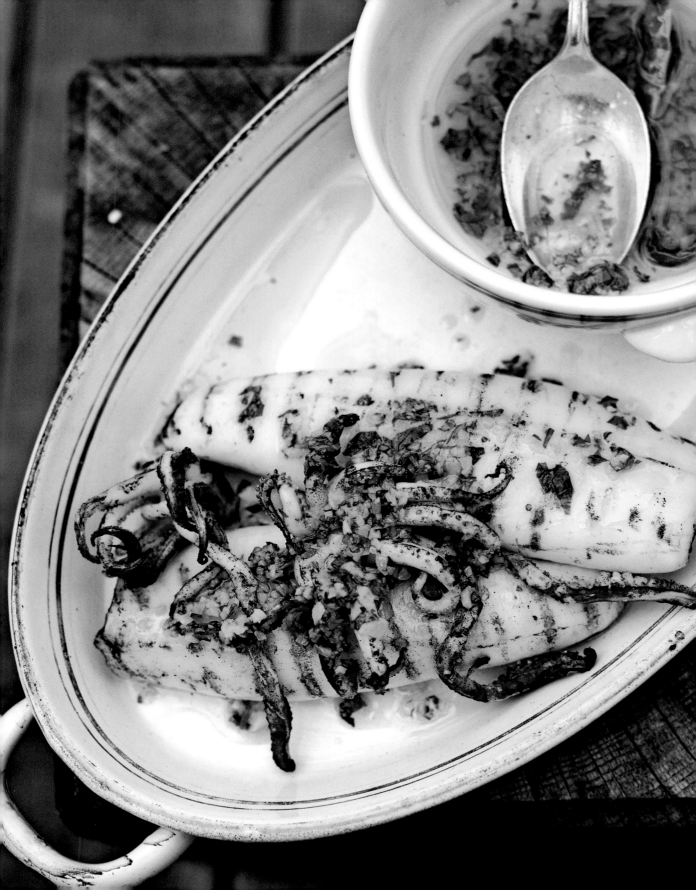

fried squid with parsley aïoli

Serves 4

250 ml/9 fl oz/generous 1 cup
 vegetable oil
300 ml/10 fl oz/1¼ cups milk
4–5 tbsp plain flour
500 g/1 lb 2 oz fresh squid
Fine salt

For the aïoli:

1 tbsp white wine vinegar
2 egg yolks
2 garlic cloves, mashed to a paste
 in a mortar and pestle
1 tsp Dijon mustard
Good pinch of salt
100 ml/3 fl oz/generous ⅓ cup
 vegetable oil
Squeeze of lemon, to taste
1 tbsp fresh parsley, finely chopped

To serve:

Lemon wedges

AT THE FISHMONGER
Ask your fishmonger to remove the
skin, fins and gut from the squid
and cut into rings of no more
than 1 cm/1/2 inch thick. The
squid must be very fresh – it
should be pure white and there
should be no pink tinges. Any sign
of pinkness means the squid has
started to turn.

Most of us will have eaten squid in the form of *calamari* and many restaurants will serve commercially produced frozen products that have been battered in a factory, which in my opinion bear little resemblance to fried squid. Squid do not need batter – they just want a light crisp coating to protect them from the hot frying. The tentacles are smaller, so they fry quicker and really crisp up, but fundamentally they don't taste different to the rest of the squid.

First, make the aïoli. Whisk the vinegar, egg yolks, garlic, mustard and the salt together in a bowl. While whisking, slowly pour in the vegetable oil in a steady stream until you have a thick mayonnaise. Add a squeeze of lemon and the parsley and stir to combine. Set aside.

Heat the vegetable oil in a deep-fryer or suitable pan to 190°C/375°F.

Place the milk and flour in separate dishes. Dip the squid first in the milk then toss in the flour and deep-fry for about 3 minutes until crisp. Drain on kitchen paper, sprinkle with fine salt and serve with lemon wedges and a spoonful of the parsley aïoli.

sautéed squid with garlic, lemon and parsley

Serves 2

350 g/12 oz fresh whole squid

6 tbsp olive oil

1 garlic clove, finely chopped

30 g/1 oz/scant ¾ cup coarse fresh
 breadcrumbs

Juice of ½ lemon

1 tbsp fresh parsley, finely chopped

Pinch of sea salt

AT THE FISHMONGER
*Ask your fishmonger to clean the
squid and remove the skin and
fins or ears.*

I have no preference for large or small squid. Larger squid will have a thicker texture and smaller squid a thinner one, and when fresh both should be as tender as each other. If you have ever had the experience of eating fried squid that turns out to be rubbery, this is not down to the cooking method but down to the species of the squid, often the species *Ilex*, which can be tough. Here is another simple but delicious preparation.

Cut the tentacles into 2 pieces and slice the squid tubes into rings, no more than 1 cm/½ inch thick. Place in a colander, give a final wash to make sure there is no grit in the tentacles or gut left attached to the inside of the squid rings and pat dry with kitchen paper.

Heat the olive oil in a frying pan, add the garlic and fry for a few minutes until the garlic starts to turn a light golden colour. Add the squid and toss the pan so the squid is coated in the garlicky oil. Add the breadcrumbs, which will crisp during the cooking process and add a wonderful texture to the dish and cook for a further 3–4 minutes until the squid turns from translucent to pure white.

Add the parsley to the pan, then remove from the heat and add the lemon juice. The pan will sizzle. Use a spoon to just stir the oil, breadcrumbs and parsley together, then serve and enjoy.

index

acknowledgements

Books are the sum efforts of many people, some of whom have been directly involved with the making and production, but also those who have provided me with inspiration or willingly shared their knowledge. I am grateful to everyone who has helped make this book possible:

Laura Cowan, my long time friend and assistant, many, many thanks for keeping it all on track as always. Clam dude, thanks for holding the fort once again whilst I did this. Mr Mark Ely on guitar – big thanks for working the room. Helen Stiles – it was great working with you on this, fish fan! Thanks to Graham, Ian and Sean Perkes for sharing their great fishing knowledge, experience and friendship; to Nigel Ward for the introduction to the most fabulous place on the planet, Brixham; to Martin Purnell for buying the most fabulous fish for the book; and to Paul Labistor, harbourmaster. To Chris Terry and Karl, whose shots have been amazing, big thanks and a raised glass of grappa – don't we have some fun?! Emily Preece-Morrison – thanks for believing in this project. Valerie Berry and Wei Tang, my home economist and stylist on this book, you were a joy to work with. Thanks to Anne Kibel, my agent. Thanks to Mike Mitchell, Wynne Griffiths, Yvonne Adam and all at Young's for your input and use of the lexicon. Mum, Dad, Ads, Mikey, Sadie, Ben, Feros, Fran, Blue and the many fisherman and people of Brixham who have chatted and drank with me about this book, I raise a glass, or two, to you all. And lastly, the biggest thanks to my wife Pen, without whom nothing would be possible.

The Publishers would also like to extend their thanks to Louise Leffler, Georgie Hewitt, Kathy Steer, Richard Bramble, Alyson Silverwood and Patricia Hymans.